Avid Editing
A Guide for Beginning and Intermediate Users

SIXTH EDITION

Sam Kauffmann

Routledge
Taylor & Francis Group

NEW YORK AND LONDON

Sixth edition published 2017
by Routledge
711 Third Avenue, New York, NY 10017

and by Routledge
2 Park Square, Milton Park, Abingdon, Oxon OX14 4RN

Routledge is an imprint of the Taylor & Francis Group, an informa business

First edition published 2000 by Focal Press
Fifth edition published 2012 by Focal Press

Library of Congress Cataloging-in-Publication Data
Names: Kauffmann, Sam, author.
Title: Avid editing : a guide for beginning and intermediate users / Sam Kauffmann.
Description: Sixth edition. | New York : Routledge/Taylor & Francis Group, [2017] |
 Includes index.
Identifiers: LCCN 2016040316| ISBN 9781138930520 (hbk) |
 ISBN 9781138930537 (pbk.) | ISBN 9781315680378 (ebk)
Subjects: LCSH: Motion pictures—Editing—Data processing. | Video tapes—Editing—
 Data processing. | Digital video—Editing. | Avid Xpress. | Media composer.
Classification: LCC TR899 .K38 2017 | DDC 777/.55—dc23
LC record available at https://lccn.loc.gov/2016040316

ISBN: 978-1-138-93052-0 (hbk)
ISBN: 978-1-138-93053-7 (pbk)
ISBN: 978-1-315-68037-8 (ebk)

Typeset in Palatino
by Apex CoVantage, LLC

Printed in Canada

Access the eResource: www.routledge.com/9781138930537

Avid Editing

Completely updated for current HD, UHD, 2K, and 4K workflows, *Avid Editing* blends the art and aesthetics of motion picture editing with technical, hands-on instruction. Appropriate for beginners and intermediate users who need to refresh their knowledge of essential post-production techniques, this fully revamped and full-color sixth edition is also an excellent tool for editors coming to Avid from other non-linear editing platforms. Topics covered include trimming, audio, effects, titles, color correction, customization, inputting, and outputting. A robust accompanying online eResource features professionally-shot footage and Avid project files, allowing readers to work alongside the lessons taught in the book.

The new edition covers:

- Avid Media Composer licensing choices
- Changes to the Avid user interface
- Basic and advanced visual effects
- Mastering Avid's audio tools
- Exploring Avid's Title Tool and NewBlue Titler Pro
- Understanding double-system sound techniques
- Syncing picture and sound files
- Understanding and applying LUTs
- The latest HD, UHD, 2K, and 4K workflows

Sam Kauffmann was named a Guggenheim Fellow in Creative Arts – Film in 2009. He teaches film production and motion picture editing at Boston University. He recently completed a film that exposes the many biases inherent in the SAT and ACT tests, called *Act Out Against SAT*, and his film *Kids Living with Slim* (2010), about African children who are HIV positive, won a CINE Golden Eagle Award. His previous film, *Massacre at Murambi* (2007), was aired on the PBS series POV. It won top prizes and was screened at festivals all over the world. In 2004, he was a Fulbright Scholar, teaching production at Makerere University in Kampala, Uganda. In 2006, he was a Fulbright Senior Specialist teaching at the National University of Rwanda.

*"Our deepest fear is not that we are inadequate.
Our deepest fear is that we are powerful beyond measure."*

—Nelson Mandela

Contents

Acknowledgments

I have many people to thank for their assistance in writing this book, but I want to give a special shout out to Ashley Kennedy. Ashley was my co-author for the fifth edition. Although her many commitments kept her from joining me in this new adventure, she agreed to serve as my consultant, guide, and touchstone as I wrote this sixth edition.

I also want to thank my many students, who, over the many years I've been teaching at Boston University, have motivated me to keep learning, and have taught me as much as I have taught them.

My colleagues at Boston University have given me advice and encouragement throughout my teaching career, especially Paul Schneider, Mary Jane Doherty, Debbie Danielpour, Charles Merzbacher, Brad Fernandes, Jake Kassen, and Jamie Companeschi. Thanks to my siblings, Bruce, Louise, and Margaret Kauffmann, who were my first teachers and forever friends.

Special thanks to the cast of *Where's the Bloody Money?*, the main project included for the exercises in this book. Actors Alicia Barrett (Sarah), Emma Guttaduaria (Colleen), and Michael Turtle (Dan) were a joy to work with. Also thanks to the talented crew who shot it with me, especially Kate Brown, Helena Bowen, Trevor Taylor, Ginny Riley, Valerie Krulfeifer, and Peter Brunet. Timothy Bussey has scored most of my films and he provided the music cue for the Documentary Practice project. You'll soon be cutting a visual montage to his music.

My editor at Focal Press, Simon Jacobs, has been particularly encouraging and helpful, and has put together a great team, including John Makowski, to deliver this edition in full and beautiful color.

This book couldn't have been written without my wife, Kate Cress, who gave invaluable support and advice along the way, and my children, Allie and Derek, who share my love of the cinematic arts—including motion picture editing.

Introduction

A lot has changed since the last edition came out, around five years ago. Then, the world was moving into high definition (HD), yet videotapes were still a popular medium of capture and the whole file-based workflow was just catching on. Now videotapes are long gone and nearly everything is file based and broadcast in HD. Today the push is to go beyond HD, even though there are currently very few outlets for ultra high definition (UHD) and 4K projects. As I write, there isn't a single broadcast network delivering content in UHD or 4K. Sure, you can buy a 4K television, but there is no 4K content to play on it. Despite this, most producers are starting to shoot everything in UHD and 4K (even though they sometimes don't know the difference between HD and UHD, let alone 4K).

But that's the way technology goes, and, unfortunately, it's often the editor who gets stuck figuring everything out. That's OK. We're up to the challenge, and it's my intention to make the transition fairly simple for you, the Avid editor. That's part of the reason I wrote this sixth edition—to help you meet the challenges of the next five years.

This book is designed for beginners who are new to Avid, and for intermediate users who might be coming back to Avid from an editing system they found lacking or problematic. Each chapter is designed to give you a solid grounding in the topic, and to prepare you to tackle the next chapter. But to be honest, after the first eight chapters, I found it difficult to figure out the best order to present the remaining chapters. The first eight chapters should be absorbed in order, but after that you may find you want to jump ahead to a topic that you find more useful. If you are suddenly asked to edit a project shot on C-Log, you may need to jump to Chapter 18. Or if you need to capture footage shot in UHD, then by all means head to Chapter 16.

Think of this book as a textbook, workbook, and user manual all rolled into one. It's written so you can read it while lounging on a couch or sitting in front of a computer following the book's step-by-step instructions.

There are two, easy-to-install practice projects that are intimately tied to the book's text and diagrams. These will help you quickly master all the Avid techniques found in the book. Both projects can be downloaded from the Focal Press/ Routledge website. The steps to guide you through this process are found on page 10 in Chapter 1.

Because I believe it's easier to start out editing a narrative film than a documentary, the first practice project is a scene from a dramatic short called *Where's the Bloody Money?* The script is located at the end of Chapter 1. With the script in front of you, you have a roadmap to start making decisions. You'll use this practice project to make basic cuts in Chapters 1 and 2, and then to master trimming in Chapters 3 and 4. Later, in Chapter 9, you'll use the master picture clips and sound clips to learn how to sync together picture and sound files, which were recorded onto separate recording devices.

The second practice project is called Documentary Practice. It includes a variety of visuals that you'll chose from in order to put together a visual montage. You'll be choosing the shots and cutting them to the length that you think works best with the music that is provided for you. You'll also use this project in Chapters 5, 6, and 7 to explore Avid's Bins, Smart Tools and an assortment of powerful Audio Tools.

In addition to the practice projects, there are suggested assignments at the end of most chapters. They are there to encourage you to practice the particular techniques and skills explained in that chapter.

When you get to Chapter 8, you'll also want to download the graphic files and a QuickTime movie, found in the Import Items folder on the website. These will help you understand the importing process, how to work with a variety of different files, and how Avid deals with files that contain an alpha or transparency channel.

Media Composer works on Apple and Windows devices, so I've tried to consistently provide the shortcut keys for both systems. Fortunately, that's really the main difference between using Avid on a Mac or PC—the shortcut keys.

Obviously, no single book can hope to explain all of Avid's features, or anticipate future changes in the software. I won't show you every technique found in the many Avid manuals, help sites, or white papers, but I'll show you the ones you'll need to know in order to cut great projects. Avid's Media Composer interface is the most stable in the industry, and this edition should last you for many years.

Getting Started

TODAY'S EDITOR

There is an ever-increasing demand for editors. Think about all the companies that are now media content creators. Netflix, yesterday's DVD distributor, now produces shows like *House of Cards*, *Narcos*, and *Daredevil*. In 2016, Netflix promised to produce 600 hours of original content and spend over five billion dollars to do it! Netflix is joined by HULU, Amazon Prime, Apple—the list goes on of companies expanding into original content creation. Add all these new providers to the long list of satellite/cable networks, like A&E, CW, AMC, HBO, BET, and Showtime, and the traditional broadcast networks, like CBS, NBC, ABC, and FOX, and that's a lot of jobs and a big demand for talented editors.

And just about every company in America now has a website that contains video content. Universities, hospitals, newspapers, magazines, tech start-ups—even car dealerships—need someone who can edit together all this new visual material. As I tell my students, you're really in demand if you can both shoot *and* edit, as nearly every company in the world recognizes the need for at least one media content creator.

In the past, editors were a special breed, sitting in a darkened room, pouring over footage to craft a story from material shot weeks before. Today it's a little different. Stories are shot, edited, and posted to a website in a single day. Even on high-end productions, cameras capture to cards that can be uploaded in minutes. The editor is often on set, creating a rough cut while the crew is busy shooting. Editing was long considered post-production, but the line between production and post-production is quickly blurring and today's editor is often part of the production team.

Although how and where an editor works may have changed, the editor's role hasn't. She or he is still critical to the success of every project. The editor remains the closest link to the audience; the story most often passes directly from the editor's computer to the audience's screen. And the editor is still faced with thousands

of decisions. *Which take is best? Can cutting out this shot speed the story? Are the lighting and composition better in this shot or that? Is the pacing of these shots too fast? Which performance is better?* And those are just the considerations for narrative projects. With documentaries, the editor often literally carves the story out of hundreds of hours of material, where countless stories can potentially exist. And short-form editors have the challenging task of telling an entire story, sometimes in less than three minutes. Like in the past, today's editors are still tasked with making magic.

IT'S ACTUALLY GOTTEN EASIER

A number of people will tell you that Avid is more complex and more difficult to learn than other competing systems, and although that may have once been true, using an Avid editing system has gotten easier over the years. Part of that has to do with the advances in camera and audio technology and the fact that you no longer need to hook up a dizzying array of video decks and video cameras in order to capture your picture and sound.

Second, there are now lots of contextual menus, "What's this?" prompts, and timeline-based tools which are more intuitive and easy to access. Finally, other companies have copied so many of Avid's timeline-based features that it's hard for anyone to claim one is easier than the other, since the workflows are often so similar.

It has gotten especially easy to get Avid onto your desktop.

AVID STORE

Simply type into your search engine "shop.avid.com" and you'll come to the Avid Store where you can purchase Media Composer software, rent it with a subscription, or share it by getting multiple licenses. This last one is for large post facilities or schools that want multiple systems available on a server. There are so many licensing options available that I've created an appendix (see page 453) to outline the different options and features that come with each.

For those of us associated with education, either a high school or college, we can get Media Composer software for an amazingly low price (Figure 1.1).

Avid Media Composer is a cross-platform system, meaning it runs on both Macs and PCs. The Avid website maintains a list of system requirements that are approved for the Media Composer family. Be sure to visit www.avid.com/US/products/media-composer/specifications to check out the qualified computers—both laptops and workstations—and their specifications.

Once you're sure that you've met all of the appropriate system requirements, go to the Avid store and buy or rent the software.

Figure 1.1

Installing the software is similar to installing any software. Just follow the steps carefully and you'll be ready to launch.

OTHER DEVICES

Although you can capture and edit with just your computer, I recommend you buy an external media drive.

EXTERNAL MEDIA DRIVE

Cameras today can create large files that can fill up your computer's internal storage really quickly and suddenly your computer won't function properly because it's full. One popular camera takes up 64 GB of space after only 12 minutes of recording time. Fortunately, storage prices are falling and you can purchase a 1 TB drive for under $150.

There are a few things to look for in your drive besides storage capacity:

- Transfer rate—look for 136 megabits per second (Mb/s) or faster
- Drive speed—look for 7200 or above
- Interface—look for USB 3.0 and, if you own a Mac, Thunderbolt (Figure 1.2).

In terms of capacity, 1 TB would be the minimum.

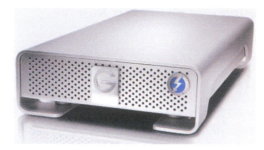

Figure 1.2 A G Technology drive with USB 3.0 and Thunderbolt.

Speakers

Sound is a critical part of any film or video, and having good external speakers is of utmost importance. If you are putting your own system together, don't try to save money here. Plan on spending at least $100 for a speaker system.

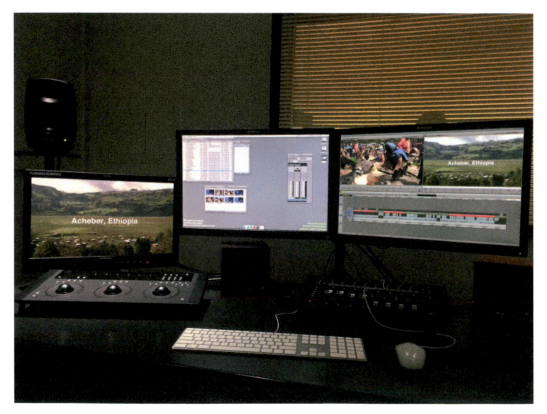

Figure 1.3

Two Computer Monitors and a Client Monitor

While I edit on my laptop when I travel, whenever I'm home I love working with two computer monitors. The one on the left is called the Bin monitor, and the one on the right holds the Source/Record monitors and the Timeline, as shown in Figure 1.3.

And many editors also add a properly calibrated client monitor, shown to the left of the two computer monitors in Figure 1.3. Although you can't alter the digital image coming into Avid, you *can* change it once it's inside, and knowing how the signal will look on a true television monitor is often critically important. The monitor has long been called a client monitor because it's the one the client is supposed to look at when the editor plays the sequence. With widescreen LCD screens dropping in price, they're a good choice because they can handle high-definition projects. You can pay many, many thousands of dollars for a top-of-the-line model, but smart shoppers can get a quality HD monitor for under $1,000.

AVID EDITING WORKFLOW

Editing a project with lots of different elements requires a great deal of organization. The following ten steps comprise a general editing workflow, but keep in mind that some of these steps can happen organically at various points throughout this process. (For example, depending on the type of project, you can begin editing, then gather more media and import and organize it, and then go back to edit further, and so on.)

We'll go over each of these steps in detail later, but this will give you a good high-level overview of the workflow.

1. Gather Files

First, gather together all the picture and sound elements that form the source material for your project. These may include:

- *Memory cards*—more and more, cameras record media to a special type of memory card—such as SD cards, Compact Flash cards and P2 cards (Figure 1.4).
- *Audio*—you can import audio files from all types of storage technologies, like CDs, Compact Flash cards, or via the Internet. These files may include mp3, aac, AIFF, wav, etc.

- *Picture, graphics, and animation*—computer graphics, animation, still pictures can be imported from all types of storage devices or via the Internet.
- *Hard drives*—many production companies will copy the camera memory cards onto external drives during production and then deliver those external drives to the editor—the editor never sees a camera memory card.

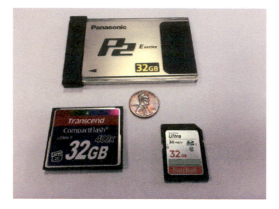

Figure 1.4 Three different camera cards—all 32 GB.

2. Create a New Project

When you launch Media Composer, you are asked which Avid project you want to open, or if you would like to create a new project. You can only work on one project at a time, but you can share bins (which house your clips and sequences) between different projects. When you start a new project you will name the project (usually the working title of the film or show) and let Avid know what kind of project it is. Is it high definition, standard definition, ultra high definition, shot on a high-resolution camera intended for theatrical distribution? At which frame rate was the footage recorded? We'll explain these choices in detail in Chapter 8, but for now, we'll soon open a project that's been created for you to practice editing.

3. Input Media

When you choose a project to work on, Media Composer opens the Project window for your new project. You can then begin inputting media. You can link to media, import media or capture media.

When you link to media, Avid creates a *master clip* and a pathway to the camera clips. If you capture or import media, Avid creates a master clip and a *media file*, which is the actual digital version of your picture or sound (and lives on your media drive).

Figures 1.5a and 1.5b The master clips in your bin (left) refer to the media files on your drive. Master clips are small "pointer files" that you can manipulate during the editing process. The media files remain unaffected.

You don't actually edit your media files or the camera clips; rather, you edit with your master clips. Think of the master clip as a shot. You can edit the shot, duplicate the shot, or flip the shot, and all of these actions affect the clip, while the media file (or camera clip) is safe and untouched on the media drive (Figures 1.5a and 1.5b).

4. Create Bins

When you link to, capture, or import your source material, you then organize it into *bins*. You can organize bins by source type, such as Card 001, Card 002, or by subject type, such as all shots that comprise a particular scene, or all your music clips. Think of bins like folders on your home or office computer. (The name "bin" actually comes from the trim bins used to hold strips of film in the days of film editing.)

Media Composer recognizes that you might be working on a large project with many bins—each holding many, many dozens of clips. Therefore, there are sophisticated search-and-find tools to help you locate just the shot you are looking for, which we'll explore in Chapter 13.

5. Add LUTs

Many of today's cameras purposely capture images that look less than ideal when screened. To capture wider exposure latitude, the camera compresses everything

into a flat and desaturated file that will, in the end, provide more latitude during the final color correction stage. A LUT (Look Up Table) for that specific camera can be quickly applied to all the clips *before* editing so that the clips approximate what they will eventually look like after the final color correction.

6. Edit

Making decisions about what part of a clip to use, and deciding which clips go in what order, is the essence of motion picture editing. Cuts have the power to change perspective, create energy, and provide new meaning. As you cut together clips in a specific order, you are creating what's called a *sequence*, like the one in Figure 1.6.

Figure 1.6

In traditional film editing, the editor starts by putting together an *assembly*, which includes all the clips that might appear in the final film, spliced together in the right order. Therefore, if you follow this method, you could call your first sequence an "assembly" sequence. Once you have assembled the material, the next stage is to create a *rough cut*, in which the clips are placed in the right order and trimmed to approximately the right length. You might name this a "rough cut" sequence. Because the material is digital, sequences are easily duplicated. You might create a sequence on Tuesday, duplicate it on Wednesday morning, and start making changes to it. At any time, you can open up the Tuesday version for comparison. As you get to the end of your editing, you begin working on what is normally called a "fine cut." Shots are trimmed to give each scene the right pace and timing.

7. Add Titles and Effects

Once you have edited your sequence, you can easily add titles and effects to it. Media Composer has tools for creating multi-layered effects and titles. Depending on how complicated they are, titles and effects can be created and added in a matter of seconds—or it can take hours to create a more complex effect. When all the titles and visual effects have been added, you have reached the stage called *picture lock*. No more changes are made to any of the video tracks.

8. Perform Sound Work

Once you have reached picture lock, it's time to add the many sound effects and music cues that will make for a rich and powerful sound track. Media Composer can monitor up to 64 sound tracks, and by using built-in tools you can make intricate sound adjustments to any and all tracks.

9. Perform Color Correction

This step is often called color grading, where each individual shot in the sequence has the luminance (light and dark values) and chrominance (color) values adjusted so that every shot is just right and each one matches the other shots that make up a scene or a sequence of connected shots. If a LUT has been applied to each clip, each one is removed so the colorist can make adjustment to the original clip.

Because the project is at picture lock at this point (and no further shot adjustments will be performed), it is often customary to send the sequence to an audio designer working with Pro Tools and a colorist working with DaVinci Resolve, and then, when the audio tracks are mixed and the shots are all color graded, the parts are brought back together. But since Avid's sound and color grading tools are first rate, more often than not, you'll be doing the work yourself, and I'll teach you how.

10. Output Your Project

Finally, the end of the Avid workflow takes place when the final edited sequence is sent out into the world. The many output options include:

- Create a compressed H.264 QT to load onto YouTube or Vimeo.
- Create a DVD or Blu-ray.
- Create a 4K file for creating a Digital Cinema Package for theatrical release.
- Create a high-resolution .mov file for screening at a film festival.

With that overview behind us, let's turn on the computer, launch the software, and explore the workspace that Avid provides us. Your system may be set up in a slightly different manner than what is described here, but all systems are fairly similar.

GETTING STARTED

We will now begin editing a scene from a film called *Where's the Bloody Money?* which we will use over the course of this book to practice techniques and skills. First, however, we need to get the project and media set up correctly.

Make sure you quit Media Composer if it's open. Follow the steps below to get to the Focal Press/Routledge website where you'll find the materials you need.

1. Go to this book's webpage on the Routledge website, which is located at the following URL: https://www.routledge.com/products/9781138930537. Then, click on the eResources tab below the book cover.
 (Note: you can also just go to https://www.routledge.com/products and type "Avid Editing" in the search field and this book will be the first result.)
2. Click on the box called "Download Avid Editing-Media and Projects" to download it onto your system. This file is nearly 3.5 GB, so it may take some time to download. If the file doesn't completely download, delete and try again.
3. The downloaded file is a zipped file. Unzip the file. Inside will be three folders: Avid MediaFiles, Avid Projects, and Files to Import.

Figure 1.7 There are three folders contained within the main Avid Editing folder: Avid MediaFiles, Avid Projects, and Files to Import.

4. **This is the most important part: in order for the software to be able to see the media, you need to place the Avid MediaFiles folder at the root level of a drive connected to your system.** (The root level just means that it needs to be at the top-most level of the drive—not inside any other folders.)

So to make this more straightforward, I'd recommend you climb inside the main folder you downloaded and just drag all three folders to the root directory of your drive.

Figure 1.8 Move the three folders provided to the root level of the drive (so that they are at the top-most level, not inside any other folders).

Once you've done that, the three folders (Avid MediaFiles, Avid Projects, and Files to Import) will be located at the root directory—at the top level, along with any other existing folders or files you have on the drive. *Note: while using an external drive is highly recommended, you can also technically place it at the root level of your computer's hard drive as long as your system permissions allow you to do so.*

Figure 1.9 Placing the Avid MediaFiles folder at the root level is absolutely essential to making sure all media is online.

5. Now that you've placed the Avid MediaFiles folder in the correct location, you're all set to begin editing. We'll explain the steps of launching the software in just a moment, but I just wanted to point out that within the "Avid Projects folder are two projects: Documentary Practice and Where's the Bloody Money. So when you launch the software and navigate to the Where's the Bloody Money project, you will search for it inside of the Avid Projects folder. Later in the course, you will access the Documentary Practice project.

Figure 1.10 There are two projects you will use in this book: Documentary Practice and Where's the Bloody Money

6. Launch Avid Media Composer. When the software finishes initializing, you will see the Select Project Window.
7. Select the "External" button, and then click on the folder icon to navigate to your project on your external drive.

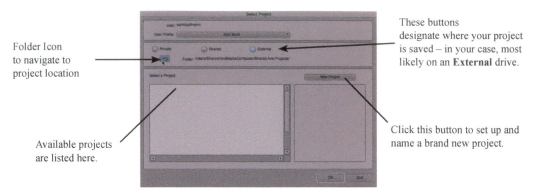

Folder Icon to navigate to project location

These buttons designate where your project is saved – in your case, most likely on an **External** drive.

Available projects are listed here.

Click this button to set up and name a brand new project.

Figure 1.11

8. Navigate to the Where's the Bloody Money project, which is located within the Avid Projects folder that you just downloaded (as shown in Figure 1.12)

Figure 1.12

9. Click Open.
10. Media Composer opens the Where's the Bloody Money project.

Once you've finished, you're ready to go!

If you have another project mounted and want to work on that instead, excellent.

The process for launching Media Composer is pretty much the same, whether you're running Mac or Windows. When the Avid software is first loaded onto the system, a shortcut or alias is usually created and left in the dock (Mac) or on the desktop (Windows). When everything is turned on, you simply click on the short-cut or alias icon to launch Media Composer (Figure 1.13). If it's not there, Mac users simply go to the Launchpad in the Dock and find it there. Windows users can find it in the Applications folder and launch it from there.

Media Composer Alias

Figure 1.13

Let's quit Avid and try again, launching from the alias.

1. Click on the Avid Media Composer alias.
2. When the "Select Project" window appears (Figure 1.14), click on the project you have been assigned. If it has been mounted, click on *Where's the Bloody Money?*

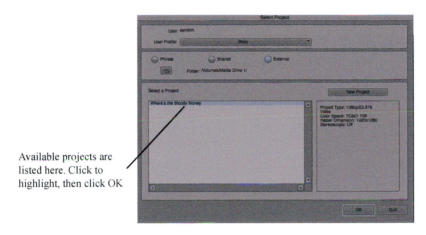

Available projects are listed here. Click to highlight, then click OK

Figure 1.14

3. Click on the OK button at the bottom of the window. The project will open, showing you the Avid interface.

THE AVID USER INTERFACE

Before we begin editing, let's make sure we are all looking at the same editing interface. Go to the menu bar at the top of your computer screen and pull down the Windows menu. Then, select Workspaces > Source/Record Editing, as shown in Figure 1.15.

Figure 1.15

If a large window called Source Browser appears, close it. We Won't need it until Chapter 8.

Your interface should basically be arranged like the windows in Figure 1.16. This is called the "Source/Record" interface, which includes the Project window containing all your bins, the Composer window containing the Source and Record monitors, and the Timeline. Drag the windows and adjust their size by clicking on the corners.

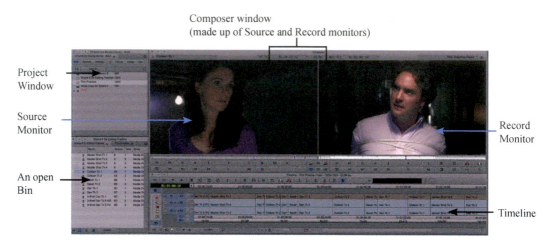

Figure 1.16 In this particular Source/Record layout, Media Composer arranges all of its windows on a single computer monitor.

So, how does everything fit together? Well, you open the bins from the Project window. Then, you select clips in the bins and load them in the Source Monitor, which holds the clips that will be edited into the project. The Record Monitor, on the right, shows the edited sequence. The Timeline presents a visual representation of the clips in the sequence.

Now, let's go over each of these windows, as well as the contents within them.

Project Window

The Project window is like a home page. It lists all the bins, and it must be open for you to work on a project, so don't close the Project window until you are ready to quit for the day.

The Project window (Figure 1.17) contains seven tabs: Bins, Volumes, Settings, Effects, Format, Usage, and Info. Let's take a look at the one you'll be using most of the time: Bins. It can also have folders, inside of which you can place bins that are similar in content. We'll be using the bins inside these folders when we reach Chapter 3 and Chapter 9.

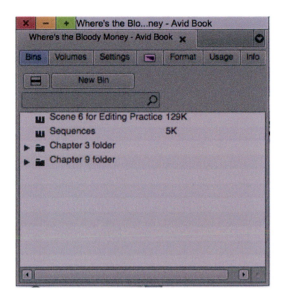

Figure 1.17

Bins

Every piece of material (video clips, music, sound effects) is housed in your bins to help organize all your important material that will make up your finished project.

To add a new bin, click the New Bin button at the top of the Project window, or press Command-N (Mac) or Ctrl-N (Windows). The bin will have the name of your project. You should then click inside the bin's name and type a new name (Figure 1.18). Here I'm creating a bin called Sequences, where I'll place the various versions of my edited project, so in this Sequences Bin, I'll place my first cut, my second cut, my third cut, and so on.

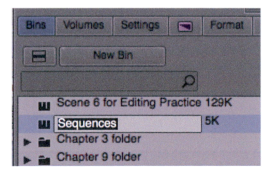

Figure 1.18

You can name the bins anything you want. Whatever makes it easiest for *you* to organize your material is the best system. However, whatever you choose to name the bin, name it immediately. Otherwise, you'll have many with the same name, and your project won't have any hope of being organized.

Here are a few tips and recommendations, though:

- Separate each type of material into different bins (Interviews, Graphics, Scenes, Music, Titles, etc.).
- Bins are arranged top-to-bottom in alphabetical order. If you want to change the order in which bins are displayed, you can add numbers in front of the bin names, or you can just add a "_" (underscore) to immediately send it to the top of the list.

To open a bin, just double-click on the icon next to the bin name. To close a bin, click on the "X" to the right of the bin name.

To open multiple bins, you can either open them in separate bin windows (by just double-clicking on each, one at a time), or better yet, you can open them in one bin window with a tabbed interface. Using a tabbed interface is a great way to save on precious editing real estate.

Creating Tabbed Bins

To create bins in a tabbed interface:

1. Shift-click on the bins that you want to have open together in a tabbed interface as I have here in Figure 1.19.

Figure 1.19

2. Click on the Fast menu icon to open the menu inside Figure 1.20. (A Fast menu, often called a hamburger, when clicked will open to reveal a menu of hidden items.)
3. Choose the Open Selected Bins In One Window.

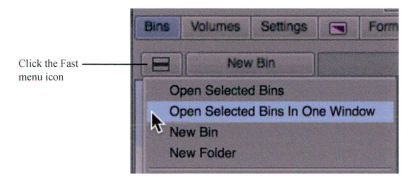

Click the Fast menu icon

Figure 1.20

The bins will form a single window, with one inside the other. Just click on the tab you want and that bin will come forward, be on top, hide the other—take your pick for how to describe it, but you'll like that all your bins are instantly available, yet tucked out of the way when not needed, as shown in Figure 1.21. Here Scene 6 for Editing Practice and Sequences are tabbed together.

Figure 1.21

There are a couple of other ways to created tabbed bins.

1. Open the first bin by double-clicking on the bin icon.
2. Drag a closed bin—one where the bin icon is black—and drop it anywhere inside the already open bin (Figures 1.22 and 1.23).

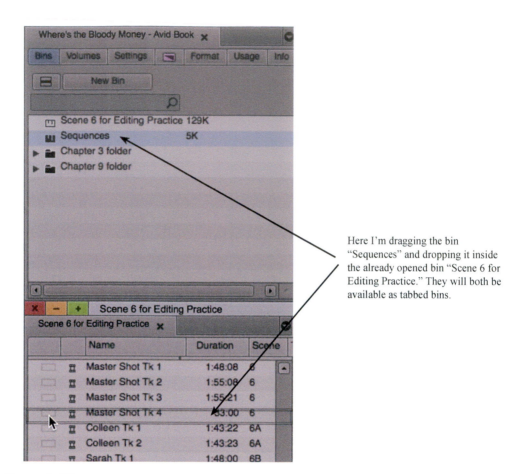

Here I'm dragging the bin "Sequences" and dropping it inside the already opened bin "Scene 6 for Editing Practice." They will both be available as tabbed bins.

Figure 1.22

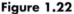

Figure 1.23

You now have two bins tucked inside each other. To see the bin that is hidden, just click on the tab and it replaces the one on top.

3. You can also stack bins that are already open, but it's a little trickier. Make sure you click and grab onto the bin tab ("Sequences"—not the main heading at the top of the bin). Then drop it on top of the bin you want it to join (Figure 1.24).

Drag and drop this Sequences tab onto the other bin, not the main heading, which is also called Sequences

Figure 1.24

You may drag as many bins as you like into the tabbed interface.

If you have a lot of bins in the tabbed interface, there might not be room for all the tabs to be visible. To access a list of all of the bins within the tabbed interface, just click on the arrow to the right of all the bin names (Figure 1.25). Here I have dragged and dropped two bins onto Video Clips for Scene 6 and by clicking on the arrow I can see and select any one of them to move to the top.

Figure 1.25

Source Monitor

Let's explore the Source Monitor. Open the bin called "Scene 6 for Editing Practice." To load a clip into the Source Monitor, just double-click on a clip icon, or click and drag it into the Source Monitor and release. Here I have double-clicked on the clip called "Master Shot Tk 1" and it appears in the Source Monitor as in Figure 1.26.

Toolbar

Position indicator within the position window

Figure 1.26

The Source Monitor is where you determine what will be edited into your project. Beneath the Source Monitor is a position bar with a position indicator, and beneath that is a toolbar with buttons that correspond to various editing commands (Figure 1.27). Click a toolbar button with the mouse and that command is executed.

Record Monitor

The Record Monitor shows you what is in your sequence; it displays what you have created by editing clips together. Just like the Source Monitor, it has a position window, position indicator, and toolbar. Figure 1.27 shows the Source Monitor on the left and Record Monitor on the right.

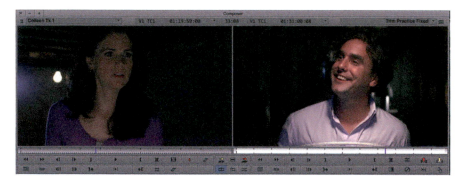

Figure 1.27

Timeline

The Timeline (Figure 1.28) shows a graphic representation of the shots you have edited into your sequence in track form—it corresponds with the Record Monitor's visual display. The Timeline can have up to 24 tracks of video and 64 tracks of

Source and Record track selectors Position Indicator Scale and Scroll bars

Figure 1.28

audio. In addition to a number of tools and workspace options along the left side, the Timeline also contains Source and Record track selectors (which we'll explore in detail in Chapter 2), Scale and Scroll bars (to zoom into and scroll along the Timeline), and a blue position indicator. Again, the position indicator in the Timeline corresponds exactly with the position indicator below the Record Monitor.

User Interface Commands

During the editing process, you will instruct Media Composer to do what you want through commands. Some of the commands are offered as buttons below the Source and Record monitors or above the Timeline.

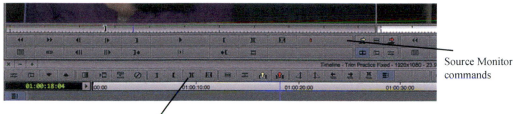

Timeline commands

Source Monitor commands

Figure 1.29

The Keyboard

In addition to the commands that are available on the Source or Record monitors, or above the Timeline, there are dozens of commands that are either already mapped to your keyboard, or that you can map to the keyboard yourself through the customization process. Indeed, these keyboard commands are *the* most important part of editing, because using the keyboard is much faster and more efficient than pressing onscreen buttons. Throughout this book, I'll continually encourage you to practice keyboard shortcuts so that you can start creating and building your muscle memory for efficient editing.

I'll discuss how to personalize your keyboard settings in Chapter 6, but for now, I'll discuss quite a few of the default keyboard commands that come with Media Composer "out of the box." The default or standard keyboard for the Media Composer can be seen in Figure 1.30.

J–K–L Three-Button Play

An extremely important keyboard combination involves three letters on the keyboard: J–K–L. Press the L key to play your clip or sequence forward. The K key acts as a pause key, and the J key plays the clip or sequence in reverse. By placing three

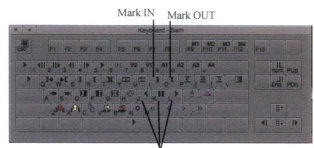

Figure 1.30

fingers on those three letters, you have a wonderful controller. Many people call this the *three-button play*.

You can also use these keys to play the sequence at different speeds. If you press the L key twice, it will play the clip or sequence at twice the sound speed. Press the key again, and it will run at three times the sound speed. Press it again, and you are running at 5x speed, but without sound. Once more will bring you to 8x speed, again without sound. Pressing the J key works the exact same way, but backward. Also, if you hold down the K key while pressing either J or L, you will creep in slow motion at ¼ speed, backward or forward.

The I and O Keys

Like the J–K–L keys, the I and O keys on the keyboard are particularly handy. When you press the I key, you are marking an IN, deciding the starting point for your clip. When you press the O key, you are marking an OUT, deciding the ending point for your clip. Notice that these two keys are right above the J–K–L keys, making it easy to mark an IN and an OUT.

The Spacebar

The spacebar is both a Play and a Stop button. If you want to play your sequence or clip in real time, press the spacebar. Press it again, and it will stop.

Other Important Commands

Examine the list of some of the most important commands and their symbols shown in Figure 1.31. Again, begin memorizing these keyboard commands and you'll have the main Avid techniques down in no time.

Additionally, two of the most important commands are Undo and Redo:

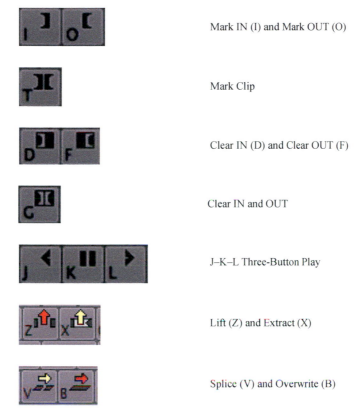

Mark IN (I) and Mark OUT (O)

Mark Clip

Clear IN (D) and Clear OUT (F)

Clear IN and OUT

J–K–L Three-Button Play

Lift (Z) and Extract (X)

Splice (V) and Overwrite (B)

Figure 1.31

- *Undo*—Command-Z (Mac) or Ctrl-Z (Windows)
- *Redo*—Command-R (Mac) or Ctrl-R (Windows)

You can go back and undo or redo up to 100 previous actions.

The Smart Tool

To the left of the Timeline, you'll see several buttons grouped together in a tool called the Smart Tool (Figure 1.32). These commands are very useful to manipulate clips once they have been edited in the Timeline—either by moving or re-arranging clips with relation to one another, or by trimming the shots to be shorter or longer.

We'll explore the Smart Tool in depth in Chapter 6, but for now, while you're first learning how to edit, I recommend that you make sure that all of the Smart Tool buttons are disabled. To disable them, click anywhere inside the border and

Click anywhere
on the border to
deselect the tools

Figure 1.32

once you do, you'll see they are no longer highlighted blue. I find it difficult to grasp the basics of Avid editing when the Smart Tools are on. It makes dragging the blue position indicator around the Timeline problematic and your mouse cursor will keep changing into an arrow or a trim icon. If you see one or more of the tools are enabled, just deselect the selected tool from the Smart Tool. But again, it's best to click on the border and disable all of them for now.

Hidden Commands

Fast menus open hidden commands. This Fast menu is called the "Tool Palette" (Figure 1.33).

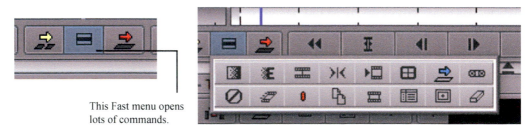

This Fast menu opens
lots of commands.

Figure 1.33

You can click and drag this tool palette and it will tear off, able to be placed anywhere on your Media Composer desktop for easy access. To return the floating tool palette to the Fast menu, just click on the red "x."

Active Window

If you want to work in a particular window, just click on it. That simple statement can solve a lot of your problems. The Media Composer contains a number of windows and monitors: the Timeline, the Source Monitor, the Record Monitor, the Project window, as well as any open bins. If you want to work within a particular window, you need to make it active. Many beginning Avid users get confused when they press a command button and nothing happens or the command gets executed in the wrong place. So, if you want to have things happen in a particular window, click on it first to make it active.

PRACTICE

There are many more commands and menus to discuss, and we'll get to them all—but for now, let's practice what we have done so far by starting an editing session. True, you haven't been shown how to use many of Media Composer's most powerful tools, but you know enough basics to be able to put together a rough cut of a scene. Just follow the instructions provided in the next section, which will guide you through your first edits and get you started. If you are cutting a different scene and not *Where's the Bloody Money?*, simply substitute your clip names for the clip names provided in the instructions.

Before you make any edits, look at the script for the scene you will be cutting to get an idea of action and dialog. If you are cutting *Where's the Bloody Money?*, you'll find the script at the end of this chapter. Most of the action has been shot from several camera angles. Each actor has a master shot and a close-up (CU). All of the action has more than one take. Your job is to make the scene come to life and to choose among the best parts. Examine the takes to find the best performances, and also determine which angle works best for that section of the scene.

Behind the Scene

The scene you will be editing was shot by a crew of nine people: a director, assistant director, director of photography, assistant camera, gaffer, dolly grip, sound recordist, and two PAs. The three actors who play Sarah, Colleen, and Dan are all members of the Screen Actors Guild. Like any scene shot on location and not in a studio, there will be unwanted sounds, spoken commands from the director, sounds of the dolly as it moves, etc. All of these "glitches" are easily fixable and we will learn to remove them later in Chapter 6. For now don't reject a clip if it has a sound issue; edit the scene, concentrating on performance and impact.

Figure 1.34 Gaffer Trevor Taylor holds a whiteboard to provide fill light on the actress playing Colleen, as the DP Helena Bowen lines up the shot.

STARTING AN EDITING SESSION

We'll start by opening the bin called "Sequences," so you have a place for your new sequence to go. Just double-click on the bin icon to open it. If you don't have a Sequences bin, click on the New Bin button and name it "Sequences."

Now click on and drag the bin called "Scene 6 for Editing Practice" onto the open Sequences bin so your bin set-up looks like Figure 1.35.

Name	Duration	Scene
Master Shot Tk 1	1:48:08	6
Master Shot Tk 2	1:55:08	6
Master Shot Tk 3	1:55:21	6
Master Shot Tk 4	33:00	6
Colleen Tk 1	1:43:22	6A
Colleen Tk 2	1:43:23	6A
Sarah Tk 1	1:48:00	6B
Sarah Tk 2	2:41:07	6B
Dan Tk 1	1:50:17	6C
Dan Tk 2	1:54:23	6C
3–Shot Dan Tk 1	2:02:18	6D
3–Shot Dan Tk 2 NG	14:02	6D
3–Shot Dan Tk 3 PU	36:01	6D

Scene 6 for Editing Practice / *Sequences*

Figure 1.35

Making Your First Cut

Follow these step-by-step instructions, which will guide you through your first editing session:

1. Double-click on "3-shot Dan Tk 3 PU." The clip will load into the Source Monitor.
2. Now, take some time to get familiar with the contents of the clip. To move quickly through the clip, drag the position indicator inside the position window in the Source Monitor. Or, you can play the clip by using the J–K–L keys on the keyboard.
3. Once you are familiar with the clip in the Source Monitor, choose your cut points. Mark an IN (press I) somewhere after the director calls "Action," and mark an OUT (press O) after the camera pans over to reveal the character Dan, and Sarah (short brown hair) starts to turn toward him (Figure 1.36). Notice the IN and OUT marks in the position indicator window.

IN and OUT marks

Figure 1.36

4. To make your first edit press the Splice button (the V key on the keyboard).
5. A dialog box should appear (Figure 1.37), asking you where you would like the "Untitled Sequence" to go. Select the Sequences bin and click OK. Presto! You have just created an "Untitled Sequence" and the Timeline will show you that the video and audio tracks have been spliced in your sequence.

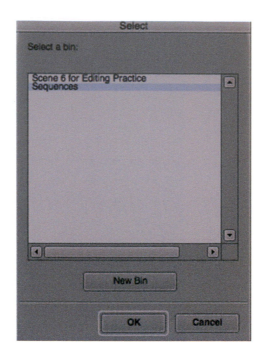

Figure 1.37

5. In the Sequences bin click on the word "Untitled Sequence" (on the letters—not the sequence icon) so you can type a name, such as *Sequence 1*.
6. Click on the Timeline so it is active. You'll see the shot you just edited. Practice navigating the Timeline by playing the shot at various speeds using J–K–L or by dragging the blue position indicator.

Adding Shots to Your Sequence

1. You are ready to cut in the next shot. The clip you want is called "Master Shot Tk 4." It also shows a 3-shot of the scene, but from a different angle—we are now focused on Sarah and Colleen looking at Dan. Double click on its clip icon to open it in the Source Monitor.
2. Play and/or scrub through the clip so you familiarize yourself with the content of the shot. You'll hear the dolly as it pushes in, but you'll notice the actress playing Sarah waits for the dolly to settle before beginning her line. She knows we can cut that sound out later, as long as the voice isn't over the dolly sound. Your goal here is to "match on action," which means you should try to find a point where Sarah's turn toward Dan matches the turn toward Dan in the first shot (as I've tried to do in Figure 1.38). If you can match these two parts of her turns, the edit will seem seamless because you're cutting on an action.

One you've marked your IN, go to the section of the clip just after Sarah says, "Where's the money?" Mark an OUT.

Figure 1.38

3. *Important*: It takes three marks to make an edit. So, to satisfy this requirement, mark an IN point at the very end of your sequence so that Media Composer knows where you want to make the edit.

Ok, you now have three marks—an IN and an OUT in the Source Monitor and an IN in the Timeline (Figure 1.39). You're all set up to make the next edit.

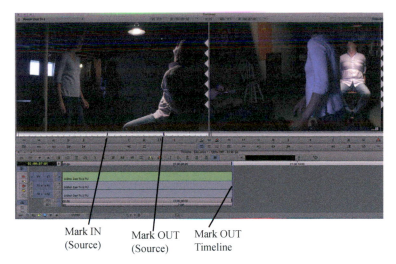

Mark IN Mark OUT Mark OUT
(Source) (Source) Timeline

Figure 1.39

4. Again, press the Splice button (V key). The new shot is added after the first shot (Figure 1.40). Play over the edit to determine if the cut works. If it's not perfect, don't worry about it. You'll learn all sorts of methods to tweak your shots and edit points once they've been edited into the Timeline in future chapters. For now, we basically just want to get the shot order correct—then we'll perfect it later.

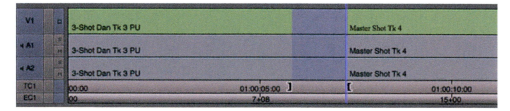

Figure 1.40

5. Keep going! Using the script at the end of this chapter, go through the entire scene, examining the angles and performances of each shot, and deciding which shots (and which portions of shots) should be edited into the Timeline for each line of dialog.

Remember, leaving your shots a bit long is just fine; you'll trim them up later. You are fairly limited as to your capabilities at this point, so just edit one shot after another, and don't worry if it's not perfect.

6. If, during this process, you want to cut certain sections of your shots out of the Timeline (say, the end of a shot is too long), you can mark an IN and then an OUT in the Timeline, as shown in Figure 1.41.

Figure 1.41

Then, to extract this section, make sure all of your tracks are selected (highlighted) and press the Extract key (X on keyboard). Again, there are *much* more efficient ways to trim up your shots, so certainly don't think that

Extract is your only option. We're just providing you the very basic knowledge of removing material just in case you need to get rid of something small during this exercise.

ENDING AN EDITING SESSION

Before leaving Avid, let's save the way we have arranged our workspace. Go to the Windows menu, then Workspaces, and then choose Save Current. Then, you can press Command/Ctrl–Q to quit the program, or choose Exit from the File Menu or Quit from the Media Composer menu.

SCRIPT FOR *"WHERE'S THE BLOODY MONEY?"*

```
INT. BASEMENT—DAY

DAN (34) is tied to a chair in the middle of the basement.
His head is down and he's unconscious. SARAH (33), Dan's
girlfriend and COLLEEN (36), his sister, are standing at a
nearby table, counting stacks of money inside three black
shoulder bags. Dan starts to stir.

                    COLLEEN
        He's waking up.

Sarah turns to look at Dan. She then moves to stand in front
of him.

                    SARAH
        Where's the money?

                    DAN
        Jeez, my friggin' head. Which one
        of you whacked me?

Colleen sets down the stack of money she was counting and
moves in front of Dan, next to Sarah.

                    COLLEEN
        Doesn't matter now does it?

                    SARAH
        Where's the rest of the money, Dan?
```

 DAN
What are you talking about!? Untie
me! This is bloody crazy.

 COLLEEN
Sarah counted it twice and I've
counted it three times. There's
only 35-grand here. The teller told
us there was over $50,000.

 SARAH
There's 15-grand missing. Where is
it, Dan?

 DAN
What a load of crap. You've been
with me every second since we left
the bank. How could I have taken
any of the money?

 COLLEEN
Listen, Danny, you can't bullshit
your way out of this.

 DAN
You're my sister. She's my fiancé.
Are you two on crack? (beat) Wait,
I get it—this is a big joke,
right? A big joke.

Dan looks at Colleen who stares back at him. She clearly
doesn't see any joke. Dan struggles to get free of the ropes.

 DAN (CONT'D)
Come on, this is madness!

Ignoring Dan, Sarah and Colleen search for answers.

 SARAH
Did you check the closet, the
drawers, under the mattress?

 COLLEEN
I did. I've gone over every inch of
the house.

 DAN
Come on, guys, I'm about to piss my
pants. Untie me!

 SARAH

What about the car?

 COLLEEN

I'll look again.

Colleen heads for the stairs, leaving Sarah to watch Dan.

 FADE TO BLACK.

2

Basic Editing

EDITING RULES

Unfortunately—or fortunately, depending on your perspective—there are no editing rules. That is not to say there isn't an aesthetic at work or that any ordering of shots is "correct." If that were the case, a trained monkey would be as good an editor as Thelma Schoonmaker, who received seven Oscar nominations and won three Oscars (*Raging Bull*, *The Aviator*, and *The Departed*).

So what makes an editor good? When you're editing a sequence involving a number of different shots, many skills and talents come into play. First of all, you must be able to choose from among the options given to you. To make the right choices you must understand the script—and not just the storyline but also the subjects' or characters' motives. If you don't know what motivates a character or subject, you can't really determine which shot or which take will work best. You also must judge performance, composition, screen direction, blocking, camera movement, lighting, and sound—for all those elements can help draw in your audience. The ability to judge the material is critical whatever the nature of the program you are editing, be it documentary, narrative, commercial, or experimental.

Once you have chosen the material that will work best, you must cut it to the right length and attach it to the right shot. And, once you think you have done that, the most important skill of all comes into play. To be a good editor you must be a good watcher. It sounds simple, but it's not. Good editors have the ability to stop being editors and quickly transform themselves into good viewers. You have to erase from your mind all your worries, hunger pangs, sore muscles, random thoughts, and anything else that could impede your concentration. And then you must really, really watch it as if for the first time—even though you've already been going over it for hours! As you watch, you are asking yourself one question: Does it work?

STARTING YOUR SECOND EDITING SESSION

As we mentioned in Chapter 1, you should start Media Composer by first connecting and turning on your external drive(s), and then launching the software. After the software loads, select Where's the Bloody Money from the Select Project window (Figure 2.1), and press OK. (If you're working in your own project, that's fine.)

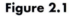

Figure 2.1

Once the project loads, open both the Scene 6 for Editing Practice bin and the Sequences bin. Remember, you can open both bins in a tabbed interface, if you like, by clicking and dragging one bin inside another.

Find your sequence in the Sequences bin, which you created during your first editing session. There are two ways to load a sequence into the Record Monitor (the monitor on the far right). You can click and drag it to the Record Monitor, or you can double-click the sequence icon. It will load in the Timeline, and you are ready to continue.

BASIC EDITING SKILLS CONTINUED

Let's review what we learned at the end of the first chapter and add some new information as we go. All of the clips for your project live in the Scene 6 for Editing Practice bin. (In fact these are all subclips, which we'll discuss in Chapter 5, but they act just like clips.) To load the clips into the Source Monitor, either double-click on the clip's icon, or click and drag it into the Source Monitor. If you want to load multiple clips into the Source Monitor, you can shift-click or lasso clips in the bin, and then drag them into the Source Monitor.

The Source Monitor pull-down menu, called the Clip Name menu (Figure 2.2), lists the clips you have loaded into the Source Monitor. Notice it lists them in alphabetical order. One useful trick to remember is that if you hold down Option (Mac) or Alt (Windows) while you click to reveal the Clip Name menu, you will see the clips listed in the order you last used them, rather than alphabetically, as shown by the right-hand menu in Figure 2.2.

Figure 2.2 The shots in the Clip Name menu will appear in alphabetical order. However, if you hold down the Option key (Mac) or Alt key (Windows), they will be displayed in the order you last used them.

Marking Clips

You select the specific portion of each shot that you want to edit into the Timeline by marking IN and OUT points. Use the J–K–L keys to play through the clip (or drag the position indicator through the position window), and once you are familiar with your clip, choose your cut points. Mark an IN by pressing the I key and

mark an OUT by pressing the O key. If you need to move either your IN point or OUT point to a different location, just set new points, and they will replace your previous points.

Once you've determined what material you want to use by setting your IN and OUT points in the Source Monitor, you must determine where that material will go. Click anywhere on the Timeline to make it active. Now, you should mark an IN point in your Timeline to let Media Composer know where you would like to make the edit.

Remember, it takes three marks to make an edit, and you now have three—an IN and an OUT in the Source Monitor and an IN in the Timeline.

Now, you have two choices. You can press the Splice button (the V key), which we explored in Chapter 1, or you can press the Overwrite button (the B key) (Figure 2.3).

Splice Overwrite

Timeline

Splice Overwrite

Figure 2.3

Splice and Overwrite: what's the difference?

Splicing is often used to edit one shot after another in the sequence—just like you did in the exercise at the end of Chapter 1. However, you don't always have to edit linearly by placing one shot after another; you can also splice shots in between other shots in the sequence. When you do this, splicing simply inserts material at the location of the IN point (or position indicator) and pushes everything after that point downstream. Regardless of whether you're splicing one shot after another, or in between shots—splicing always adds material, thereby making the sequence longer.

Overwriting, on the other hand, is usually used to write over a portion of the sequence with new material. Let's take a look at an example.

Let's say your second shot, Master Shot Tk 4, is a bit too long. You can use Overwrite to write over the end of the shot while simultaneously editing in the

third shot. In Figure 2.4, we've placed the position indicator in the Timeline where we want the third shot to go and marked an IN. Overwrite will place "Dan Tk 1" right at the location of the position indicator (our IN point) and get rid of the tail of the previous shot (Figure 2.5).

3–Shot Dan Tk 3 PU	Master Shot Tk 4	
3–Shot Dan Tk 3 PU	Master Shot Tk 4	
3–Shot Dan Tk 3 PU	Master Shot Tk 4	
00:00	01:00:10:00]
00	15+00	

Figure 2.4

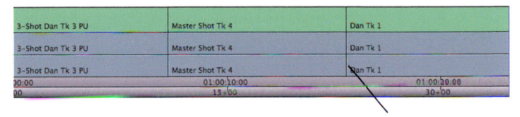

"Dan Tk 1" goes here, overwriting the tail of "Master Shot Tk 4"

Figure 2.5

THE TIMELINE

As mentioned in Chapter 1, the Timeline is a graphic representation of the shots in your sequence. It is designed to get you to make clear choices when you edit. That's why it's very important that you understand how to select your tracks when editing, using the Track Selector panel.

Selecting and Deselecting Tracks

As long as you have a sequence loaded into the Timeline, the Track Selector panel is displayed to the left of the Timeline tracks. When you have a clip loaded in the Source Monitor, the Source Track Selector panel appears beside Record Track Selector panel (Figure 2.6).

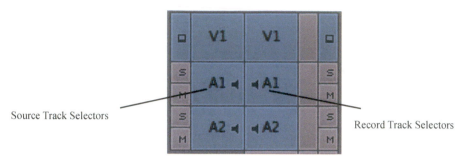

Source Track Selectors

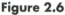

Record Track Selectors

Figure 2.6

For every edit you make—either a Splice or Overwrite—you need to be aware of which track selectors are enabled. Basically, the rule of thumb is: "If it's selected, it's affected." This just means that whichever tracks you've selected in the Track Selector panel—on both the Source and Record side—*participate* in the edit.

For example, in Figure 2.7, if we were to try to splice the material from the Source Monitor into the sequence, the audio on tracks A1 and A2 will *not* get spliced in. Why? Because the Record Track buttons for A1 and A2 are *deselected*. To select the record tracks for A1 and A2, simply click on the track buttons.

Conversely, if the record tracks were selected but the Source Track buttons were not, the source material will likewise not get spliced or overwritten into the sequence. Again, always check your tracks before splicing or overwriting.

All Source tracks are selected

This Record video track is selected

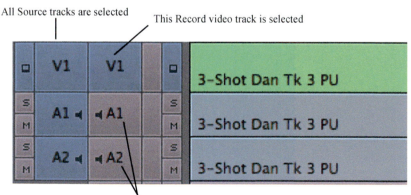

These Record Audio tracks A1 and A2 are deselected. Click on the buttons to select them.

Figure 2.7

Navigating the Timeline

We already know several ways to move around the Timeline; we know that we can use the J–K–L keys or the mouse to drag the blue position indicator. There are a few more tips and tricks for efficient Timeline navigation that will help you as you edit.

Snapping to Cut Points

When editing, it's essential to be able to park the position indicator directly between two shots in order to perform a splice or overwrite (Figure 2.8). But, getting the position indicator to quickly land there isn't that easy. And if you don't take the time to do this, you'll end up with little orphan frames in your sequence, which is certainly not desirable. Therefore, you need a shortcut to automatically snap to these transition points.

- To quickly snap to the head of a clip in the Timeline, press the Command key (Mac) or the Ctrl key (Windows) and click the cursor near the transition.
- To quickly snap to the tail of a clip, press the Option–Command (Mac) or Ctrl–Alt (Windows) keys and click near the transition.

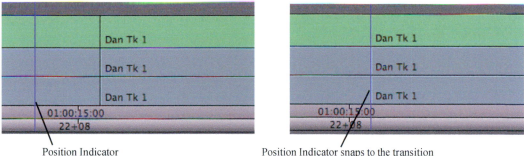

Position Indicator Position Indicator snaps to the transition

Figure 2.8

Practice this technique until it's automatic. Most editors use it constantly.

Single Frame Keys

To move a very precise amount, click on the single frame keys (the left and right arrow keys on your keyboard) (Figure 2.9). Each click will move you one frame forward or backward.

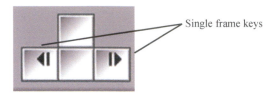

Single frame keys

Figure 2.9

The 3 and 4 keys also move one frame backward and forward, respectively. (The 1 and 2 keys move backward 10 frames and forward 10 frames, respectively.)

Digital Scrubbing

While we're playing with the single frame keys, note that when you hold down the Shift key and press the single frame keys, you can "scrub" or hear the audio digitally. We'll use this technique in Chapter 9, but try it now. Also try holding down the Shift key while playing in slow motion, using the K and L or the K and J keys. This also scrubs the audio. If you get tired of holding down the Shift key, press Caps Lock and it works as well.

CHANGING THE TIMELINE VIEW

There are times when you want to see a complete view of the entire sequence, and there are times you want to view just the section you are currently editing. Obviously, if you have a show that is an hour long and involves a thousand cuts, displaying the entire Timeline isn't useful because all you'll see is tiny black lines. Therefore, to edit effectively, you need to zoom in and look at a specific edit point or region. There are several ways to control exactly how much of your sequence is shown in the Timeline.

The Timeline Fast Menu

The Timeline Fast menu contains a number of options that allow you to change the Timeline's appearance and the view of your sequence. When you click the Timeline Fast menu and select Zoom, you'll see a list of options.

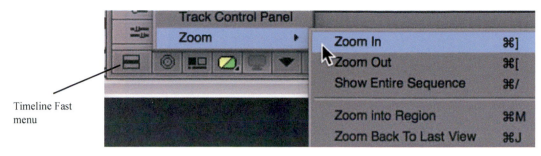

Timeline Fast
menu

Figure 2.10

- **Zoom In** and **Zoom Out** allow you to choose to see more or less of your sequence.
- **Show Entire Sequence** let's you see everything—all your clips in the Timeline.
- **Zoom into Region**. When you select this—Command-M (Mac) or Ctrl-M (Windows)—the cursor changes to a box with a double-sided arrow. Simply click and drag across an area of the Timeline with the cursor. When you release, this area is displayed in the Timeline.
- **Zoom Back to Last View**. You are returned to the region you were looking at before you chose Zoom into region.

Scaling and Scrolling the Timeline

Another way of changing your Timeline view is by dragging the Scale and Scroll bars found at the bottom of the Timeline (Figure 2.11). The bar on the left is called the *Scale bar*. Drag the small slider to the right to zoom in to look at just a few cuts—or even just a few frames. Drag it to the left, and the Timeline compresses so you're looking at a much larger percentage of the sequence.

Scale and Scroll bars

Figure 2.11

The bar on the right is called the *Scroll bar*, which has its own slider. You won't actually see it until you drag the Scale bar slider to the right. Then it appears because there are clips hidden from view, and it gives you the option of scrolling to see them. Just drag the Scroll bar slider to the left and right, and you can display different sections of the Timeline.

As you drag the Scale bar all the way to the right, the position indicator splits into two lines. This is because the position indicator travels over one frame of video at a time (Figure 2.12).

Position indicator spans over one frame of video

Figure 2.12

Finally there's the Focus button (Figure 2.13). Click once, and you zoom in a fixed amount. Click once more, and you zoom back out.

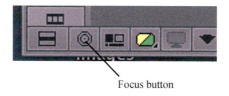

Focus button

Figure 2.13

Enlarge or Reduce Tracks

In addition to zooming in and out of your sequence, you can also perform a vertical resize by expanding the size of your tracks to make them tall and viewable; or

you can reduce the size of your tracks so that you can display many tracks in the Timeline at once.

To change the size of your tracks, select the ones you want to change (and pay extra attention to *both* the Source and Record tracks selectors, because they both matter when changing track size) and then press:

- Command-L (Mac) or Ctrl-L (Windows) to enlarge
- Command-K (Mac) or Ctrl-K (Windows) to reduce.

If you want to quickly change the size of just one track, hold down Option (Mac) or Alt (Windows) while carefully placing the cursor at the bottom line of a track button. The pointer changes shape and becomes a *resize track cursor*. In Figure 2.14, it is between V1 and A1. Drag this cursor down, and the V1 track gets larger. Drag it up, and the track gets smaller.

Resize track cursor

Figure 2.14

You'll notice that when you hold down Option (Mac) or Alt (Windows) while placing the cursor in the middle of a track button, the cursor turns into a hand (Figure 2.15). This enables you to move the entire track up or down, so A2 is moved to where A1 was before. It's not a good idea to do that now; let's wait until it is helpful before messing with this.

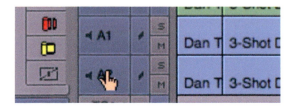

Figure 2.15

Track Monitor Icons

You can easily control what you see and hear as you play your clips and sequence by selecting a few buttons on the Track Selector panel. The small boxes on the outsides of the audio track selectors display the Solo (S) and Mute (M) buttons. The icons on the outsides of the video track selectors display the video track monitor icons (Figure 2.16).

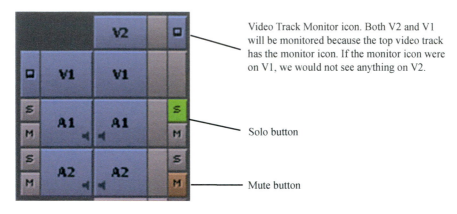

Video Track Monitor icon. Both V2 and V1 will be monitored because the top video track has the monitor icon. If the monitor icon were on V1, we would not see anything on V2.

Solo button

Mute button

Figure 2.16

You can solo or mute one or multiple audio tracks, which makes it very handy for isolating a particular group or type of audio tracks, such as voiceover, music or natural sound. (This is why it's good practice to edit all the audio of a certain type together—so that when you solo A3 and A4, for example, you can listen to just your music, or just your voiceover narration.)

The Video Track Monitor behaves a little differently, in that it's basically a "top-down" approach to viewing your material. In other words, if the top video track has the monitor icon, then all the video tracks beneath it will also be monitored.

MARKING CLIPS IN THE TIMELINE

One of the most useful buttons at your disposal is the Mark Clip button. Often you will be working on your sequence and see that you want to replace or remove a shot. One way to prepare a shot for removal is to mark an IN point at the head of the shot and an OUT point at the tail of the shot (and to get the marks at the exact

right spot, you'd need to snap to the edit points). But, fortunately, there's a much simpler way to do this:

1. Park the position indicator on the clip you want to mark.
2. Press the Mark Clip button.

The Mark Clip command can be found on the T key on the keyboard or in the Timeline toolbar (Figure 2.17).

Figure 2.17

When you mark a clip in the Timeline, you'll see an IN point at the head and an OUT point at the tail, highlighting the entire shot (Figure 2.18). This marked portion is often called a *segment*.

Colleen Tk 2	Sarah Tk	Dan Tk 1	Co
Colleen Tk 2	Sarah Tk	Dan Tk 1	Co
Colleen Tk 2	Sarah Tk	Dan Tk 1	Co

:00:50:00　　　　] 　　01:0[00:00　　　　01:0

Figure 2.18

Note that, if you accidentally select empty tracks, such as V2, or if you have A3 and A4 tracks, the Mark Clip command will mark the entire sequence and not the segment you want. So, deselect all empty tracks first, and then mark the segment you want. In Figure 2.18, I marked Sarah's segment.

Now we're ready to master two important commands: Lift and Extract. But, before practicing these commands on your sequence, let's *duplicate* it first, so if we totally mess it up we won't care because we've still got the original.

DUPLICATING A SEQUENCE

The ability to save versions of your work is important, because it's always useful to be able to view and possibly revert to a previous version. You should generally make a duplicate before trying an ambitious idea (which might not work), and also at the end of every editing session.

Let's make a duplicate of our first sequence—Sequence 1.

1. From the Sequences bin, find the sequence you've been working on.
2. Select the sequence icon so it is highlighted.
3. Right-click on the sequence icon and choose Duplicate (also found in the Edit menu), or type Command-D (Mac) or Ctrl-D (Windows). Now, you have created an identical copy of your sequence. The suffix ".copy.01" is added to it so you can differentiate between the two versions.
4. Replace ".copy.01" with today's date or a new name so you can easily tell your versions apart (Figure 2.19). I'll rename mine Sequence 2.

Sequences ✕		
Name	Duration	D
▦ Sequence 1.Copy.01	16:20	
▦ Sequence 1	16:20	

Figure 2.19

Now double-click on the new sequence icon to load it into the Timeline. You have a new version to edit with an old version ready to come back to, if needed.

LIFT AND EXTRACT

Now let's start exploring Lift and Extract, two very important editing commands that will let you remove material from your sequence.

Figure 2.20

Even though you can find these commands on your user interface underneath the Record Monitor and in the Timeline toolbar (Figure 2.20), definitely get used to using the keyboard shortcuts: Z (Lift) and X (Extract). Again, doing so will make you a faster editor.

Before performing a Lift or Extract, make sure all of your active tracks are selected (V1, A1, A2). Then, let's go to the third shot in the Timeline. Place the position indicator anywhere within the segment and then press the Mark Clip button (Figure 2.21).

	V1	V1							
				Sarah Tk	Dan Tk 1			Colleen Tk 1	Mas
	A1	A1		Sarah Tk	Dan Tk 1			Colleen Tk 1	Mas
	A2	A2		Sarah Tk	Dan Tk 1			Colleen Tk 1	Mas
		TC1			01:01:00:00			[1:01:10:00	

Figure 2.21

Now press the Lift button. The shot is gone and black *filler* is in its place (Figure 2.22). Notice that, when you lift, the length of your sequence does not change, and the shots on either side of the gap remain where they are.

	V1	V1					Colleen Tk 1	Master Shot
				Sarah Tk			Colleen Tk 1	Master Shot
	A1	A1		Sarah Tk			Colleen Tk 1	Master Shot
	A2	A2		Sarah Tk			Colleen Tk 1	Master Shot
		TC1			01:01:00:00		[1:01:10:00	

Figure 2.22

Press Command-Z (Mac) or Ctrl-Z (Windows) to undo the Lift.

Now use the Mark Clip button to mark this shot again. This time, however, press the Extract button. Hey! The clip's gone, and the Timeline has shrunk

Figure 2.23

(Figure 2.23). What really happened was that all of the clips to the right of the gap shifted down to the left to fill in the space. This one can fool you sometimes because it happens so fast you don't see it, and you wonder if you actually did anything.

You can also use Extract to quickly trim the head or tail of a shot, rather than the entire shot. To do this, you would just make sure all tracks were selected, and then mark an IN and an OUT around the portion that you wanted to extract, remembering to snap to the edit point by pressing Command (Mac) or Ctrl (Windows) when clicking near an edit point. Then, just press X to extract, and the shot is shortened.

Remember, if you want to undo an Extract, press Command-Z (Mac) or Ctrl-Z (Windows).

Now let's try performing some lifts and extracts when not all tracks are selected. In Figure 2.24, the audio tracks are selected, but the video track (V1) is deselected.

Figure 2.24

When we press the Lift button, the video remains, but the audio has been replaced by black filler (Figure 2.25). Again, no other clips have been affected, and the sequence's duration has remained constant. If Dan wasn't talking here, and there were extraneous sounds we wanted to get rid of, we could replace Dan's audio with audio from another take.

Figure 2.25

Lift works without a problem, but watch out for Extract. As you can see, in Figure 2.26, when you *extract* the audio but not the video, the audio downstream rushes in to fill in the gap. Notice how this throws everything out of sync.

Figure 2.26 In this example, because 202 frames of audio were extracted while leaving the video in place, the sequence becomes 202 frames out of sync everywhere after the extraction.

This is obviously not something you want to do. Fortunately, the Timeline shows you when you are out of sync and by how much. Plus and minus signs indicate the direction of the sync problem, and the frame count indicates the extent of the sync drift.

Bottom line—when you extract clips from the Timeline, you will almost always need to extract all tracks (V1, A1, A2, etc.) at once. Remember, if you extract some tracks, but not others, you will end up with unwanted sync drift.

IT TAKES THREE MARKS TO MAKE AN EDIT

This is a rather simple statement of fact, yet, when you really understand it, it makes profound sense. Whenever you perform a splice or overwrite, you need to make three marks.

There are only four possible choices, which are listed in the chart below. So far, we have really only concentrated on the first choice: marking IN and OUT points in the Source Monitor to define the shot, and marking an IN point in the Timeline where you want it to go.

Source Monitor	Record/Timeline Mark
1. Mark IN and OUT	IN
2. Mark IN	IN and OUT
3. Mark OUT	IN and OUT
4. Mark IN and OUT	OUT

Let's look at the other three choices. They are most often used with the *Overwrite command*, whereas choice 1 is used most frequently with the *Splice command*.

Choice 2 is useful whenever you want to replace a shot (or audio) that you've already cut into your Timeline with a better shot. Let's say you've cut a shot of a smiling baby into your sequence. When you play the sequence, you see that it would make more sense to use the shot of a crying baby. You like the length of the shot, but not the content. So you simply mark the shot in the Timeline (using the Mark Clip button). Then, find the clip of the crying baby in the bin, and load it into the Source Monitor. Play through the shot in the Source Monitor and mark an IN where you want the shot to begin. Now press Overwrite, and the shot of the crying baby replaces the shot of the smiling baby. The length of the sequence doesn't change.

Choice 3 is just like choice 2 except it marks the clip in the Source Monitor from the OUT rather than the IN. Think about it. You mark your clip in the Timeline that you want to replace. Then you find the shot you want to put in its place. Perhaps the end of the shot of the crying baby is what makes it special. So you use an OUT point rather than an IN point. You've got your three marks, and now you press Overwrite. The shot of the smiling baby is replaced by the crying baby. The length of the sequence doesn't change. You've simply replaced one shot with another—based on its OUT.

With Choice 4, the material you select in the Source Monitor gets backed up onto the Timeline. That often causes a problem. When I drove a truck for a living, I was told that 99% of all trucking accidents happened while backing up (no rearview mirror). While this does have some uses (like when you want to lay in music), it can end up erasing material you want to keep, so be careful with this one.

Like a Mantra

It takes three marks to make an edit. Think about this simple sentence. Examine the choices. Imagine different situations where you would use each of them. Try them out. See what we mean? Profound.

USING THE CLIPBOARD

The Clipboard is one of Avid's most useful tools. You can mark a section in the Timeline with an IN and OUT and then place it into the Clipboard by pressing Lift or Extract or by pressing the Clipboard icon, which is the "C" key on the keyboard.

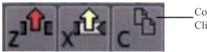

Copy to
Clipboard key

Figure 2.27

Unlike Lift and Extract, which remove the material from the Timeline, when you press the Clipboard key (Figure 2.27) the material stays in the sequence and a copy of it, including all the audio and video tracks that you have selected, is saved to the Clipboard. This way you can take something you've done and place an exact copy of it elsewhere—either in the current sequence or another sequence.

To see the material you placed in the Clipboard, go to the Tools menu and hold down the pull-down menu. Select the Clipboard Monitor (Figure 2.28), which is near the bottom of the pull-down menu.

Calculator	⌘2
Clipboard Monitor	
Command Palette	⌘3
Console	⌘6
Timecode Window	

Choose Clipboard Monitor to load the last material you selected, either by the Extract, Overwrite, or Clipboard commands

Figure 2.28

A small monitor (Figure 2.29) appears that contains everything that you copied, whether it's a clip, three clips, or an entire scene.

Figure 2.29

UNDO/REDO LIST

As we noted earlier, you can Undo and Redo your actions simply by pressing Command-Z (Mac) or Ctrl-Z (Windows). If you press the Undo command four times in a row, you can undo your four previous actions. Four is easy, but what about if you want to undo 15 previous actions? Fortunately, there's an efficient way to do this. From the Edit menu, open the Undo/Redo List, like the one shown in Figure 2.30. You'll see a list of your actions—the most recent action is on top. If you've been working for a long stretch, you may have up to 100 actions in the list. Find the one you want to Undo or Redo and select it from the list (yes, it can be difficult to pick out a specific action from its description among many, but you can usually get close). Just remember that all previous actions—those actions above it on the list—will also be undone. Who said you can never go back in time?

Figure 2.30

SUGGESTED ASSIGNMENTS

1. Duplicate your sequence. Change the name of the duplicate version to "Rough Cut" and add today's date.
2. Practice snapping to Cut Points.
3. Change the Timeline view using the Timeline Fast menu, the Focus button, and the Scale and Scroll sliders.
4. Try making your tracks larger and smaller.
5. Use the Mark Clip command to select segments in the Timeline and then use the Lift and Extract commands. Note the differences.
6. Practice splicing and overwriting clips into the sequence—both at the end of the sequence and in between shots.
7. Place material in the Clipboard Monitor and splice and overwrite it into the Timeline.
8. Use the Undo/Redo lists to go back in time in your editing session.

3

Trimming

So, if you were posed the question, "How do you know how long to hold a shot?" what would you say? It's not as easy to answer as you might imagine. Even great editors often have trouble articulating exactly how they know how long to hold a shot, or when to cut. Matilde Bonnefoy, who edited *Run Lola Run*, was recently asked by my colleague Norm Hollyn how she knows when to cut. She explained that she watches the shot and when she feels it's time, she says to herself, ". . . and now." At that point she presses stop and cuts there. Many editors are even more vague than Ms. Bonnefoy and evasively answer, "Well, umm, you just know."

In reality, sometimes it's obvious how long to hold a shot. If the shot is of a specific action, you want to hold the shot at least until the action is finished. For example, if someone is putting a cake into an oven, you don't want to cut before the cake is safely on the cooking rack. The difficult decisions involve the length of a cutaway, or the how long to hold on a person who is talking, or how long to hold a static shot or a reaction shot. Honestly, there is no one answer, just as we know there are no real rules. But you can, in fact, learn to master the art of *timing*.

The key to being a good editor—and in turn, to master the art of timing—is to learn to really *watch*. You make the cut the way you think it should be, and then you watch it. And you watch it again, and you pay attention to the timing. Is the cut too fast? Too slow? Confusing? Does it increase the energy of the scene or drag it down? Then, you try extending and shortening the shot until it's just right.

Avid boasts a powerful feature called *Trim Mode*, and when you're in Trim Mode you can quickly and easily lengthen or shorten the shots in your sequence. This is the tool that helped make Avid the television and film industry standard, and it's the main reason it will make you a better editor. Remember, a good editor has the ability to really watch. In Trim Mode, you can cut *and* watch at the same time. Sounds incredible, and it is.

TRIM CONCEPTS

Once you splice or overwrite clips into the Timeline, the real editing begins—trimming the shots to the right length, getting the correct timing and rhythm, creating a perfect match cut—and this all happens within the Timeline while in Trim Mode. Trimming takes place at the transitions, or *edit points*. The edit points are simply the boundaries where one shot ends and the next shot begins.

The important thing to realize is that you chose the part of the clip you wanted—using IN and OUT points—when you cut it into the Timeline. Remember that the clip is still whole, and still resides in your bins. Therefore, the unused portions of this material (i.e., to the left of the IN point and to the right of the OUT point) are still completely available to you.

This "extra" material is called *handle* (Figure 3.1), and it is this material that you can access when extending a shot. In turn, if you choose to shorten a shot, then material that *was* edited in your Timeline goes away, and becomes part of the shot's handle, ready to be used again if you should decide to extend the shot later.

The portion of the clip you edited into your sequence

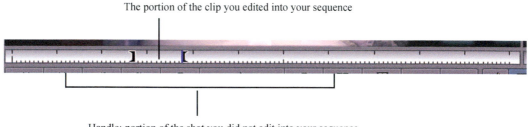

Handle: portion of the shot you did not edit into your sequence

Figure 3.1

TRIM MODE PRACTICE

For those of you who mounted the *Where's the Bloody Money?* scene from the website, there's a folder in the Project window entitled Chapter 3. Double-click on the folder icon and you'll see a bin called Trim Practice, which is there for you to use throughout this chapter. Open the bin and you'll see the sequence named "Fix These Problems"(Figure 3.2). Most of the cuts are either too short (dialog has been cut out) or too long (we hear off-microphone dialog that should be removed).

Duplicate the sequence by selecting it and pressing Command–D or Alt–D and then load the duplicated sequence into the Timeline by double-clicking the sequence icon. Now play the sequence while looking at the script for *Where's the*

Bloody Money? provided at the end of Chapter 1. You'll notice all the glaring mistakes, and you'll soon fix the problems using Trim Mode.

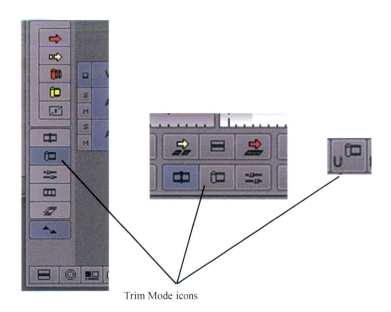

Figure 3.2

ENTERING TRIM MODE

To enter Trim Mode, click the cursor near the cut point, or transition, you want to work on, make sure the appropriate tracks are selected, and then click the Trim Mode button. The Trim Mode button is located in several places—on the Timeline toolbar, beneath the Splice/Overwrite commands, and on the U key on the keyboard (Figure 3.3).

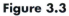

Trim Mode icons

Figure 3.3

DUAL-ROLLER TRIM MODE

As you'll see, when you press the Trim Mode command, two things happen. First, the Composer monitor changes—you are no longer looking at the Source and Record monitors. Instead, you are looking at the A-side monitor on the left, and the B-side monitor on the right (Figure 3.4). The image in the A-side monitor is the last frame of the A-side shot (Colleen medium shot), and the image in the B-side monitor is the first frame of the B-side shot (Dan's medium shot).

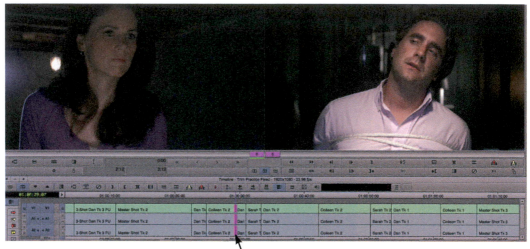
Dual-Rollers

Figure 3.4

Second, you will see pinkish colored rollers appear on both sides of the cut point in the Timeline (Figure 3.5).

We are in Dual-Roller Trim Mode. Dual-Roller Trim simply means that there are rollers on both sides of the cut point, and, therefore, the changes you make at this edit point will affect both the A-side and the B-side shots.

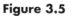
Dual-Rollers

Figure 3.5

Now that you know how to get into Trim Mode, let's talk about how to get out of Trim Mode.

LEAVING TRIM MODE

Any one of these methods will take you out of Trim Mode:

- Press the Trim Mode button again.
- Press either of the step-one-frame buttons (the left and right arrow keys).
- Click the mouse in the timecode track (TC1) at the bottom of the Timeline, or in the ruler above the Timeline (Figure 3.6).

Click anywhere in the TC1 track

Figure 3.6

When you click on the timecode track, click to the left of the transition. That way, the position indicator jumps to the spot directly before the edit point, and you're ready to watch the transition you just trimmed.

LASSOING THE TRANSITION

There are actually several additional ways to enter Trim Mode. We'll discuss one very efficient method now, which is to lasso the transition, and then we'll discuss two others in Chapter 4, when we discuss the Smart Tool.

To enter Trim Mode by lassoing the transition, click the cursor in the gray area above the tracks and near the transition you want to work on. Then, encircle the transition—dragging either left-to-right or right-to-left—including all the desired

tracks, and release the mouse (Figure 3.7). This instantly puts you into Trim Mode. Lassoing the transition is usually the fastest method, because you don't need to select any of the track selectors. To exit Trim Mode, simply use any of the methods discussed in Leaving Trim Mode.

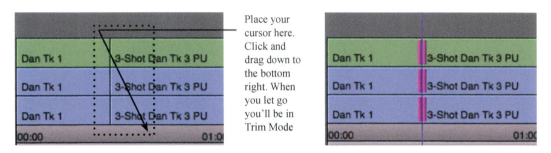

Figure 3.7

When lassoing the transition, you need to be careful that you only lasso the transition and not the entire clip or segment in the Timeline. If you do, you'll instead enter Segment Mode (see Chapter 4). You'll know that you've done this because the entire segment(s) will be highlighted. If you inadvertently enter Segment Mode, click on whichever Segment button is highlighted in the Smart Tool to the left of the Timeline (Figure 3.8). Doing this will get you back into Edit Mode. Now, try again, but lasso just the transition.

Figure 3.8

SINGLE-ROLLER TRIM MODE

Dual-Roller Trim Mode is the default trim mode. As we discussed earlier, when you're in Dual-Roller Trim Mode, you've got rollers on both sides of the edit, which means that both sides of the transition are set up to be trimmed. Dual-Roller Trim certainly has its place, but most trims you make in your sequence are Single-Roller Trims. This is because you typically need to focus on just one side of the transition when correcting timing issues.

Getting into Single-Roller Trim Mode

Getting into Single-Roller Trim Mode is pretty straightforward—you just enter Dual-Roller Trim Mode, and then you click on the *picture* on the A-side or B-side. Don't click in the Timeline. Let's try it.

1. Lasso the transition or click on a Trim Mode button so you are in Dual-Roller Trim Mode.
2. Place your cursor in the Trim Mode display and click on the A-side image (left) of Dan. The rollers move to the A-side in the Timeline (Figure 3.9).

Figure 3.9

3. Place your cursor in the Trim Mode display and click on the B-side image (right) of Colleen and Sarah counting the money. The rollers move to the B-side in the Timeline (Figure 3.10).

Figure 3.10

When you enter Single-Roller Trim Mode, just make sure that you've got rollers on the A-side *or* the B-side, and not both.

PERFORMING TRIMS

Ok, so now you know how to enter both Dual-Roller and Single-Roller Trim Modes. Now, let's put it all to use.

Trim Frame Keys

If you look at Figure 3.11, you'll see four Trim Frame keys at the bottom of the Trim Mode display. As you see, these four buttons correspond to trimming backward and forward by either one frame or 1/3 second. Depending on the type of project you're in, 1/3 second is either eight frames (for a 23.976 or 24 fps project) or ten frames (for a 30 fps project). *Where's the Bloody Money?* is a 23.976 fps project, so pressing these buttons will move you back and forth by eight frames at a time.

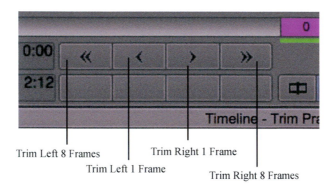

Trim Left 8 Frames
Trim Left 1 Frame
Trim Right 1 Frame
Trim Right 8 Frames

Figure 3.11

Now while you *could* use these buttons to trim, as always, it's always a much better idea to use the keyboard for most of your primary editing commands. Therefore, let's introduce the keyboard shortcuts right off the bat, so you can begin incorporating them into your workflow, and your muscle memory.

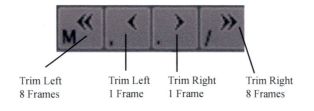

Trim Left 8 Frames
Trim Left 1 Frame
Trim Right 1 Frame
Trim Right 8 Frames

Figure 3.12

The , (comma) and . (period) keys are single-frame trim keys. They will trim the shot by one frame, left and right, respectively. The M and / (backslash) keys will trim the shot by eight frames, left and right, respectively (Figure 3.12).

SHORTENING CLIPS IN TRIM MODE

Let's go ahead and practice this by looking at a specific cut and see what happens when we use these keys in Single-Roller Trim Mode. Examine Figure 3.13. It's the first cut point in the sequence, where Dan is knocked out, but starting to come around, and Colleen, who is counting the money with Sarah, notices his movement. Play the Sequence and you'll see that the A-side—Dan Tk 1 clip—is fine, but the B-side (3-Shot Dan Tke3 PU) has the director shouting, "Action" before Colleen says her line, "He's waking up." This clip needs fixing.

The 3-Shot (the "B-side clip")
needs trimming

Dan Tk 1	3-Shot Dan Tk 3 PU			Master Shot Tk 2
Dan Tk 1	3-Shot Dan Tk 3 PU	96	3-Shot Dan	Master Shot Tk 2
Dan Tk 1	3-Shot Dan Tk 3 PU	96	3-Shot Dan	Master Shot Tk 2

Figure 3.13

1. Enter Trim Mode using any method you like.
2. Click on the B-side monitor. The rollers jump to the 3-Shot Dan Tk 3 showing Colleen and Sarah (Figure 3.14).

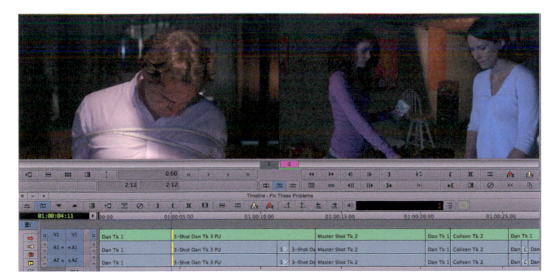

Figure 3.14

3. Click the Trim Right 8 Frames key two times to make the beginning of the clip 16 frames shorter (Figure 3.15). Now the word "Action" has been trimmed away. Clicking twice on the keyboard's/(backslash) key will do the same.

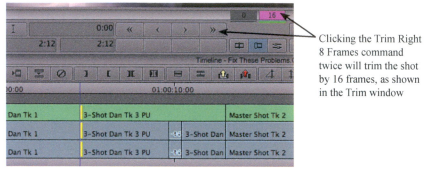

Clicking the Trim Right 8 Frames command twice will trim the shot by 16 frames, as shown in the Trim window

You are trimming the shot to the right, removing "Action."

Figure 3.15

To see and hear what you've done, click on the TC1 track below the Dan Tk 1 clip and you'll leave Trim Mode. Press Play and you'll hear that "Action" has been removed.

Now, let's move to the next cut point and play it. Here the B-side clip works, but the A-side has Sarah turn too far and move away from the table. We need to make a better match with the B-side, as that side contains Sarah's important dialog.

1. Get in Trim Mode and click the cursor on the A-side monitor. The rollers jump to Sarah in the Trim Mode display, and now the Trim Frame keys will affect Sarah's movement only.

Figure 3.16

2. Click the Trim Left 8 Frames key four times to make Sarah's movement 32 frames shorter (Figures 3.17 and 3.18).

Click four times to trim
Sarah back 32 frames

Figure 3.17

![Timeline showing Master Shot Tk 2 and 3-Shot Dan Tk 3 PU]

You are trimming the shot to the left to make it shorter

Figure 3.18

Now we have trimmed the A-side so Sarah's turn better matches her movement on the B-side.

Notice that we've trimmed frames in the exact opposite direction as in the previous example. On the A-side, trimming to the left takes away the end of the clip. On the B-side, trimming to the right takes away from the start of the clip.

LENGTHENING CLIPS IN TRIM MODE

Now let's try trimming where we are adding frames so the clip gets longer.

In the next cut point there are problems with both sides of the cut. But we'll tackle them one at a time. At the end of the Master Shot Tk 2, Sarah is asking Dan, "Where's the money?" But there's a mistake because part of her words got cut off. Instead she says, "Where's the—." So we must lengthen or extend her cut point using Single-Roller Trim Mode.

1. Get in Trim Mode and click the cursor on the A-side monitor. The rollers jump to the A-side in the Timeline.

2. Click the Trim Right commands to add 18 frames to make Sarah's clip (Master Shot Tk 2) that much longer. Use a combination of Trim Right 8 Frames and Trim Right 1 Frame commands. Your Trim Mode display should look like Figure 3.19.

Trim Right command

Figure 3.19

Reviewing the Transition Using the Play Loop Button

One very useful tool is the Play Loop button (Figure 3.20), which allows you to see your edit played out after you trim. This only works when you are still in Trim Mode.

Where is the Play Loop button? Well, basically any button that is *usually* a regular Play button (the spacebar, the 5-key, the play button under the B-side monitor) turns into a Play Loop button when you're in Trim Mode. I prefer using the spacebar. Let's try it.

Figure 3.20

1. After you have trimmed in either direction, while still in Trim Mode, press the Play Loop button to see how the shots look with the newly edited transition point. This button reviews the scene as you just cut it, in a continuous playback loop.
2. Press the button again to stop the loop and return to the Trim Mode display.

So let's fix one more shot together and we'll use the Play Loop button to perfect the timing.

We just fixed Sarah's line, on the A-side of the cut, but there's still a problem with Dan on the B-side (Dan Tk 1). He should say, "Which one of you whacked me?" but instead the word "which" is cut off and he says, "—one of you whacked me?" We need to extend his clip (Figure 3.21).

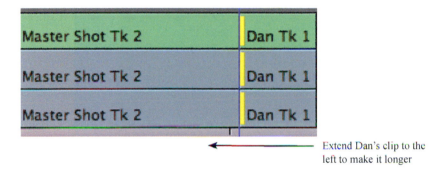

Extend Dan's clip to the
left to make it longer

Figure 3.21

1. Get into Trim Mode, and move the rollers to the B-side. You want to use the Trim Left commands to reveal the words that were cut off. Try clicking once on the Trim Left 8 Frames command button.
2. Press the spacebar (or any Play Loop button) to see how the shots look with the newly edited transition point. This button reviews the scene as you just cut it, in a continuous playback loop.
3. Press the spacebar (or any Play Loop button) again to stop the loop and return to the Trim Mode display.
4. Try adding more frames and then watching the result with the Play Loop button until the edit point is just right.

The length of the Loop depends on the type of project you're editing, but usually its plays about 2.5 seconds before the cut and then 2.5 seconds after the cut, in a continuous loop. You can change the length of the loop in Trim Settings, but we'll get to that later in the book.

Trim by Dragging

When I started out using Avid, it took me awhile to understand which direction, Trim Left or Trim Right, was the right choice. I found that actually dragging the Trim Rollers helped me visualize which direction to trim. So let's try dragging the roller.

To trim by dragging:

- Once you are in Single-Roller Trim Mode, simply hover the cursor on one of the rollers at the transition point.
- Notice as you place the cursor near the roller, the cursor turns into the Trim Mode icon (Figure 3.22).
- If you now click on the roller, you can drag it left or right.

Dragging the rollers can really give you a sense of how Single-Roller Trim Mode works. Let's try it.

If you place the rollers on the A-side, dragging left will shorten the clip; dragging right will lengthen the clip.

Figure 3.22

If you place the rollers on the B-side, as in Figure 3.23, dragging to the right will shorten the shot and dragging left will lengthen the shot.

Figure 3.23

Practice dragging to the left and right of both the A-side and B-side of a cut point. Practice until you really understand which direction does what to the clip.

Notice that if you drag the rollers so far that you reach the end of the shot, you'll hear a beep and see a small red marker in the frame to indicate that you can't roll any farther because there are no more frames to extend from the shot's handle.

Frame Counters

As you've probably noticed, the frame counters in the Trim Mode display show how many frames you have added or subtracted to the segment (Figure 3.24). If you press the trim keys that point left m or , (comma), the numbers will be negative. If you press the trim keys that point right . (period) or ./ (backslash), they will be positive numbers.

Figure 3.24

As you begin your experience with trimming, take a look at how many frames you trimmed. As you become more experienced, you'll start to intuit exactly how many frames you'll need to perform a specific edit.

Undo in Trim Mode

Remember, you can always undo and redo work in Trim Mode. If you made several trims, keep pressing Undo until you are back where you started—or, you can always use the Undo/Redo list from the Edit menu.

USING DUAL-ROLLER TRIM MODE

As we've learned, Dual-Roller Trim Mode is the default Trim Mode: when you press the Trim button or lasso a transition, you are automatically put into Dual-Roller Trim Mode (Figure 3.25). Also, as we learned, when you're in Dual-Roller Trim Mode, you've got rollers on both sides of the transition, which means that you affect both the A-side and the B-side with every trim.

Figure 3.25

In general, there's almost never any reason to trim your shots using Dual-Roller Trim Mode, because Dual-Roller Trim doesn't allow you to *isolate your problems*. For instance, say you've identified that the A-side needs to be lengthened by 15 frames. You surely didn't simultaneously decide that the B-side needed to be shortened by 15 frames. But if you used Dual-Roller Trim Mode, that is what you'd be doing every time you trimmed—each side will be lengthened and shortened by the same amount of frames. Because this is an impractical way to work, we instead use Single-Roller Trim Mode, first on the A-side and then on the B-side.

However, Dual-Roller Trim does have its place in several very specific workflows—most commonly to create a picture and sound overlap, often called a split edit or an L-cut.

Split Edits or L-Cuts

So far, we've been working with straight cuts, which just means that the video and audio end at the same time. Then, the next shot is cut in, and the video and audio end at the same time with that shot too, and so on. This is how you should initially build out your sequence—just to get the shots laid in the Timeline. However, you almost never leave a sequence full of straight cuts. This is because it often happens that the best place to cut the picture isn't necessarily the best place to cut the sound. When a picture and its sound are cut at different points, you have a *split edit*, also know as an *L-cut*. Some people call them overlaps. Let's look at how Dual-Roller Trim creates these split edits.

Let's say we have Sarah finishing her line and Colleen about to say her line. This specific situation happens at the cut point in the Timeline close to the end of the scene, as shown in Figure 3.26. We have a straight cut. There are no glitches to be fixed; no shots to be shortened or lengthened with Single-Roller Trim.

Sarah says, "Did you check the closet, doors? Under the mattress?"

Colleen says, "I did. I've checked every inch of this house."

Although the straight cuts work OK, I want to create a more powerful edit. In this case I feel creating a split edit can create more urgency than a straight cut. Let's try it.

Figure 3.26

To perform a split edit with Dual-Roller Trim:

1. Enter Trim Mode by the cut point. You are now in Trim Mode with the dual rollers on V1, A1, and A2.
2. Click on the A1 and A2 audio track selector to remove the rollers on A1 and A2 as I've done in Figure 3.27.

Figure 3.27

3. Perform the trim by using one of the following trim methods:
 - Drag the rollers 20 frames to the right.
 - Press the Trim Right 8 Frames twice and the Trim Right 1 Frame four times.
 - Press the keyboard / and . period until the Frame Counters look like Figure 3.28

Figure 3.28

and the Timeline looks like Figure 3.29.

Figure 3.29

4. Now Press the Play Loop button to review the transition. Now get out of Trim Mode and play both shots, from Sarah through Colleen.

When the split edit is made, Colleen begins to speak before we see her. We are still looking at Sarah. And then we see Colleen appear on camera and complete her line. In this case, I've decided that this result is more interesting to their exchange and better serves the scene than the straight cut we had.

Why, you ask? I have two reasons. First, notice that the camera pans to the right during Sarah's clip. By extending Sarah's image over Colleen, it helps the camera movement settle before the cut is made. Also, having Colleen's voice begin over Sarah's image makes Colleen seem more urgent and exasperated. It shows her impatience with what's going on in the scene.

I could have made the split edit the other way and had Colleen's image break in over the end of Sarah's dialog. So, let's try it to see how that works. Get back

into Dual-Roller Trim Mode, deselect the audio tracks so that the rollers are only on the V1 track, and then move the rollers 20 frames over Sarah's clip as shown in Figure 3.30.

Sarah Tk 2	Colleen Tk 1
Sarah Tk 2	Colleen Tk 1
Sarah Tk 2	Colleen Tk 1

Figure 3.30

This doesn't work quite as well because it reveals a camera pan on Colleen's side.

Split edits can make for powerful edits, but be careful you don't over use them. Oftentimes they can make a scene move too quickly and your audience suddenly loses touch with what is happening in the scene because everything is moving too quickly. Like any cut, use them only when you have a reason, as when we created a split edit with Sarah and Colleen.

Removing a Split Edit

After working on a transition and creating a split edit, you might decide that in fact a straight cut would work better. A quick way to turn a split edit back into a straight cut is to Command-drag (Mac) or Ctrl-drag (Windows).

To remove a split edit:

1. Get into Trim Mode by lassoing just V1, the track with the split edit.
2. Hold down the Command key (Mac) or Ctrl key (Windows) while you drag toward the straight cut. The trim will snap to the transition point.

A word of caution: You always want to create split edits using Dual-Roller Trim Mode. Because you are working with one track and not the other, Dual-Roller Trim Mode keeps everything in sync. If you use Single-Roller Trim Mode to trim one track and not the other, you will immediately go out of sync.

So, the basic rule is this:

- Use Single-Roller Trim Mode to adjust the length of your shots.
- Use Dual-Roller Trim Mode to create split edits.

Adding and Removing Rollers

Often in Trim Mode, you sometimes want to add or remove a roller so you're working with some tracks and not others. If you get into Trim Mode and notice that one or more of your tracks don't have rollers, it's probably because the appropriate Track Selector wasn't enabled. To add rollers to that track, simply click on the track selector. Likewise, to remove rollers on a particular track, just deselect the track selector.

Another quick way to add or delete rollers is to hold down the Shift key while clicking on the transition point you want to change.

- Shift–click on a roller to remove it.
- Shift–click on a transition to add a roller.

Changing from Single-Roller to Dual-Roller Trim Mode

If you're in Single-Roller Trim Mode and you want to be in Dual-Roller Trim Mode, simply move the mouse to the Trim Mode display and click on the line *between* the A-side and B-side. You don't have to click exactly on the line. A bit to either side will work.

TRIM MODE REVIEW

Let's review some of the hows and whys of Trim Mode.

Getting into Trim Mode

- Lasso the transition.
- Click the cursor near the transition and press the Trim Mode key.

Getting Out of Trim Mode

- Press the Trim Mode button again.
- Press either one of the step-one-frame buttons.
- Click the mouse in the timecode track (TC1) at the bottom of the Timeline, or the ruler above the Timeline.

Switching Trim Modes

- To go from Dual-Roller Trim Mode to Single-Roller Trim Mode, click either the A-side or the B-side frame in the Trim Mode display.
- To go from Single-Roller Trim Mode to Dual-Roller Trim Mode, click the frame line between the A-side and B-side frames.

Methods of Trim

- Use the Trim keys below the A-side Trim monitor to trim by one or eight frames left or right, respectively
- Use the Trim keys on the keyboard (m , . /) to trim by one or more eight frames left or right, respectively

Drag the Rollers

- Click and drag the rollers left or right.

Add Rollers and Remove Rollers

- In Trim Mode, Shift–click on the transition side where you want to add a roller.
- To remove a roller, Shift–click on it and it will be removed.

SUGGESTED ASSIGNMENTS

Although Trim Mode is a fantastic feature, it isn't always intuitive. Study this chapter and then practice, using all of the many techniques discussed. If you haven't fixed the *Where's the Bloody Money?* practice sequence inside the Chapter 3 folder, you should do that now. Otherwise, use your own sequence and follow these steps:

1. Make a duplicate of your sequence and give it today's date or a different number.
2. Practice getting in and out of Trim Mode.
3. Practice Dual-Roller and Single-Roller trims, trimming and lengthening the A-side and the B-side and creating picture and sound overlaps.
4. Practice dragging the rollers.
5. Practice adding and deleting rollers.
6. Using Trim Mode, create a fine cut, with split edits where appropriate, of *Where's the Bloody Money?* or whatever assignment you have been editing to date.

4

Advanced Trimming

IMPORTANCE OF TRIM MODE IN YOUR EDITING WORKFLOW

Now that you have Trim Mode at your disposal, the way you edit changes significantly. If you have a shot in the Timeline that is too short or too long, it's easy to trim it to just the right length. Trimming enables you to make every edit just the way you want.

So, as you go through your sequence, try to think of the trimming process as a transition-by-transition problem-solving mission. Every single transition should be analyzed to determine whether the A-side or B-side (or both) need shortening or lengthening.

Assuming that you are comfortable with trimming as explained in Chapter 3, and you want to work faster and with even more precision, let's look at a couple of advanced techniques. If you have already fixed the duplicate version of the sequence "Fix These Problems," you can go back to the original sequence and duplicate it again. If you haven't finished it, let's continue working on it.

Trimming While Watching

We have talked about the important role that watching plays in every phase of editing. Well, fortunately, there's a very simple technique that allows you to trim a cut while watching it play out in real time.

You're already familiar with using the four trim keys on the keyboard (Figure 4.1). And you're also familiar with using the Play Loop button (the spacebar) to review a transition. Now, we're going to combine these two concepts into one step.

Here's how it works. When you're in Trim Mode, press the Play Loop button, and as you're watching the edit play and loop around, press the trim keys on the

keyboard with your fingers *while keeping your eyes on the screen*. As you watch, continue to use those trim keys until the cut works. Watch and trim, watch and trim, until it's perfect.

Let's practice.

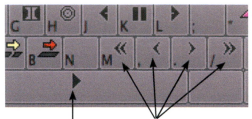

Use the spacebar with the four trim keys on the keyboard

Figure 4.1

Let's try it.

1. Get into Trim Mode.
2. Choose a side that you want to work on, either the A-side or the B-side.
3. Press the Play Loop button.
4. While the transition is looping, press any of the keyboard trim keys (M , . /).

How does this work? Well, during the Play Loop, Avid incorporates the number of times you pressed the trim keys. Then, when the loop plays through again, Avid performs the trim and updates the transition to show you what the new edit looks like. You can keep pressing the trim keys until the cut looks right. You can go in either direction, depending on what works. Go ahead and try this.

For example, let's say you are trying to fix the head of Colleen's shot so it works with Dan Tk 1. Dan asks, "Which one of you wacked me?" As Colleen Tk 2 plays, we see Colleen throw a stack of money into the bag and walk toward Dan to say her line, but before she speaks, there's Dan's voice, saying his line again. To fix it we need to get into Trim Mode, click on Colleen's image on the B-side and trim the shot. We want to remove Dan's repeated dialog (Figure 4.2).

Say you press the Play Loop button and then click the / (backslash) key, shortening the shot by eight frames. As the loop plays, you see it needs just a little more trimming, so you press the . (period) key while it's still looping. It's better, but maybe trimming another few frames will make it perfect, so you press the . (period) key until it's just right. When you're happy with the results, you press the

Dan Tk 1	Colleen Tk 2
Dan Tk 1	Colleen Tk 2
Dan Tk 1	Colleen Tk 2

Figure 4.2

Play Loop button to stop the loop. If you trimmed too many frames, you can press the , (comma) or M key to add frames back.

Look at the frame counter under Colleen's frame in the Trim Mode display before you leave Trim Mode. How many frames you added or removed doesn't really matter. What matters is that the shot is now working. And it's working because you trimmed and watched, trimmed and watched, trimmed and watched—until you got it right.

Trim One Side, Then the Other

It often happens that after you've finished cutting one side, it becomes apparent that the other side needs to be trimmed. Without leaving Trim Mode, simply click on the other window in the Trim Mode display and the rollers will jump to the other side. Now press the Play Loop button and use the Trim Frame buttons to trim the other side.

J–K–L Trimming

J–K–L Trimming is one of the greatest editing innovations of all time. Some people call this *trimming on the fly*, or *dynamic trimming*. You don't use the trim keys; instead, you trim as you play, using the J–K–L keys in Trim Mode (Figure 4.3).

We already know that J–K–L is a very powerful combination of editing buttons.

Figure 4.3

To review:

- Press J to go backward in real time.
- Press K to pause.
- Press L to go forward in real time.
- Hold down K and press L you go forward in slow motion.
- Hold down K and press J you go backwards in slow motion.

Now, you can do the exact same thing while in Trim Mode. This is a very powerful way to work, since it allows you to play through the edit as you trim frames.

Let's try J–K–L trimming by working on the A-side or B-side of a transition. You can keep practicing with this same dialogue sequence to see how J–K–L works.

1. Lasso a transition and then get into Single-Roller Trim Mode.
2. Press the J or L keys; your transitions will lengthen or shorten as you watch.
3. When you see the frame where you want to end the trim, press the K key.

When you first try this, things can get confusing, so slow things down by pressing and holding down the K key and then either J or L:

1. Hold the K key while pressing J or L to glide slowly (about 1/4 speed) backward or forward as you shorten or lengthen your clip.
2. When you reach the frame where you want to end the trim, release the J or L key.

This method is how you should perform most trims. Being able to watch the edit as you trim is truly a dynamic way to work.

TRIM PRACTICE

Let's look at a specific edit point in our "Fix These Problems" sequence in the Trim Practice bin. The cut point we're fixing has Colleen finishing her dialog and Sarah is beginning to say hers (Figure 4.4).

Here's the dialog:

Colleen: *"Sarah counted it twice. I've counted it three times. There's only 35-grand there. The teller told us there was over 50."*

Sarah: *"There's 15-grand missing. Where is it, Dan?"*

Imagine that when you spliced into the sequence of the clip Colleen Tk 2, you cut Colleen before she finished her line, so that we never hear say "50."

Hey, mistakes happen. So we need to extend the tail of Colleen's shot.

1. Lasso the transition point, including all of the audio tracks, or press the Trim Mode key.
2. Click the cursor on the A-side monitor (Colleen's image). The rollers jump to the left of the transition in the Timeline.

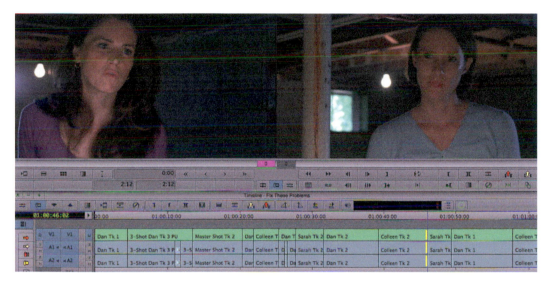

Figure 4.4

3. Hold down the K key while pressing L to slowly roll to the right to extend the shot. Listen closely to make sure you are including the "50" that was missing. When you think you have it, release the L and the K keys.
4. Press the Play Loop button. Now, watching the cut, you see that Colleen finishes her line.
5. If you're not happy, trim left or right to make it perfect.

To get out of Trim Mode, do one of the following:

- Click the mouse in the timecode track (TC1) at the bottom of the Timeline.
- Press the Trim Mode button again.
- Press either of the step-one-frame buttons.

Let's try another. At the next cut point, Sarah says "There's 15-grand missing. Where is it, Dan?"

Now the shot should have been cut after she says her line, but it was cut too long and we hear Dan saying, off-microphone, "What a load of—."

So let's fix it. Go to the transition in the Timeline and get into Single-Roller Trim on the A-side, as in Figure 4.5.

Sarah Tk	Dan Tk 1
Sarah Tk	Dan Tk 1
Sarah Tk	Dan Tk 1

Figure 4.5

Now hold down the K key and press the J to roll slowly to the left, trimming out Dan's off-microphone words.

Figure 4.6

Dual-Roller Trimming Using J–K–L

Dual-Roller Trimming with J–K–L behaves just like Single-Roller Trimming with J–K–L, with one addition. You'll see a green line below the Trim counters. If you are dual-roller-trimming audio tracks, this line dictates which side's audio you are hearing, because after all, you can't hear both the A-side and B-side audio simultaneously. Just move the mouse over the window (don't click on it) to choose which side you want to hear. The green line shifts to the side the cursor is on. In Figure 4.6 the green line is on the A-side.

Dragging to a IN point or OUT Mark

Earlier we discussed dragging the rollers to extend or shorten a shot. By simply clicking on the rollers, you can drag them left or right. It's less precise than using

the Trim Frame keys; however, if you *combine* dragging with placing an IN point or an OUT point, then dragging can be very efficient. I find dragging the rollers to an IN or OUT mark really useful whenever I'm playing the sequence and I see or hear the perfect cut point. I place my Mark IN or Mark OUT and in seconds I've made the perfect trim.

Let's try it. Before you go into Trim Mode, play your sequence. If you find a shot that needs trimming, place an IN point if it's to the left of the transition, or an OUT point if it's to the right of the transition. In Figure 4.7 I've placed an IN.

Figure 4.7

Now, enter Trim Mode. Hold down Command (Mac) or Ctrl (Windows), and click and drag the roller to the mark. The trim stops precisely on the mark (Figure 4.8). This technique works with either Single-Roller or Dual-Roller Trim Mode.

Figure 4.8

ENTER TRIM MODE ON SELECTED TRACKS

When writing a book like this, it's always hard to figure out when to introduce various Avid techniques. This is one of those times where we haven't really gotten to a point where we have more than a couple of sync dialog tracks. But soon we'll be adding music tracks and sound effects and perhaps narration, and being able to get into Trim Mode on tracks that are far from the top track will come in handy. Since this is the Advanced Trimming chapter we'll learn this now, but we'll probably go over it again in subsequent chapters.

So, it often happens that you want to enter Trim Mode on tracks that are not adjacent to the gray area that lies above or below the sequence. Perhaps you want to create an L-cut (split edit) by trimming some audio tracks. Or you want to adjust where the music cue comes in, as in Figure 4.9. Well, if you want to lasso the transition, you're going to run into a problem, since lassoing the trim requires you to drag the lasso from the gray area above or below the sequence. Yes, you can enter Trim Mode by pressing the Trim Mode button, then deselecting the Track Selector buttons to isolate the tracks where you don't want rollers, or you can Shift–click on the specific rollers to add or remove them, but that's very time consuming. There's a much easier way to get the rollers on the desired tracks in this situation.

Hold down Option (Mac) or Alt (Windows) and then lasso just the tracks you want. Examine Figure 4.9. I placed the cursor on track A2 and dragged down and across tracks A3 and A4. Presto, I got into Dual-Roller Trim, without having to select or deselect tracks.

Figure 4.9

Now you can adjust where the music starts by dragging the rollers either way. You stay in sync because this is Dual-Roller Trim Mode. Practice this. You'll use it often when working with multiple tracks in the Timeline.

SYNC PROBLEMS IN SINGLE-ROLLER TRIM MODE

We already mentioned that you should be careful not to use Single-Roller Trim on only one track, since it causes your sequence to go out of sync. Well, sometimes it just happens inadvertently, so this is a good time to examine what to do in that situation.

Sarah T	Colb...n Tk	Sa:16 Tk	Dan Tk 2	-16
Sarah T	Colle16	Sarah T16	Dan Tk 2	16
Sarah T	Colle16	Sarah T16	Dan Tk 2	16

Figure 4.10

In Figure 4.10, you can see that we've accidentally thrown the video out of sync from the audio by trimming in Single-Roller Trim Mode, while mistakenly selecting the video track but not the audio track. In effect, the video of Colleen's shot was lengthened by 16 frames, but her audio stayed the same duration. Also, as you can see, anything downstream of this transition point will be out of sync by 16 frames. This sort of situation can happen if you inadvertently turn off the sync locks, as shown in Figure 4.11. (We'll examine sync locks in more detail in Chapter 14.)

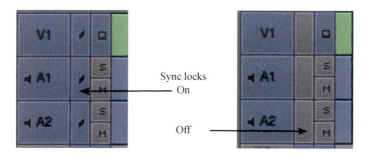

Figure 4.11

When your tracks go out of sync when editing, you'll see these out of sync lines appear.

When you're out of sync, you have to turn off all the sync locks by clicking in their little box, and then getting into Single-Roller Trim Mode to fix the problem. So, click on the V1 track and deselect the A1 and A2 tracks. Enter Trim Mode, and click on the B-side monitor. The single roller will jump to trim Colleen's video (Figure 4.12).

Figure 4.12

To get back in sync, we must either remove 16 frames from Colleen's video track or add 16 frames to Colleen's audio tracks. Let's remove 16 frames from the head of Colleen's video.

Let's try pressing the / (backslash) key once, which trims right by eight frames (Figure 4.13).

Press the / (backslash) key once

Figure 4.13

Now we can see that we are still out of sync, but we know we're trimming in the correct direction because instead of being out of sync by 16 frames, we're only out of sync by eight frames, as shown in Figure 4.14.

Figure 4.14

We press the / (backspace) key once more and we're perfectly in sync as shown in Figure 4.15.

Figure 4.15

Clicking on the keyboard keys isn't the only way to do this. We also can do the following:

- We can drag the roller to the right and watch the frame counter until 16 appears.
- We can hold down K, then press L until the edit moves by 16 frames.

So there we have it. We have explored all the ins and outs of Trim Mode. Now you know one of the main reasons why Hollywood's top feature film editors won't leave Avid for one of the newer editing software products.

SUGGESTED ASSIGNMENTS

Study this chapter and then practice, using all of the many techniques discussed. If you haven't fixed the "Fix this Sequence" inside the Chapter 3 folder, you should

do that now. If you've already fixed it, you can try fixing it again by duplicating the original sequence and using these advanced trim techniques. Or use your own sequence and try practicing all these skills that you learned here and in Chapter 3:

1. Make a duplicate of the sequence and give it today's date.
2. Practice getting in and out of Trim Mode.
3. Practice getting into Single-Roller Trim Mode and Dual-Roller Trim Mode.
4. Practice placing the cursor on the rollers and then dragging the rollers.
5. Practice dragging to an IN or OUT mark.
6. Practice trimming while you watch, using the Trim Frame key and the Play Loop command.
7. Practice adding and deleting rollers.
8. Practice entering Trim Mode on selected tracks using Option (Mac) or Alt (Windows).
9. Practice J–K–L Trimming.
10. Practice holding down the K key as you use J–K–L Trimming.

All About Bins

GETTING A NEW PROJECT TO EDIT

To better appreciate many of the bin controls, we'll leave the dialogue scene between Sarah, Colleen, and Dan for a while, and we'll start working with some documentary footage, which is really a great way to show off some of these more advanced Avid editing techniques. Specifically, I have included a short project called Documentary Practice. As long as you followed the steps to load this book's media on page 10 in Chapter 1, you should now be able to go right into the Documentary Practice project (Figure 5.1). Just launch Media Composer, and when the Select a Project window opens, select the Documentary Practice project and click OK.

If the Documentary Practice project isn't listed, then you'll need go to page 10 in Chapter 1 and follow the steps listed.

I shot the footage in Kampala, Uganda while I was there making a film and its visual nature makes it better suited for some of our work going forward. If you have your own visual material or a short documentary to work with, by all means use it to practice the techniques outlined in this chapter. If not, please load and then launch the project Documentary Practice. If you forget how to load a project, pages 11–12 in Chapter 1 explains the steps.

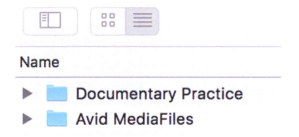

Figure 5.1

Once you launch the project, you'll see there are three bins in the Project window as shown in Figure 5.2.

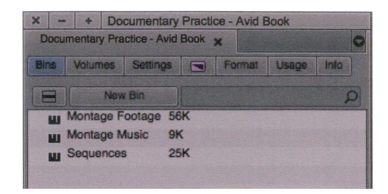

Figure 5.2

BINS AND FOLDERS

As your projects get more ambitious, you'll need ways to organize your material because there will be lot's more of it. You'll have camera clips from different cards or different shooting days; you'll have audio from various sources—sound effects, music, narration, and dialog; you'll have titles, animation, stock footage, or company logos. Figure 5.3 shows the bins I created for a short video project I filmed

Each bin contains a different type of material

Bins of like-types, but of different subjects can be organized in folders

Figure 5.3

in Ethiopia for a client called "One World Futbol." Although the finished video is less than two-and-a-half minutes long, several days of shooting and a lot of editing went into it.

Getting Folders

In Chapter 1 we learned how to create bins. To create folders to place bins into, go to the Bins tab in the Project window, click on the Bins Fast menu and choose New Folder (Figure 5.4).

Figure 5.4

Once you see the folder you can name it (My Folder) and drag Bins in and out of it. For now, let's leave it empty. We'll use it later in the book.

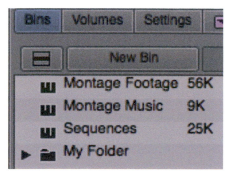

Figure 5.5

EXPLORING THE FOOTAGE

As we open the bin Montage Footage (Figure 5.5), we see there are eleven clips in the bin. As we open them in the Source Monitor, we see that some of them could be divided into smaller clips because there are multiple sections in a single clip. Examine the clip called Traffic Jams. It's over a minute long. Some of it is good and some of it isn't. Why not break it into shorter pieces so it's easier to see the wheat from the chaff. For instance, if you drag the cursor to about 27 seconds into the clip, there's a section where cars, motorbikes, and vans are coming from all directions; that would make a good section for a montage. So let's make a subclip of that section.

Creating Subclips

To create a subclip:

1. Double-click on the clip to load it into the Source Monitor.
2. Play the clip and mark the IN and OUT points for the section you want.
3. Click on the picture and drag the picture from the Source Monitor to the bin in which you want to store the subclip. Drop the subclip in the bin.

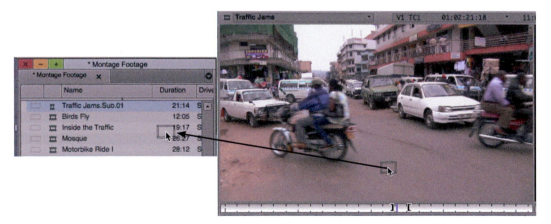

Figure 5.6

As you can see from Figures 5.6a and 5.6b, once you click and start to drag, a box forms, showing you that you are dragging the subclip.

Once the subclip is dropped in the bin, you'll see that the subclip has the same name as the master clip it came from but with the addition of Sub.*n*, where *n* is the number of times that the master has been subdivided. Also notice that the subclip icon is smaller than a clip icon—it's like a mini-clip icon (Figure 5.7).

Figure 5.7

During editing, subclips behave just like master clips, so you can do anything to them that you do during normal editing. I often click on the letters and rename the subclip, removing the Sub.*n*, so Traffic Jams.Sub.01 becomes Lots of Motorbikes (Figure 5.8).

Figure 5.8

Go ahead and break up the Traffic Jams master clip into other subclips, which will make editing together a montage easier to do because you won't have to go through over a minute of the clip to find the best material.

A slight aside: as I briefly mentioned in Chapter 1, all the clips we used in the *Where's the Bloody Money?* project weren't actual master clips—they were all subclips. That's because in order to marry the audio clips to the video clips, so the dialog stays in sync, we needed to subclip the audio and video. So try to remember how to subclip, as we'll need our subclipping skills in Chapter 9, when we learn how to sync picture to sound.

EXPLORING THE FOOTAGE IN DIFFERENT VIEWS

So far we have looked at the clips and sequences in our various bins in Text View, which is the default view when you open Avid. But you can actually look at the clips in the bins in three different ways: Text View, Frame View, and Script View.

Let's go over the three views. Just click on the buttons at the bottom of your bin to switch from one view to another (Figure 5.9).

Figure 5.9

TEXT VIEW

Text View allows you to see lots of information about your clips, and lets you customize which information is displayed. There are six categories of information that you can choose: Capture, Custom, Film, Format, Media Tool, and Statistics. You can access these from the pop-up menu at the bottom of the Text View window, which is named *Untitled* until you choose one of the categories (Figure 5.10).

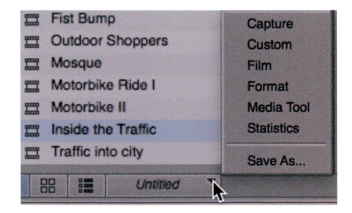

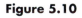

Figure 5.10

Custom allows you to build your own view by adding your own columns. Let's start by clicking Statistics. If you drag the bottom right of the Bin itself to the right, you can see how the columns of information are displayed (Figure 5.11).

	Name	Tracks	Start	End	Duration	Mark IN	Mark OUT	IN-OUT	Tape
	Birds Fly	V1 A1-4 TC1	09;28;59;28	09;29;17;16	17;16				
	Taxi Conductor	V1 A1-4 TC1	08;57;32;20	08;58;00;06	27;14	8;57;32;20	08;58;00;06	27;14	
	Traffic Jam	V1 A1-4 TC1	09;42;41;26	09;47;18;04	4;36;06	9;42;41;26	09;47;18;04	4;36;06	

Figure 5.11

Those are the default columns of information in Statistics. You can change the columns that are available by clicking inside your bin, and selecting "Choose Columns" from the Bin menu, or by accessing "Choose Columns" via the Bin Fast menu in the lower left corner of your Bin (Figure 5.12).

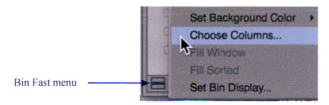

Bin Fast menu ⟶

Figure 5.12

More than 100 column headings are available to you (Figure 5.13), each providing specific information about each one of your clips.

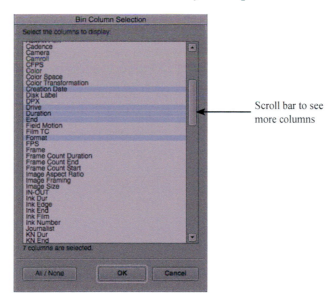

Scroll bar to see more columns

Figure 5.13

You can select or deselect column headings by clicking on them. Some headings are more useful than others, and you'll want different headings at different stages of editing. Displaying all of the headings is too confusing, so only select those you find useful. Let's change what's in the Statistics column. Remove all the columns except these. To do so, you'll have to remove Audio SR, IN-OUT, KN Start, Mark IN, Mark OUT, and Tape by clicking on them so the blue selection line is gone. Now to get the ones we want you'll need to click on the following to add them: Format, Take, Tracks, and Video.

Some good ones to use in the early stage of editing include things like:

- Creation Date When the media was created
- Drive Media drive on which your media is located
- Duration Clip length
- End Ending timecode
- Format Video format and frame rate
- Start Starting timecode
- Tracks What video and audio tracks are present
- Take We'll use this in Chapter 16.

Other column headings will be more helpful later on, when we become involved with more complex operations.

Once you deselect and select the appropriate columns, click OK. Notice Statistics is now italicized with the number .1 added. Let's give that *Statistics.1* column view a name.

1. Click on the arrow next to the Statistics.1 name. Click on Save As . . .

Figure 5.14

2. When the View Name window appears, type a name like My View and then click OK.

Moving Columns

If you would like to change the order of the columns, simply click on the column heading and drag it to a more convenient position. In Figure 5.15, I have dragged the Duration column to the left so it is now next to the Name column.

Name	Start	Duration
Outdoor Shoppers	01:00:57:28	7:26
Taxi Conductor	01:00:17:16	11:27
Birds Fly	01:00:02:03	12:05

Name	Duration	Start
Outdoor Shoppers	7:26	01:00:57:28
Taxi Conductor	11:27	01:00:17:16
Birds Fly	12:05	01:00:02:03

Figure 5.15

Let's put the columns in our My View in the following order by clicking on the column headings and dragging:

Name Duration Start Creation Date End Format Tracks Drive Video

Make Your Own Column

One handy Avid feature is it allows you to create your own special column in any of the column views. Avid calls it a Custom Column. It's amazingly quick and easy. So let's add a special column to My View.

1. Right-click anywhere in the list of columns to place a custom column. A menu appears.
2. Select Add Custom Column (Figure 5.16).

Figure 5.16

3. When an Untitled column appears, type a name.
4. Click in the column next to a clip and add information.

As you can see in Figure 5.17, I've called my custom column "Stars," and I've added a rating system to my clips, listing which are the best and worst shots, according to how many stars I give them. You can name it whatever helps you keep track of information.

Name	Stars
Outdoor Shoppers	***
Taxi Conductor	****
Birds Fly	*****

Figure 5.17

FRAME VIEW

Click on the Frame View button to switch from Text View to Frame View (Figure 5.18).

Frame View button

Figure 5.18

You'll see all your clips as individual images, like small postage stamps, or thumbnails, as shown in Figure 5.19.

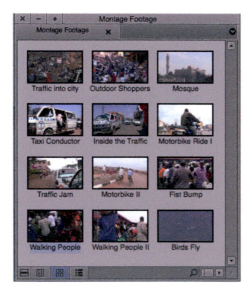

Figure 5.19

By default, Avid shows you the first frame of the clip. If we look at the clips from *Where's the Bloody Money?* in Frame View, we see how that isn't very helpful, as the first frame shows a slate in every thumbnail (Figure 5.20).

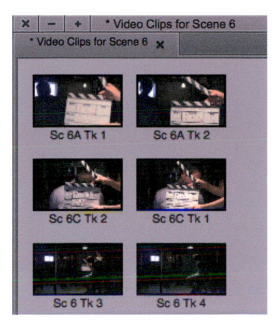

Figure 5.20

If you want to display a thumbnail that is *not* the first frame, simply click on the image and then use the J–K–L keys to find the most representative frame. Or click the spacebar until you progress to the desired frame. When you've found the replacement frame, press spacebar again.

- If you want to make these thumbnails larger, press Command–L (Mac) or Ctrl–L (Windows).
- If you want to make the thumbnails smaller, press Command–K (Mac) or Ctrl–K (Windows).

If you want to clean up the view of your thumbnails in Frame View, you can select Fill Window or Fill Sorted from the Bin Fast menu (Figure 5.21). If you click on a clip in the Bin in Frame View, you get more choices in the Fast menu. All of them are there to help you keep the clips in view.

Figure 5.21

SCRIPT VIEW

This view allows you to type comments about a clip or sequence (Figure 5.22). It displays a combination of Frame and Text View. Entering comments is a great way to give more subjective information about your footage.

Figure 5.22

Create a Quick Sequence in Frame View

One thing you can do in Frame View is to physically re-arrange the clips inside the bin (Figure 5.23), which is a great way to map out, or storyboard, your shots. This is helpful if you organize your thoughts best visually, rather than textually.

Figure 5.23

What's even more important is that you can quickly create a sequence by lassoing the clips that you've organized into a storyboard and dragging them into the Timeline. Place four clips in Frame View below the other clips, as I've done in Figure 5.23. If you're working with the Documentary Practice project, provided as part of this book, choose the four clips from Montage Footage bin and place them in a row.

First open the Sequences bin and select it. Now go to the Timeline menu, select New and choose Sequence. An Untitled Sequence will appear in the Sequence bin and an empty Timeline will open. Name this sequence "Montage." Click back on the Montage Footage bin and lasso those four clips, so they are all selected, and then Drag and Drop them into the Timeline as in Figure 5.24.

Figure 5.24

Presto! You've got a sequence of four shots, as shown in Figure 5.25.

Figure 5.25

We'll use this Montage sequence in the next two chapters.

DELETING SEQUENCES AND CLIPS

You can delete just about anything you have created. You do this by working right from within your bin. Say you wanted to delete a sequence. Just click on the sequence icon and press the Delete key on your computer's keyboard. Because you don't want to accidentally delete something important, you will immediately see a dialog box—kind of an "Are you sure?" prompt just like the one shown in Figure 5.26. To make sure you're *really* OK with deleting the sequence, you have to physically click the cursor inside the empty checkmark box before clicking OK.

Figure 5.26

You'll probably delete a lot of sequences in the course of your work. Let's face it—not everything is worth saving. But, you should probably think twice before you delete a master clip. Remember that a master clip is the shot. It's your footage or sound. It has two parts: the master clip itself, which contains all the metadata, and the media file, which is the captured material on the hard drive.

If you have selected a master clip for deleting, the buttons that dictate which part of the clip are to be deleted will not be checked. You have to click inside the button to check off your choices. You can delete either the master clip or the media file(s), or both. This is an important decision! Let's look at why we might want to delete any part of a master clip.

Let's say you select a clip in one of your bins and press the Delete key. Figure 5.27 shows the dialog box that appears. Here are your choices:

Figure 5.27

1. If you want to get rid of the shot because it's worthless, you will never use it, and you want to permanently remove it, then check *both* boxes: *Delete master clip(s)* and *delete associated media file(s)*. The clip and its media file are deleted. The footage may still exist on a back-up drive, but Media Composer doesn't know anything about it.

2. If you are running out of storage space and you need to make room for other material, delete the associated media file but *not* the master clip itself. In this case, click *only* the box *Delete associated media file(s)*. The actual footage gets erased from the media drives but all the information about the clip, including editing choices about the shot, remains stored within Media Composer. Whenever you look for that clip you will find it in the bin, but a "Media Offline" tag will appear if you load it into the Source Monitor. To get your clip back, you'll just need to re-link or reimport it, which we'll explore in Chapters 8 and 9.

3. You almost never want to check *Delete master clip(s)* by itself. If you deleted in this way, you would be using up space on your drive to store material you can't even use because Media Composer has no way of finding it.

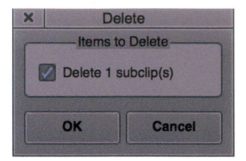

Subclips can be deleted as well (Figure 5.28). What's important to understand is that deleting a subclip does not affect the master clip it came from. The master clip still exists, safely in the bin where you placed it. That's why when you select a subclip and hit your computer's Delete key, the checkbox is already checked. Just press OK and it's gone.

Figure 5.28

SUGGESTED ASSIGNMENTS

1. Load a master clip into the Source Monitor and make several subclips from it.
2. Rename the subclips.
3. Change the view of your clips and subclips from Text View to Frame View and Script View.
4. Write comments in the boxes in Script View.
5. Go back to Text View, click on the Bin Fast menu and select Choose Columns from the menu. Examine the choices. Click on additional columns.
6. Select Frame View. Make the thumbnails bigger or smaller.
7. Click on the Bin Fast menu and try the commands that Fill and Align the thumbnails.
8. Re-arrange the thumbnails to make a storyboard of the clips, at the bottom of the bin, from left to right.

6

Sound

THE IMPORTANCE OF SOUND

Many people don't realize just how important sound is to the success of a project. "It's a visual medium" is the common wisdom handed down as gospel. Well, that's only half right. In truth, stunning cinematography can be totally diminished by a poor-quality soundtrack. Indeed, good sound is critical to good filmmaking; it reaches into the subconscious and affects viewers in ways that picture simply can't.

During the production process, the only sound you usually care about while shooting is the sync sound—the dialog or words spoken by the subjects. A good sound recordist works really hard *not* to record the ambient sounds—the traffic, people in the background, footsteps, etc. Yes, ambient sounds are vitally important to the creation of a believable aural environment, but you add them during editing—*not* during shooting. That way, you can separately adjust the relative levels of your dialog and your ambient sounds.

So when exactly do you create the sound design? Most often, sounds are added to films and videos after the picture and dialog have been edited. This stage is often called *picture lock.* Once picture lock is reached, sound editors begin finding and creating the sound effects that were kept out during shooting. Often, sound editors must invent sounds. For instance, what does a dinosaur sound like in *Jurassic World*? Or what sound does Rey's lightsaber make as she battles Kylo Ren?

And doesn't sound designer Ethan Van der Ryn, who worked on all three *The Lord of the Rings* movies, deserve as much credit for the films' success as Andrew Lesnie, the cinematographer—because so much of the emotional impact comes from the sound track. Film is *shot*. Sound is *built* a layer at a time during post-production.

Although Media Composer is known for its ability to cut picture, you'll soon realize that it also gives you tremendous control over your sound tracks. Take advantage of that capability. It'll make a huge difference in the success of your work.

As a quick aside, this is a longish chapter, in part because Avid has so many ways of helping you get great sound. Fortunately a lot of this information is easy to grasp, and the tools themselves are nicely designed. I've added a break less than halfway through the chapter so that you can begin to edit the Montage sequence, cutting to the Montage Music. Then you can come back, refreshed and anxious to learn more Avid sound tricks and techniques.

LOAD A PRACTICE SEQUENCE

Let's start by opening up the Documentary Practice project. You should find the Sequence bin, which holds the "Chapter 6 Sequence" that we put together at the end of Chapter 5. Duplicate the sequence, and then load the duplicated sequence into the Timeline. When you play it, you'll notice the audio levels of the four clips are very uneven and need work.

CHANGING AUDIO LEVELS

When you capture your audio, the sound levels aren't always perfect, and often they are quite uneven—like the ones in our practice sequence. Often, you need to raise or lower the levels once you start editing. This becomes especially important when you begin adding multiple audio tracks and mixing many different sounds together. After all, you don't want your sound effects to obstruct your music, or your music to drown out the actors' voices. Media Composer provides several tools to help you control the sound levels of your tracks so they work well together.

AUDIO TOOL: WHAT LEVEL IS CORRECT?

The Audio Tool is there to help you set the appropriate audio levels. Go to the Tools menu and select the Audio Tool. There are six different tools that deal with audio so select the right one. When it opens it will not have the green and yellow color bars you see in Figure 6.1. Only when you play your audio will Avid tell you graphically how loud or soft your sounds are.

Audio level is a measure of a sound's intensity, and is measured relative to a reference audio level. A reference level of -20 is the standard professional level. Normal conversation should fall around the -25 dB to -14 dB range on the digital scale (left-hand scale is digital; right-hand scale is analog). Quiet sounds should fall around -60 dB to -30 dB, and loud sounds can peak at -4 dB for the loudest shout or bang—but you shouldn't let any of your levels get higher than that. In other words,

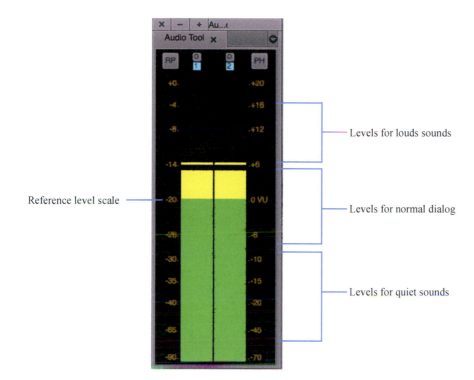

Reference level scale

Levels for louds sounds

Levels for normal dialog

Levels for quiet sounds

Figure 6.1

place your average sounds around the reference level and let your loud sounds use the headroom, but never let anything get higher than -4 dB.

Your audio levels are also displayed in the VU meters in the Timeline window, right above your sequence (Figure 6.2).

Figure 6.2

The Audio Tool and VU meters warn you when your levels are much too loud, by visually indicating when the audio is clipping—which can result in sound distortion. When clipping occurs, the color of the VU meter turns from yellow to brown, and the audio channel numbers at the top of the Audio Tool turn red (Figure 6.3). If you play the "Man rolls barrel" clip, you'll see what clipping looks like.

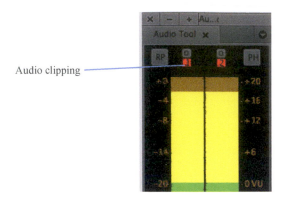

Audio clipping

Figure 6.3

Audio Mixer

Now that you know how to approach setting your audio levels, let's talk about how to actually adjust them.

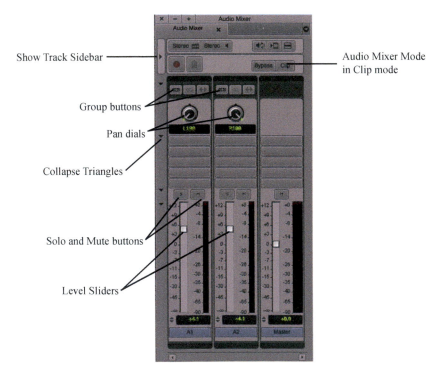

Show Track Sidebar

Audio Mixer Mode in Clip mode

Group buttons

Pan dials

Collapse Triangles

Solo and Mute buttons

Level Sliders

Figure 6.4

The Audio Mixer looks like a standard mixing board, with level sliders for adjusting the level of each track of audio (Figure 6.4). The tracks directly correlate to your Source or Record track selectors. If you have two, three, or four tracks of audio, they'll appear in the window, plus the Master track.

The little Collapse Triangles on the left-hand side of the mixer allow you to hide sections of the mixing board that you don't need to free up space.

SHOW TRACK SIDEBAR

You can create up to 64 audio tracks, which is great, but the Audio Mixer would take over all your computer real estate if you couldn't hide the ones you aren't working on. If you click on the Show Track Sidebar arrow, located near the top left of the Mixer, a window opens showing you a list of all the tracks, as in Figure 6.5. If you don't want to see a track, simply click on a track's blue button and it disappears. Click on the empty button and it reappears.

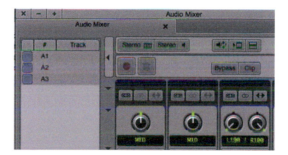

Figure 6.5

CHANGING LEVELS WITH THE AUDIO MIXER

You use the Audio Mixer to change the audio levels of a) clips in the Source Monitor or b) clips that have been edited into the Timeline.

- To change the level of a source clip, load it in the Source Monitor, make sure the Source Monitor is selected, and then raise or lower the appropriate slider(s) in the Audio Mixer.
- To change the level of a clip in the Timeline, click in the Timeline and place the position indicator on the segment you want to change. Then, simply raise or lower the appropriate sliders to change your levels (Figure 6.6).

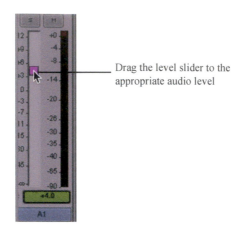

Drag the level slider to the appropriate audio level

Figure 6.6

Grouping

If you want to adjust multiple tracks at the same time, like A1 and A2, you can group your tracks. Just click on the group buttons, and they will become highlighted. Then, as you click on one slider, the other slider moves up and down with it (see Figure 6.7). This is how I'll work with the clips in the Chapter 6 Sequence, because they both need adjusting and adjusting them together is faster and more accurate.

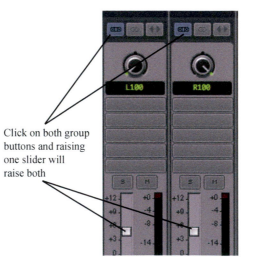

Click on both group buttons and raising one slider will raise both

Figure 6.7

Here's a rule of thumb for adjusting your audio levels:

If the audio is too loud or too quiet when you bring it into Media Composer, you should adjust the audio level of the clip in the Source Monitor *before* you edit with it. This will ensure that every time you subsequently edit an instance of that clip into the Timeline, your level changes will be retained.

If a clip's audio levels are good coming in, then the only reason you'd want to make a level adjustment is to change the way it combines with other audio— within the sequence as a whole. So, in this scenario, you'll make the adjustment in the Timeline. When adjusting clips in the Timeline, you are only affecting the level for the clip on which the position indicator sits—not the entire track.

ADDING AUDIO TRACKS

When you begin to deal with additional sound you need to think about add- ing audio tracks to the Timeline to hold those sounds. Dialog, like we dealt with in *Where's the Bloody Money?* is often recorded onto two tracks, and so we had A1 and A2 tracks. When shooting documentary-style material, like our Documentary Practice project, the camera that was used to shoot that footage captured the sounds onto two channels as well, and so we have A1 and A2 tracks when working with those clips. Now we will be adding music to our Chapter 6 Sequence. Obviously, we don't want to lose the sounds on A1 and A2 with music, so we need to create additional tracks to hold the music.

As we add sounds, try to keep each type of sound on dedicated tracks, rather than having different types of sound placed on any available track. Don't place music on the dialog track(s). Don't place Sound Effects on the tracks dedicated to music, even if there's empty space on the music track.

Let's practice adding tracks. We'll start by opening the Montage Music bin.

Stereo or Mono

Music is always stereo. And when you bring music into your Avid project you have a choice of bringing it in as two mono tracks (left and right tracks make stereo) or as a single stereo track (the sound is sent to different channels or speakers). The trend is to bring music in as a single stereo track. You'll notice when you open the Montage Music bin that there are two clips. They are identical except one is a single stereo track and the other contains two mono tracks (left and right) (Figure 6.8).

Figure 6.8 **Figure 6.9**

If you double-click on the Montage Music Stereo clip in order to place it in the Source monitor, you'll see that one audio track appears on the Source side of the Timeline. But there's a blank space on the Record side of the Timeline; we need to add a stereo track to hold the music (Figure 6.9).

To add a stereo audio track, do one of the following:

- Press Shift-Command-U (Mac) or Shift-Ctrl-U (Windows)
- From the Timeline menu, select New > Audio Track > Stereo (Figure 6.10)
- Right-click in the Timeline and select New > Audio Track > Stereo.

Figure 6.10

Now, we see that a stereo track is waiting to have us Splice or Overwrite the music into the Timeline, as shown in Figure 6.11.

Figure 6.11

If you want to go ahead and add the music now, you'll want to do a couple of things first.

1. Deselect all the other tracks V1, A1, and A2.
2. Mark an IN in the Source Monitor at the beginning of the Music and an OUT at the end. Now place an IN in the Timeline wherever you'd like the music to start (Figure 6.12).
3. Now Press B or the Overwrite command.

Figure 6.12

Mono Audio Tracks

Mono tracks behave differently. Let's see how. Duplicate the Chapter 6 Sequence again and load it into the Timeline. Now double-click on the Montage Music Mono clip to place it in the Source Monitor, you'll see that two audio tracks appear on the Source side of the Timeline, but they appear alongside our sync A1 and A2 tracks (Figure 6.13). If we Splice or Overwrite we'll lose our sound on the Record side.

Figure 6.13

So we need to add additional mono tracks to the Record side.

To add a mono audio track, do one of the following:

- Press Command-U (Mac) or Ctrl-U (Windows) to add one mono audio track at a time.
- From the Timeline menu, select New >Audio Track > Mono.
- Right-click in the Timeline and select New > Audio Track > Mono.

Because there are two tracks to give us stereo sound, we need to do this action twice.

The result looks like that shown in Figure 6.14.

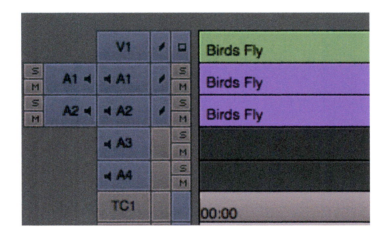

Figure 6.14

PATCHING AUDIO TRACKS

Now we have two empty mono Record tracks, and we'll need to patch the Source tracks A1 and A2 to the appropriate Record tracks, in this case A3 and A4.

To patch, click and hold the mouse on the first Source track that you want to patch. In the example provided here, you drag the mouse from the A2 source track to the A4 record track. You'll notice that, as you hold down the mouse and drag, a black arrow appears and points to A4, and when you release the mouse the source track (A2) moves down to line up with your record track on A4 (Figure 6.15). Try it.

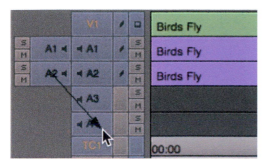

Figure 6.15

Now, do the same thing with A1. Patch it to line up with A3 (Figure 6.16).

Figure 6.16

Now we're almost ready to Overwrite our music. Notice in Figure 6.17 that I've deselected V1, A1, and A2, so they won't be affected. I have marked an IN and OUT on the Source Monitor and an IN in the Record Timeline.

Figure 6.17

Now I can press B to Overwrite and end up with the results I want (Figure 6.18).

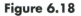

Figure 6.18

DELETING TRACKS

If you need to delete a track or tracks, deselect all the other tracks and select just the one(s) you want to delete. Press the Delete key on the keyboard. A dialog box will ask if you are sure you want to do that, and you click OK. If you make a mistake and delete an important track, hit the Command-Z (Mac) or Ctrl-Z (Windows) and undo your mistake.

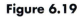

Figure 6.19

SOLO AND MUTE

When cutting clips together in the Timeline, you want to bring in music so you can cut the sequence of images to the music. But often you can't concentrate on the music because the sync audio is too loud, or uneven. You could adjust each clip's level, but sometimes you want to see which shots work with the music, so why bother spending all that time adjusting levels, when you might reject the clip after cutting it in and playing it?

So, in the Timeline itself you have Solo and Mute buttons. When you solo a track, it mutes all the others. When you mute a track, it affects only that track. Here

we're going to open the sequence we made for this chapter, which has our music track, and we'll solo the Montage Music stereo music track, A3, so we can hear just the music. Now we can concentrate on how the Montage Visuals work with the Montage Music. Later, after we've cut our sequence to the music, we'll un-Solo the music and adjust the levels of the individual sync sounds that go with each clip to make a rich sound track of music and sync sounds.

Figure 6.20

CUTTING TO THE MUSIC—NOW!

So we're almost ready to cut to the Montage Visuals to the Montage Music. But first we want to click on the space indicated in Figure 6.20, which says "Click to deselect Sync Lock." When you do, the thing that looks like a hash tag will disappear. We'll learn more about sync lock later in the book.

OK, you're ready to cut to the music. You don't need to use the "Chapter 6 Sequence" that we've been working with to learn audio techniques. Start with any clip you want. My favorite music composer, Timothy Bussey, who works at Berklee College of Music in Boston, wrote the music for these specific clips, so I know a powerful montage can be created.

Just remember to de-select the music track(s), whether it's the one stereo track, as in Figure 6.21, or the two mono music tracks, whenever you Splice and

Figure 6.21

Overwrite the Montage clips and subclips into the Timeline. That way the Music on A3 stays where it is and doesn't get dislodged whenever you Overwrite, Splice, or Trim to perfect your montage sequence.

Have fun. And when you come back, we'll continue to learn more about sound.

PANNING

The dials at the top of each track are for *panning* the audio. Panning is a technique used whenever you have more than one channel of sound coming from more than one speaker. When you set the pan you determine how much of the sound will come from the left speaker, how much from the middle (both speakers equally), and how much from the right speaker. To set the pan, click on the dial and turn it to the left or right. In Figure 6.22 we have the A1 and A2 tracks from a sound effects library that came in panned Left and Right. In fact all voices and all sound effects should be centered, so we should set A1 and A2 to MID.

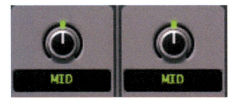

Figure 6.22

Figure 6.23

There's a speedy way to do this. If you Option-click (Mac) or Alt-click (Windows) on the Pan dial, it will jump to MID, the center pan position, as shown on the right.

A single stereo track will contain both pan knobs, and since usually the stereo tracks are music, they should remain panned Left 100 and Right 100, as shown in Figure 6.23.

Again, voices and sound effects should always be set at MID. Stereo music should be panned left and right. There is rarely a situation in which you would have a clip that wasn't panned either L100, MID or R100.

There's a trick to getting music tracks that are centered or in the MID position to go to L100 and R100. Don't try clicking on the dial and dragging in a circle.

Instead take the mouse and drag from the dial to bottom left or right. Imitate the arrow in Figure 6.24 to move the pan dial all the way to R100.

Figure 6.24

Changing Level and Pan on Multiple Clips

Rather than making changes to individual clips, it's often easier and faster to change the volume or pan throughout the sequence, or throughout a large portion of the sequence. This is all easily accomplished by accessing options within the Audio Mixer Fast menu.

If you have been working with the Montage Visuals sequence and you soloed the music track, it's time to click on the Solo button to de-activate it and tackle the ambient or sync sound levels on A1 and A2. We've learned how to set them one clip at a time, but since most of them are at about the same level, and that level is too loud for the music, let's lower some of them at once.

To affect volume levels or pan for a portion of a track in your sequence:

1. Identify how much of your sequence you want to affect levels (or pan). Place an IN point inside the first clip; place an OUT point inside the last clip. Deselect any tracks you don't want to change. In Figure 6.25 I have deselected the Music track A3.

Figure 6.25

2. If you are changing more than one track. Like A1 and A2, click the group button for each track to group the tracks together (see Figure 6.27).
3. Raise or lower the level slider (or adjust the pan dial) in the Audio Mixer.
4. Go to the Audio Mixer Fast menu and drag down to Set Level On Track-In/Out or Set Pan On Track-In/Out (Figure 6.26).

Figure 6.26

If you want to affect the entire track rather than the area inside your marks, don't place any IN or OUT points. Instead, do the following:

1. Remove any IN and OUT points.
2. If you are changing more than one track, click the group button for each track to group the tracks together.
3. Raise or lower the volume slider or adjust the pan dial.
4. Go to the Audio Mixer Tool Fast menu and drag down to Set Level (or Pan) On Track-Global (Figure 6.27).

Figure 6.27

The Audio Mixer Tool is ideal for making changes to entire clips or large segments of your audio; however, Media Composer also has a host of other tools to help you manipulate and analyze your audio.

AUDIO DATA

You make many audio manipulations within your sequence using tools from the Timeline Fast menu. Click on the Timeline Fast menu (Figure 6.28) and you'll see a menu item called Audio Data with a submenu listing audio tools. Let's take a look at what each of these tools does, starting with the most useful—Volume.

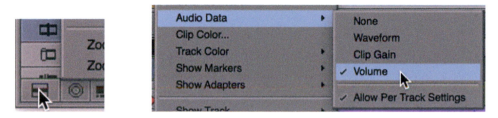

Figure 6.28

Volume

We've learned how to use the Audio Mixer to change the level of an *entire* clip. The Volume function uses *keyframes* to change the levels *within* a clip. This technique, which allows you to exercise precise control within each clip in your sequence, is sometimes called *volume rubber-banding*.

From the Timeline Fast menu select Audio Data > Volume. Then, select the appropriate tracks. In this case, we'll go ahead and select A3, our stereo music track (or A3 and A4—the two tracks containing our stereo music). We'll deselect A1 and A2. Finally, we want to click on the Keyframe button to the left of the Timeline, underneath the Smart Tools and Toolset buttons, as shown in Figure 6.29 to make sure it's active.

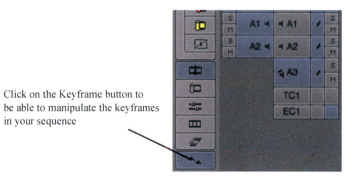

Click on the Keyframe button to be able to manipulate the keyframes in your sequence

Figure 6.29

Let's say that we want to adjust the music cue to make it louder in the beginning but then keep the sound after that point where it is. Place the blue position indicator in the Timeline where you want to make audio changes. Then press the " (quotation mark) key on the keyboard to create your keyframe.

A keyframe appears in the Timeline. Because only track A3 is selected, keyframes appear only there. Move the blue position indicator further along the Timeline, and press the keyframe key again. Another keyframe appears (Figure 6.30).

Figure 6.30

Now, it's time to manipulate the volume using your keyframes.

Using the mouse, move the pointer to the first keyframe. Notice that the pointer changes into a hand. Now drag the keyframe up, vertically, in the Timeline (Figure 6.31).

We have created a volume ramp. Play the section in the Timeline and listen to the volume change.

Sometimes you want to create a dip. Keep the first keyframe where it is and drag down the second keyframe, as in Figure 6.32.

Figure 6.31 **Figure 6.32**

If you find that you have placed the keyframe in the wrong place, you can easily move your keyframes horizontally so you can affect the volume at a precise point in time.

To move a keyframe:

1. Make sure the Keyframe button is selected to the left of the Timeline.
2. Hold down the Option key (Mac) or Alt key (Windows).
3. Click the mouse on the keyframe you want to move, and drag it to the left or right.

If, after you have placed keyframes in the Timeline, you deselect Volume from the Timeline Fast menu, the keyframes disappear, but small pink keyframes appear to show that there are keyframes in the track, and where they are located (Figure 6.33).

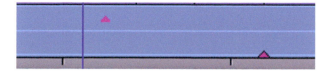

Figure 6.33

To delete a keyframe:

1. Make sure the Keyframe button is selected to the left of the Timeline.
2. Hover the mouse pointer over the keyframe you want to remove.
3. When the cursor turns into a hand, click to select the keyframe and press the Delete key on the keyboard.

Keyframes with Two Tracks

Figure 6.34

Let's say we wanted to add keyframes to A1 and A2 because the sound at the end of the clip gets too loud. Using the Mixer won't work, because the level is fine, it's just the end that needs work. We want to create a dip at the end, so we deselect the Music track and select A1 and A2. When we click on the " (quotation mark) key on the keyboard to create a keyframe, we get one on both tracks. We move the cursor down to where we want the audio to dip and click the " again, to get the second set of keyframes, as in Figure 6.34.

But when we click on one of the Keyframes to pull them down, only one moves down, as shown in Figure 6.35 on the left. What we need to do is hold down the Shift key on the keyboard and then click on the one that isn't highlighted. Then both become highlighted and we can then drag either one of them and they will both dip down together, as shown on the right. Practice this so you get comfortable with this technique.

Figure 6.35

Waveforms

An audio *waveform* is a visual representation of your audio's signal strength, or amplitude. Being able to see your sound makes editing sound so much easier, whether you're raising or lower the volume, or in Trim mode and finding wanted and unwanted sounds.

The Waveform option is found within the Timeline Fast menu, where you found Volume. Once you select it, the waveform will be drawn for all of your audio tracks. Once the waveform is drawn, you can see where your sounds begin and end, as well as how quiet or loud the sounds are (Figure 6.36). This can be helpful when you are fine-tuning your audio.

Figure 6.36

A couple of commands will help you to better see the waveforms:

- To make your tracks larger, use Enlarge track—Command-L (Mac) or Ctrl-L (Windows). Command-K (Mac) or Ctrl-K (Windows) will reduce the size of your tracks.
- To make the *waveform* larger, use Command-Option-L (Mac) or Ctrl-Alt-L (Windows). Command-Option-K (Mac) or Ctrl-Alt-K (Windows) will reduce the size of your waveform.

Waveforms are quite helpful whenever you're trying to edit complex sounds, such as music. For example, let's say you wanted to lengthen a music cue because it ends a bit too soon. You can easily do this by copying a section of the music into the Clipboard, opening the Clipboard Monitor, marking the section, and then cutting it into the Timeline at the end of the music. Now the music is extended. The waveform shows you where the beats are in the music. Use those beats to make your marks and edit points.

Clip Gain

Clip Gain is like a mini-Mixer Tool. It let's you raise or lower volumes on each clip in the Timeline, while giving a sort of graphic look at the changes you're making. It works best when you enlarge the audio tracks.

Figure 6.37

To display the Clip Gain, select Audio Data > Clip Gain from the Timeline Fast menu (Figure 6.37).

When the Auto Gain opens, you'll see little slider icons on the bottom of each clip. Click on the slider icon and a mini slider opens that affects just that track (Figure 6.38). Drag the circular slider button up and down to raise or lower the volume, and see a line appear, showing the decibel setting on that track.

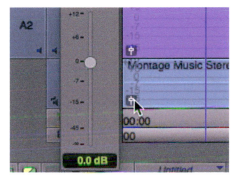
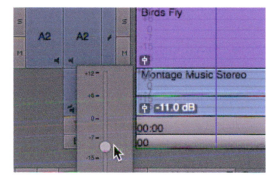

Figure 6.38

TRACK CONTROL PANEL

As always, Avid offers you different ways to get things done. The Track Control Panel allows you to display and employ each type of Audio Data without leaving the Timeline.

To display the Track Control Panel, just click on the small triangle-shaped button to the right of the Timeline timecode display (Figure 6.39).

Figure 6.39

A panel of options will open up in between the track selectors and the sequence, one panel for each track (Figure 6.40).

To use these tools on a track-by-track basis, you'll need to go to the Audio Data Timeline Fast menu and select Allow Per Track Settings. It might be checked already. Also, you will need to disable any selected options within the Audio Data Timeline Fast menu by choosing None as shown in Figure 6.41. Otherwise, if the Waveform is checked here, you won't be able to use the waveform options on a track-by-track basis via the Track Control Panel.

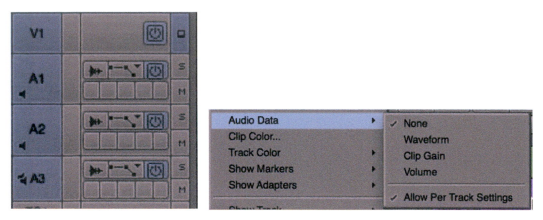

Figure 6.40 **Figure 6.41**

From left to right in the Track Control Panel (Figure 6.42), let's go over the three options:

- *Waveform*. Displays the waveform for each track.
- *Audio Data drop-down menu*. Allows you to enable Clip Gain, Volume, and Pan for each track.
- *Power button*. The blue power button looks like a Pan control button, but it's not. It turns the audio track on or off. It works just like Mute.

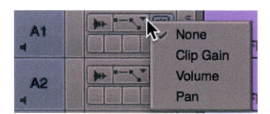

Figure 6.42 **Figure 6.43**

EQUALIZATION

On most sound mixing boards there are dials that you can turn to boost or decrease various frequencies—low, midrange, high—to alter or improve the sound. Such alteration of frequencies is called *equalization.* For example, if a voice has too much bass, you can improve it by cutting the low frequencies and boosting the midrange frequencies.

Media Composer has a tool that enables you to do the same thing. The Audio EQ Tool (Figure 6.44), which is found in the Tools menu, affects the equalization of clips in the Timeline. I won't go too deeply into this tool, but I'll give you some very basic fundamentals so that you can use the Avid EQ templates and tweak them as necessary to achieve your goal.

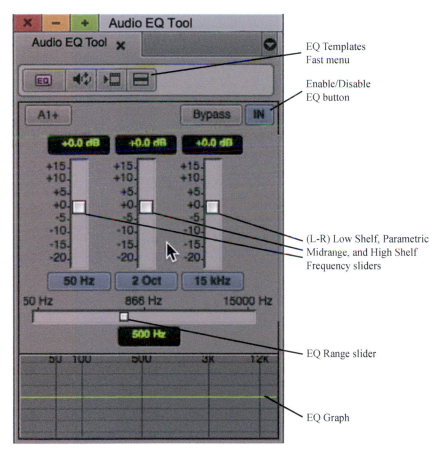

Figure 6.44

Setting the EQ

The sliders allow you to emphasize (boost) or de-emphasize (cut) the low, middle, and high frequencies (the Low Shelf, Parametric Midrange, and High Shelf). The horizontal EQ Range slider allows you to change the shape and placement of the parametric curve, which lets you isolate the frequency that you most want to boost or cut. Watch the EQ graph to see the changes.

The Audio Loop button will play the sound in a continuous loop and allow you to hear the changes you make as you adjust the sliders. There is also an IN button, which acts as the Enable/Disable EQ button. If you toggle it off, it disables the EQ effect so you can tell how your EQ changes compare to the original sound.

To apply EQ:

1. Select Audio EQ from the Tools menu.
2. Select the tracks you want to change in the Timeline (e.g., A1 and A2).
3. Place the position indicator on the clip in the Timeline.
4. Drag the sliders to boost or attenuate the low, middle, or high values.
5. Click the Audio Loop button to hear the changes.
6. As the Audio Loop repeats, continue adjusting the EQ sliders until you achieve the desired effect.

That's all there is to it. You will see an EQ icon on the track (Figure 6.45).

To remove the EQ, just click on the EQ effect in the Timeline and then press the Remove Effect button, which looks a bit like the Ghostbusters logo (Figure 6.46).

Figure 6.45

Remove Effect button

Figure 6.46

EQ Templates

If you don't know much about the science of audio equalization, that's OK—Media Composer has a number of EQ templates that fix common audio problems. A really good way to teach yourself how to equalize your sound is to examine the

graphs that these different templates produce. Look at the frequencies that are boosted and cut. Examine the point where the center of the parametric curve is located. These EQ templates cover most of the problems you'll encounter, so use them as a jumping-off point for fixing your sound. You can't change any of the templates, but you can recreate them and then make adjustments to fit your own set of problems. Let's start with a Template. I'm choosing Female Voice with Presence:

1. Put the position indicator on the audio clip in the Timeline that you want to change.
2. Choose the template from the EQ Fast menu (Figure 6.47). The EQ effect will be placed on the clip.

Figure 6.47

Figure 6.48 on the left shows you what the template does. Look at the EQ Graph. The template rolls off, or lowers, the low frequencies, and it boosts the mid-range where the average female voice registers. If it's close but not perfect, examine the graph, and then remove the template effect by clicking on the bar that says Overwrite with DEFAULT EQ. You'll be back looking at the EQ Tool with no changes made. Now, using the template as your guide, try to make adjustments that are similar but work even better than the template, as I've done in the right-hand screen.

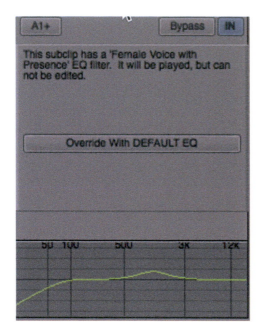
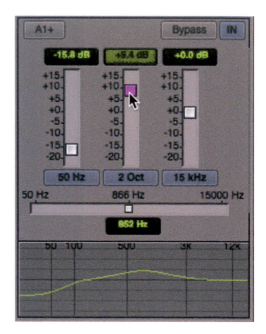

Figure 6.48

To apply EQ to more than one clip:

1. Mark a portion of the track with IN and OUT points.
2. When you are satisfied, stop and then choose Set EQ In/Out from the EQ Fast menu.

Saving Your EQ Effect

You can also save an EQ effect so you can use it later on in your project. You might spend ten minutes setting different EQ levels to fix a problem in your actor's dialog

track. Once you have the effect set up the way you want, simply click and drag the *EQ icon* (Figure 6.49) to whichever bin you would like it saved.

Once it's in the bin, you should rename it (Figure 6.50), to something specific, like "Colleen's Voice EQ".

Drag the EQ icon
to a bin to save
the EQ as a template

Figure 6.49

Figure 6.50

Now simply click and drag it from the bin to other clips in the Timeline with the same audio problem, and they will have the identical EQ applied to them. If you need to tweak it, you can edit it further.

WHEN TO USE THE DIFFERENT AUDIO TOOLS

So, as you can see, you've got a lot of audio tools at your disposal. How do you know what tool to use for which situation?

In general, you use the Audio Mixer to set the overall levels of your clips. From the Timeline, put the position indicator on the first clip, and then raise or lower it with the slider. Make sure to constantly monitor the sound via the Audio Tool, where you're always looking to make sure that quiet sounds, normal sounds, and loud sounds peak at the appropriate levels.

Once you've adjusted the first clip, do the same thing with the next clip that needs adjustment. You might find that a whole section is too low. In that case, you can mark an IN and an OUT in the Timeline and then from the Audio Mixer Fast menu, you can choose *Set Levels On Tracks-In/Out.*

Now, let's say you don't like the way something sounds—the voice of one of your characters seems muffled or there's too much sibilance or an undesired hum— then you can use the EQ Tool. Remember, you may want to test out some of the EQ templates, and then make your own adjustments accordingly.

The last tool you'll use, after you have set levels and EQ, is Volume keyframing. Say you want an audio ramp because you have music or sound effects that you want to bring down or up. You'll just go to the Timeline Fast menu and select

Volume (or, you can enable it from the Track Control Panel). Then, you place your keyframes, using the " key, and then you can raise or lower keyframes to set a ramp up or down.

Remember, do your gross adjustments first, using the Audio Mixer Tool, then work on the quality of the sound with the EQ Tool, and then fine-tune the levels with the Auto Gain.

OTHER AUDIO TECHNIQUES

Add Edits

When you click on the Add Edit command, it creates a break in your timeline. It divides a single video clip into two pieces or an audio clip into two pieces. I use it all the time to break audio clips in order to make a sudden sound change to a clip of music. Let's say I have a scene where there's a piece of music coming out of a set of audio speakers in the kitchen. And I make a cut to the living room. The music should be there, because the living room is next to the kitchen, but the music volume should be instantly lower on the cut. Since it's one piece of music, I simply select the music track(s) in the Timeline and press the Add Edit command, which can be found on the Timeline toolbar or inside the Tool Palette (Figure 6.51).

Add Edit command

Figure 6.51

Now that I have two separate music segments, I can use the Audio Mixer Tool to drop the levels in the second part of the music segment, in line with where I make my cut to the living room.

I use Add Edits with sound effects as well. Let's say I have a man on his doorstep, looking up at the sky as we hear the loud sound of a helicopter. As soon as that person goes inside and shuts the door, the helicopter sound will still be there, but much quieter. To do this I simply place an Add Edit on the helicopter sound

track, right in line with where the door closes, and I use the Audio Mixer to drop the level at the exact instant the door closes. The helicopter sound drops, but the helicopter sound doesn't completely go away.

Replacing Bad Sound

What if you've got audio that is just plain unusable? Or let's say you have off microphone dialog that you want to remove. To get rid of the offending audio, select the audio tracks and deselect the video track(s) and mark the bad area with IN and OUT. Then use the Lift command to lift it out of the Timeline, as shown in Figure 6.52. Once you've eliminated the offending section of audio, you need to fill in the blank spot with some sort of room tone or ambient sound.

Lift Command

Mark the section with an IN and an OUT, and then press the Lift Command

Figure 6.52

To replace a blank space with ambience:

1. The IN and OUT marks should still be there after you lift; if not, Mark an IN and an OUT in the Timeline around the blank space.
2. Load an identical or similar clip (as the one edited in the Timeline with the bad audio) into the Source Monitor.
3. Now play the clip in the Source Monitor until you find "silence." You're not looking for silence, really, but ambience that matches.
4. When you find some nice ambience, just mark an IN in the Source Monitor and overwrite that ambience into the Timeline, replacing what you lifted out.

MAKING MORE ROOM

As you continue to add audio tracks, sometimes seeing all your tracks is difficult. Remember in Chapter 2 we learned how to make tracks smaller by pressing Command-K or Ctrl-K. But sometimes even that doesn't work.

Scrolling Your Tracks

If you still can't see all your tracks, a Scroll bar appears on the right-hand side of the Timeline so you can click on it with your cursor and scroll up and down to see all of your tracks (Figure 6.53).

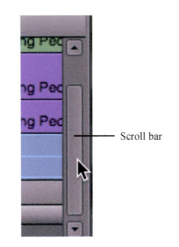

Scroll bar

Figure 6.53

SETTING UP YOUR TRACKS

In Media Composer, it's easy to add tracks, but it's important to be organized and give some thought to how your tracks are laid out. Here are some general guidelines you might like to follow:

- If you have **narration**, it should go onto the topmost audio track—A1.
- Reserve the next two tracks for **dialog**.
- The **sound effects** come next.
- Finally, your **music** tracks go at the bottom of your Timeline. If you have no narration, the topmost tracks will contain your dialog.

CREATING CENTERED OR ALTERNATING LEFT/RIGHT MONO TRACKS OR STEREO TRACKS

In Chapter 8 we'll learn how to import audio clips and files into our project. Before we do that we need to determine how we want the audio to come in—centered or panned left and right; as mono or stereo. As we learned in this chapter, dialog, narration, and sound effects should be centered and should come in as mono tracks. Music is often stereo and can come in as two mono tracks that are panned left and right, or as a single stereo track.

To Import Narration, Dialog or Sound Effects as Centered, Mono Tracks

1. Go to the Settings tab in the Project window and double-click on the first setting: Audio.
2. In the Default pan for mono tracks, select the Centered radio button (Figure 6.54).

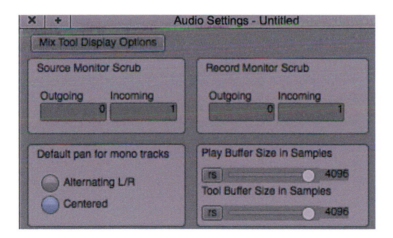

Figure 6.54

To Import Stereo Music Tracks

The industry is moving toward music as a single stereo track and so you need to be able to control how your tracks come in. In the Project window, click on the Settings Tab and scroll down until you come to Import (Figure 6.55).

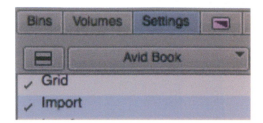

Figure 6.55

1. Once you double-click to open the window, you'll see the Import Settings—Current. Click on the Audio Tab and then click on Edit . . . (Figure 6.56).

Figure 6.56

2. In the Set Multichannel Audio window you'll see that each pair of tracks has a small pull-down triangle. I want the music to come in on A1 and A2. When I click their triangle, I see that Mono is the default setting. If I want to change it to Stereo, I click on Stereo, and as soon as I do that the sync box below A1 and A2 lights up green. Now I leave Settings and return to Bins (Figure 6.57).

Pulldown triangle

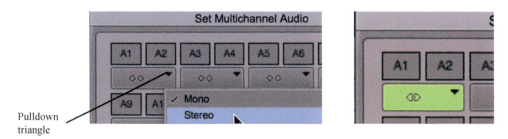

Figure 6.57

From now on, all the audio I import will come in as a single stereo track—not as a mono track. So in the pull-down triangle, I switch to Stereo when I'm bringing in stereo music, and I switch it back to Mono whenever I'm bringing in dialog, narration, or sound effects.

TELL THE STORY FIRST

We've examined many of the important techniques and tools at your disposal, all of which will help you create clean, clear sound. Perhaps the most important advice we can give you is this: Wait to add sound effects and music until as late in the editing process as possible. Editors who are new to Avid often create complex sound tracks much too early in the editing process, making even the simplest change an onerous task. Bottom line—tell the story first by cutting the picture and the picture's sync sound. Then build your other tracks, laying down the sound effects and music cues that will give tone and emotional content to your project.

SUGGESTED ASSIGNMENTS

1. Load a sequence into the Timeline.
2. Starting with the first clip in your sequence, adjust the volume of your clips using the Audio Mixer Tool.
3. Experiment with changing the pan on several of your clips.
4. Add Mono audio tracks.
5. Splice audio into these new tracks by patching.
6. Enlarge all of your audio tracks, and reduce the size of your video tracks.
7. Select Volume and Waveform from the Timeline Fast menu.
8. Select Volume from the Timeline Fast menu, and place several keyframes on your music clip in the Timeline. Create volume ramps so the music plays at different levels.
9. Move the keyframes (horizontally through time) in the Timeline.
10. Now, try cutting audio, using the waveforms as cutting guides.
11. Place an EQ template onto a clip in the Timeline.
12. Save an EQ setting by placing it in a bin.

Using the Smart Tool

THE SMART TOOL

I already mentioned the Smart Tool in Chapter 1, if only to recommend that you leave it alone while you learn to edit with Media Composer. Now, however, we'll examine how this tool can best serve you, now that you've got some experience under your belt.

The Smart Tool (Figure 7.1) houses four main editing tools that allow you to manipulate material in the Timeline in various ways: Lift/Overwrite Segment Mode, Extract/Slice Segment Mode, Overwrite Trim, and Ripple Trim.

The Segment
Mode Tools

The Trim
Mode Tools

Figure 7.1

You can use each tool individually, by clicking on it to make it active, and clicking on it again to make it inactive. Or, you can use the Smart Tool as a group of interconnected tools. Personally, I prefer using each one individually and not as a group, but some people—especially those coming from a more mouse-centric editing application—really enjoy the "grabby" functionality of the Smart Tool. But we'll

discuss each tool and what it does, and then you can decide if you want to use each individually, or as part of Smart Tools.

Let's take a look at the two Segment Mode tools first. To have something to practice on, we'll load the sequence we created at the end of Chapter 5, called "Chapter 6 Sequence," into the Timeline. To start, duplicate the original one, shown in Figure 7.2, which doesn't have any music. Then, when we have learned how to move segments in the Timeline, we'll open the sequence we created that contains the Montage Music.

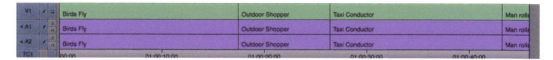

Figure 7.2

SEGMENT MODE TOOLS

Segment Mode editing lets you move segments, or clips, in the Timeline, so you change their order. Let's say that you realize that the second shot in your sequence should actually be the first shot. Enter Segment Mode, click on the shot in the Timeline, and drag it to the new position. Presto!

Extract/Splice Segment Mode Button

We're actually going to start off by discussing the second button down, which is the Extract/Splice Segment Mode button—the one that's yellow (Figure 7.3).

When you click on the Extract/Splice button, it will be highlighted and you'll enter Segment Mode.

To let you know you are in Segment Mode, the background color on the button within the Smart Tool is highlighted blue. When you're first starting out, it's important that you *only* have the yellow Extract/Splice Segment Mode button highlighted, and not any of the other Smart Tool buttons. If you then click on a clip in the Timeline, the clip is highlighted. If the clip has both video and sync sound, you normally want to move both of them together. To select the sound clip, either hold down the Shift key and click on the accompanying audio track, or lasso both video and audio tracks with your cursor. Now both are selected, as shown in Figure 7.4.

Figure 7.3

You can also toggle the Link Selection button to automatically join your synced tracks. To take advantage of this, simply click on the Link Toggle Selection

Figure 7.4

button, which is located directly above the Smart Tool (Figure 7.5) so that it is highlighted.

Link Selection
Toggle

Figure 7.5

Let's say we want the shot called "Outdoor Shoppers," which is the second shot in this sequence, to become the first shot. We want to move it so it switches spots with "Birds Fly." To move the clip, click on it and then drag it to the spot where you want it to go. As you drag, a white outline will appear around the clip to show you it is moving (Figure 7.6).

Figure 7.6

If you hold down the Command key (Mac) or Ctrl key (Windows) as you drag, the segment snaps to cut points, or to the blue position indicator, or to IN and OUT points. Most of the time when using Extract/Splice Segment Mode, you will want this snapping behavior, so get used to holding down the modifier key as you drag (Figure 7.7).

Figure 7.7

When you release the mouse, the clip moves to the new location.

As you can see here, "Outdoor Shoppers" is now the first shot in the sequence, and "Birds Fly" is now the second shot (Figure 7.8). They've just switched places. Because you're just moving segments, the length of the sequence remains the same, and everything stays in sync. You can drag shots in either direction.

Figure 7.8

To leave Segment Mode, click on the highlighted segment button within the Smart Tool again.

Lift/Overwrite Segment Mode Button

Lift/Overwrite Segment Mode (red) behaves somewhat like Extract/Splice Segment Mode, but instead of repositioning and shuffling around shots, its job is to pick up a shot and overwrite it wherever you let it go.

Click on the Lift/Overwrite button (Figure 7.9). Make sure that the Lift/Overwrite button is the *only* Smart Tool button that is enabled.

Now when you click on a segment in the Timeline, you're in segment mode.

Figure 7.9

Examine Figure 7.10 to see what happens when we use Lift/Overwrite to drag "Birds Fly" to place it back as the first shot, reversing what we did using the Extract/Splice segment Mode button. I click on the clip while pressing Command (Mac) or Ctrl (Windows) to snap it to the head of the sequence.

![Figure 7.10 timeline showing Birds Fly clips]

Figure 7.10

The shot is lifted from its old position, leaving blank fill in its place, and is moved to its new position. But, instead of pushing "Outdoor Shoppers" to the second spot, it erases (overwrites) the whole thing (Figure 7.11)! That's not what we want to happen.

![Figure 7.11 timeline showing Birds Fly clips]

Figure 7.11

Obviously, this is not what the Lift/Overwrite Segment Mode is used for. Instead, its primary function is to move around audio, like music or narration, as well as titles and occasional video within the Timeline. Let's take a look at how Lift/Overwrite Segment Mode really works.

To do this we want to load the Chapter 6 Sequence that already has the Montage Music spliced in, as in Figure 7.12.

Figure 7.12

When we first cut in the music, let's pretend we cut it when the birds are already well into flight across the city skyline, and what we want is to have the music start when the birds first appear. Here's where the Lift/Overwrite Segment Mode excels.

In the example shown in Figure 7.12, we want to move the music on A3 to the exact point where the birds enter the frame. We therefore place the position indicator where that point is, as shown in Figure 7.12.

Next we select the red Lift/Overwrite Segment Mode button within the Smart Tool, then click on the music segment, and Command-drag (Mac) or Ctrl-drag (Windows) it to the position indicator (Figure 7.13).

Figure 7.13

When we release the mouse, the block of music is positioned perfectly at the position indicator (Figure 7.14).

Figure 7.14

Figure 7.15

Another handy trick involves the use of the red Lift/Overwrite segment Mode button with the Trim Frame keys that are on the keyboard. Select the red Lift/Overwrite Segment Mode button, and then select the segment(s) you want to move. Press any of the Trim Frame keys (M , . /) to nudge the segment back and forth through the Timeline by one or multiple frames at a time (Figure 7.15). Try it. It is quite precise.

MOVING SOUND TO DIFFERENT TRACKS

You will also use the Lift/Overwrite segment Mode button whenever you want to move a piece of video or audio vertically from one track to another track. In Figure 7.16, the sound for "Montage Music" is on A3, and I want it to go onto A4. Notice there is no A4 track. Not to worry. When you drag the track on A3 downward, Avid senses you want a new track and creates one for you (Figure 7.17).

Figure 7.16

1. Click the red Lift/Overwrite Segment Mode button. If you want to keep the segment from sliding horizontally, hold down Command (Mac) or Ctrl (Windows).
2. Click on the audio segment you want to move.
3. Drag it downward and watch as Avid adds A4 so it moves onto A4.

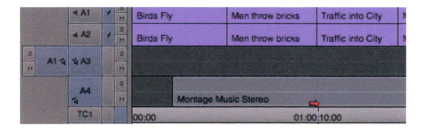

Figure 7.17

If you would like to move it back to A3, simply get into red Lift/Overwrite Segment Mode, click on the Montage Music track and drag it onto A3. Again, to keep it from sliding out of alignment, hold down the Command (Mac) or Ctrl (Windows) before you click and drag it.

The result, as shown in Figure 7.18, is what you expected.

Figure 7.18

USING THE KEYBOARD TO ENABLE SEGMENT MODE BUTTONS

Instead of selecting the Segment Mode buttons by clicking on them in the Smart Tool, you can also use the keyboard shortcuts:

- Lift/Overwrite Segment Mode: Shift-A.
- Extract/Splice Segment Mode: Shift-S.

Practice toggling on and off the Segment Mode commands using these keyboard shortcuts. You'll probably find that it's much faster than constantly selecting the buttons on the user interface. In Chapter 13, we'll learn how to map buttons to the keyboard, so you can even assign these often-used commands to single-button keys, if you like.

Combining Segment Mode Functionality via the Smart Tool

So now that you know how these tools behave in isolation, let's explore how to use them in tandem.

To link the functionality of Lift/Overwrite Segment Mode with Extract/Splice Segment Mode:

1. Select both the Lift/Overwrite Segment Mode and the Extract/Splice Segment Mode in the Smart Tool (Figure 7.19).

Figure 7.19

2. Do one of the following:

 • To enable Lift/Overwrite Segment Mode, position the cursor in the upper half of the track (Figure 7.20).

Figure 7.20

 • To enable Extract/Splice Segment Mode, position the cursor in the lower half of the track (Figure 7.21).

Figure 7.21

3. Perform Segment Mode functions as usual.

So, in this way, you can enable both Segment Mode commands, and the type of segment edit you perform will be determined by *where* you position the cursor within the track. As we said before, some people really prefer this way of working, while others might be bothered by it. Try it out for yourself and see how you like it.

LASSOING TO GET INTO SEGMENT MODE

As with most things in Avid, there's always more than one way to do something. Fortunately, the same holds true for working in Segment Mode. So, if selecting and

deselecting Smart Tool buttons really isn't your thing, you do have another option for entering Segment Mode.

As you know, you enter Trim Mode by lassoing a transition from left to right. If, instead of lassoing a transition, you lasso a segment, you'll enter Segment Mode (Figure 7.22).

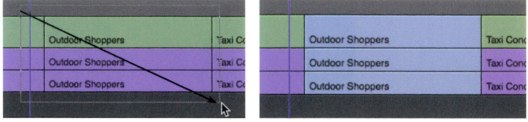

Lassoing a segment will enable Segment Mode

Figure 7.22

If one of the Segment Mode buttons isn't selected within the Smart Tool, which Segment Mode will you enter when you lasso a segment? Extract/Splice (yellow) is the default, as you'll use it most often. To Lift/Overwrite just click on the Red button and you'll lasso into that mode instead.

When lassoing segments, you can move more than one segment at a time. For instance, you may want to take the fourth and fifth shots and move them to the beginning of your sequence. You *could* press the Extract/Splice Segment Mode button, click on a segment, and then Shift-click to get all of the segments selected—or you could just lasso them all in one quick move. Although in Figure 7.23 we're only moving two shots, you can move 10 or 100 shots at once. If there is blank filler between segments you want to move, you can select and move that also.

Figure 7.23

SELECTING MANY SEGMENTS IN THE TIMELINE

When you want to select all segments from one location to another in your sequence, there are two buttons that are quite useful. In the Timeline toolbar, you'll see the Select Left and Select Right commands.

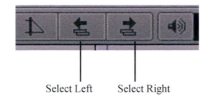

Select Left Select Right

Figure 7.24

These commands allow you to select segments to the left or right of the position indicator. This is a great way to move a large section of your sequence all at once.

USING SEGMENT MODE TO DELETE CLIPS FROM THE TIMELINE

You can use either Segment Mode command to delete material from the Timeline. Just select a segment using either Extract/Splice Segment Mode or Lift/Overwrite Segment Mode, and then press delete. Below is what happens when you do.

When you delete a segment (or multiple segments) using Extract/Splice Segment Mode, the segment is removed and the segments move in to fill the gap. In Figures 7.25 and 7.26, Outdoor Shoppers is gone and Taxi Conductor filled the gap.

Figure 7.25

Figure 7.26

Figure 7.27

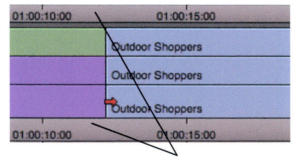

Figure 7.28

When you delete a segment (or multiple segments) using Lift/Overwrite Segment Mode, blank filler will be left behind, and all other shots stay where they are (Figures 7.27 and 7.28).

Disabling the Segment Mode Buttons by Clicking in the Timecode Track

Segment Mode buttons can only be turned off by re-clicking on them within the Smart Tool, but that can get a bit tedious. Fortunately, you can quickly turn them off by clicking on the Timecode track, above or below the tracks.

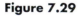

Click the cursor anywhere on either of these Timecode tracks to get out of either Segment Mode

Figure 7.29

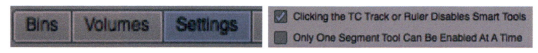

Figure 7.30 **Figure 7.31**

If this doesn't work with your version of the software, click on the Settings tab in the Project window, scroll to the Timeline Settings, click the Edit tab, and choose "Clicking the TC Track or Ruler Disables Smart Tools" (Figures 7.30 and 7.31).

SMART TOOL TRIM TOOLS

When creating the Smart Tool, Avid added two buttons to your arsenal of trimming: Overwrite Trim and Ripple Trim. The functionality of each can also be joined or un-joined with one another, just as with the Segment Mode buttons.

Now, I say that these commands were added, but in truth, these trim functions previously existed by default once you entered Single-Roller Trim Mode and began trimming away frames—just like we discussed in Chapter 3 and 4. However, now they've been converted into separate buttons; you may prefer them in this form.

Ripple Trim

Let's start with the yellow, Ripple Trim (Figure 7.32) because it is essentially the same as Single Roller Trim, except it just exists in button form.

Ripple Trim

Figure 7.32

To use Ripple Trim:

1. Select the Ripple Trim button in the Smart Tool. (Make sure that all other Smart Tool buttons are deselected.)
2. Click on the A-side or B-side of a transition as in Figure 7.33.

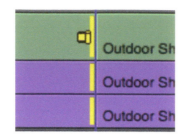

Figure 7.33

Now you can perform all the Trim Mode techniques you've already learned: drag the rollers left or right; J–K–L Trim; use the Trim keys, etc.

Overwrite Trim

The red Overwrite Trim (Figure 7.34) allows you to click on a transition and trim away frames, leaving blank filler in its place. Before Avid introduced this command button, you had to enter Single-Roller Trim and trim away frames while pressing Alt (Windows) or Option (Mac). Now, this functionality is all contained within this button.

Overwrite Trim

Figure 7.34

When do I use this Trim key? Often when editing, I like the picture cut point, but the audio tracks might have issues such as off-microphone dialog. So, most often I use this to take away audio that is problematic, while leaving the picture where I cut it into the Timeline.

To use Overwrite Trim:

1. Select the Overwrite Trim button in the Smart Tool.
2. Click on the A-side or B-side of a transition. (Note: if you click in the middle of the transition, the button acts as Dual-Roller Trim.)
3. Deselect the Video track, V1.
4. Drag the transition as a reductive trim in which you trim away frames; if you selected the A-side of the transition, you would drag to the left; and if you selected the B-side of the transition, you would drag to the right.
5. Release the mouse. The Trim is performed, and blank filler is left in place of the trimmed frames (Figure 7.35).

Figure 7.35

Combining Trim Mode functionality via the Smart Tool

As with Segment Mode, you can join Overwrite Trim and Ripple Trim together in functionality, depending on where in the track you place your cursor.

To link the functionality of Overwrite Trim and Ripple Trim:

1. Select both the Overwrite Trim and Ripple Trim buttons in the Smart Tool (Figure 7.36).

Figure 7.36

2. Do one of the following:

- To enable Overwrite Trim, position the pointer in the upper half of the track (Figure 7.37) and then click to enter Trim Mode.

Figure 7.37

- To enable Ripple Trim, position the pointer in the lower half of the track (Figure 7.38) to enter Trim Mode.

Figure 7.38

COMBINING ALL MODES VIA THE SMART TOOL

As you can probably guess, if you would like to combine all four functions—both Segment Modes and both Trim Modes—you simply enable all four buttons (Figure 7.39).

Then, whenever your cursor is in the upper or lower part of a segment, the appropriate Segment Mode is applied, and whenever your cursor is at the upper or lower part of a transition, the appropriate Trim Mode is applied. Again, if you like working with the mouse, this can be a very useful tool, and the more you practice, the more intuitive it can become.

Remember, though—you don't *have* to use the Smart Tool commands. We've already learned how to trim using other methods (i.e., lassoing the transition or using the keyboard), and we've also learned

Figure 7.39

how to enable and disable the Segment Mode buttons via the keyboard shortcuts of Shift-A and Shift-S. So if you find the Smart Tool isn't for you, then it's no problem to just work without it. How (Figure 7.40)?

Click on the Toggle Smart toolbar, to enable or disable the Smart Tools

Figure 7.40

SUGGESTED ASSIGNMENTS

Create a new Sequence, cutting together a montage of shots using the clips (and subclips) in your Montage Footage bin from Documentary Practice. Within your editing session, practice the following Segment Mode skills:

1. Enter Segment Mode by clicking the Extract/Splice Segment Mode button within the Smart Tool. Now move a clip—either a visual or an interview—toward the head of your sequence. Make sure to either Shift-click on both

the video and the audio clips, or first enable the Link Selection toggle in order to move them simultaneously.

2. Leave Segment Mode by clicking on the button again in the Smart Tool.

3. Lasso a clip, making sure to lasso both video and audio, and move it to the start of your sequence.

4. Go into Segment Mode by clicking the Lift/Overwrite Segment Mode button within the Smart Tool. Move a video/audio clip to the head. (Oops, not what you want.)

5. Undo. Leave Segment Mode.

6. Get into Segment Mode by clicking the Lift/Overwrite Segment Mode button. Select the music and move it along the Timeline. Try moving the music using the Trim Frame keys (M , . /).

7. Lasso three clips to get into Segment Mode. Check which mode you are in. Move the clips as appropriate.

8. Leave Segment Mode.

9. Enable the Ripple Trim button in the Smart Tool.

10. Click on the A-side of one of your transitions. Shift-click to select both the video and the audio transitions.

11. Drag the transition to the left to perform a reductive trim, and then to the right to perform an additive trim. Get a sense of where you would like to trim the clip, and then release the mouse.

12. Now, in addition to Ripple Trim, click on the Overwrite Trim button in the Smart Tool. Place your cursor at a transition. Move the cursor to the upper part of the transition and notice which Trim Mode is enabled. Then, move your cursor to the lower part of the transition and notice which Trim Mode is enabled.

13. Using Overwrite Trim, Shift-click to select both the video and the audio transitions. Practice trimming away frames to leave filler behind.

14. Finally, in addition to both Ripple Trim and Overwrite Trim, enable both Segment Mode buttons in the Smart Tool. You should now have all four editing tools selected. Slowly move your cursor through the tracks and notice how the tool changes depending on whether it is in the upper or lower portions of the track.

8

Starting a New Project and Bringing in Your Media

So far, we've learned a lot about working in Avid Media Composer—but it has always been by using media that has *already* been input into Avid. Now that you hopefully have the confidence about working in this editing environment, we're going to drop back to the very first stage in the editing process, and discuss how to actually bring media into a new or existing project. Specifically, we'll touch upon how to import files, how to access files via Linking media – what used to be call the AMA workflow.

In this chapter I'll walk you through all the steps to bring in media, but I'll leave the specific workflow for projects larger than HD for Chapter 16. So after you master the ins and outs of working in HD projects in this chapter, I'll show you how to input and edit 2K, 4K, and Ultra HD in Chapter 16.

STARTING A NEW PROJECT

When you start Media Composer, the Select Project window appears. In the past, we've selected a project that was already created. But now we're creating something new. Before we click on the New Project button, click first on the folder icon as in Figure 8.1 and navigate to the drive where you would like this project to live. Usually for my students, that's their external drive. Select your drive and click Open. You see next to the folder icon that I've chosen my external drive called "Sam Drive 2." Now we'll click on the New Project button.

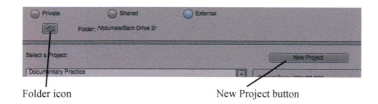

Folder icon New Project button

Figure 8.1

157

When the window in Figure 8.2 appears, you'll see the Project Name box. Think about the name for a second before typing anything that pops in your mind, because this is one thing that you won't be able to change. It will stay with this project forever. Changing the project name later on can cause you to lose important links and files. Most people type in the working title of their project. I'm naming this new project "Starting Out."

Once you've entered a name, you're going to click on the Format pull-down menu and select a format type.

Take the time to select your project's format, which, in a nutshell, refers to your project's resolution and frame rate. As you can see there are seven formats available, ranging from standard definition projects such as NTSC or PAL (the European standard definition), to the two HD formats, 720 and 1080, to 4K, 2K, and Ultra HD, often called UD (Ultra Definition). The rule of thumb is to choose whichever format matches the format of the media that you are bringing into Avid. Usually it's the format your camera was set to when shooting.

Figure 8.2

Inside each of those formats you'll find a submenu that offers more choices. Most often these choices want you to match the frame per second rate that the camera was set to when shooting (Figure 8.3).

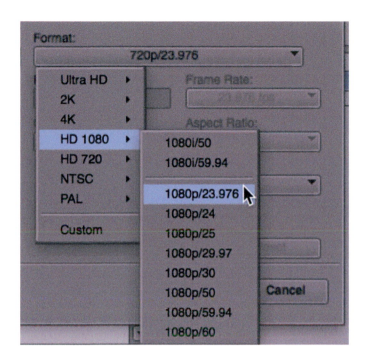

Figure 8.3

As you see in Figure 8.3, I've chosen the format and frame rate that most of my students in the beginning and intermediate production classes at BU will choose. A student might check out a Canon C100, and set it to the HD format, 1080, and select 1080p rather than 1080i, so her or his project has a more filmic look to it, and of the 1080p choices she/he will select the 23.976 frame rate because it also has a more filmic look. So, since those are the settings on the camera, she will select the same settings for her Project Format.

Don't worry, you aren't locked into any one format for an entire project. Media Composer allows you to easily work with media of different formats and different frame rates and motion types (interlaced or progressive), so if your project is shot over several years, or different cameras are used with different settings, Avid can handle it. But in general, set your project up to match the format and type media you shot with your camera.

RASTER DIMENSIONS

Once you select a format, you'll see two small boxes that tell you the Raster Dimension of that format, as in Figure 8.4. You'll see the number of pixels for

the height and then the number of pixels for the width. Raster is another way of describing the *aspect ratio*, which to simplify things, tells you how wide your image is compared to how high it is. A square box has an aspect ratio of 1:1. A rectangle that was twice as wide as it was high would have an aspect ratio of 2:1. All HD formats have an aspect ratio of 1.77777778:1. That number comes from dividing the number of horizontal pixels—1920—by the number of vertical pixels—1080. Because that's an awkward number people say HD's dimensions are 1.78:1 or they often say 16x9. Divide 16 by 9 and you get 1.77777778. When we watch a standard motion picture, screened at a movie theater, it usually has an aspect ration of 1.85:1, which is a bit wider than HD. We'll explore other raster dimensions in Chapter 16. But just remember all HD projects are 16x9—also called 1.78:1.

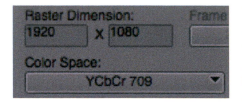

Figure 8.4

There's another HD flavour, often called 720p. Its raster dimensions are 1280x720. It's also 16x9. Divide 1280 by 720 and you get the same 1.77777778:1, or 1.78:1. This flavor is becoming less common than 1920x1080, because the trend is for larger files with great resolution, not smaller files with less resolution.

COLOR SPACE

Digital cameras that we use to shoot our HD films and TV projects use a color system know as YCbCr 709. You will often see it written as Rec 709. Rec 709 is Avid's default color space for all HD projects and the one you'll want.

So we've named the project and selected the correct format, we'll click the OK button (Figure 8.5).

Figure 8.5

At that point the Select a Project window will open, we'll see all our projects in the Select a Project window (Figure 8.6), and we'll click on the name of the project we just created. For me I'm clicking on "Starting Out." Now press OK.

Figure 8.6

SUPPORTED CAMERA FILES WITH AMA

About eight years ago, Avid, working with major camera companies, created Avid Media Access (AMA). This is a workflow that allows you to link directly to camera media cards without going through the process of creating new media. Instead, you can view and edit content directly, without importing files to your media drives. It's an instantaneous process that has made editing with file-based media a snap.

As of the printing of this book, Avid's AMA workflow supports the following types of media or camera files:

- Arri Alexa
- RED
- QuickTime
- ProRes
- XAVC-I
- AVCHD (Sony, Panasonic, Canon, JVC)
- Phantom Cine cameras media
- Blackmagic
- Sony XDCAM and HDCAM
- Panasonic P2
- MPEG2 and GFX.

This list is growing all the time, so be sure to check out Avid's AMA webpage (http://avid.com/ama) for all of the up-to-date supported file types, as well as the updated version of each file type's AMA plug-in.

Avid installs several important Plug-ins when you get the software, or Avid works directly with that camera, so chances are you can link to your camera card without getting a Plug-in. But if not, or if there's a newer version, just go to the AMA webpage. It is here that you can download plug-ins for your camera or file type. Figure 8.7 shows Avid's AMA page explaining how to get the plug-in for the various Arri Alexa cameras.

ARRI ALEXA plug-in

Get direct access and full native support of DNxHD files recorded on ARRI ALEXA and ALEXA Plus cameras, without having to transcode.

Download now

Figure 8.7

Installing a Plug-in

To download and then install a plug-in

1. Quit Avid.
2. Go to (http://avid.com/ama).
3. Find the plug-in you need and click on the Download now.
4. Inside that download page, choose Mac or Windows.
5. When the package lands on your computer, double-click to launch the installer package.

If you ever need to check what specific AMA plug-ins are installed on your system, go to the Info tab on your Project window. You will be presented with a list of plug-ins installed on your system.

LINKING TO YOUR CAMERA'S FILES ON MEDIA DRIVES

The protocol that I teach my students, and the one most professionals follow, is to take the camera's media card and transfer its contents to an external drive. Larger budgeted projects have a person, called a DIT (Digital Imaging Technician), who backs up the media to drives during the shoot, as camera cards get filled up. But with most student and lower budget projects, it usually gets done at the end of the day. You don't need Avid software to do this backing up, and in fact it's better not to have Avid running when you do.

First, connect your external drive to your computer. Now connect your card reader to your computer; soon you'll see a disk image appear. When I double-click I see a folder called PRIVATE and inside I see a file called AVCHD (Figure 8.8).

Figure 8.8

You're going to copy the entire contents of that disc to your external drive. Follow along as I do this with a card from a Canon C100 camera. Substitute your camera's disc name to match what I'm doing here.

1. Create a New Folder and place it in your external drive. Name the folder "Card_001."
2. Double-click on the Canon disc image—or your camera's disc image.
3. Drag everything that's inside the camera's disc image over to the Card_001 folder you just created on your external drive, as I've done by dragging the PRIVATE folder that I found inside the Canon disc image (Figure 8.9) into my Card_001 folder.

Figure 8.9

4. Now make certain to eject the Canon disc image from your computer before launching Avid. This is an important step!!!

Steps 1–4 above are ones you probably know already. It's how we back up our camera cards so we can re-use them. Most people copy the camera card folder (Card_001) onto a second external drive before erasing the camera card, so they have two redundant copies.

Always name the folders with no spaces and no symbols. The first card you back up is Card_001 the second is Card_002 and so on. Or use Card001 and Card002. Once inside Avid, you can name your bins Card 001 with a space. But for the folders containing the camera media, it's best to follow my suggestion for naming.

OK. Let's launch Media Composer, go to our New Project and link to this Card_001.

1. Inside Media Composer, go to File Menu, then to Input and select Source Browser as shown in Figure 8.10. In earlier versions of Avid, it's Link to Media.

Figure 8.10

2. When the Source Browser appears (Figure 8.11), navigate to the Card_001 in your external drive.
3. Double-click on the Card_001 to open it.
4. Click on the Private Card to select the private folder.
5. Check the target bin to see if it's the correct one. When starting a new project, Avid creates a bin, opens it, and gives it the name of the project—here it's Starting Out.

6. Check to see that the Link radio button on the left is selected and then click on the Link button on the far right, underneath the Target Bin as shown in Figure 8.11.

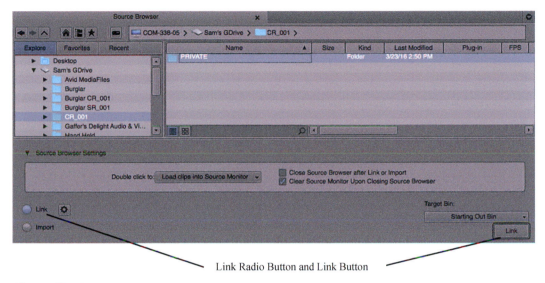

Link Radio Button and Link Button

Figure 8.11

You will see your Starting Out Bin filling up with all the clips (shots) that are on your camera card, as shown in Figure 8.12. Make sure the Source Browser doesn't hide your bin, because you can click on the Link button and think nothing happened. Yet if you look at your bin, it's already full of clips.

		Name	Creation Date	Duration	Drive
		00005	9/23/16 4:54:49 PM	1:13:12	/Volumes/Sam's GDrive/
		00004	9/23/16 4:54:49 PM	1:13:12	/Volumes/Sam's GDrive/
		00003	9/23/16 4:54:49 PM	1:12:00	/Volumes/Sam's GDrive/
		00002	9/23/16 4:54:48 PM	1:15:12	/Volumes/Sam's GDrive/
		00001	9/23/16 4:54:48 PM	1:22:12	/Volumes/Sam's GDrive/
		00000	9/23/16 4:54:48 PM	1:18:12	/Volumes/Sam's GDrive/

Figure 8.12

Source Browser

The Source Browser makes linking to media much easier than before. Under previous versions of Avid, you needed to navigate to just the right folder to be able to link

Figure 8.13

to media. The correct folder was usually one above the actual media file. That's what we did here with the Canon card. But the Source Browser is more forgiving. As soon as you notice that the Link Command is not greyed out, that means the link is established and you can click on it (Figure 8.13).

If you see that the Link button is greyed out, as in Figure 8.14, try going deeper into the folder structure to select the correct Camera Card.

Figure 8.14

The top of the Source Browser window shows you the drives, cards, and files you've selected. You can also look at the Source Browser in either Text View or Frame View, which is handy. We'll explore Frame View in more detail in Chapter 16.

I prefer to have the Source Browser closed after I've pressed the Link button, so I checkmark the Close Source Browser box after Link or Import (Figure 8.15).

Text and Frame View

Figure 8.15

LINKED MASTER CLIPS

Examine the master clips that appeared in the bin. Notice that the icon for linked clips looks slightly different than regular master clips (Figure 8.16). It has what looks like a chainlink fence on the right-hand side.

Figure 8.16

You can view, rename, and edit with these linked master clips, just like you would with any other master clips.

TRANSCODING YOUR LINKED CLIPS

While it's true that you can rename, play, and edit these linked clips, it's often better and safer to *transcode* the linked clips so they become real Avid media files. When you transcode, Avid turns the camera's way of dealing with media into an MXF file and that MXF file has many advantages over the linked files. Because new media files are created during this transcoding process, it does take some time to perform, but the time spent on the front end will be gained back during the rest of the editing process.

Why is transcoding advantageous? Let's say you're editing a project that was shot with a RED or Arri Alexa camera and the media is really high resolution— 4K or above. Yes, you can easily link to that media, but it won't play back in real time because the files are too large to play normally. Everything is sluggish. Even a Canon C100 can have problems playing normally because the C100 doesn't capture every frame as a unique frame. It records in a process called GOP, where only the 1st frame and the 15th frame are real frames; the frames in between are like hollow shells that contain only the information that has changed from the frame before it. When you hit play, Avid has to fill in the information that is missing. When you transcode this GOP material, Avid permanently fills in those shell frames, so every frame is a full frame. Nice.

To transcode clips:

1. Select all the linked clips in your bin.
2. Select Clip > Consolidate/Transcode, or right-click in the bin and choose Consolidate/Transcode. The Consolidate/Transcode dialog box opens (Figure 8.17).

Target Video
Resolution menu

Figure 8.17

3. Select the Transcode button in the upper-left corner.
4. Select the drive to which you want to consolidate your media (Sam Drive 2).
5. Select "Video and audio on same drive(s)."
6. Along the right-hand side of the window is a Target Video Resolution. Here we'll click on the pull-down menu and choose DNxHD 175 MXF for our 1080p project.
7. Click Transcode.

Note that the Transcode button at the bottom of the Consolidate/Transcode window won't be active until you click and select a drive. Only then can you start your Transcode process.

Each clip is transcoded, one by one. You will then have two sets of clips in your bin—the linked clips and the "new.01" transcoded clips (Figure 18.18).

	Name	Duration	Drive
🎞	00001.new.01	1:17:00	Sam Drive 2
🎞	00002.new.01	14:00	Sam Drive 2
🎞	00000.new.01	41:12	Sam Drive 2
🎞	00003.new.01	1:58:00	Sam Drive 2
🎞	00000	41:12	Sam Drive 2
🎞	00001	1:17:00	Sam Drive 2
🎞	00002	14:00	Sam Drive 2
🎞	00003	1:58:00	Sam Drive 2

Figure 8.18

Setting Up Your Bins

At this point you want to move your transcoded clips out of the bin with the linked clips into a new bin.

1. First rename the bin with both the linked clips and transcoded clips "Card 001 Linked."
2. Create a new bin and call it "Card 001."
3. Drag all the new clips into the Card 001 bin as in Figure 8.19

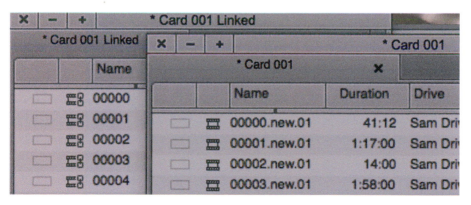

Figure 8.19

4. Close the Card 001 Linked bin. You are done with it, but don't delete it.

When Not to Transcode

There are projects that I might edit where I'll choose to skip the Transcode process after linking to my media. If I'm working under a really tight deadline and the project is a regular HD project, most computers with good RAM can handle the strain and not slow me down. Television news and sports editors love to link to media and start editing the clips instantly. But if I have a few weeks to edit, I'll always transcode. And if I'm working with 4K clips, I'll pretty much have to transcode because my computer won't play the clips without stuttering.

TARGET VIDEO RESOLUTION MENU

When we chose to transcode our linked files, one of our decisions was to determine which video resolution we would transcode the linked clips into. I selected DNxHD 175 MXF from the Target Video Resolution pull-down menu, shown here in Figure 8.20.

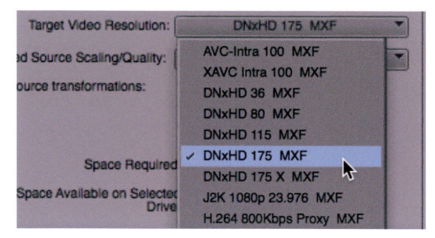

Figure 8.20

As you can see, I had plenty of other choices.

What's interesting is that the list of choices is determined by the format you chose in the New Project window, back when you were creating a new project on page 158. As I mentioned then, the camera settings you choose when you shoot your project determine the format you chose in the New Project window, and that

format determines your resolution options. A 720p project will have different resolution choices. A 2K or 4K will also have different resolution choices entirely.

We'll discuss this topic in greater detail throughout the book, and especially when we learn to work with 2K, 4K, and UHD projects in Chapter 16. But let me start my explanation here.

DNxHD

Avid spent a lot of time, money, and engineering power developing an industry standard compression/decompression (codec) system for high definition projects. What they came up with is called DNxHD. There are quite a few different DNxHD flavors, as you can see in Figure 8.20. The higher the number, the higher the quality. You'd think that DNxHD 36 would look pretty crummy and DNxHD 175 would look great. Yes, DNxHD 175 does look great, but you'd be amazed at how good DNxHD 36 looks. Still, DNxHD 175 is for creating a high resolution HD project for broadcast television or festival screening.

Why then choose DNxHD 36? The higher the number, the more storage space is needed. You need a lot of space for 175, and a lot less for 36. So there are a number of cinema schools that have a server where all the student projects live. To save storage space, they have all their students transcode their assignments at DNxHD 36. But when the time comes for those students to make their thesis films, then they transcode at DNxHD 175.

DNxHR

Knowing that the world is quickly moving from HD cameras and televisions to larger systems, such as ultra high definition and 4K, Avid has developed a codec called DNxHR, which will allow editors to work in these larger formats without overwhelming a network or post-production facility's storage capacity. We'll work with DNxHR in Chapter 16.

Other Project Formats

As you can see from Figure 8.21, there are many other formats and frame rates. Again so much depends on the camera you used to shoot with. Let's do a quick overview.

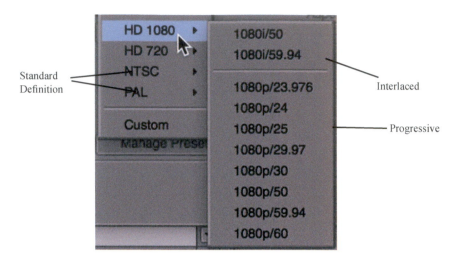

Figure 8.21

There are two flavors of HD, 1080 and 720, and each has several frame rates. We have spent the entire chapter working with only one of them—1080p/23.976. The 1080i/50 is the brand of HD in Europe and many other countries that use PAL. The "i" stands for interlaced. Interlaced was the standard for all television until recently, and is still used in many sports broadcasts—it looks like video, not film. The 1080i/59.94 is the interlaced flavor used in the USA for sports and some reality shows. The 1080 frame rates below the line are all progressive. The 1080p/25 and /50 are European frame rates (and most of the rest of the world as well). The 1080p/24 is only for projects that are going to be released theatrically, and is often used when the project is shot on motion picture film. HD 720 is a lower resolution HD. The bottom two choices, NTSC and PAL, are both standard definition (SD) formats, so if you have an old tape or SD files, you'd use one of these standards. In the USA it is NTSC. In Europe and most of the rest of the world, it is PAL.

IMPORTING MEDIA INTO AVID

There are a lot of visuals and sounds that aren't on a camera card. Sync dialog, music, photographs, computer designed graphics, videos from other sources or the internet—all need to be *imported* rather than linked. Basically, if you can't link to a camera file, you'll want to import the file into Avid. Importing is simply bringing a file in from outside of Media Composer into a bin inside your project. It could be a .wav, .mp3, QuickTime movie, a JPEG image, a Flash animation, or dozens of

other types of files. Whatever the file is outside your Avid, once you import it, it becomes a master clip inside your project and turns into Avid MXF media.

IMPORTING AUDIO FILES

Usually your sync dialog was recorded on a separate recording device, usually onto a CF card, a process we'll discuss in Chapter 9. In order to sync picture to sound, you'll need to import the audio files from the CF card. And, as we mentioned in Chapter 6, a lot of the sound work takes place after a fine cut is created. You've pretty much made all your editing decisions in terms of how the picture is structured and the sync sound that goes with that picture. Now it's time to bring in music, sound effects, Foley sounds, and any voice-over narration. Importing audio files is easy.

If you're importing audio files (like an .mp3, .wav, .aiff, .mov, etc.) from a memory card, place the card's contents inside a folder you create on your external media drive. For sync dialog, I call the folder SoundCard_001 or SoundCard_002, for each new memory card my audio recorder captured. For music files, I'll create a folder called Music.

To import audio files:

1. In your Avid projects, create a new bin called "SoundCard 001, or Music Cues," "SFX," or "Narration," or whatever type of audio you are importing. Click in the bin to make sure the bin is highlighted.
2. Go to the File menu, choose Input, and then select Import Media (Figure 8.22).
3. When the Select Files to import dialog box opens, click on the Options button at the bottom of the Import Files window, as shown in Figure 8.23.

Figure 8.22

4. When the Select Files to import dialog box opens, click on the Options button at the bottom of the Import Files window, as shown in Figure 8.23.

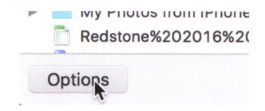

Figure 8.23

5. In the window that opens, you can ignore the Resolution box because audio has no resolution, but you want to make sure that the media is created on your external drive, as shown in Figure 8.24—Sam's GDrive.

Traffic Music.wav		Apr 3, 2014, 1:47 PM
	Enable:	Any
Options...		Sam Drive 2
Resolution:		
DVCPro HD MXF		
	Disk Label:	

Select the drive where you want the imported media to go

Figure 8.24

6. Navigate to the folder or file(s) you want to import. In Figure 8.25, I've navigated to my sync dialog files that I placed in the SoundCard_001 folder. I select all the files and press Open.

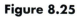

Figure 8.25

Depending on the file you are inputting, once you click Open, you may get an Audio Start-Time Options window like the one in Figure 8.26. Click on the Select menu and choose the frame rate the audio was recorded at. For my students, that's usually the camera's frame rate, which for my students is usually 23.976. They would choose 23.98, which is 23.976 rounded up.

Figure 8.26

Once you choose a frame rate, the window will ask you if you want to bring just one audio file in like this, or, if there's more than one, if you want all of them, and you want OK to All (Figure 8.27).

Figure 8.27

Once you click OK, the import won't take much time, and when the file(s) come into your bin, they will be displayed as audio master clips (Figure 8.28).

Figure 8.28

Double-click the audio master clip icon to load it into the Source Monitor.

IMPORTING GRAPHICS

When we use the term "graphic," it can mean a lot of different things. It can be a chart, a picture, or a series of pictures that, when joined together, form an animation. No matter what visual file we are importing, we want to make sure that, when the file comes in, it matches the specific video resolution that we set in the Projects Format settings. If we're a 1080p HD project, or a 4K project, we want the graphic to come in at the same resolution and frame rate.

Understand that this means that if your project is 1080p and you import a very large image, like, for example, a 4K image file (4096 pixels×2160 pixels), you'll want to transcode the file to your project's native video resolution—say, 1920 pixels×1080 pixels (1080p). Whereas if you're in a 4K project format, you'll want it to come in as 4096 pixels×2160 pixels. It also works the other way, too—bringing smaller images into your project's "larger" native video resolution.

Because of these potential resolution discrepancies, as well as aspect ratio discrepancies and other mis-matches between "inside-Avid" and "outside-Avid," there are several essential Import settings that you should become familiar with—beyond just selecting Import and OK (as many beginning editors are likely to do).

Ok, first thing's first: in order to import, you must have a file to bring in. It can be located anywhere, really—on your computer's desktop, an external drive, a flash drive, etc.

That said, I highly recommend that you copy all files (of each type) to a single folder on your external media drive before importing. I create a folder and name it "Graphics_to_Import." This allows you to better manage files from multiple sources and also makes it easier to reimport those graphics if you should need to, since they all originate from a single path.

To import:

1. Select the bin into which you want to import the file, and then select Input from the File menu and choose Import Media.

Once you do so, you'll see your file system and be able to search through your desktop, folders, and external drives.

2. Now click on the Options button at the bottom.

The Avid Import dialog box (Figure 8.29) opens.

3. Navigate to the file you want to import and select it. But before you click Open, let's make our choices.

As we did when we imported music, you choose the type of file you are importing in the Enable box. You select the drive in which you want the media to be stored—usually your primary external drive (like my "Sam Drive 2").

Unlike an audio file, a photo or graphic needs to match the resolution of your project, so you want to additionally choose the correct media resolution in the Resolution pull-down menu.

The button that requires a bit more explanation is Options. Let's click on it and take a look at what we see.

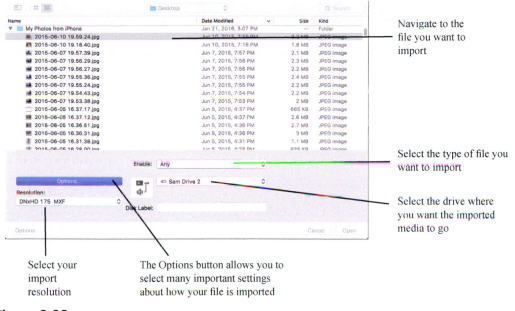

Navigate to the file you want to import

Select the type of file you want to import

Select the drive where you want the imported media to go

Select your import resolution

The Options button allows you to select many important settings about how your file is imported

Figure 8.29

IMPORT OPTIONS FOR GRAPHICS OR STILL PICTURE IMAGES

If you are importing an image that was taken by just about any still photography camera, or an image or graphic that was created in a paint/photo/graphic application software, such as Adobe Photoshop, After Effects, Illustrator, etc., you need to click on the Options button. You'll see a dialog box like in Figure 8.30. Let's go ahead and break down each of the categories, and we'll explore the most important options in detail.

Figure 8.30

Image Size Adjustment

The first box you see is Image Size Adjustment, and this is an important one, as it will determine how your image is sized when it comes into Media Composer. We have four choices: 1) Image sized for current format; 2) Crop/Pad for DV scan line difference; 3) Do not resize smaller images; and 4) Resize images to fit format raster. Let's take a look at these:

- *Image sized for current format* assumes that your file is already sized correctly for import into Media Composer. Then terrific—it comes in looking perfect. If, however, the image is *not* sized correctly, and it is "forced to fit" inside Media Composer's video frame, that's when you can get some unwanted stretching and squeezing.
- So what does "sized correctly" mean?
- In HD video, there are two formats: 720 and 1080. So if you or your graphic artist is creating an image for your project, create it in the native HD resolutions—that is, 1920 pixels wide by 1080 pixels high for a 1080 HD project, or 1280 pixels wide by 720 pixels high for 720 HD project. Once you've done that, just select the first option, *Image sized for current format*, and everything will look great upon import.
- *Crop/Pad for DV scan line difference.* To be honest, you're probably never going to deal with this unless you're editing someone's home videos that were shot on a standard definition miniDV tape. This choice deals with

the discrepancies between DV and standard definition. The miniDV and DVCAM formats have 480 horizontal lines, not 486. Therefore, this choice either adds or deletes the six lines, depending on if you're importing DV material into a non-DV project, or non-DV material into a DV project.

- *Do not resize smaller images* keeps the graphic just the way you designed it, with no change in size. For instance, you wouldn't want a company logo to force-fill in Avid's entire video frame (as would happen with the first option, *Image sized for current format*). Rather, you would want it to stay small in the corner of the frame.

- *Resize image to fit format raster* expects that the image is not sized "correctly" for the video frame, and then forces it to fit within Avid's frame. However, instead of forcing it to fit *both* horizontally and vertically (as happens with the first option), it instead maintains the graphic's native shape, and just fits it *either* horizontally or vertically. Therefore, a tall image will fit into the frame—it won't be cropped or squeezed—but to make it fit, a black border is added along the left and right sides. A wide image will be imported so we see the entire image (no cropping or squeezing), but a black or transparent border is added along the top and bottom.

Color Levels

Computer graphics create colors that are RGB (red, green, and blue) and don't mix well with video colors like our Rec 709. So if you're bringing in a graphic file made on a computer and not by a camera, choose "Scale from full range to legal range" (Figure 8.31). If you're bringing in a still image that was taken from video, then you want "Do not modify, treat as legal range." But most often your choice is "Scale from full range to legal range."

Figure 8.31

Frame Import Duration

When you import a still frame, Media Composer will turn that single frame into a master clip. Here, you simply dictate how long you want that master clip to last. The default is 30 seconds. In Figure 8.32, I've typed 10 seconds.

Figure 8.32

Autodetect Sequentially-Numbered Files

Often, an animation program, like Adobe After Effects, exports a series of individual still frames that make up a whole animation. These individual frames are sequentially numbered, so if you want to import the whole animation into Media Composer, just select the first file in the sequentially-numbered series, and then check this option to automatically import the rest of the files. Or say you shot

a time-lapse sequence with a GoPro camera, you'll want to checkmark this box before clicking OK, as I've done in Figure 8.33.

Figure 8.33

Alpha Channel

If the image you are importing has an opaque layer and a transparent layer (which is called an alpha channel), then you need to tell Avid how the image was created. Most animation and graphic applications set up the alpha channel opposite to how Avid does, so you will want to select *Invert on import (white = opaque)*. For graphics created using an Avid program, you should choose *Do not invert (black = opaque)* (Figure 8.34).

Figure 8.34

Once you have made the correct choices in the Import Settings dialog box, click OK. The Import Settings dialog box will close, and you'll be returned to the Avid Import dialog box shown in Figure 8.29 on page 177.

It's a bit frustrating, but now you'll have to again select the file you want to import, even though you've probably done it already. If it's a folder with individual images, such as that created by a GoPro camera, select the folder containing all the images.

Now when you click Open in the Avid Import dialog box, the file will be imported into the bin you selected. Usually it will become a master clip.

It Doesn't Look Right!

If the image you imported doesn't look right, no worries. It happens to me. I thought it would look good with one set of options, but it's squeezed or the opaque channel isn't opaque. So I delete the file and try again with a different set of options.

PRACTICE IMPORTING

To give you practice importing graphic files and a QuickTime movie, I have included a couple of graphic files created for *Where's the Bloody Money?* You can import them into any project. You don't have to go back to that project if it's easier not to. One is a called "WTBM Title" and the other is called "WTBM Logo." In addition there's a time-lapse QuickTime movie called "Night Comes." To download these files from the website for this book, follow the steps outlined on page 10 of Chapter 1.

Practice Importing Graphics

Now that we have two graphic files to import, let's try importing them. The WTBM Logo image has an alpha channel and the WTBM Title doesn't; and one is sized correctly for import, and the other isn't. Therefore, we'll have quite a few options to play with here.

To import a graphic (title) without an alpha channel:

Note: The "WTBM Title" was sized correctly for import, which means that it was created in Photoshop at 1920x1080 pixels to be imported into a 16:9 video frame.

1. In the *Where's the Bloody Money?* project (or whatever project you're working in), create a new bin and call it Titles.
2. Click inside the Titles bin to make it active.
3. From the File menu, select Input > Import Media. The file directory window opens. Click Options.
4. In the Avid Import window, select the project's resolution. Also make sure the drive is set correctly.
5. Click on the Options button.

6. Because this image was sized correctly for import, select the first option: *Image sized for current format.*
7. Type "10" for the Frame Import Duration amount.
8. Because there is no alpha channel, select *Ignore*.
9. Click OK.
10. Navigate to the "WTBM Title" file in the "Files for Import" folder.
11. Select Open.
12. The graphic is brought into the project, and now lives in the Titles bin. You can cut this into a sequence just like any other clip.

To import a graphic (logo) with an alpha channel:

Note: The "WTBM Logo" was not sized correctly for import, as it is a small logo that needs to be inserted in the corner of the video frame.

1. In the *Where's the Bloody Money?* project (or whatever project you're working in), click inside the Titles bin to make it active.
2. From the File menu, select Input > Import Media. The file directory window opens. Click Options.
3. Make sure your resolution and drive selections are set correctly.
4. Click on the Options button.
5. Because this image was not sized correctly for import, select the third option: *Do not resize smaller images.*
6. Type "10" for the Frame Import Duration amount.
7. Because there is an alpha channel, and this graphic was created outside of Avid, choose *Invert on import (white = opaque)*.
8. Click OK.
9. Navigate to the "WTBM Logo" file in the "Files for Import" folder.
10. Select Open.
11. The graphic is brought into the project, and now lives in the Titles bin. Notice that because it had an alpha channel, the graphic has a Matte Key effect. You can place that on V2 and it will superimpose over an image because of its alpha channel.

Importing a QuickTime Movie

So far, we've imported still images. Now, let's bring in a movie file—specifically, a time-lapse that was shot with a GoPro, imported into Avid, cut into a new

sequence, had a title added to it, and then was exported as a QuickTime movie. It is called "Night Comes."

1. In either the *Where's the Bloody Money?* project or Documentary Practice click inside a bin to make it active.
2. From the File menu, select Input and then Import Media. The Import window opens.
3. Click on Options.
4. In the Avid Import window select the resolution and drive. Click Options.
5. Select the following options: *Image sized for current format*, *Ignore Alpha*. Click OK.
6. Navigate to the "Night Comes" QuickTime movie.
7. Click Open.

The file will appear in the bin as a master clip. Open it in the Source Monitor and hit Play. This was filmed in a village in Ethiopia and shows dusk giving way to night, with a copyright title added.

As you can see, you can import many different types of files, and there are quite a few options involved in the import process. Now that you know the basic parameters, you should be able to import just about any file successfully. As with anything else, you'll learn best through practice and experimentation.

AUDIO SAMPLE RATE

When audio is captured, the signal is sampled and then converted to digital information. *Sampling* means that not all of the sound is converted, but a representative sample of it is. The more samples that are taken, the better the fidelity, or faithfulness, to the original analog signal. Back in the day, when people bought and played CDs the sample rate was 44.1 kHz. Just about all recording devices today record at 48 kHz. That is Media Composer's default setting and the one we recommend you use. (Audio sample rate can be changed via the Audio Project settings in the Settings list of the Project window.)

Just the Beginning . . .

File-based workflows have replaced tape-based workflows, so you'll continue to see great advancements on this front. And keep in mind, I've really just touched the tip of the iceberg of the Avid's Link to Media and Transcoding workflows—certainly

enough to get you started with confidence. There are more complex techniques, such as transcoding in the background and dynamically linking and unlinking between various video resolutions. We'll explore some of these techniques in subsequent chapters but I definitely recommend exploring the Avid documentation as new techniques evolve.

Double-System Sound Workflow

Many people shoot their first projects on a digital camera or smartphone that records the picture and the sound together. That way, when they play what they've shot, their picture and sound plays perfectly in sync. What's great about this is the simplicity—one device does everything. However, these devices usually do a great job of recording images, but the sound runs from acceptable to terrible. That's because the best place to capture the image isn't always the best place to capture the sound. The further the camera is from the source of the sound, the weaker the sound signal becomes. And too, sounds you don't want, such as traffic and other people's conversations, can be closer to the camera than the person you're recording, and thus will often interfere with the sounds you care about.

If there is one key rule to follow if you want great sound it's this: get the microphone as close as possible to the source of the sound you want to record. And in order to obey that rule, it's best to split up the job of recording the sound and recording the picture. The camera team places the camera to capture the shot they want and the sound team places the microphone where they want. This division of labor insures that you get great sound as well as great images. Having two different devices capture the picture and sound is called double-system recording.

DOUBLE-SYSTEM SOUND RECORDING TECHNIQUES

Whenever you see pictures of Hollywood crews shooting features, there is often a person holding a long boom pole in the air, with a microphone at the end of the pole, stretched out over the actors' heads. The sound team is obeying the key rule: they are getting the microphone as close as possible to the actors' mouths to record the dialog. And let's face it, most of the time the sound team is concerned with recording dialog. Sound recording on a narrative film is really all about dialog recording. Natural sounds like traffic, ocean waves, footsteps—these can all be recorded later or downloaded from a sound effects library during editing. While

a boom-mounted microphone is used over 90% of the time, there are often multiple microphones in use as well. Actors often have wireless microphones hidden beneath their clothing, or a tiny microphone may be placed on a table or tucked behind a mirror, out of view of the camera. There can often be six or more microphones used to record the actors' dialog, especially if the actors move around a lot and there are lots of actors in the scene.

HOW DOUBLE-SYSTEM IS SHOT AND SLATED

Let's start at the beginning. The cast and crew are getting ready to shoot the first scene of the production. Usually there's a brief technical rehearsal with the actors before filming begins so the camera crew can determine framing and focus and the sound team can strategize as to where the boom operator should stand to hold the boom, and, if other microphones are needed, where they should be placed. The sound team also uses this rehearsal to set the proper volume levels for the boom microphone and any other microphones that might be in use.

The Assistant Camera person (AC) is tasked with the job of preparing the slate before filming (Figure 9.1). A motion picture slate has two parts and two functions. The bottom part contains space for writing information—information about which digital camera card, or roll of motion picture film is loaded into the camera (1), which scene (Scene 1), which camera set-up (A), and which take (Take 3) will be

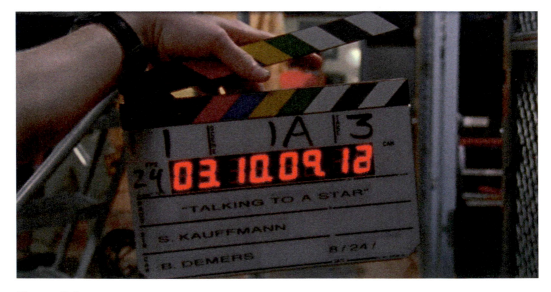

Figure 9.1 A motion picture slate in use.

recorded next. We can see that 24 frames per second is the camera frame rate. There is also the working title of the production (in this case, "Talking to a Star"), the name of the Director and Director of Photography, and the date. This is a "smart slate" so it can display time of day or timecode information, shown by the red numbers. The slate we'll be using for *Where's the Bloody Money?* is the cheaper wooden version, not a smart slate, but they work the same.

The top part of the slate has a wooden or plastic "stick" attached to the body of the slate by a hinge, and this stick is dropped onto a matching stick mounted on top of the information part of the slate to create a sound like a "clap" (Figure 9.2). The sound recorder captures the sound of the clap and the camera records the moment when the clap is made. This visual and sound reference is used to "sync" picture and sound in the editing process, which we will learn how to do shortly. The slate is often referred to as "clapsticks" or simply "sticks."

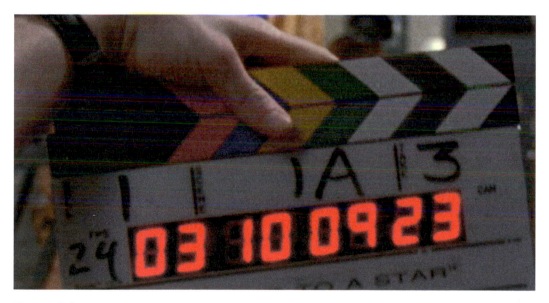

Figure 9.2 The clapsticks come together to create the sync reference.

THE SLATE INFORMATION

Recording the clapsticks coming together is key to this process, but the slate information is critical as well. If you're only shooting one scene, it's not too difficult to keep track of all the clips, but imagine a much longer production—even

a feature—and think about the thousands of clips involved. If you're the editor on this feature, or the assistant editor asked to organize and sync up all these clips, you sure hope the production crew followed the industry standard protocol for naming the clips and shooting the slates.

So let's review this protocol. The camera will photograph the information written on the slate at the beginning of each take. But what about the sound? We're shooting double-system and the separate sound recorder needs this information as well. So before the director calls "Action," the slate information is read out loud so that it is recorded onto the sound recording device. Now, during editing, the editor can identify each picture clip by the information written on the slate, and identify each sound clip by the information spoken and recorded.

The need to change the take number each time there is an additional take from that camera angle is fairly obvious. Another piece of the slating protocol involves identifying the different camera positions or "set-ups" when shooting a scene. Often scenes are shot from several different camera positions. The crew might start off shooting the scene with a wider lens to capture all the action. This is often called the "master shot." Then the camera might be moved to get a medium shot of one of the actors throughout the scene, and then the camera is moved a third time to get a medium shot of the other actor. As we know, Scene 6 from *Where's the Bloody Money?* was shot from five different camera positions.

Every time the scene is shot from a different camera position or set-up, a letter is added to the scene number. So after the first set-up is completed (Scene 6), the slate is changed to Scene 6A to signify this is a second positioning of the camera—a second set-up. When all the takes from this new position are recorded, and the camera is moved to the third position, the slate is changed to Scene 6B. Because handwriting can be hard to read, and voices can be muffled, the Assistant Camera (AC) will often say a word that begins with that letter when calling out the scene information. The AC might say, "Scene 1 Apple, Take 1." Most ACs stick to Apple, Baker, Charlie, Delta—military designations—though some ACs get creative.

Some letters in the alphabet are never used. The letters I, O, Q, U, and Z are not used because they look so much like numbers and could cause confusion. What if you run out of letters? Let's say you're filming a huge battle scene and you are shooting the scene from many different camera positions. If that happens, just double them up, so you would use AA, AB, and so on.

STANDBY!

Let's imagine the first scene we're filming is Scene 6, and the camera is set up with a wide enough lens to film the master shot first. The AC will write a "6" in the slate's

Scene box and a "1" in the Take box. Often a production assistant will do this job and hold the actual slate during filming, but no matter who holds it, the AC should make sure it's done and done correctly.

Now the director is ready to start shooting the scene. The Assistant Director (AD), if there is one, will get everyone's attention by saying "Standby to roll sound." Everyone moves to his or her opening positions.

So let's listen in to what is spoken, once the director nods at the AD to indicate that the actors are ready.

AD:	*Roll sound.*
Sound Recordist:	*Speed.*
AD:	*Roll camera.*
AC:	*Speed (or Rolling)*
AD:	*Mark it*
AC:	*Scene 6, Take 1.*

At this point the AC brings the sticks down onto the slate and then steps back next to the camera.

Director: Action.

So what's happening? The recordist hears, "Roll sound," so she or he presses the record button on the recorder and waits until a red light goes on to signify that it is in recording mode. As soon as the recordist sees that red light, the recordist says, "Speed," meaning the recoding device is recording properly. The AD then says, "Roll camera." At this point the AC starts the camera and once the camera is in record mode, the AC says, "Speed." The AD then says, "Mark it." This means that the information about the scene number and take number are called out, and then the sticks are brought together, creating the clap sound. The director finally says, "Action." When the scene is over, the director says, "Cut," and it is then that the camera and recorder are turned off.

If there's no AD, the director might handle those duties, or the AD may hold the slate and mark it, as was the case with *Where's the Bloody Money?* It doesn't matter who says it as long as the sound recorder is always started first and the camera doesn't start until after the sound recordist has indicated that the recorder is on and working. It is only when both the sound recorder and camera are actually recording properly (at speed) that the "clapsticks" are brought together. On really low-budget films, sometimes there's not even a slate. In that case, an actor will clap hands together to create a visual and sound sync reference point. It works, if done carefully, but it makes the editor's job more difficult.

IMPORTING AUDIO FILES FROM A DIGITAL RECORDER

Figure 9.3

Although I have clips for you to practice with, you'll soon need to do this on your own projects. Here's how we do it at Boston University, where students record their sound using a Sound Design 702T digital recorder, which records .wav files onto a compact flash memory card. Because audio files aren't very large, a 4 GB card like the one in Figure 9.3 is large enough.

The audio is recorded at 23.976 fps and the sample rate is 48 kHz. After filming, students will back up the sound card by placing it in a folder on their external drive, calling the folder "SoundCard_001." Once they do that, they usually import the files from this folder. Others will import directly from the recorder's flash card and then make the back-up.

If you've likewise recorded your audio onto a digital recorder, you can follow these steps to import your audio:

1. Insert your flash card into a flash card reader.
2. Go to File > Import and navigate to the flash card (or SoundCard_001 folder).
3. You'll see a number of folders; open the one that contains your .wav files. Select all the files.
4. Click Open.
5. If they are .wav files, you'll get a window like the one in Figure 9.4. In the Select pull-down menu choose 23.98 and then, in the next window, click on OK to All.

Figure 9.4

All your .wav files will appear in the bin as master clips.

If you haven't already done so, bring in the camera's files from your external drive, as explained in Chapter 8. Once you've linked the camera files and transcoded them, place them in a separate bin. Now all that's left before you can begin editing is to sync your picture and sound. The steps we do from here on will be the same whether you use the practice clips from *Where's the Bloody Money?* or your own project.

PRACTICE SYNCING PICTURE AND SOUND

Just to warn you, syncing picture and sound is often a time-consuming endeavor. Usually, you have a lot of takes and each one has to be synced by hand. Feature projects often hire assistant editors to do the syncing, and so this could be one of your first jobs.

To practice syncing and working within the double-system workflow, we'll return to *Where's the Bloody Money?* Once we've launched Avid, and selected the *Where's the Bloody Money?* project, we'll double-click on the Chapter 9 folder that's in the Project window. You can see from Figure 9.5 that there are two bins inside the folder: Audio Clips for Syncing and Video Clips for Syncing. Each contains the clips that need to be married together.

Figure 9.5

I suggest you place the bins together in a tabbed interface, shown in Figure 9.6, as we learned to do in Chapter 1. That way you can click on the

Video Clips for Syncing tab, it opens, and when you click on the Audio Clips for Syncing, it replaces it.

		Name	Duration	Start	End
		Master Shot Tk 1	1:51:03	01:12:18:00	01:1
		Master Shot Tk 2	1:59:06	01:14:09:05	01:1
		Master Shot Tk 3	2:00:10	01:16:08:13	01:1

Audio Clips for Syncing ✕ Video Clips for Syncing ✕

Figure 9.6

When you click the Video Clips for Syncing bin, you'll see there are 13 master clips. When you click on the Audio Clips for Syncing bin you'll see 13 audio clips (Figure 9.7).

One important note. The names of the clips in the bins have been changed from when we shot the scene. As I explained earlier, the scene number is written on the slate, so they were named Sc 6 Tk1, Sc 6 Tk 2, etc. To make it easier for you to practice editing in Chapters 1 and 2 and trimming in Chapters 3 and 4, I renamed them to better describe what they represent. So Sc 6 Tk 1 became Master Shot Tk 1. All you need to do is match up the audio clip names in the Audio Clips bin with the picture clip names in the Video Clips bin.

	Name	Duration
	Master Shot Tk 1	1:53:22
	Master Shot Tk 2	2:04:21
	Master Shot Tk 3	2:03:22
	Master Shot Tk 4	41:00
	Colleen Tk 1	1:52:22
	Colleen Tk 2	1:54:22
	Sarah Tk 1	1:55:22
	Sarah Tk 2	2:48:20
	Dan Tk 1	1:58:22
	Dan Tk 2	2:09:21
	3-Shot Dan Tk 1	2:07:21
	3-Shot Tk 2	30:00
	3-Shot Tk 3 PU	41:00

Audio Clips for Syncing ✕ Video Clips

Figure 9.7

Now let's go through the steps to put the picture and corresponding audio clips in sync.

To sync your clips:

1. Create a new bin and call it "Synced Takes." Now create a second new bin and call it "Synced Subclips." Double-click to open both outside the tabbed interface and position them next to each other (as shown in Figure 9.8) and just below the Source and Record monitors.

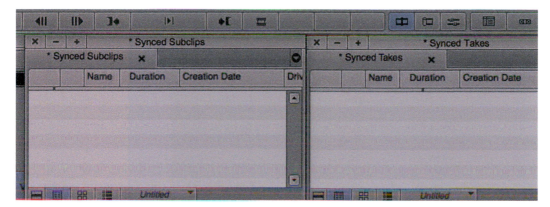

Figure 9.8

2. Open the Video Clips for Syncing bin or your own bin with your captured picture clips.
3. Load the first clip (Master Shot Tk 1) in the Source Monitor.
4. Find the first frame where the clapstick closes. If there was sound, it would "clap" here. Mark this frame with an IN. Go to the end of the take and mark an OUT.
5. Make a subclip of this clip by clicking on the image in the Source Monitor and dragging and dropping the picture to the Synced Subclips bin as shown in Figure 9.9.
6. Go to the Audio Clips for Syncing bin and load "Master Shot Tk 1" into the Source Monitor.
7. Play forward until you hear the crunch. You'll hear the scene and take announced and the crunch will come soon after that. Play in Reverse until the position indicator is just before the crunch. Now, hold down the Shift key on the keyboard so you can use "digital scrub" to hear the sound.

Drag from
here to here

Figure 9.9

Pressing the Caps Lock instead will free up your finger. Now, step forward frame by frame, using the single-frame keys (Figure 9.10), until you hear the first full frame of "clap." Mark an IN on this frame. Go to the end of the take and mark an OUT.

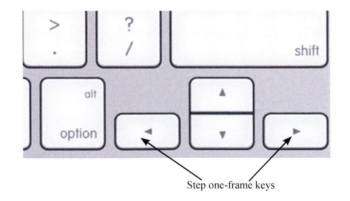

Step one-frame keys

Figure 9.10

8. Make a subclip of this audio by clicking on the center of the Source Monitor (it's black because you just have an audio clip loaded) and dragging it to the Synced Subclips bin (Figure 9.11).

		Name	Creation Date	Duration
☐		Master Shot Tk 1.Sub.01	11/23/16 5:33:44 PM	1:48:22
☐		Master Shot Tk 1.Sub.01	11/23/16 5:28:53 PM	1:47:20

Figure 9.11

9. Now you have two subclips in the bin. Notice how one has the icon for audio subclips and the other has the icon for picture subclips. Each icon looks like a Mini-Me of the master clip icon. Now, shift-click so that both these subclips are selected, as in Figure 9.12.

		Name	Duration	Drive	Creat
☐		Master Shot Tk 1.Sub.01	1:48:22	Media Drive 1	11/23/
☐		Master Shot Tk 1.Sub.01	1:47:20	Media Drive 1	11/23/

Figure 9.12

10. From the Clip menu, choose AutoSync.

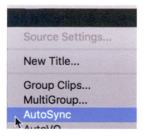

Figure 9.13

11. A dialog box appears like the one in Figure 9.14. Select the Inpoints button.

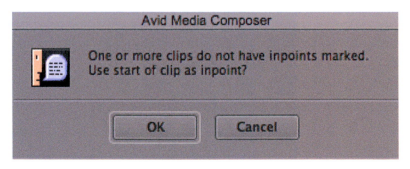

Figure 9.14

12. Now click OK. A dialog box will say that one or more of these subclips are without Inpoints. You can ignore this prompt. Simply Click OK (Figure 9.15).

Figure 9.15

13. A third subclip is formed and appears in the bin—combining sound and picture locked in sync. Fortunately this synced subclip is always on top.

Figure 9.16

14. Double-click on this top subclip icon to place it in the Source Monitor and play it to check if it's in sync. If it is, drag this subclip icon to the Synced Takes bin. Then, you can rename the subclip by deleting the ".Sub.01. sync.01" portion, so it is simply named Master Shot Tk 1 (Figure 9.17).

Figure 9.17

15. Now sync up the other clips in the same way.
16. When you've finished syncing, you can delete all the subclips in the Synched Subclips bin—you're through with them. You'll just work with the Synced Takes bin from now on.

Most dramatic films/digital projects are organized by scenes, so at this point we'll rename the Synced Takes bin and call it Scene 6 (or whatever scene the clips come from). Then as we have more scenes to sync, we'll open the empty Synched Subclips bin, create a new Synced Takes bin and start synching the next scene, and keep going.

There. We've learned to sync picture and sound.

Syncing Tips

It's easy to identify the precise film or video frame in the Source Monitor where the clapsticks on the slate come together. Identifying in the Source Monitor which precise frame of audio has the first frame of the "Crunch" is harder because you can't see anything. Ah, but you can. You can use the Toggle Source/Record button to display your source clip in the Timeline. With Toggle Source/Record toggled to Source (bright Green), you can then get into your waveform view so you can easily see where the clapsticks strike. Now it's easy to mark your IN point. It looks like a black thumbtack or a spike (Figure 9.18)

Source/Record toggle button

Figure 9.18

You may discover in Step 14 that the synched subclip is not in sync—that you somehow made a mistake. No worries. Simply select the faulty subclip and press the delete key. Click "OK" in the prompt and it's gone. You can always delete subclips because the master clips remain.

So what could have gone wrong? You probably grabbed the wrong audio clip. So after deleting the faulty audio clip, start over. This time, double check that the audio clip is the same take as the video clip. If it is, try using the Source/Record Toggle button to make sure you picked the correct "clap" frame.

MORE SLATING TIPS FOR THE EDITOR

- If you see a slate with the designation "PU" as in Figure 9.19, it stands for Pick Up. It means that this take doesn't capture all the action that the previous takes do. Usually the action at the beginning of the scene is not filmed again. Instead the action is "picked up" at a later point in the scene.
- If for some reason the camera operator misses photographing the clapsticks coming together (the sticks drop out of the frame), she or he will call out, "Second sticks!" Whoever is holding the slate will reposition it for the camera and bring the sticks together a second time (hopefully this time the

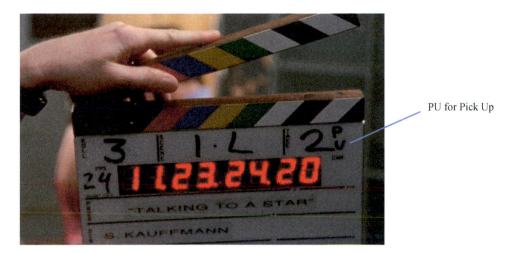

PU for Pick Up

Figure 9.19

sticks are visible in the frame). As the editor syncing the clips, you should mark an IN at the second crunch of the audio clip, not the first.

- If you see that there is a hand in between the sticks and the slate, preventing the sticks from "clapping," that means that there is no sound recorded with this shot. So don't try to find sound because it's not there. It's MOS or "Mit (With) Out Sound." Sometimes closed sticks indicate this.
- If there is no slate at the beginning of a clip, it may be because the director wanted to start filming immediately to capture a special moment, and so sound and camera rolled without slating. An alert camera and sound team won't stop recording when the director says, "Cut," but will keep recording until they hear, "Hold for Tail Slate!" At this point the slate will be brought in front of the camera, held upside down, and then marked. Only then is the camera and sound recorder turned off. Avid has the option of synching by Outpoints (Figure 9.14) so you're all set.
- Sometimes continuous action is broken up by flashbacks. These flashbacks are actually different scenes in the script, and they have different scene numbers assigned to them. This is the case in *Where's the Bloody Money?* Scene 6 is actually several scenes that are broken up by flashbacks showing what took place during the bank robbery. You can see the multiple scene numbers on the slate, as shown in Figure 9.20. But because the actors will perform better if we shoot it as a continuous scene, we do it that way, and let the editor intercut the flashbacks into the continuous action that we filmed and you edited.

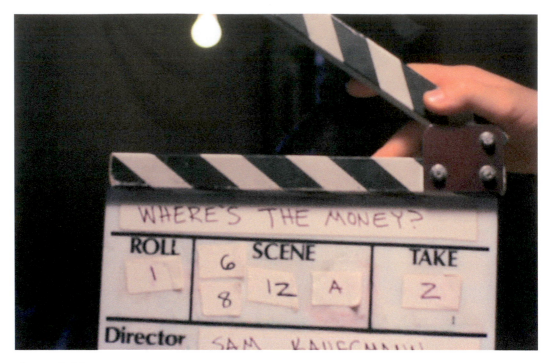

Figure 9.20

10

A Few Editing Tips

You've been working on the scene from *Where's the Bloody Money?* or the Montage sequence, or perhaps your own project. Let's say you've reached the point where you're fairly happy with it. Or perhaps you know something is not quite right and you're not sure what it is. In either case it's time to get some feedback. That means bringing in friends, classmates, and relatives—whoever you think can help you improve your scene by telling you how he or she honestly feels about your work. But, before you subject yourself to all that honesty, let's go over a few editing pointers. These may seem obvious, but they have helped my students over some bumps, so perhaps they'll help you, too.

Figure 10.1 Dan is interrogated by Sarah and Colleen about the missing $15,000 in a scene from *Where's the Bloody Money?*

WHEN TO CUT

Everyone agrees that a cut brings energy to any film or video. By changing the angle of view or cutting to a new location, you are participating in the essence of filmmaking. Without editing, movies are no more than recorded plays. If you go to a theater to see a play, you buy your ticket and take your seat, and everything happens from that one vantage point—your seat. No matter what the action—a swordfight, a kiss, a verbal argument—you see it from the same distance and angle.

But what if you could change your seat during the play to get a better view of specific actions? You might go to the front row to see the kiss, and you might move up to the balcony to see the sweep of the swordfight, but if the lead actor gets stabbed and falls, you might race back to the front row to hear his dying words and see the expression on his face.

As the editor, it's your job to give the audience the best seat in the house. Whatever the action, you pick the shot that gives the audience the best vantage point to see and hear what is going on. Establishing shot, long shot, medium shot, close-up, over-the-shoulder shot, reaction shot, master shot—these all describe what the camera is seeing. Don't worry about the names or following some half-baked rule about cutting from one to the other. Instead, look at the choices and decide where the audience would want to be in order to view that action. Once you've picked the best seat, stay with it until there's a better seat. You cut at the precise moment when you feel that you (and the audience) want to change to a better vantage point in order to get a better view of that action or dialog. See, it's not that complicated.

CONTINUITY AND EYE TRACE

Most narrative films are shot using one camera. With all the lights, technicians, and sound equipment on a set or location, a second camera isn't practical because it would film the crew and equipment. Most sets are pretty packed and there's not much space for another camera. So, instead of shooting with multiple cameras, the camera is moved for each shot, the crew and equipment are placed out of frame, and the action is repeated. The main problem with this method is that there are often continuity problems. The actor holds the cup in his left hand in the master shot, but the cup is in his right hand in the medium shot. You want to cut from one shot to the other but that cup is making it hard. Or, perhaps the problem isn't as blatant as a cup in the wrong hand. More often it's the position of an arm, or the position of someone's head that changes on the cut. But, no matter what the problem, how do you, the editor, make such a cut when it's so blatantly awkward?

There are a couple of tricks. The easiest is to go to a cutaway; the audience forgets the continuity problem and you're home free. Unfortunately, this almost never

works because that's not what the audience *wants to see*. That cutaway is not the best seat in the house. A better choice is to find movement and cut on it. Make the cut when the actor sits down or gestures with her arm. Then you'll be cutting on the action, rather than before or after the action. This will usually hide, or at least obscure, the continuity problem.

Eye trace is another important concept. The bigger the screen, the more our eyes are attracted to different parts of the screen. Where do we look when we watch a film or TV show?

- We look at the eyes and mouth of the person talking.
- We look at the part of the frame where there is movement and not where things remain still.
- We look at bright areas before dark ones.

Pay attention to where your eyes go as you watch a shot. Ask yourself, "What am I looking at right before I cut to the next shot?" Examine your eye trace. If your eye is on the far right of the frame, and then when you cut there's not much there to look at, your eyes search the frame to find something of interest. Your eyes move around the frame to find a face, or movement, or brightness. That movement is called eye trace.

If you're trying to make a match cut, watch where your eyes go when you make the cut. If your eyes don't move much at all, you'll have a pretty good match cut. This is especially important if there's a continuity problem. Make the audience move their eyes very little when you cut. The cut will seem smooth, and that smoothness will hide the continuity problem.

SCREEN DIRECTION

Sometimes we *want* the eyes to move at the cut. If Sarah is on the left-hand side of the frame and you cut to Colleen, the person she's talking to, Colleen should be in the right-hand side of the frame (see Figure 10.2). Our eyes expect to jump from Sarah to Colleen, from left to right—like a tennis match. Here we are talking about *screen direction*.

Look at Figure 10.2 to get a better understanding of screen direction. In Figure 10.2 Sarah is on the left-hand side of the frame looking to the right. Another way to say this is that she is looking from screen left to screen right (left to right, or L–R). And Colleen is looking screen right to left, or R–L.

Now, the way Sarah and Colleen are looking makes sense. They are talking to each other and facing each other. The screen direction is correct.

Figure 10.2a Sarah is screen L–R.

Figure 10.2b Colleen is screen R–L.

Often good directors and their editors use screen direction to help tell a story. In Oliver Stone's Oscar-winning film *Platoon*, edited by Claire Simpson, there is a climatic scene in which Willem Defoe's character is murdered by Tom Berenger's character. This cold-blooded killing is wonderfully telegraphed by the screen direction of the two characters. Defoe is running from the left of the screen to the right (L–R) to battle Viet Cong soldiers who are moving toward him, screen right to left (R–L). They are racing toward each other and for a while Berenger moves from screen left to right (L–R), as if he too is going to battle the enemy. But, suddenly he turns and begins moving from the right of the screen to the left, toward Defoe, the same direction as the Viet Cong, setting up the final confrontation where Berenger's character kills Defoe's.

Unfortunately, most directors and editors get hopelessly lost when dealing with screen direction, and the result is a lot of confusion for the audience. Often editors end up making it look as though two characters, who are supposed to be talking to each other, aren't talking to each other at all. Examine Figures 10.3. Colleen is looking L–R. She's talking to Dan. But when we cut to Dan, he's looking over at Sarah and we're confused, because both Colleen and Dan are looking L–R. This throws off the audience because the characters have the same screen direction.

Figure 10.3a Colleen is screen L–R.

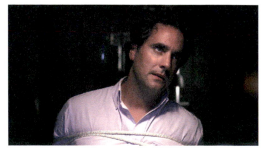

Figure 10.3b Dan is screen L–R.

Therefore, don't cut to Dan when he's looking at Sarah. Instead, you cut to Dan while he's looking at Colleen, as in Figure 10.4.

Figure 10.4a Colleen is screen L–R.

Figure 10.4b Dan is screen R—L

Now, if you want to bring Sarah in, wait until Dan turns and looks L–R. Then you can cut to Sarah, as we see in Figure 10.5

Figure 10.5a Dan is screen L–R.

Figure 10.5b Sarah is screen R–L.

Examine Figures 10.2 to 10.5—these are classic cases of letting screen direction help you decide when to cut. Understand that nearly every shot involving people has screen direction. A person is either walking, standing, or looking from one direction to another (left to right or right to left). So, when you cut from different angles and takes, make sure that the people who are talking or walking toward each other don't suddenly share the same screen direction, as happened in Figure 10.3.

PACING

Pacing is crucial to effective editing; yet it is perhaps the most difficult skill to write about or to teach. But here goes.

Let's think about cutting a conversation between two people. The content of their conversation, together with the actor's delivery, determines the pacing. A talk between friends or an amiable exchange between people, where each person is listening to the other, would be slower paced and involve more pauses. Instead of cutting as soon as one person stops, you might want to let the dialog breathe by putting in pauses before each person talks. That way we can see them thinking or reacting, rather than just delivering their lines. An argument where two people aren't really listening to each other would be faster paced. You would have more cuts with few if any pauses between lines. At times, one person might cut in before the other person finishes.

Reaction shots and split edits (L-cuts) are important components of any conversation. You don't want to always stay on Sarah until she finishes her lines, and then cut to Dan, and stay on him while he says all his lines—always on camera. It is often better to start a scene off that way, so the audience learns who is talking and gets a handle on their voices, but once the audience gets it, you can depart from the talking-head approach and spice things up with reaction shots and split edits. Again, you must constantly ask yourself—what does the audience *want* to see right now? Which seat do they want to be sitting in to see this action?

Let's start with reaction shots. If Colleen says something hurtful or ironic or funny, we want to see how Dan responds. So, instead of staying on Colleen, we cut away to see Dan's reaction to her as she talks about him. The length of the cutaway depends in part on his reaction, but you would tend to want the reaction to be a bit longer during a normal conversation than during an argument or fight. You can use the length and frequency of reaction shots as a way to speed up or slow down the pace.

Split edits are also useful to introduce reactions. For example, you have a close-up of Sarah talking to Dan, you might want to introduce Dan's stunned reaction as she finishes her dialog over a shot of Dan listening, and then he starts to reply. As we discussed in Chapter 3, we can easily use Dual-Roller Trim to change the picture cut point by dragging the rollers on V1 to the left (Figure 10.6).

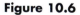

Figure 10.6

Be careful that you don't overdo split edits, because they often make the scene go by too quickly. Students sometimes complain that their scenes behave like runaway trains—going much faster than they intended. The culprit is often the same—they've used too many split edits. Unless it's a fast-paced argument, you want to keep enough of the necessary pauses that straight cuts provide, but which split edits remove.

STORY STRUCTURE: BEGINNING, MIDDLE, AND END

If you think about it—every story has a beginning, a middle, and an end. And every film or TV show should too—be it a narrative or documentary. Editors often lose sight of this as they grapple with hours of footage and thousands of choices, but whether you're working on an hour-long documentary with twelve sections or a feature film with forty scenes, everything should fit into the beginning, middle, or end. If it doesn't, you probably can cut it out. Go ahead and offer *Memento* or *Pulp Fiction* as a point in rebuttal, but both started with a beginning, a middle, and an end—the writers simply scrambled them after the story was written.

DOCUMENTARY ISSUES

Editing a documentary often means working with talking-head interviews or voice-over narration. With talking-head interviews, you often cut away from the subject's head to more interesting visual material. In television speak, that visual material is often called *B-roll*, a term I don't like because it makes it seem like this material is less important—the B-team, not the A-team—when it's often just as important.

Say the main subject is a man named Seifu Ibssa who is talking about how education can change lives in Ethiopia. Look at the Timeline in Figure 10.7. You might start with him speaking on camera, and then superimpose a lower-third title that identifies him while he talks. After this introduction, you might keep the sound of his interview, but exchange his talking-head with shots of people living

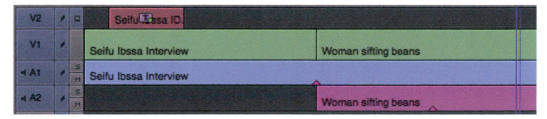

Figure 10.7

their lives in the same manner as in prehistoric times to show what education can change. You cut in these visuals on V1 and their live sound on A2, but you keep his interview as voice-over narration on track A1.

Because we're cutting to a visual—the woman sifting beans—we can edit Seifu's audio on A1, since he is no longer on camera. We can cut out pauses, coughs, ums, and extraneous parts. If Seifu goes on a tangent, we can cut that tangent out, and cover up our audio cuts by hiding them beneath the image of the woman sifting beans, as illustrated by the cuts to track A1, in Figure 10.8.

Figure 10.8

In general, though, these visuals are your friend, and you should use them not only to offer additional visual information and stimuli, but also to act as the paste that holds your chopped-up interview footage together.

The problem many editors have is in choosing the visual material. Too often the visual they choose is identical to the narration. The narrator says "It was a cloudy day" (we see clouds in the sky), "The wind blew the leaves along the ground" (we see leaves blow across the ground). This is called *Mickey-Mouseing* (long story). Essentially, you're just repeating the information twice. Try instead to find footage that *amplifies* the narration so the audience gleans more information than could otherwise be discerned from the narration alone. But, be careful you don't undercut the narration. If the narrator says "We owe it to our children to give them a cleaner, less polluted world," don't show smokestacks billowing out pollution. That undercuts your narration. A shot of kids swimming in a clean mountain lake would work better.

As useful as these visuals are, if the subject is saying something really interesting or with great emotion, you want to show the subject speaking on camera.

SHORT IS BETTER THAN LONG

Too often filmmakers crafting their first projects think that longer is better. Yet festival judges, film curators, and busy agents greatly prefer short and tight.

Put yourself in the seat of a judge at a film festival trying to put together a program of shorts. All things being equal, if you can select four 30-minute films or six 20-minute films, you'll pick the six films every time. Put another way, everyone can find 10 minutes to watch your 10-minute film, but ask someone to watch your 45-minute film, and it's a harder sell.

Don't get me wrong. If your film is a powerful feature-length documentary, that's great. There is no "correct" length—it's dictated by the material. I'm just urging you to fight to get your projects as tight as possible. Be ruthless in cutting away non-essential material. Be willing to cut out every shot that doesn't carry its weight.

SCREENING A WORK IN PROGRESS

Now you're ready to show your work. You've got a good cut, but you need some honest feedback. Most editors place a high value on screening their work while still editing it. Call it a rough cut or a fine cut screening—whatever name you give to it—it's a screening of your work in progress.

The biggest reason to have screenings along the way is that during the editing process, you've most likely been working in a vacuum. What you're looking for now are fresh eyes and ears. You need an audience (it can be one or two people or a classroom full of fellow students) to tell you what's working and what isn't.

Holding a Screening for a Live Audience

If you're holding a screening for a live audience, get the screening room ready before people arrive. Even if it's just a computer screen and two speakers, make sure everything is just right. Are the speakers on? Are they set at the right level? Are the sightlines good, or will someone have an obstructed view? What about the ambient light? Can you pull a shade to make it darker? If you close a window, will the traffic noise diminish?

GRILLING YOUR AUDIENCE

Whenever possible, start off small with an audience of just a few people. Try splitting your attention between the audience and the screen. Usually if something isn't working, you'll know it by feeling the attention (or lack of attention) the audience is giving to a particular section. After you've screened the project, start your inquiry as wide as possible and then work toward the specific. Take notes! If the audience members aren't all that forthcoming, ask them questions. How did it

work? Were you confused about what was going on? What emotion did it evoke? If it's a narrative piece, you might ask about the actors' performances. Which actor did they like best?

Because you're working on a digital machine, you can quickly go to any section to review it. If your project is over 10 minutes long, there's probably a lot to talk about in terms of structure, pacing, character development, and dramatic tension. With a scene as short as *Where's the Bloody Money?*, you can probably move on to an analysis of specific editing problems. At this stage, you're trying to find places where your audience tripped over things that didn't work. If you're lucky, the audience will give you feedback that's right on the money:

Audience member:	*When Colleen says he's waking up, I was sort of confused.*
You:	*Why? What confused you?*
Audience member:	*I didn't know who "he" was. All I saw was the two women.*

That's specific—and helpful. So after the screening, you might try opening the scene with a shot of Dan slouched in the chair, just starting to wake up, and then cut to the two women.

Or someone might say that she thought a cut seemed awkward or an actor remained on the screen for too long before you cut to the next shot. More times than not, especially if your audience knows nothing about filmmaking, they won't tell you what tripped them because they honestly don't know. In those instances, you have to play detective to figure out what's going wrong. I've often found that, when people who don't know much about editing say that something doesn't work, the problem isn't always where they think it is; it's usually before that. If they can't tell you what is bothering them, but they feel a bit confused, it's often a good idea to slow down the beginning. Make sure the audience is grounded at the start. Once they know who's doing what, then you can speed things up.

Whatever you do, don't argue with your audience. You might be the expert on the project you're cutting, but they're the experts on their *feelings* about it. If they criticize your work and point out shortcomings, it's human nature to be defensive. Have you ever met anyone who *liked* being criticized? But, if you argue with them, you're missing the point of the screening, which is to learn what is working and what isn't. You don't have to take any of their suggestions. If you think they're way off base, so be it. Toss out your notes and find another audience. But if you get the same response from these folks as you did before, it's time to really listen.

Sometimes you leave a screening embarrassed. The suggestions were so good you feel embarrassed that you didn't see the problems yourself. Other times you feel grateful because you identified a problem, know how to fix it, and can't wait to get back to work. Then there are the times when you realize there are lots of

problems and it's depressing to think how far you have to go. Those are the days when, if possible, you take the afternoon off and go for a long walk. Once in a while, people will pat you on the back, shake your hand, and tell you it's brilliant, but unless you get raves from everyone, you'll probably head back to work, fix the problems, and try to schedule another screening with another group with fresh eyes and ears.

Using Vimeo or Dropbox

What if your favorite professor or an editor you admire, or a really insightful film-maker isn't available to come by your editing room because she/he lives in a distant city or a different state? That's where services like Vimeo and Dropbox come in handy. It's easy to send them a password-protected link. And then, a few days later, you'll get back pages of insightful notes or you'll be able to then engage in a lengthy Skype or FaceTime session. I have a number of former students in New York, LA, Chicago, and Austin who have surpassed me in many areas, and upon whose advice I am always grateful. Often they send notes that show they've spent hours watching and re-watching my fine cut and identifying specific problems and offering simple but brilliant solutions. With so many ways to get feedback on your project, there's no reason not to get helpful advice.

Developing Thick Skin

This feedback process should be repeated at least three times for a short and twice as often for a feature. Yes, it can be painful, but it's much better to endure the pain now, when you can fix the problems, than later on, when it's out in the world and getting rejected by festivals or excoriated by the press. These sessions can be invaluable, if you take the criticism to heart. Or, they can be a waste of time if you ignore what your teachers, friends, and loved ones have to say. Develop a thick skin now; learn to learn from these screenings. Soon, you'll get the applause you've earned and a chance to raise high your share of gilded trophies.

PREMIERES, FESTIVALS, AND OTHER IMPORTANT SCREENINGS

After all the work is done, and you're about to show your project to the world at the premiere, or perhaps your film is screening at an important festival (and if your film is in it, then it's an important festival), you've got to put on another hat—that of a professional projectionist. I've screened my films all over the world, and learned

many painful lessons, the most important being that, if you want your screening to go smoothly, then you have to get deeply involved in the projection. You must arrive at the theater or venue early, meet with the projectionist, and screen several minutes of your film before the audience arrives. Check that the sound levels are right. Make sure the QuickTime file is cued up properly, or that the projectionist has your Blu-ray disc or your Digital Cinema Package. The projectionist is happy to do this. She/he is used to this request, so don't feel embarrassed or pushy when asking. If you don't do it, everything may work out fine—nine times out of ten. But chances are there will be that one screening when the sound is too low or the focus is soft and you'll kick yourself for not checking it out ahead of time. Once you've done that check, you'll have a great screening. You've earned it.

SUGGESTED ASSIGNMENTS

1. Hold a screening of your edited scene, taking notes of the various suggestions.
2. Duplicate the sequence.
3. Make changes to the new version of the sequence.
4. Compare your old version to the one that is based on the feedback you received.

Effects

Avid has an expansive array of effects that will enable you to do many impressive things to your footage—everything from adding basic transitions to creating very complicated multi-layer effect composites.

Keep in mind that certain scenes are great candidates for eye-catching visual effects, while others may benefit from effects that alter a scene in ways not as obvious to the viewer. For example, a music-driven montage can benefit greatly from flashy visual effects, because they often heighten the mood and visual impact of the sequence. On the other hand, certain effects are designed to work invisibly, enabling you, the editor, to create believable, but imaginary worlds. A well-executed chroma-key can place your characters in a world they've never actually visited. Or you can zoom in on an important subject or character via the use of a Resize or 3D Warp effect, giving you options that the cinematographer did not shoot. Effects can give you wonderful and creative editorial alternatives, or simply allow you to correct otherwise unusable footage.

Because Media Composer's Effect Palette is so far-reaching, we've divided our examination of effects into two chapters—the first is for standard effects and the

Figure 11.1

second for more complex ones. Master this chapter before jumping into the deep end that is Chapter 17.

KINDS OF EFFECTS

Click on the little purple icon next to the Settings Tab in the Project window (Figure 11.1) and you'll see Avid's Effect Palette. Avid's effects are divided into four groups: Filters, Transitions, Audio Track, and Audio Clip. The Filters and Transitions tabs contain Avid's visual effects, so we'll only deal with those two tabs in this chapter.

Avid divides all its many visual effects into two columns: Filters and Transitions. The strange thing is, if you click on each, you'll see that they contain some of the same effects. That's because those are the ones that can act as both.

Transitions

I'll start with Transitions. Inside this tab are all the effects that are applied at the cut point, or transition point, between two clips in the Timeline. They affect the way Shot A transitions to Shot B. Certainly, the most often used transition effect is the dissolve, whereby Shot A fades into Shot B, creating a brief melding of the two shots. While the dissolve is far and away the most popular, Media Composer has dozens of other transition options, some of which we'll explore shortly.

Filters

The other tab contains effects that are applied to the entire clip, or segment, in the Timeline. These used to be called Segment Effects. Filters change the way the entire shot looks. For example, you might have a shot where your actor is facing screen left-to-right and by applying a *flop* the screen direction of the entire shot is changed so the actor is facing screen right-to-left. Filter effects can also provide subtle or sweeping corrections—for example, the Color Effect can give a shot just a bit of extra contrast, or can completely change its color scheme. Finally, filters can work on one video track, or on multiple video tracks (Figure 11.2).

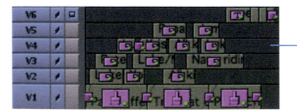

An effect composite with six video layers

Figure 11.2

Motion Effects

Although there's no tab for *Motion Effects*, they are a third category of effects. They are applied to either source clips or to clips in the Timeline. They slow down, speed up, or reverse the motion of your footage, or create a freeze frame.

EFFECT PALETTE IN TOOLS MENU

Besides clicking on the Effect Tab in the Project window, we can also go to the Tools menu (Figure 11.3) to display the Effect Palette as a free-floating window. The keyboard shortcuts are Command-8 (Mac) or Ctrl-8 (Windows).

Figure 11.3

Effect Palette Up Close

Let's click on the Transition tab first (Figure 11.4). In the left-hand column is a list of all the categories of transitional effects and in the right-hand column are all the effects in that specific category. Here, I've selected the Blend category, and the types of Blends that affect a transition are listed. These are Transition Effects.

Figure 11.4

Figure 11.5

Now let's click on the Filters tab and click on Blend in the left-hand column (Figure 11.5). Now we'll see a list of the Blends that act on the entire clip in the Timeline. These are Filter Effects.

Go ahead and scroll through the category list under both the Filters and the Transitions tabs, clicking on the different categories, to get a sense of the many choices offered.

APPLYING AN EFFECT

Ok, now that you know where the effects live, let's talk about how to get them where they need to go. It's actually quite easy to apply an effect. From the Effect Palette, just click on an effect in the right-hand column, and drag it to the Timeline. Release it when you've reached the transition or segment of your choice.

Applying Transition Effects

Let's try a transition effect first. Go to the Effect Palette and click on the Transitions tab, now click on Film in the left-hand column as in Figure 11.6 and now click and drag the Film Dissolve icon to a transition or cut point in your Timeline's video track.

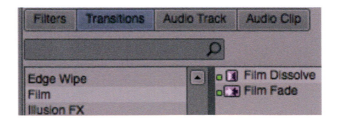

Figure 11.6

You'll see the icon appear on top of the transition in the Timeline as in Figure 11.7.

Figure 11.7

Play through the transition and watch as one clip dissolves into the next.

Try experimenting with each of the different types of transitions. Avid makes it easy to try out different effects. By clicking and dragging one Transitions effect on top of an existing Transitions effect you will overwrite the first Transitions effect. So you can easily try dragging new Transitions effects to the same cut point as you experiment. The PlasmaWipes are interesting.

Most of these Transitions effects are preset—they start with default settings. But nearly all of them are adjustable, and we will learn how to modify them later in the chapter.

Applying Filters

Now let's try a Filters effect. From the Effect Palette, choose the Filters tab and click on Image in the left-hand column, and you'll then find Flop as one of the Image effects (Figure 11.8).

Illusion FX		Flip
Image		Flip-Flop
Key		Flop
L-Conceal		Mask

Figure 11.8

Click and drag Flop onto any segment clip in the Timeline (Figure 11.9). Flop changes the screen direction of a shot. So someone walking left-to-right, is now walking right-to-left.

Figure 11.9

Remember to drag the Flop icon onto the segment itself—not onto the transition—and the screen direction changes as shown in Figure 11.10. The man rolling the barrel suddenly changes direction.

Again, try experimenting with different types of Filters. Because most Filters require manipulation before you see a noticeable difference (which we'll learn later in this chapter), here's a couple to practice with, as these are preset and produce an immediate visual change.

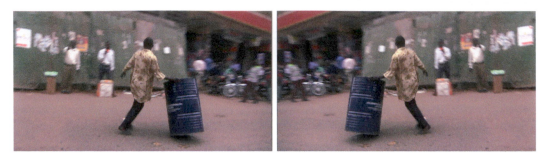

Figure 11.10

Filter Category—Image

- Flop
- Flip
- Flip-Flop.

USING THE QUICK TRANSITION

Let's briefly go back to Transitions for a moment. Because dissolves are so common, there is a fast and direct way to apply them. There exists a Quick Transition but-

Quick Transition button

Figure 11.11

ton (Figure 11.11) and it's in the Timeline tool-bar. This button gives you the ability to quickly and efficiently add dissolves to your transition, without having to open the Effect Palette.

To add a dissolve via the Quick Transition button:

1. Park the blue position indicator on a transition in your sequence, and make sure the appropriate video and/or audio tracks are selected.
2. Press the Quick Transition button. The Quick Transition dialog box appears, giving you choices to control how the dissolve will look (Figure 11.12). A standard "Dissolve" is the default transition type, but you can change this to another type if you desire. For now, let's leave it as a Dissolve.
3. Choose the duration. A 24-frame dissolve is the default length for 23.976p and 24p projects.
4. Choose whether the dissolve is Centered on Cut, Starts on Cut, Ends on Cut, or is custom designed by you.

Quick Transition

Apply to:

V1
A1
A2

Add | Dissolve

Position | Centered on Cut

Duration | 24 frames

Start | 12 frames before cut

A

B

108 | 76

Target Drive | Sam Drive 2

Add | Add and Render | Cancel

Figure 11.12

5. In the Apply to section choose which tracks will be dissolved.
6. Choose the Target Drive.
7. Click Add to place the dissolve on the transition.

If you apply a dissolve to your audio transition, it results in an audio crossfade, which is an extremely common method to blend places where your audio starts or ends. In fact I've often used short 2-frame dissolves on audio transitions whenever there's a glitch that sounds like a tiny "pop" at the transition. This tiny dissolve hides it perfectly.

TRANSITION MANIPULATION

There are numerous ways you might want to change a transition once it's been edited into the Timeline—such as its duration, starting point or ending point. Fortunately, there is a quick way to do this via the Transition Manipulation button, which is the final tool in the Smart Tool, and the only Smart Tool we haven't discussed.

If you click on the Transition manipulation button (Figure 11.13), your cursor will allow you to edit your transitions if you hover over them in your Timeline. To move a transition to the left or right, just click directly on the transition and nudge it back and forth.

Figure 11.13

Figure 11.14

To lengthen or shorten a transition, hover over the edges of the transition and a double-arrow appears allowing you to drag in or out (Figure 11.14).

As you move a video transition to the left or right, you will see the Source and Record monitors turn into a view called Transition Corner Display (Figure 11.15). This shows you the beginning, middle, and last frame of the transition on the A-side clip, and the first, middle, and last frame of the transition on the B-side clip.

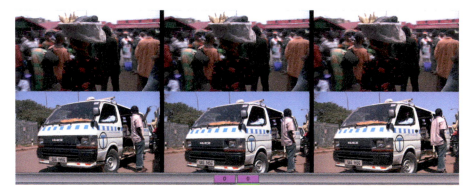

Figure 11.15

DELETING EFFECTS

Removing effects is as easy as adding them. Just make sure the appropriate track is selected, and then park the position indictor on the effect in your sequence (either transition or segment) and press the Remove Effect button. You can find this button in the Timeline toolbar (Figure 11.16). You might want to map it to your keyboard for faster effect editing.

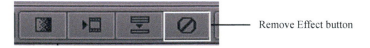

Remove Effect button

Figure 11.16

REAL-TIME EFFECTS

If you look in the Effect Palette, the effects with green dots to the left of their name are *real-time effects* (Figure 11.17), which means they will play in real time. Media Composer has the ability to play these without rendering—you can just apply the effect and instantly see the result when you hit Play. However, the effects without green dots are non-real-time effects. They are more complicated and you won't be able to see the results when you hit Play. These effects require *rendering*—or the creation of new media—to see the effect result. Once you place a non-real-time effect in the Timeline, a blue dot will appear. We will discuss rendering at the end of this chapter.

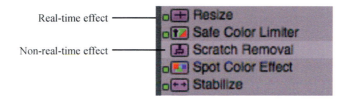

Real-time effect ──────
Non-real-time effect ──────

Figure 11.17

EFFECT EDITOR

So far, we've looked at some fairly straightforward effects that don't require us to alter them in order to see the result. Now let's take a look at some effects that require changes and manipulations in order to create the look you want to achieve.

Almost all effects have *parameters*, which are specific features that can be altered or adjusted. For example, you might have two shots on screen, each reduced in size so they appear as two boxes, in a sort of split screen. There are a lot of parameters that you could manipulate to enhance this effect. Besides changing the size and position, you could put a border on the boxes. You could give the border a color. You could have the boxes move across the screen during the duration of the shot. There are many possible parameter adjustments—all of which you can control via the Effect Editor.

Once you've dragged the effect to the clip in the Timeline, you park the position indicator on your clip with the effect (making sure the appropriate track is selected), then you open the *Effect Editor* from the Tools menu, or you can just click on the Effect Mode button that is conveniently located below the Overwrite button and in the Timeline toolbar, as shown in Figure 11.18.

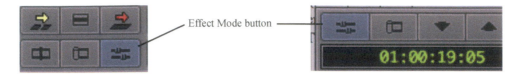

Effect Mode button

Figure 11.18

Let's see how the effect works.

In Filters, click on the Blend category and drag the Picture-in-Picture effect (often called a PIP) to any segment in the Timeline. Make sure the track is selected.

Then:

1. Place the blue position indicator on the segment in the Timeline that contains the effect.
2. Click the Effect Editor button.

When the Effect Editor opens, you'll see that the Record Monitor changes appearance. It is now officially called the *Effect Preview Monitor*, and you're looking at just the clip containing the effect, not the entire sequence (Figure 11.19).

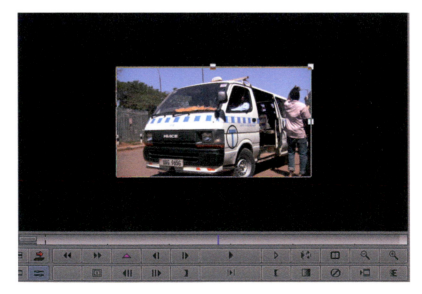

Figure 11.19

When the PIP is applied you'll see that the size of the image has been reduced by 50%. What else is possible? Let's briefly examine the Effect Editor to find out.

At the top of the Effect Editor, you'll see the name of the effect you are editing. Underneath that, you'll see the parameters that you can adjust. Disclosure triangles give you access to sliders and buttons, which control the amount or quantity of a particular parameter. Click on a triangle to show or hide these controls (Figure 11.20).

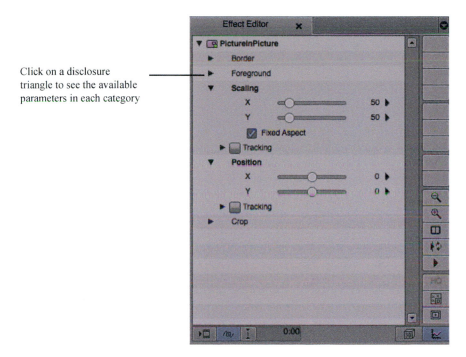

Click on a disclosure triangle to see the available parameters in each category

Figure 11.20

Each effect will have different parameters, but the effects within a category usually have similar parameters. As you can see, within the PIP, you have five main categories: Border, Foreground, Scaling, Position, and Crop. Within those categories are options and suboptions that you can play around with. Go ahead and manipulate some of these parameters on your own, and see how your image changes.

Most of the time, a PIP is applied to a video clip that is *above* V1, instead of to the base video layer, as we have here. We'll explore the stacked (or vertical) PIP

design in Chapter 17, but for now, start with just one video track to experiment with these parameters.

To get you started, here are some of the different parameters you will encounter (you will need to click on each disclosure triangle to see all of these options) (Figure 11.21):

Figure 11.21

- *Border*—Changes the color of the border around the box. You can also change the width and softness of the border. You can use a fixed border (one color), or a blended border (where one color gradually shifts into another).
- *Foreground Level*—On blends and key effects, foreground represents the video's transparency.
- *Reverse*—This reverses the keyframes within your effect, so that all parameters are reordered last to first. Instead of a box starting out small and getting bigger, it will start big and shrink. (This will make more sense when we start talking about keyframes.)

- *Scaling*—This changes the size of the effect (like the PIP box); you can manipulate width and height, either separately or together, by checking the Fixed Aspect box. You can also use direct manipulation by dragging the handles to change the size and shape of the frame within the Effect Preview Monitor (Figure 11.22).

In addition to using the parameter sliders and button in the Effect Editor, you can click and drag on the points in the Effect Preview monitor to make basic scaling and position adjustments

Figure 11.22

- *Position*—This enables you to move an effect, such as a PIP box. You can also use direct manipulation by clicking in the center of the box and dragging it to a new position.
- *Crop*—This allows you to crop the top, bottom, left, and right sides of your frame.

Start experimenting with different effects to get to know each type of adjustable option.

More Effect Editing Tools

As you know, when you open the Effect Editor, the Record monitor changes into the Effect Preview Monitor. If you look closely, you'll see that the toolbar offers a different set of command buttons (Figure 11.23).

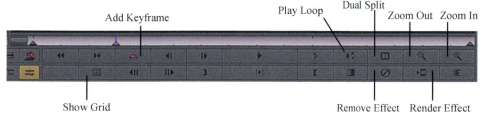

Figure 11.23

Some of these commands include: Zoom In and Zoom Out buttons (for enlarging or reducing your view in the Effect Preview Monitor), a Show Grid button (so you can view your effect with Safe Action and Safe Title boundaries), a Dual Split button (so you can view a before-and-after of your effect), a Play Loop button (to loop through the effect from start to finish), a Remove Effect button and a Render Effect button. Additionally, the position bar below the monitor contains a space where you can place keyframes to make your effects change over time. You can add keyframes with the Add Keyframe command, which is available via the toolbar or on the ' (apostrophe) key on the keyboard.

The bottom and right side of the Effect Editor also contain several extra tools (Figure 11.24).

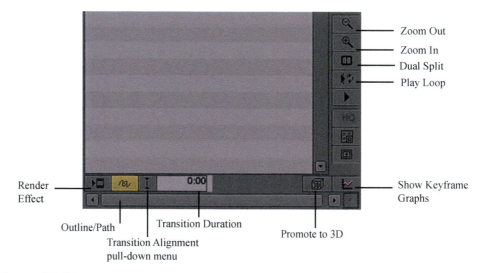

Figure 11.24

The Effect Editor has some of the same tools as the Effect Preview monitor toolbar (Zoom In, Zoom Out, Dual Split, Render Effect, Play Loop), but there are several unique ones: Outline/Path (which shows a wireframe around the frame in the Effect Preview Monitor so that you can grab onto the effect with direct manipulation handles, as shown in Figure 11.22), a Transition Alignment pull-down menu (which lets you adjust where a transition starts and ends at a cut point, shown in Figure 11.25) and a Transition Duration text entry box (to control the duration of your transition).

There are also some options to show Keyframe Graphs (which allow you to map the animation for each parameter separately via graphs), and to promote an effect to 3D (which allows you to bring an effect into 3D space). These last two are

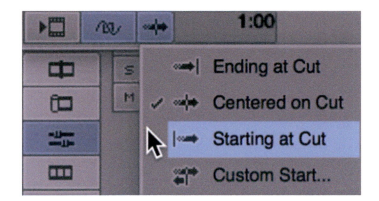

Figure 11.25

beyond the scope of this book—but if you feel like it, click on them to see the new windows and tools that appear, and the new possibilities they provide.

Creating Additional Video Tracks

To do more advanced effects work, we'll need to put effects on multiple video tracks. You can easily create a new video track by pressing Command-Y (Mac) or Ctrl-Y (Windows) or by going to the Timeline menu and selecting New > Video Track.

WORKING WITH KEYFRAMES

We already know about keyframes from working with audio. Well, in video effect editing, they serve a very similar purpose—they are points of change between two values. But instead of interpolating changes in audio levels, these keyframes will interpolate changes in whatever effect parameters you are using.

Let's start working with keyframes to change the way a parameter works over time. We'll begin with a basic Superimpose, which is available in the Blend category of effects.

For a superimposition to work, you need two clips stacked on top of one another—V2 atop V1, for example.

If you like, you can follow along by working with the *Chapter 11 Effects sequence* in the Documentary Practice project Sequences bin. We've already stacked the clips for you; you just need to drag the Superimpose effect onto V2—the shot of the Taxi Conductor (Figure 11.26).

Figure 11.26

Figure 11.27

Here are the two clips (Figure 11.27).

And here is the result of the superimposition once you drag the Superimpose Effect onto V2—the Taxi Conductor (Figure 11.28).

Figure 11.28

By default, the level is set at 50, meaning that the two images are blended evenly together (half and half, or 50%). To see this for yourself, open the Effect Editor. Again, you just place the position indicator on the clip and press the Effect Mode button (Figure 11.29).

Figure 11.29

If you press on the Play button under the Effect Preview Monitor, you'll see that the two images remain blended at a consistent level throughout the length of the clip. To change these values over time, we'll need to add some keyframes and change their values.

First, we need to add a keyframe at the beginning and the end of the effect. Just park on the first frame of the effect, and press the ' (apostrophe) key, and then do the same for the last frame. Then, click on the first keyframe in the position bar to make it active (pink) and make the last keyframe inactive (no longer pink) (Figure 11.30).

Figure 11.30

Now, go to the Effect Editor and drag the Level slider to the left, resulting in 0 opacity at the start of the clip (Figure 11.31). When you do that, the foreground image, V2, will not be seen at all.

Figure 11.31

Now, insert a new keyframe further along the position bar, as shown in Figure 11.32. To create this new keyframe, just drag the position indicator to a spot further along the position bar and then click on the Add Keyframe button. Now, click on the keyframe to make sure it is pink.

Figure 11.32

In the Effect Editor, move the Level slider to 50.

Finally, click on the last keyframe at the end and change the opacity to 100.

Ok, so what have we got now? The image begins with V1 totally filling the frame—Level is set at 0. Over time, the image on V2 slowly takes over, as increasing amounts of opacity are set, until finally the opacity value is 100, and only the V2 image appears on the screen.

Changing the Keyframes

- After you have created a keyframe, you can move it to the left or right by holding the Option key (Mac) or Alt key (Windows) and dragging it to a new position.
- You can delete a keyframe by selecting it and pressing the Delete key.
- You can change the parameter for any given keyframe by clicking on it (it turns pink) and changing the parameters in the Effect Editor.
- You can select more than one keyframe at a time by shift-clicking each one. You can select all keyframes by selecting one, and then pressing Command-A (Mac) or Ctrl-A (Windows).

Saving an Effect as a Template

After doing all the work involved in setting parameters for an effect, you can save those parameters so you can use them again on another transition or segment in the Timeline. Simply drag the icon in the Effect Editor window to a bin and rename it. Here I've placed it in the same bin as my sequence (Figure 11.33).

		Name	Creation Date
☐	〰	Superimpose Taxi	4/27/16 3:25:59 PM
☐	▦	Practice Effects	4/23/16 5:52:37 PM

Figure 11.33

To place the template you created on a different transition or a segment, simply select it in the bin and drag it to the appropriate location in the Timeline.

Transition and Segment Effect Quick Review

Steps for adding effects:

1. Load a sequence into the Timeline.
2. Open Effect Palette from the Tools menu or from the Project window.
3. Choose the effect and drag it to a transition or segment in the Timeline.
4. Adjust the effect's parameters with the Effect Editor.

MOTION EFFECTS

Motion effects are the third type of effect. There are three basic types: freeze frames, motion effects, and Timewarp effects. Let's go over each.

Freeze Frames

A freeze frame is a still image that is created from a clip loaded in your Source monitor. New media and a new master clip are formed when creating a freeze frame. To freeze a frame from a source clip:

1. Load the clip with the frame you'd like to freeze into the Source Monitor. Or, if the frame you'd like to freeze is in your Timeline, go to the frame you want to freeze (usually the tail of the shot), and park the position indicator on that frame. Then, click on the Fast menu between Splice and Overwrite, and press the Match Frame button (it looks like a single frame of film) (Figure 11.34), and the clip will appear in the Source Monitor with the appropriate frame marked by an IN. We'll explore Match Frame in much more detail in Chapter 15; all you need to know for now is that it loads the frame from the Timeline into the Source Monitor.

Click on the Fast menu and then Match Frame button to load your Timeline clip into the Source Monitor

Figure 11.34

2. Go to the Composer menu and click and hold on Freeze Frame (Figure 11.35). Select the length you want from the pull-down menu.

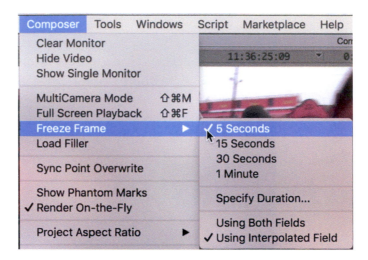

Figure 11.35

3. If you change from one length in seconds to another, you may need to select the Composer menu again, click on Freeze Frame, and choose a new length.
4. A Select Media Drive window appears. Choose the correct drive and then click OK
5. A new clip is created, labeled "Clip name" FF. (Figure 11.36). It automatically opens in the Source Monitor.

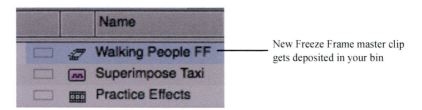

New Freeze Frame master clip gets deposited in your bin

Figure 11.36

6. If you want to edit the freeze frame into your sequence, just mark an IN and an OUT in the Source Monitor, and then in the Timeline, go to the desired edit location and mark an IN. With the appropriate tracks selected, splice in the freeze frame.

Remember, freeze frames have no sound, so you'll need to add sound separately.

Motion Effects

Motion effects let you change the speed and direction of a clip. You can make people walk backwards, slow them down, speed them up, or even do all three in the same clip.

We'll be working with a clip already in the Timeline that is already part of your sequence, and apply the Timewarp Effect to it. If you'd like, you can follow along by working with the Chapter 11 sequence Sequences bin.

To find Timewarp, click on the Filters tab and scroll down to the bottom of the list until you see Timewarp (Figure 11.37). When you select it you'll see there are seven Timewarps to choose from. We'll be working with the main one, which is also called Timewarp. The others come with preset motion changes and are easy to practice with as you just drag to the Timeline and observe how they work.

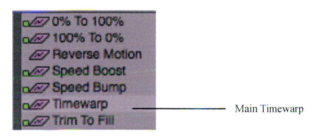
Main Timewarp

Figure 11.37

All the seven Timewarps vary the motion within a clip—that is, they speed up time, or slow down time, and even make freeze frames. They do not, however, change the duration of the segment in the Timeline; they merely change its speed. If you have a five second clip in the Timeline, and you slow it down by 50%, you still have a five second clip, but you will lose half of the shot. If you want to change the duration of a Timewarped clip, you'll need to trim it to make it longer (or shorter), after you make adjustments to the clip's speed.

Let's take a look at the main Timewarp effect.

To use the main Timewarp effect:

1. Apply the main Timewarp effect to a segment in the Timeline.
2. With your position indicator parked on the clip, click on the Effect Mode button to open the Effect Editor, or go to the Tools menu and Choose Motion Effect Editor.

As you can see in Figure 11.38, the Timewarp Effect Editor looks a little different. There are small black boxes in the upper-left corner, each of which you need to click on in order to open the Speed graph (left) and the Position graph (right).

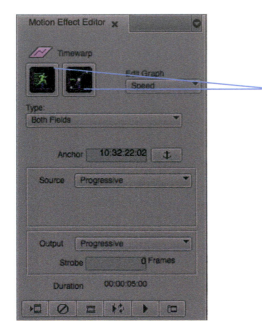

Click on the Speed graph and Position graph buttons to open them, as shown in Figure 11.39

Figure 11.38

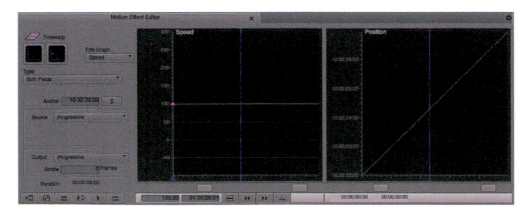

Figure 11.39

The graph you will be manipulating is the Speed graph, on the left. The Position graph is used to alert you if you have enough frames to do what you are trying to do. For this basic exercise, we won't be working with the Position graph, so you can just close it again by clicking on the small black box on the right.

3. In the Speed graph, the green line that runs horizontally along 100 represents real-time motion in a forward direction. So, to modify this, you need to add some keyframes. (Notice there already is one keyframe at the very beginning of the effect.)

 To add your keyframes, you can either click on the Add Keyframe button within the Timewarp window, or you can press the ' (apostrophe) key. As you see in Figure 11.40, I've added four keyframes throughout the duration of the effect.

Figure 11.40

4. Now, raise or lower the keyframes as desired. To make your clip go faster, raise the keyframe above 100; to make your clip slow down, lower the keyframe below 100. If you want the clip to go in reverse motion, lower the keyframe below 0. In Figure 11.41, I've sped the clip up, then slowed it down gradually until it became a freeze frame.

Figure 11.41

In Figure 11.42, I've created a slow motion effect that slows the action by 50%. To create it I simply dragged the first key frame to 50%.

Figure 11.42

In Figure 11.43, I've created a Freeze Frame using the Timewarp Effect. Here the action starts in real time, and then by placing two more key frames, and then Option/Alt dragging the third key frame just below the second key frame, I have a perfectly executed freeze.

Figure 11.43

SETTING THE PLAYBACK RATE OF A CLIP

If you bring in a clip that was shot at a different frame rate than the project's frame rate, Avid may change your clip's frame rate to the project frame rate. For instance, say you shot a clip at 60 frames per second (or higher), because you wanted to create a slow motion effect inside the camera. If Avid changed it to 24 frames per second, you lose the slow motion effect. Setting or resetting a clip's playback rate is a bit different than anything we've done in effects because in this case we are working with the source clip, *before* we edit into the Timeline. We'll spend more time manipulating source clips in Chapters 17 and 18, but since we're dealing with frame rates, it's time to quickly look at Source Settings.

1. In the bin, right-click on the clip whose playback rate you want to change and in the menu choose Source Settings (Figure 11.44).
2. In the Source Settings window, click on the Playback Frames tab. The Source Settings dialog box will show you the various properties of the clip.
3. In the pull-down menu, select the correct Playback Frame Rate.
4. At the bottom right, click OK.

Figure 11.44

RENDERING

At some point you'll need to render at least some of your effects, thereby creating new media. Most Avid effects are real time, so unless you have a lot of tracks stacked in a complex composite, you will *not* need to render everything. You will just need to render non-real-time effects (blue dot effects), and certain more complex effects arranged in a stacked composite. We'll cover this in more detail when we talk about "Expert rendering" in Chapter 17.

Rendering Single Effects

1. Place the blue position indicator on the effect's icon in the Timeline.
2. Click the Render Effect button in the Timeline toolbar (Figure 11.45). (Again, mapping this button to your keyboard might not be a bad idea.)

Render Effect

Figure 11.45

3. When the dialog box appears, choose a target disk—your media drive.
4. Click OK.

Rendering Multiple Effects

First, click the track selectors for the tracks that are holding the effects you need to render.

1. Mark an IN before the first effect and an OUT after the last effect.
2. From the Clip menu, select Render In/Out.
3. When the dialog box appears, choose a target disk.
4. Click OK.

If you have complex effects, rendering can take up a lot of time and some space on your hard drive, so render as late in the editing process as possible. One strategy is to wait until you have created a number of effects and then render them all at once, while you go do something else.

SEARCHING FOR AN EFFECT

Because there are so many effects, Avid has a search box in the Effects Tab where you can type the name of the effect you are looking for, and a list will appear. In Figure 11.46 I've typed the word "Timecode" in the Filters tab. This particular effect is hard to find, so using the search box makes sense. Once you type in the Search box, you can click back and forth between Transitions and Filters in case you're not sure in which category it belongs. Click on the X and you'll leave search mode.

Figure 11.46

TIMECODE BURN-IN EFFECT

Now that we've found it, let's practice with it. We'll use this effect when we learn how to send our project to a sound mixer in Chapter 21. If you're sending a QuickTime movie to someone at a different location, be it a sound mixer, special effects creator, or animator, you want to be able to discuss precisely where a particular sound or visual effect starts and ends. If you have placed a Timecode Burn-In effect on the Timeline, it's easy because every frame will have a unique number, visible on the screen. You can both reference that same exact point. Timecode numbers usually start at 01:00:00:00 for one hour, and then minutes, seconds, frames. In Figure 11.47, the frame in the sequence my cursor is on is at 01:00:35:13, or 35 seconds and 13 frames from the start.

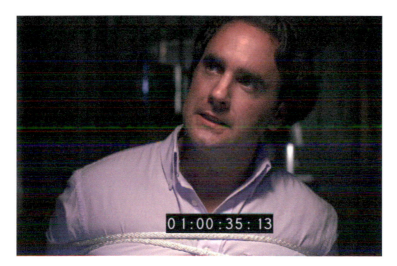

Figure 11.47

To place the Timecode Burn-In effect on the Timeline, simply create a new video track and then drag the effect to the empty video track. Make sure the Video Track Monitor icon is on the top track (V2) (Figure 11.48).

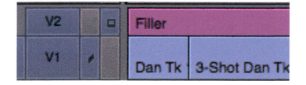

Figure 11.48

You'll see the timecode appear on the Source Monitor, but it will be quite small. To change the size and position of the burn-in, click on the Effect Editor and then click on the Appearance and Position triangles (Figure 11.49).

Drag the wheel to make the numbers larger or smaller

Figure 11.49

The X and Y sliders let you change where the burn-in appears and clicking and dragging on the Font Size wheel changes its size.

To remove this Timecode Effect, deselect the other tracks, press the T-key to Mark IN to OUT on the entire effect, and then press Lift. Or you could delete the entire track by selecting only V2 and pressing Delete.

PRACTICE (OR ELSE)

Make sure you've practiced all the steps outlined here. I go much deeper into Effects in Chapter 17. If you're in a hurry to master Effects, you can proceed directly to Chapter 17, but it might be worth waiting to learn some other key Avid techniques first.

12

Titles

As you continue building your story, you should consider text as a tool that can help you communicate your message and relay important information. Text, in the form of titles, is an essential part of any project. There are many different kinds of titles, and they serve different functions in a production. In addition to the main title of the show, there are the opening and closing credits, identification titles (lower thirds), subtitles, and copyright information.

Usually you add titles when you are nearing the end of the editing process. This is because, if you're still making a lot of changes to your sequence, your titles can easily get out of sync and drift away from the images they belong to. So, wait to add titles as late in the editing process as possible.

THREE KINDS OF TITLE TOOLS

Avid has its traditional Title Tool application, an advanced, but limited tool called Marquee, and a great new tool called NewBlue Titler Pro. Titler Pro enables you to create an amazing array of high-end titles that rival anything you can create in After Effects. We'll start with the traditional Title Tool application, as it's great for simple titles that provide information; next we'll learn NewBlue Titler Pro, which is perfect for creating eye-catching text. I'm going to skip Marquee, as Titler Pro is a far richer tool.

LAUNCHING THE AVID TITLE TOOL

If you want to add a title over video in your sequence, you just park the position indicator on that image in the Timeline and then open the Title Tool. That way, the video background becomes a visual reference for the title you create. If you'd like to follow along with the book, go ahead and open up the Documentary Practice project, and load one of the sequences you've been working on. Then, just park your position indicator on any clip that you'd like to use for a title. I'm using the shot "Traffic into City."

To open the Title Tool, select *Title Tool Application* from the Tools menu, or select *New Title* from the Clip menu.

You will get a prompt, like the one shown in Figure 12.1, asking you if you want to use Marquee, Title Tool, or Titler Pro.

Figure 12.1

If you click on Titler Pro, you'll get a warning saying that it opens through the Effects palette and not here.

Since this prompt will appear each time you open the Title Tool, which gets annoying, let's check the Persist? option and then select the Title Tool button—the middle one. That way we'll go directly to the Title Tool each time we select the Title Tool application.

Once you open the Title Tool, you will see the frame that you're parked on in Media Composer as the reference background. Ever since 2009, the Title Tool runs as a separate application with its own menu bar. (Previously, it was just a floating window within the Media Composer interface.)

It's usually a good idea to enable the Safe Title/Safe Action boundaries, which you can select from the Object menu (*Safe Title Area/Global Grid*). You may have to drag the Title Tool out to its widest display to see both lines (Figure 12.2).

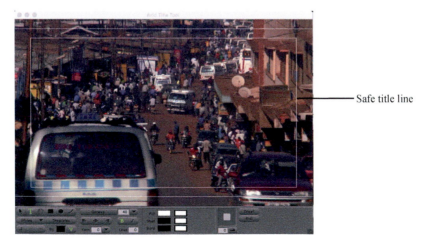

Safe title line

Figure 12.2

CHOOSING A BACKGROUND

You can either make a title with a transparent background so it shows over your video in your sequence, or you can make a title with an opaque background. To choose which you want, simply click on the V toggle (Figure 12.3). If the V is green, it will create a title with a transparent background, and if the V is black, it will change the background to an opaque color. As you toggle, you will see the reference video background appear and disappear from the display.

The V toggle determines whether you make a title with a transparent or opaque background

Figure 12.3

Black is the default background color, but you can click and hold the cursor inside the Bg box and a color picker will appear. Move the cursor through the colors of your background clip to select the one you want. Or you can click on the button below the eyedropper to open the Mac or Windows color picker.

CREATING YOUR FIRST TITLE

Creating titles is fairly straightforward. To demonstrate the basics, we are going to make a lower third title for Traffic into City. Let's click on the V toggle so it turns green, and the video image appears as a reference within the Title Tool window. Now, let's type out our title, making sure the T (for Text Tool) is selected so it's green (Figure 12.4).

Selection Tool 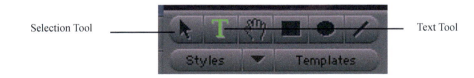 Text Tool

Figure 12.4

Simply click where you would like the text to start, and the cursor becomes an I-beam. As you type, the text appears (and will flow to the next line if you type enough characters). You can delete letters, edit letters, type additional letters—basically all the functions provided by most word-processing programs. If you want to add another text box, just click in another area of the title frame, and start typing again. In Figure 12.5, we have created one text object, identifying Kampala and the time. Geneva is the default font and 48 is the default point size.

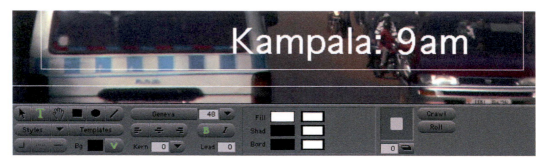

Figure 12.5

Selection Tool

If you want to manipulate the text that you've typed, click on the Selection Tool, which is the arrow next to the T (Figure 12.4). When the arrow is green, you can make changes to the text. In fact the T is only for typing your text. Everything else is done with the arrow selected (green). Let's start by making some changes to the title's font and font size.

Click on the Selection Tool so the arrow turns green and then click on your title. A bounding box with selection handles appears around the title. Go ahead and change your font by clicking on the font button (where Geneva is) and choosing a different one from the list. Here I've selected News Gothic MT (Figure 12.6).

Figure 12.6

To select a different font point size, click on the arrow to choose another size option, or just type in a number within the Font size box. Also, note that Bold is the default setting, so deselect the letter B if you want to un-bold your text.

Once you've changed font or point size, you'll probably need to adjust the size of the bounding box around your title. Drag one of the six selection nodes to do this. For instance, if your text wraps around to a second line and you want it to all fall on one line, drag the right and/or left selection node to create enough room to hold all of your text, as I'm doing here in Figure 12.7.

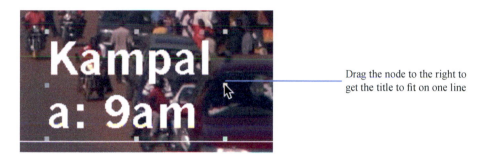

Drag the node to the right to get the title to fit on one line

Figure 12.7

To change the justification of your title, you can click on one of the three justification buttons (left-justified, centered, or right-justified). The text justifies appropriately within the bounding box.

Kerning allows you to change the spacing between letters. To change the kerning value, select the text you want to kern and choose an option within the Kern drop-down menu, or type a number into the box as I have in Figure 12.8. Negative numbers tighten the spacing; positive numbers loosen the spacing. Here I've typed -2 and tightened the spacing.

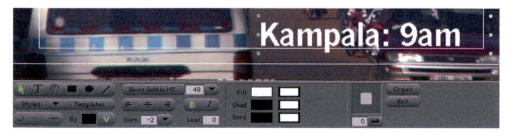

Figure 12.8

Leading changes the spacing between whole lines of text. Again, negative numbers lessen the distance between lines of text, and positive numbers increase the distance between lines of text. For leading to work, you need to have all of your text

within the same bounding box, separated by carriage returns. Just select the bounding box, and increase or decrease the leading amount, and the lines will become closer or farther apart, accordingly.

The Selection Tool also allows you to click anywhere inside the title and drag it to a different area of the frame. Since we're designing a lower third, let's make sure the title is resting on the lower part of the safe title lines.

If you want to delete any text, just select it with the Selection Tool and press the Delete key.

SHADOWS

You can add a *drop shadow* or *depth shadow* to your titles. Shadowing can often help your titles stand out from a busy background. To add a shadow, select your title with the Selection Tool. Then, click on the Shadow Tool and drag in any direction inside the box. Drag farther away from the center square to increase or decrease the depth of shadow. The number will change in the Shadow Depth Selection box to indicate how much shadow you are creating. Here, we've set the direction so the shadow appears to the lower right of the letters and at a depth of 7 (Figure 12.9).

Figure 12.9 Drop shadow.

By toggling the Drop and Depth Shadow button, you change from one type of shadow to the other (Figure 12.10).

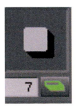

Figure 12.10 Depth shadow.

You can also just click on the Shadow Depth Selection box, type a number, and press Enter or Return.

COLORED TITLES

In the panel on the right-hand side of the Title Tool, you can change your text color, shadow color, or both. (You can also change the color of your border.) Additionally, you can create a blended gradient, which gradually shifts from one color to another across the text.

To change a title's color, first select the Selection Tool and click inside the bounding box. Then, press and hold your cursor on the Fill Color Selection box (Figure 12.11) and a color picker appears (Figure 12.12).

Fill Color Selection box ————

Shadow Color Selection box ————

Border Color Selection box ————

Figure 12.11

Click in the Fill Color
Selection box and a color
picker appears

Figure 12.12

Drag through the colors and select which one you want using either the color picker or the eyedropper (Figure 12.13).

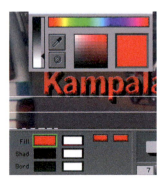

Figure 12.13

You can also select a color other than black for your shadows (Figure 12.14). Just select the title using the Selection Tool, and then click and hold on the shadow Color Selection box. Again, choose your color via the color picker or the eyedropper.

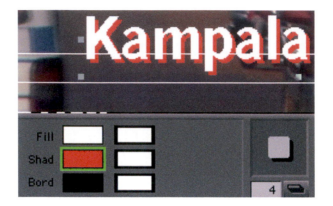

Figure 12.14

You may be wondering what the boxes directly to the right of the Fill and Shadow Color Selection boxes are. Those are the Transparency Level boxes, which allow you to change the opacity of your text and objects.

CREATING A GRADIENT

If you want to add a gradient to your title, just click on the Fill Color Selection box (Figure 12.15), and you'll see two small Blend windows appear (Figure 12.15). Click and hold on the left window and select a color. Click and hold on the right window and pick another color. Your choices appear in the respective box, and the mixture

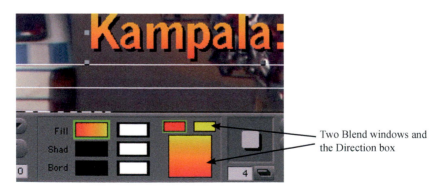

Two Blend windows and the Direction box

Figure 12.15

of the two appears in the Blend Direction box. You can change the direction of the blend by dragging the cursor inside this box. Figure 12.15 shows the resulting title. Notice how the letters go from red to yellow, from bottom to top.

SOFT SHADOWS

When you add shadows to your text, they have a hard edge by default. Sometimes giving the shadow less definition improves its appearance. To add some soft-ness, select your title with the Selection Tool, and then go to the Object menu from the Avid Title Tool menu bar and select Soften Shadow. As soon as you select it, a dialog box appears, like the one shown in Figure 12.16.

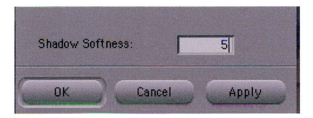

Figure 12.16

Type in an amount from 4 to 40. Try 5, and then click Apply. You'll see the amount of softening in the title's shadow. If you like what you see, press OK. If not, change the value and click Apply again until you're happy with the look.

CREATING TITLE STYLE SHEETS

After doing a lot of work to create a title just the way you like it, it would be nice not to have to reinvent the wheel the next time you create a similar title. Fortunately, the Title Tool has a *style sheet* feature so you can set the same title parameters to any new titles you create.

To create a style sheet:

1. Click on the title or object with the Selection Tool.
2. Press the disclosure triangle next to the Styles button so the Save As . . . option appears (Figure 12.17).
3. Choose Save As . . .

Figure 12.17

4. The Style Sheet dialog box appears.
5. Make sure that the parameters reflect your choices.
6. You'll see the name of the font style in the box near the middle of the window. Type over this, substituting a name such as "Lower Thirds" or "Credits."
7. Click Done.

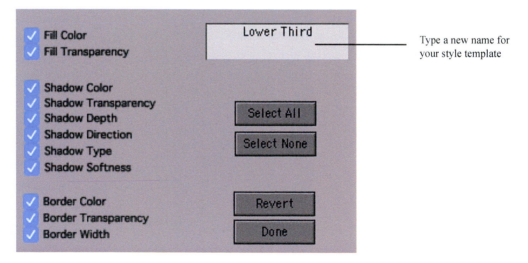

Figure 12.18

Once you have created a style, your style sheets appear in the Save As . . . window (Figure 12.19). To apply a style to a new title, click on the text with the Selection Tool, and then select your style sheet from the Styles menu. The same parameters will be applied to the new title.

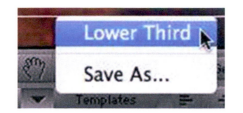

Figure 12.19

SAVING TITLES

Ok, so you've done all of the work in creating a good-looking title—now how do you make sure your changes are saved in Media Composer? Well, as you know, all clips and sequences must reside within bins, and titles are treated no differently. To save a title to a bin, just select Save Title from the Avid Title Tool File menu, or press Command-S (Mac) or Ctrl-S (Windows).

A dialog box will open asking you to select the bin that the title will be saved to, the hard drive on which the title media will be created, and the desired title resolution. I always choose the resolution of my project—in this case DNxHD 175. After making the desired choices, click OK. The title will be saved in the bin you selected, and ready to edit into your sequence.

Figure 12.20

CUTTING TITLES INTO YOUR SEQUENCE

Once you've saved your title and have closed or minimized the Title Tool, you'll see that the title has been saved to your bin and conveniently placed in the Source Monitor.

With the title in the Source Monitor, you're ready to cut it into your sequence. But, wait—where will it go? Because titles are typically superimposed over video, you just need to create a second video track. We already know from Chapter 11 that you can create a new video track by pressing Command-Y (Mac) or Ctrl-Y (Windows) or by going to the Timeline menu and selecting New > Video Track. When you do this, Track V2 will appear in the Timeline. Now, just patch the V1 source track to the V2 record track (Figure 12.21). We did this with audio tracks in Chapter 6.

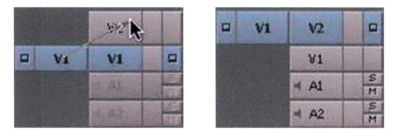

Figure 12.21

Now, you are ready to cut the title in using the rule of *three marks make an edit*. There are a few things you should know before you make the edit.

Media Composer generates a 2-minute title from the Title Tool. Because that's far more than you will ever need, don't mark your IN on the first frame in the Source Monitor. Instead, go in several seconds and then mark your IN. That way you will have enough frames within the handle if you need to fade or trim your title.

Three seconds is a good length for most short titles. To make the edit, mark an IN, play for about 3 seconds, then mark an OUT. Next, go to the Timeline and mark an IN where you want to cut the title into the sequence. These are your three marks to edit your title—an IN and an OUT in the Source, and an IN in the sequence. Alternatively, you could mark an IN and an OUT in the Sequence, and an IN in the Source.

Once you have marked your shot, go ahead and perform the Overwrite. The title then is edited in the Timeline above the shot over which it will be superimposed (Figure 12.22).

Figure 12.22

A tiny green dot on the title icon tells us that the title is *a real-time effect.* As we learned in Chapter 11, a real-time effect is one in which the effect—in this case, a title—does not need to be rendered in order to play.

Adjusting the Title Length

If it turns out that the title is on screen a bit too long, use Dual-Roller Trim mode to trim the head or tail of the title. If it's not on long enough, use Dual-Roller Trim mode to extend the tail of the title.

Figure 12.23

ADDING FADES TO YOUR TITLE

Most of the time, you don't want your title to just pop on and off the screen. Instead, adding fade-ins and fade-outs is a great way to subtly let a title enter and exit your frame.

To add a Title Fade:

1. Make sure your title's video track is selected.
2. Place the position indicator on the title clip in the Timeline.
3. Click the Fade Effect button in the Fast menu in the Timeline toolbar (Figure 12.24).

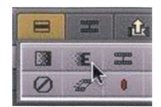

Figure 12.24

4. Type in the number of frames you want for your fade (try eight frames) and click OK (Figure 12.25).

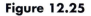

Figure 12.25

You won't see any indication in your Timeline that the fade effect is in place, but you'll see the results when you play through the title.

EDITING TITLES

It often happens that you create a title, cut it into the sequence, and then later you discover a mistake that needs correcting, or you want to modify the title in some other way. To edit an existing title, park on the title in the sequence, making sure the appropriate track is selected, and then open the Effect Editor. Then, just click on the Edit Title button (Figure 12.26) to open the Title Tool.

When the title opens inside the Title Tool, you can then modify it however you like, and then save it back to your bin in Media Composer.

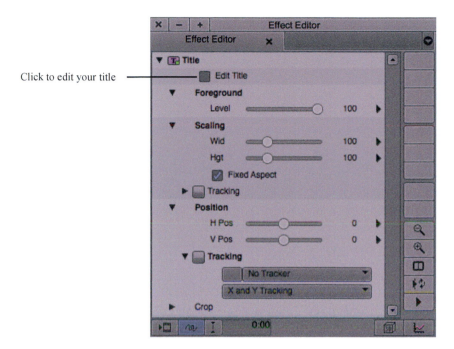

Click to edit your title

Figure 12.26

DRAWING OBJECTS

The Title Tool has drawing tools with which you can create boxes, circles, lines, and arrows of various shapes and colors (Figure 12.27). Often, you can use shapes to help define text from the background, or to add creative design elements and accent shapes to otherwise plain titles.

Figure 12.27

To use these tools, just click on a shape button to choose your desired drawing tool, and then drag the cursor within the Title Tool frame to form the shape. You can add color and shadow by using the Fill and Shadow controls the same way that you use them for text manipulations.

If you add multiple shapes (or you just want to combine shapes with text), you can control how the shapes are stacked by selecting various options from the Object menu. Bring Forward and Send Backward move objects forward and backward one layer at a time; and Bring To Front and Send To Back move objects forward and backward through all layers at once (Figure 12.28).

Figure 12.28

ROLLING TITLES

You've seen rolling titles a gazillion times—mainly as credits that appear at the end of films. These are not that difficult to create in the Avid Title Tool. One thing to note is that the *speed* at which the title rolls is determined by the length of the clip in the Timeline. To make the crawl go faster, you trim the clip. To make it go slower, you extend its length (size) in the Timeline. Let's take a look.

To create a rolling title in the Avid Title Tool:

1. On the far right of the Title Tool, select the Roll button. It turns green (Figure 2.29).
2. Select a background—black or video—by clicking the V toggle (see the "Choosing a Background" section earlier in this chapter). FYI, with a rolling or crawling title, you cannot save your title with a colored background, even though you can design the title while displaying a colored background.
3. Choose whether you will have one column or two. For one column, you will most likely want to center justify your text, so click the center justify button. (For this exercise, we will just stick with one centered column, but just know that if you want to play around with it on your own, you can arrange two side-by-side columns for your credits.)

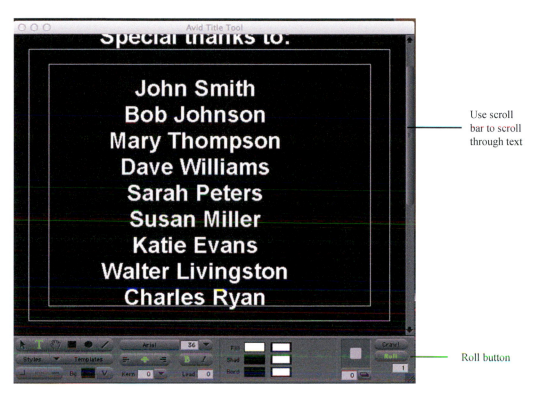

Use scroll bar to scroll through text

Roll button

Figure 12.29

4. Click on the Text Tool, choose your font and point size, and then begin typing. If the words wrap to the next line, don't worry about that for now. Just type and press Return/Enter after each line.

5. If the text goes onto more than one page (screen), your screen will keep scrolling down so that you can appropriately see what you're typing. If you like, you can drag the scroll bar that appears on the right-hand side of the title window to scroll through the text.

6. When you're done, enable the Selection tool, and drag the handles of your bounding box to the left and right to properly align the text, and to make the text box wide enough to prevent word wrap. (You may need to decrease the size of your text if extending the bounding box alone doesn't prevent word wrap.)

7. Select Save Title As from the File menu.

8. Save the title:

 • Select the target disk and bin.
 • Select the resolution.
 • Don't save with Fast Save.

9. Click OK.
10. The title is saved as a title in your bin.

Cutting in Rolling Titles

When you save the rolling title, it will be placed in the Source Monitor. It may not look like anything initially, because a rolling title starts out empty (black) and then the text rolls into view. To view your text, you have to drag across the Source Monitor position bar.

To edit the title into the Timeline:

1. Patch the V1 source track to the V2 record track (or whatever the highest blank video track is in your sequence).
2. Mark an IN in the Timeline where you want the rolling title to start.
3. Move the cursor along the Timeline and mark an OUT after your IN, calculating the number of seconds between your IN and your OUT. If the IN and OUT are 40 seconds apart, that will be the time of your rolling title.
4. Go to the Source Monitor and mark an IN at the very first frame of the title. You've got three marks.
5. Press Overwrite.

You'll see the title is in the Timeline, with a small RT for "rolling title." It will also have a blue dot on it, which means it won't play in real time. Therefore, you will need to render it in order for it to play.

Rendering Your Titles

Regular titles play in real time, but Crawling and Rolling titles need to be rendered in order for you to see them in real time.

To render a rolling title:

1. Select the track containing the title.
2. Place the blue position indicator on the title clip.
3. Click the Render Effect button in the Timeline toolbar (Figure 12.30), or choose Render at Position from the Clip menu.

Figure 12.30

4. When the dialog box appears, choose a target drive for the effect.
5. Click OK.

Adjusting the Speed of the Rolling Titles

Once you see your rolling title play, you may decide that it goes by too quickly or slowly. To adjust the speed, you use Trim Mode (Figure 12.31). Just lasso the end of the title to enter Trim Mode. Now drag the roller to the right to slow the roll down, or drag it to the left to speed the roll up.

Figure 12.31

One recommendation I have is that when you render your title, abort the render about a quarter of the way through by pressing Command + . (period) (Mac) or Ctrl + . (period) (Windows). This allows you to keep a partial render (Figure 12.32), and then judge if the speed is working well.

Figure 12.32

When you partially render your title, the unrendered portion will have a red bar above it (Figure 12.33)

Figure 12.33

If you play through the first part of the title and the timing works well, then you can finish rendering. If not, then you can trim again, and not waste more time or drive space than you need to.

CRAWLING TITLES

A title that moves across the screen horizontally right to left is called a *crawl*. You create crawling titles the same way you create rolling titles, but you click on the Crawl button instead of the Roll button. Again, you'll need to use the Selector Tool handles to keep the letters from word wrapping. For example, let's say you wanted the following title to crawl across the screen:

"Chicago Cubs win World Series! Watch the News at 11 for highlights."

To get this text to crawl as a single line, drag the selector handle to the far right so the text doesn't word wrap.

NEWBLUE TITLER PRO

This is a fantastic tool because it let's you treat every word and every letter in your title as unique, allowing you to change everything about that word or letter; your titles can really stand out. There are several versions of the tool, accessible via the application manager. I have a subscription-based copy of Media Composer, so I have access to the latest version.

Titler Pro is resolution independent, so it doesn't matter if your project is HD, UHD, 4K, or 8K. In fact, this is the Title application you must use when creating titles for projects that are higher than HD resolution. Titler Pro comes with lots of preset styles and animations, which do much of the work for you, yet you can customize the preset effects by adding keyfames. Titler Pro also makes it easy to generate 3D texts and logos.

Titler Pro works a bit differently than the normal title tool, so let's start with the first difference. Before creating a title, you want to create a parking space for it and to do that we'll use the Add Edit command.

Add Edits

As you may recall in Chapter 6, when you place the blue position indicator on a track and press the Add Edit command, it creates a break in your timeline. It

divides a single video clip into two pieces or a single audio clip into two pieces. We learned how to use it on audio clips to make a sudden sound change.

Here we are creating a space for the title we're about to create so it will be superimposed over the shot of the Birds Fly clip. As you can see in Figure 12.34, I have twice pressed the Add Edit command to create a unique section of V2.

Figure 12.34

Opening Titler Pro

Unlike Avid's regular title tool, you don't open this from the Clip or Tools menus. Instead you open it from the Effect Palette.

1. Go to the Effect Palette and click on the NewBlue Titler Pro effect.
2. Drag the Titler Pro icon to the space on V2 that we just created with Add Edits as shown in Figure 12.34.

Figure 12.35

Depending on the software version you have, you may need to click on the icon in the Timeline and then click on the Effect Editor and launch the interface from the Effect Editor, or it may launch as soon as you drag the icon to the Timeline, as mine does.

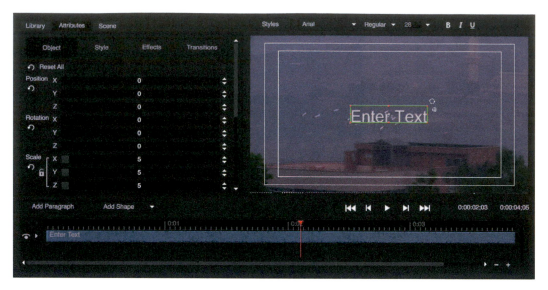

Figure 12.36

Let's examine the Titler Pro interface (Figure 12.36). In the upper-left corner you'll see Library, Attributes, and Scene buttons. We want to start with Attributes, so if it isn't selected, click on it. The main title screen opens with a text box, called a Paragraph, where a title has already been created—called "Enter Text." Because I placed the Titler Pro icon on V2, above the Birds Fly clip on V1, we see the text is superimposed over that clip. We've got buttons for Object, Style, Effects, and Transitions. Just above the screen is a pull-down menus for selecting the Font. The default is Arial. You can change the point size and select Bold, Italics, or Underlined letters.

To the left of the screen are XYZ controllers for positioning the paragraph, rotating it, or making it larger or smaller.

At the bottom is a blue timeline. The duration is the same as the time between my Add Edits on the Avid Timeline.

Follow along as I explore this tool.

Starting a New Titler Pro Title

1. Place the cursor on one of the corner nodes in the paragraph box and drag to make the title larger or smaller. Notice in Figure 12.37 how the cursor turns into a double-sided arrow, showing that, by dragging in or out, you can make the title smaller or bigger.

Drag a corner node to
make larger or smaller

Figure 12.37

2. Place the cursor on an orange node in the middle of the box, and you can stretch the letters.
3. Click inside the box until the cursor becomes a cross, which enables you to move the paragraph box around the frame (Figure 12.38).

Figure 12.38

4. Click on the small circle to rotate the paragraph (Figure 12.39).

Figure 12.39

5. Double-click inside the box so that Enter Text is highlighted. Now type the real title. I've typed "Birds Over Kampala" (Figure 12.40).

Figure 12.40

6. With the letters still highlighted, click on the Font box to choose the font you'd like from the pull-down menu. Here I've switched from Arial to Knewave Outline (Figures 12.41 and 12.42).

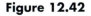

Figure 12.41

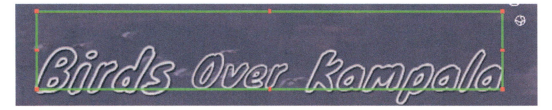

Figure 12.42

Hmm. Not a great choice. Never mind. I think I'll hit Undo.

Now let's look at ways we can treat each word as unique entities. In Figure 12.43, I have used the cursor to highlight just the word "Birds." Notice how it has a box with nodes of its own, so I can make it bigger or smaller, and by putting the cursor inside the text box I can get the cursor to change to a cross, which enables me to move it anywhere I want.

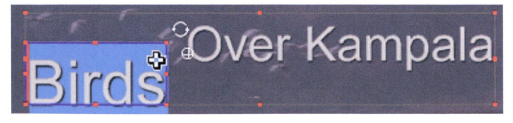

Figure 12.43

So continuing, I'll move each word so that the word "Over" is over the other words, as shown here.

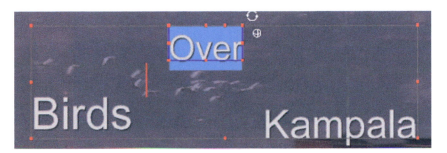

Figure 12.44

Styles

If you click on Styles, you can add color to your title, or a gradient (two colors that you can re-arrange with the small circles) (Figure 12.45). You can even place an image or video inside the title by clicking on Image/Video.

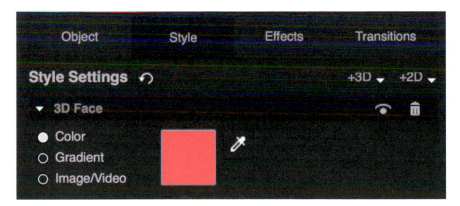

Figure 12.45

Style is also where you add and adjust shadows. Depending on your software version, you may already have shadows, but the settings are set so that the shadow is hidden. Scroll down past the main 3D Face until you see a Shadow section (Figure 12.46). If there is no Shadow section, click on the +2D button to create a Shadow section.

Figure 12.46

With the Offset setting at 1, you won't see any shadow effect, even though there's a shadow there. What you need to do is manipulate the various options inside Offset. You use the X and Y coordinates to change the positioning of the shadow—X for left to right, Y for above or below the title face. Just click and drag inside the rectangle and the numbers change, or you can click on the up and down arrows to the right of the X–Y coordinates. Figure 12.47 shows the X and Y coordinates I chose to get the huge amount of Drop Shadow shown here.

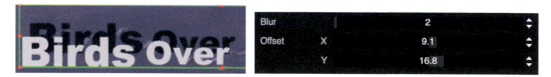

Figure 12.47

There's a tiny amount of blur applied, but if you want even softer shadow, drag the edge of the Blur bar. You can change the color of the shadow by clicking inside the Black Color box. Layer Depth is subtle, and provides more shadow drop, and Width let's you change the width of the shadow. Play with them to get a sense of what they do. I don't use them much—manipulating X, Y, and Blur is plenty of control for me.

Transitions

By default, the Titler Pro gives you a quick Fade In and Fade Out effect. You can open the Timeline by clicking on the small triangle. Then you'll see the entire

Timeline and the Fade In and Fade Out (Figure 12.48). It's easy to change the length by simply clicking on the edge until the cursor changes to an arrow, and then dragging.

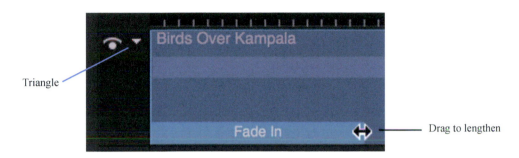

Figure 12.48

Adding a Paragraph

It's quite simple to add more text. In Titler Pro language you are adding a Paragraph. Just double-click anywhere inside the main screen and you'll get another Edit Text box. I'm going to add a title that says, "Small" as in, Small Birds Over Kampala. Your Timeline will now have two triangles and two tracks. One will be blue and the other will be dark, to show which one is active and which isn't (Figure 12.49).

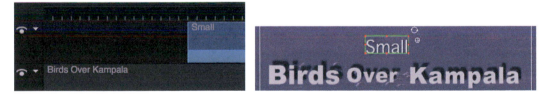

Figure 12.49

Changing the Start and Length

Wherever my red Position Indicator is placed on the Timeline, that's where my second paragraph will start. As you can see, it's easy to change where a paragraph starts, or to make it longer or shorter simply by placing the cursor on the edge and dragging left or right. Here my title Small starts after my Birds over Kampala title (Figure 12.50).

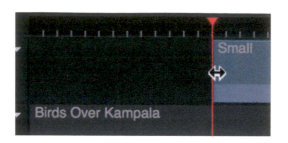

Figure 12.50

Saving a Titler Pro Title

When you're through, simply go to the NewBlue Titler Pro menu, click on File, and choose Save or Save as. When the Save window opens, name the title and be sure to save it onto your drive!

How to Edit a Titler Pro Title

If you want to make changes after you've closed the Titler Pro tool, simply place the Blue Position Indicator on the Titler Pro title in the Avid sequence, make sure the track is selected and click on the Effect Editor. The Effect Editor will open and you'll click on the box that says Launch User Interface (Figure 12.51).

Figure 12.51

Library

Here is where things get interesting. When you click on the Library button at the upper left of the tool, you'll see an incredible list of templates that allow you to create all sorts of moves and animated effects (Figure 12.52). You apply these to the title(s) you have created.

Figure 12.52

It's very easy get a sense of how these look because you can simply hold your cursor over each one and you'll see a preview of how your title will appear.

The Effect section changes the behaviour of the entire title. After trying a number of Animations, I selected one of the Float choices called Letter Jump, double-clicked on it, and saw that it became part of my Timeline and created a nice animated title. Although you can't see it here that well, each letter gets bigger (jumps) and then smaller across the entire paragraph (Figure 12.53).

Figure 12.53

Special Transitions

Another section is for transitions. These are special Fade In and Fade Out templates. Here I have selected Transitions > 3D Page Turn > Hatch Up (Figure 12.54). I put the cursor on it and watched what it created. I liked it, so I double-clicked and added it to my "Small" paragraph (the title Small).

Figure 12.54

I still had the original, or default, Fade In on the Timeline, but it lessened the impact of this new transition, so I clicked on that old Fade In and hit the Delete key and it disappeared. Here's the Timeline as it appears (Figure 12.55). Notice it doesn't tell me which 3D Page Turn I selected (Hatch Up).

Figure 12.55

Delete Paragraphs and Effects

How to delete things you create but no longer want is a bit tricky. Click on the thing you wish to delete in the Timeline and then right-click until the menu pops up, as shown in Figure 12.56. Here I'll select Delete paragraph. If it's an effect you've clicked on in the Timeline, the menu will have a choice to Delete Effect.

Figure 12.56

Do It Your Way

I've tried to do more than scratch the surface here, but there are still a lot of options that I didn't explore. For instance, inserting keyframes can modify every effect (Figure 12.57). We'll explore keyframes at greater length in the Advanced Effects chapter, so you may want to revisit this section later.

Figure 12.57

SUGGESTED ASSIGNMENTS

1. Open the Title Tool and select the Text Tool. Choose a font and point size.
2. Type text for your title.
3. Click on the Selection Tool and if necessary, drag out the selection handles to make the title fit on one line.
4. Move the title around inside the frame.
5. Add a drop shadow. Increase and decrease the depth and direction of the shadow.
6. Change to a depth shadow.
7. Add color to your title. Now create a blend (gradient) for that title. Optionally, change the shadow color, or add a small colored border.
8. Save your title output as a style sheet. Then, save the title to your Avid bin.
9. Close the Title Tool and cut your title onto V2.
10. Use the Lift/Overwrite Segment Mode button (see Chapter 4) to move this title along the Timeline.
11. Open the Title Tool. Create a rolling title. Save the rolling title to Media Composer, and cut this title into the Timeline.
12. Perform a partial render on the title.
13. Change the speed of the rolling title.
14. Render the title again.

15. Create add edits on V2.
16. Open the NewBlue Titler Pro from the Effects Palette and drag it to the space on V2 between the Add Edits.
17. Follow the steps outlined above until you're comfortable, and then start making your own titles.

13

Customization and Organization

We've spent the past 12 chapters really getting to know the power of Avid and the art of editing. You now have a good foundation—you can organize, mark, edit, remove, trim, and re-arrange your footage. You have an understanding of Avid's many audio tools, titles, and effects.

Let's put editing down for a chapter and spend some time tackling some important peripheral topics. In this chapter, you'll learn how to optimize your Avid workspace by customizing settings and streamlining the editing process through smart organization and powerful search tools.

DIVING INTO SETTINGS

Customization of editing settings is so important. Most good editors carry their Avid user settings around with them (on a flash drive, or some other portable device) so that they can load their personal editing workspace at a moment's notice. Editors can customize their entire editing environment—every single keyboard key, interface button, and accessible tool. We'll take a look at several common customization techniques, but mostly, I'll give you the tools to unlock the potential of making your *own* customized workspace.

You can pretty much find every customizable option in one central place: the Settings tab. Go ahead and click on it, and from the Fast menu on the upper-left side of the window, you'll see a pop-up menu that lists the setting options: Active Settings, All Settings, and Base Settings. For now, select All Settings.

Now, resize the window so that you can see the column to the far right, as shown in Figure 13.1.

As you can see, each setting falls under three types: User, Project, and Site. User settings follow the editor; they are defined by the options you set. Project settings follow the project; they are defined by the options set within each individual Avid project. Site settings follow the site, or system; they are defined by the options

Settings tab

Figure 13.1

set on the editing system (and all peripheral equipment). In this chapter, we'll focus primarily on user settings, which will allow you, the editor, to customize and save settings that you can take with you anywhere.

There's obviously a plethora to choose from, but in this chapter, we'll focus our efforts on four big types of settings: Keyboard, Bin View, Timeline, and Workspaces.

Before we make any changes, though, let's make sure that we've set up our own User Profile, so that any changes we make are reflected in our own profile.

To create a User Profile:

1. Click on the drop-down menu at the top of the Settings window. Choose Create User Profile (Figure 13.2).
2. In the Create User Profile dialog box, type in a name (i.e., your own name).
3. Press OK.

Creating your User Profile is only part of the story. Once you've read this chapter and done all of the important work in customizing your settings, you need

Figure 13.2

to make your User Profile transportable. That is, you need to export your User Profile—which is also within the drop-down menu in Figure 13.2—usually to a portable device like a Flash drive. Then, when you're at another Avid system, it's just a matter of importing your User Profile, which is also an option within this same drop-down menu. This allows you to immediately load each of your customizable preference, thereby making you "at home" in your editing environment. On pages 292–3 of this chapter I'll give you detailed instructions on exporting and importing your User Profile.

MAPPING BUTTONS AND MENU ITEMS TO YOUR KEYBOARD

Probably the most popular and useful type of Avid user setting is the mappable keyboard. Because Avid editing is so keyboard driven, each editor takes his or her keyboard settings very seriously because they define exactly how he or she edits.

To get started, double-click on your keyboard setting (from the Settings tab). You'll see most of the keys on the keyboard are already mapped with commands, but if you hold down the Shift key (the actual one, not the one on your Avid interface), you'll see that there are also many blank keys available (Figure 13.3). Also, keep in mind that you always have the option of re-mapping any of the keys that already have commands.

There are no rules; you can do anything that makes sense for the way that *you* edit. Granted, you are still in the process of learning commands that will ultimately define your own editing preferences, but the great thing about a mappable

—— Regular keyboard

—— Shifted keyboard

Figure 13.3

keyboard is that it is a living device; as you find more things that you want to add, you can just add them to your keyboard settings.

Before we make any changes to our keyboard, let's first make a duplicate of the Default settings and then make changes to the duplicate rather than the Default:

1. Click on the Keyboard setting so it's highlighted.
2. Press Command-D (Mac) or Ctrl-D (Windows).
3. Click on the space just to the right of the name and in the box type "Default" in one and type *Edit* in the other (Figure 13.4).
4. Click in the space just to the left of the Edit keyboard to move the check mark to that location. This enables the Edit keyboard.

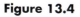

| Keyboard | Default |
| Keyboard | Edit |

Figure 13.4

Now we're ready to make some changes. Let's start with mapping buttons to our Edit keyboard. To get those buttons, we're going to open the Command Palette.

Command Palette

The Command Palette is a window that holds just about every command button Avid offers. The commands are organized into functions and each function has a tab. There are 14 tabs. To open the Command Palette, go to the Tools menu, and look near the bottom of the long menu, or press Command-3 (Mac) or Ctrl-3 (Windows). In Figure 13.5, I've clicked on the Edit tab.

Now let's map some commands.

1. Click on the Settings tab (Figure 13.1), and open the Edit keyboard by double-clicking on it.
2. Open the Command Palette from the Tools menu (Figure 13.5).

Segment Mode buttons

Figure 13.5

3. Select the "Button to Button" Reassignment radio button in the Command Palette.
4. Drag any one of the commands from the Command Palette onto a key on your (virtual) keyboard. (Keep in mind that you can also map buttons to Shifted keys.)

For our purposes, go ahead and drag the red Segment Mode (Lift/Overwrite) button from the Smart Tools tab to the 9 key on the keyboard. Then, drag the yellow Segment Mode (Extract/Splice) button to the 0 key on the keyboard. This allows you to place your segment mode buttons right above your IN and OUT

buttons—which in turn are right above the J–K–L buttons—so you'll have all of your navigating, marking, and moving commands grouped into a pyramid on the right side of your keyboard (Figure 13.6).

Figure 13.6

5. Close the Command Palette and close the keyboard. Press the buttons you mapped on your keyboard, and they will respond accordingly. (If you mapped the above segment mode buttons, notice how pressing the buttons acts as a toggle to easily turn them on and off.)

Try exploring the various commands within each one of the 14 headings tabs; we've already covered quite a few. One key I find handy is the "blank" key found in the Other tab, which lets you remove a command from a key (so that it has no command mapped to it). If you find yourself clicking on a key by mistake, which in turn executes a command you don't want, get rid of the command by replacing it with a blank key.

Mapping Menu Items to Your Keyboard

In addition to buttons, you can also map menu items to your keyboard. This includes any main menu or fast menu item within Media Composer. In Chapter 12, we learned how to create titles. The one thing that slows that process down is searching for the Title Tool Application. It's in the Tools menu, but it is faster if we can map the Title Tool Application menu item to a key on the keyboard. It will help me to remember where it is if I put it on the T key of the keyboard, but the command that's there, Mark IN and OUT is useful. So I'm going to instead hold down the Shift key and place it on Shift-T. Let's do it.

To map a menu item to your keyboard:

1. Open your keyboard from the Settings tab (we named it *Edit*).
2. Open the Command Palette from the Tools menu.

3. Select the 'Menu to Button' Reassignment radio button in the Command Palette (Figure 13.7). Notice that the mouse cursor now looks like a white menu.

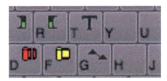

Figure 13.7

4. Now click your cursor on any button on the (virtual) keyboard. This will be the button to which you map the menu item. For us, let's hold down the Shift key on the actual keyboard and now press the T key to map this menu item to this key.
5. Now go to any menu item in any of the main menus or Fast menus in the application, and release the mouse. For us, we'll go to the Clip menu and click on New Title. Notice there's now a large T on the Shift-T (Figure 13.8).
6. Close the Command Palette. Close the keyboard.

Figure 13.8

Here are several menus we've already used that you may want to map to your keyboard:

- **More Detail** (Timeline Fast menu > More Detail): zooms into your Timeline in increments. Many editors map this command to the Up arrow.
- **Less Detail** (Timeline Fast menu > Less Detail): zooms out of your Timeline in increments. Many editors map this command to the Down arrow.
- **Source/Record Editing**: Windows > Workspaces > Source/Record Editing. This is the default edit mode in which we've been working so far in this book. As we start learning other workspaces (Audio Editing, Color Correction, Effects Editing), you can map these to other keyboard buttons, and then easily toggle between them as you edit.

Mapping Commands to Your User Interface

In addition to mapping buttons and menu items to your keyboard, you can also map buttons and menu items to command spaces on your user interface (like under the Source or Record monitors, or above the Timeline). Just follow the same steps as above, but instead of clicking your cursor on the virtual Avid keyboard, you instead click your cursor on a space on the user interface.

In Figure 13.9, I've opened the Command Palette, clicked on "Button to Button" Reassignment, gone to the FX tab and mapped the Add Keyframe command to the line of commands just above the Timeline.

Add Keyframe command

Figure 13.9

ORGANIZING YOUR CLIPS AND SEQUENCES

Organizing your clips and sequences will speed up the editing process. On larger projects, it's hard to keep track of all the many bins and the clips in those bins. Searching for the one clip you know exists but can't find is frustrating and a waste of precious time.

Sort

The first speed tip is called Sort, which is in the Bin menu (Figure 13.10). It organizes clips in a bin by using the column heading. Let's go to a bin, like Montage Footage, in the Documentary Practice project.

Figure 13.10

To perform a Sort:

1. Within Text View, click on the column heading that you want to sort. Let's start with the Name column. Click on it as shown in Figure 13.11 on the left-hand side.
2. Go to the Bin menu and choose Sort.

The clips are alphanumerically reordered within the bin as shown in Figure 13.11 on the right-hand side.

Name	Duration	Start
Outdoor Shoppers	7:26	01:00:57:28
Taxi Conductor	11:27	01:00:17:16
Birds Fly	12:05	01:00:02:03
Inside the Traffic	19:17	01:01:53:22
Traffic Chaos	21:14	01:02:17:11
Mosque	26:27	01:00:57:28
Motorbike Ride II	27:12	01:01:26:10
Motorbike Ride I	28:12	01:00:57:28
Walking People	32:05	01:00:00:00
Walking People II	57:27	01:00:00:00
Traffic into City	1:21:20	01:02:13:09
Traffic Jams	4:10:02	01:00:00:00

Name	Duration	Start
Birds Fly	12:05	01:00:02:03
Inside the Traffic	19:17	01:01:53:22
Mosque	26:27	01:00:57:28
Motorbike Ride I	28:12	01:00:57:28
Motorbike Ride II	27:12	01:01:26:10
Outdoor Shoppers	7:26	01:00:57:28
Taxi Conductor	11:27	01:00:17:16
Traffic Chaos	21:14	01:02:17:11
Traffic into City	1:21:20	01:02:13:09
Traffic Jams	4:10:02	01:00:00:00
Walking People	32:05	01:00:00:00
Walking People II	57:27	01:00:00:00

Figure 13.11

You can also press Command-E (Mac) or Ctrl-E (Windows) to sort your column.

Try arranging them in the bin by the length of the clip; click on the Duration column and press Command-E (Mac) or Ctrl-E (Windows).

If you want to reverse the order, so the last letters in the alphabet or the largest number appears at the top, hold down the Option (Mac) or Alt (Windows) and then press Command-E (Mac) or Ctrl-E (Windows).

Sift

This is another way to find what you're looking for. When you choose Sift Bin Contents from the Bin menu, Avid puts a filter on your data, causing some clips to be displayed and others to be hidden, depending upon the criteria you set.

To perform a Sift:

1. Click on a Bin so it is active. From the Bin menu, choose Sift Bin Contents. The Sift window appears (Figure 13.12).

Figure 13.12

2. Do the following:

 • In the *Criterion* drop-down menu, choose from the options *Contains, Begins With* or *Matches Exactly.* As you can see, I left it as Contains.

- In the *Text to Find* field, type the text by which you want to filter. I typed the word "Traffic" as shown in Figure 13.12.
- In the *Column or Range to Search* drop-down menu, choose the column that the text falls within. I left it at Any.

3. Press Apply to see the clips filtered.
4. If you're happy with the sift, click OK.

Figure 13.13 shows that I got what I was looking for—all the shots with the word "Traffic."

	Name	Duration
	Inside the Traffic	19:17
	Traffic Chaos	21:14
	Traffic into City	1:21:20
	Traffic Jams	4:10:02

Figure 13.13

If you want to "unsift" the clips in the bin, choose Show Unsifted from the Bin menu (Figure 13.14).

Figure 13.14

We just set up a Sift based on just *one* piece of criteria—the shots with the word "Traffic" in them. If, however, you want to sift based on multiple pieces of criteria, you'll want to enter data in multiple text fields.

THE FIND TOOL

The Find Tool allows you to search for any piece of metadata that you could possibly want to find—across all of the bins in your project. It even lets you search for text in your Timeline and monitors, and within your imported scripts. To be honest, I don't use Sift that much anymore because Avid has now provided such a powerful search tool.

You bring up the Find Tool by selecting Find from the Edit menu, or by pressing Command-4 (Mac) or Ctrl-4 (Windows). When you do, you'll see a window like the one in Figure 13.15.

At the top of the window is the search bar where you input your search criteria. However, before you type anything, there are a couple of things you need to check out.

Figure 13.15

First, you need to make sure that Media Composer has indexed all of your bins. This just means that all of the text in your bins has been analyzed and is ready to go. The Bin Index indicator at the bottom of the window will be lit up green if indexing is complete (Figure 13.16).

Figure 13.16

Next, you need to choose the location in which the search will be performed. If you want to search in all of your bins, click on the first tab (Clips and Sequences). Then, you need to select whether you will search within all the Bins in Project, the Current Bin, or bins that are tied to a script or screenplay you have brought into Avid. I almost always use Bins in Project (Figure 13.17).

Figure 13.17

Once you've prepped your search, you're ready to go.
To perform a search in the Find Tool:

1. Type in your search criteria in the search bar, and click on the Find button. The clips, subclips, sequences, and titles that match your search criteria will appear in the main window, as in Figure 13.18.

Name	Bin	Duration	Video	Creation Date	End	Start
Fast Traffic Rough Cut	Sequences	31:29		2/18/16 2:53 PM	01:00:31:29	01:00:00:00
Inside the Traffic	Montage Footage	19:17	DNxHD 80 (HD720p)	12/28/15 12:32 PM	01:02:13:09	01:01:53:22
Traffic Chaos	Montage Footage	21:14	DNxHD 80 (HD720p)	12/31/15 3:29 PM	01:02:38:25	01:02:17:11
Traffic Jams	Montage Footage	04:10:02	DNxHD 60 (HD720p)	12/28/15 12:27 PM	01:04:10:02	01:00:00:00
Traffic Music	Montage Music	01:00:22		2/18/16 2:55 PM	01:01:00:22	01:00:00:00
Traffic Into City	Montage Footage	01:21:20	DNxHD 60 (HD720p)	12/31/15 3:16 PM	01:03:34:29	01:02:13:09

Figure 13.18

As you can see, Avid found a sequence, three picture master clips, a subclip, and a music clip, all with the word "Traffic."

2. You have the ability to filter your search further—across every bin in your project, if you like. Just type your second search criteria in the Filter search bar. For example, I want to find the traffic music not a traffic clip. So I type "Music" in the Filter bar and, as in Figure 13.19, I quickly burrowed down and found the exact clip I was looking for by applying a filter (Music) on the Traffic search.

Figure 13.19

3. If you want to apply even more filters, just click on the plus button to the right of the first filter and repeat the process.
4. Now just double-click on the clip or sequence in the Find Tool, and it will load in your Source Monitor or Timeline.

If, instead of searching through your bins, you want to search for a clip in your Timeline, you can click on the third tab: Timeline and Monitors. Just make sure to select the Clip Names check box, and then enter your search criteria in the search bar (Figure 13.20).

Figure 13.20

When you press Enter, the position indicator will snap to the first clip in the Timeline that matches your criteria. To find the next instance, you can Find Again by pressing Command-G (Mac) or Ctrl-G (Windows).

As you can see, you really have the ability to burrow down very deep into your project and find exactly what you need from hundreds of items.

CUSTOMIZING YOUR TIMELINE

The last big setting we'll discuss is Timeline customization. Changing the appearance of the tracks in your Timeline is often helpful for different stages of the editing process. When you're editing video, you might like to display the video tracks larger than the audio tracks; and when you're editing audio, you might like to display the audio tracks larger than the video tracks, as well as show the audio waveform.

Many of the options for modifying your Timeline are located within the Timeline Fast Menu, which we touched upon in Chapter 2, when we discussed how to zoom in and out, and to increase and decrease track detail. You can spend a lot of time going through all of the options within this menu, but we'll just go over a couple of the most useful ones. At the end, we'll learn how to create a Timeline View, which will speed up our work tremendously.

To create a Video timeline:

1. In the project Documentary Practice open a sequence, select the video track selector, and deselect the audio track selectors. Now, continually press Command-L (Mac) or Ctrl-L (Windows) until the video track is about twice it original size. (See the "Enlarging and Reducing Tracks" section of Chapter 2 for additional ways to configure track size.)
2. Now select all audio tracks and deselect the video track.
3. Now, press Command-K (Mac) or Ctrl-K (Windows) until the audio tracks are smaller. We can customize our Video Timeline view further. Go to the Timeline Fast menu and select Clip Frames, which displays a thumbnail of each clip in the Timeline (Figure 13.21).

Figure 13.21

4. To save this as a Timeline View, click on the *Untitled* label at the bottom of the Timeline and select Save As (Figure 13.22).

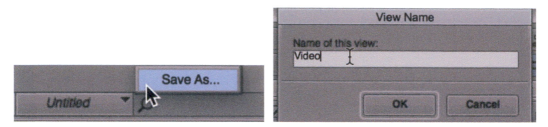

Figure 13.22

5. In the View Name box, type a name (Video) for this Timeline View and click OK.

So now, we have a view we like and have saved. But to see the power of this, let's create a different view—one for when we're more concerned about editing the audio tracks.

To create an Audio timeline:

1. Select your audio tracks and deselect your video tracks. Now continually press Command-L (Mac) or Ctrl-L (Windows) until your audio tracks are larger.
2. Now, go to the Timeline Fast menu and deselect Clip Frames, so they disappear.
3. Now, deselect the audio tracks and select the video track. Now press Command-K (Mac) or Ctrl-K (Windows) until the video track is smaller. You should now have a Timeline view with audio tracks larger than the video track.
4. Now let's display the audio waveforms. To do so, select Audio Data > Waveform from the Timeline Fast menu (Figure 13.23).

Figure 13.23

5. To save this view, click on the label at the bottom of the Timeline (it will probably now say *Video.1*) and select Save As (Figure 13.24).

Figure 13.24

6. Type a name (Audio) in the View Name box and click OK to create this Timeline View.

Now you can quickly switch between your two Timeline Views of Video and Audio by choosing them from the pop-up menu at the bottom of the Timeline (Figure 13.25).

Figure 13.25

Let's go ahead and make these two views more distinguishable.

Track Color

To add further definition to your Timeline views, you can also change the color of the tracks. It's certainly not as important as track size, but it can help define each of your views a little better.

To change track color for each Timeline view:

1. From the pop-up menu at the bottom of the Timeline, switch your Timeline view to Video.
2. Select your video tracks and deselect your audio tracks.

3. Choose Track Color from the Timeline Fast menu by holding and dragging the mouse to a color you would like to use (Figure 13.26). Release the mouse, and your tracks will reflect your selection.

Figure 13.26

4. To update the changes we've made to the Video Timeline View, Option-click (Mac) or Alt-click (Windows) the pop-up menu at the bottom of the Timeline.
5. Choose Replace "Video" (Figure 13.27).

Figure 13.27

6. When the dialog box appears asking you if you're sure you want to replace the Timeline View, press Replace.
7. Perform Steps 1–6, but instead of customizing the track colors for the Video view, customize the track colors for the Audio view. (Make sure to choose different colors for each set of tracks.)

Step number 4 is really useful. You can make changes to your view, and then Option-click (Mac) or Alt-click (Windows) the pop-up menu at the bottom of the Timeline and replace the old set-up with the new.

Other Useful Timeline Settings

Now that you're comfortable with creating, saving, and replacing Timeline Views, let's just quickly touch upon a couple of other options that you may want to add as you customize your different Timeline Views.

- **Audio Data**: in addition to Waveform (as shown in a previous exercise), you can also display Volume and Clip Gain. We learned about these in Chapter 6. I set up a Volume view because doing so saves a lot of time.
- **Clip Text**: displays various metadata labels for each segment in the Timeline. Text options include things such as Clip Names, Clip Tracks, Clip Durations, Comments, Source Names, Clip Resolutions, etc.

NAMING YOUR TRACKS

If you have more than three or four tracks, keeping track of them can get tricky. Avid let's you name your tracks, as shown in Figure 13.28.

Figure 13.28

To rename a track:

1. Right-click on the track you'd like to rename.
2. Select Rename Track . . .

3. When the rename box appears, type in a name, such as Sound Effects or Music.
4. Click OK.

Figure 13.29

As you can see from Figure 13.29, I've renamed A1 and A2. What's nice about this is the renamed tracks stay with the sequence, but other sequences you've created, or create in the future, will not be changed—they'll stay A1 and A2 and so on.

EXPORTING AND IMPORTING YOUR USER PROFILE

Ok, so you've been busy making all of these useful changes to your User Profile; you've changed your keyboard settings, bins views, Timeline views, and workspaces. Now what do you do? We already mentioned that editors carry their User settings with them wherever they go, so we need to figure out how exactly to do that.

To save your User Profile:

1. From the drop-down menu in the Settings tab, choose *Export User or User Profile* (Figure 13.30).

Figure 13.30

2. When the Export User Profile window appears, click on the folder icon in the Location option, and navigate to your thumb drive (or wherever you are saving your profile) (Figure 13.31)

Figure 13.31

3. Choose Local User Profile, as shown in Figure 13.32.

Figure 13.32

4. Click OK.

Now, you have a copy of your User Profile that you can use on any Avid editing system. The other choice is to click on Personal, in the Shared User Profile. You would do this if you were working on server, and not a standalone computer. Then you would export your profile to the server. When you go to another Avid station on that server, you would import your profile from the server. I prefer the Personal choice because any changes I make are updated to the server.

To use your User Profile on any Avid editing system:

1. From the drop-down menu in the Settings tab, choose *Import User or User Profile.*
2. Navigate to your thumb drive or the user profile on the server.

3. Click Choose. Your User Settings are loaded, and you're ready to go. (I recommend creating a new User Profile each time you upgrade your Media Composer software.)

As you can see, you can completely customize your User settings and transform them into a portable profile that you can load on any Avid system in the world.

MARKERS

Markers, are like "digital post-it notes" to communicate editing information during various stages of the post-production process. You can use markers to tell yourself something ("Remember to get the rights to this image"), or to tell someone else something ("This video is too dark, but we're re-shooting it").

Markers come in all different colors, so you can assign different colors to different tasks, or different people.

To access Markers:

1. Open the Command Palette from the Tools menu, or press Command-3 (Mac) or Ctrl-3 (Windows). Make sure "Button-to-Button" Reassignment is selected in the lower left corner.
2. Click on the "More" tab. You'll see eight colored markers in the left part of the window (Figure 13.33).

Figure 13.33

3. Drag an "Add Marker" buttons to an empty space above the Timeline (Figure 13.34).

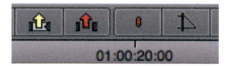

Figure 13.34

4. Close the Command Palette.

Ok, now that you have some markers at your disposal, you can start adding them to shots in your sequence.

Adding and Navigating Markers

Make sure that the appropriate tracks are selected (V1, A1, A2, or TC1), as the marker gets applied to your highest selected track. In general, you should apply the marker to the track that contains the material on which you want to comment. Here I'm going to place it on V1.

Once you've selected the track to apply your marker, just press the Marker button that you mapped. A marker will be added to the Timeline, and you will see a marker in the Record monitor. Don't worry, though—it won't be visible when you play the sequence. Additionally, a pop-up text box will appear, where you can enter comments (Figure 13.35).

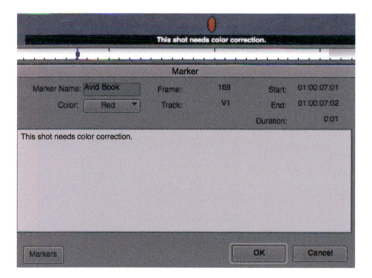

Figure 13.35

If you click on the Markers button in the lower left corner of the Marker pop-up box, you will see a list of all the markers in your sequence (Figure 13.36). You can also access this list of markers by right-clicking on your Record Monitor and choosing Markers.

#	Marker Name	TC	End	Track	Part	Comment
0001	Avid Book	01:00:07:01		V1		This shot needs color correction.
0002	Avid Book	01:00:17:01		V1		A bit shaky. But I can stabalize it.
0003	Avid Book	01:00:26:10		A1		I love the sound here, but is it too loud?

Figure 13.36

The list contains columns of information related to the marker color, such as the timecode and track information, and the comment.

If you double-click on one of these markers in the list, you will immediately be transported to that location in the Timeline.

Another way of getting the information contained at each Marker is to click on it in the Timeline (Figure 13.37).

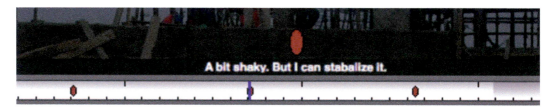

Figure 13.37

Deleting Markers

To delete a marker, click on the marker in the position bar under the Record Monitor. If it doesn't appear in the monitor window, step-frame until it does, and then press the Delete key.

COLOR CODING CLIPS

If you want to draw attention to a clip in a bin, or all the clips in a bin, just add a color to the clip icon. Go to the clip and right-click on it. A little color palette will open and you select the color you like best. To remove, select None (Figure 13.38).

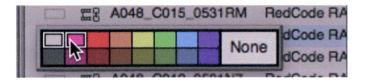

Figure 13.38

SUGGESTED ASSIGNMENTS

1. Create a new User Profile.
2. Duplicate the keyboard settings and name it.
3. Open your new keyboard settings, and open the Command Palette. Choose "Button to Button" Reassignment.
4. Map at least three buttons from the Command Palette to your keyboard.
5. Switch to Menu to Button Reassignment.
6. Map at least three menu items to your keyboard.
7. Create two Timeline Views named Video and Audio.
8. Change track sizes, track colors, and various Timeline settings for each of these views. Make sure that you're always amending the appropriate Timeline View. As you make further changes, remember to "Replace" the previous view.
9. Rename one or more of your tracks on the Timeline.
10. Export your User Profile to a thumb drive.
11. From the Command Palette, place a colored Marker on your Timeline toolbar and add a Marker to one of your tracks.
12. Add a message in the text box.
13. Navigate to another section of your Timeline and add a second Marker, but on a different track.
14. Navigate to the first Marker and open the text box, by clicking on the Marker icon.

14

Keeping in Sync

SYNC PROBLEMS

Over the last couple of chapters, we've been adding tracks through our exploration of audio editing, effect editing, and title design. As you continue to add tracks, you also add to the possibility that your clips will go out of sync through even the simplest of editing tasks. If it hasn't happened to you thus far, you're good, but it will probably happen at some point. The tips you learn in this chapter will help minimize the problems that can result from such sync issues.

Keep in mind that when we talk about sync problems, it's more than just married video and audio falling out of sync. If a music cue should be heard as soon as a door opens, and instead it comes in 2 seconds late—it's out of sync. If you have a lower-third title that is supposed to identify your primary character, but it instead identifies a shot of a building—you're clearly out of sync. Fortunately, there are tools that help you stay in sync and others that will get you back into sync quickly.

SYNC LOCKS

Because keeping in sync is so important, Media Composer provides a tool that enables you to lock your tracks together with the goal of maintaining sync between all tracks; it's aptly named *sync locks*.

In the track selector area, there is a small box in between the track selectors and the Solo and Mute buttons (Figure 14.1). In earlier versions of Media Composer, you needed to click on these boxes to engage sync locks—they weren't there by default. But with the latest versions of Avid software, these are now engaged and working as soon as you create a sequence in the Timeline.

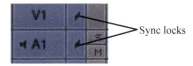

Figure 14.1

1. If you click inside the box, the sync lock will be removed. Click on it again and it will return.
2. To add or remove sync locks to all tracks at once, click in the box in the TC1, or timecode track (Figure 14.2).

Click inside the TC1 sync lock to toggle on or off the sync locks for all tracks

Figure 14.2

Sync locks work primarily in Trim Mode, specifically in Single-Roller Trim Mode (also known as Ripple Trim), so that Media Composer maintains the proper relationship with all of your tracks. You'll find that sync locks also work with Lift and Extract. For instance, if you were to select the Video track and not the Audio track(s) and pressed Lift, the sync locks will lift out the audio tracks as well, to keep you in sync. With the sync locks off, try lifting just the Video track and see what happens. You're out of sync.

IF SYNC LOCKS ARE TURNED OFF

To better understand what they do, let's look at what happens when they are turned off, either on purpose or inadvertently. If they are off, there are three actions that will throw you out of sync:

- Single-roller trimming on one track but not the other
- Splicing material to one track but not to the other
- Lifting material from one track but not from the other.

Each of these actions either adds or removes material in an uneven way across tracks, thus resulting in sync drift. Figure 14.3 shows how, with sync locks off, we

got out of sync. Here we made the mistake of entering Single-Roller Trim (Ripple Trim) on just one track, inadvertently adding eight frames of video to Man rolls barrel, but not adding eight frames to the sync audio.

SYNC BREAK INDICATORS

If your video and audio were captured at the same time (i.e., "married"), or you synched your dialog tracks with your picture, as described in Chapter 9, Avid knows that these tracks should remain together. If you go out of sync, *sync break indicators* will appear in the Timeline to show you you're out of sync.

Figure 14.3

The sync break indicators also indicates how many frames and in which direction we need to go to restore sync (Figure 14.3). In this case, we should use Single-Roller Trim mode to add or subtract the number of frames indicated, either subtracting eight frames (–8) from the video, or adding eight frames (+8) to the audio.

It might be a little confusing as to which direction to trim in order to restore sync. One piece of advice is to just pick one—either add or subtract—and see if it fixes your sync problem. If it doubles your sync problem instead of fixing it, then just Undo and perform the opposite operation.

But understand that titles, sound effects, narration, and music that you added to your sequence—if they go out of sync, there won't be any sync break indicators. Sync break indicators only appear if the sound and picture came in together, or you married them, as we did in Chapter 9.

So make sure you keep sync locks on, because they work, until they don't. You'll see shortly.

WORKING WITH SYNC LOCKS

Ok, we now know what happens when we don't have sync locks to keep our tracks in sync. Let's look at how sync locks work. So we can better see what's happening, I've added a row of red Markers to each track in a line to see if tracks that aren't married go out of sync.

In Figure 14.4 I've clicked the TC1 sync box to put the sync locks on all my tracks. I get into Single-Roller Trim on the tail of "Birds fly." Notice that, because sync locks are on, Avid has added phantom Single-Roller Trim rollers on the other tracks. When I drag my yellow rollers left to trim the tail of the shot by 16 frames, those phantom rollers will trim 16 frames of fill before the title and 16 frames of fill before the music to keep those tracks in sync. These will maintain sync even though I didn't put rollers there.

Figure 14.4

Now let's turn sync locks off and try the same Single-Roller Trim again.

Figure 14.5

Compare Figure 14.4 with Figure 14.5 and look at the row of red Markers. See how sync locks added phantom rollers and kept me in sync, whereas without sync locks on, my title and music tracks went out of sync.

WHEN SYNC LOCKS DON'T WORK

This works pretty well, huh? Well, sometimes it's a disaster. Let's take a look.

In Figure 14.6 we've got sync locks on all of the tracks, and we're going to extend the tail of the "Men throw bricks" shot (the A-side) by Single-Roller trimming to the right.

Figure 14.6

So I drag the single-rollers to the right to extend the shot. Examine what happened in Figure 14.7.

Figure 14.7

Whoa! My music cue has been cut in two and a chunk of black filler (silence) has been added. I didn't want *that*. This happened because even though A3 and A4 weren't selected for trimming, they are locked to the other tracks by the sync locks. Media Composer is dutifully maintaining sync.

So, as you can see, sync locks work some of the time, but not all of the time. If the other tracks in line (vertically) with the tracks you are editing are empty, sync locks can be fast and foolproof. But, if the other tracks have material in line with the tracks you are cutting or trimming, Avid can blindly remove important material in its quest to keep you in sync.

FIXING THE PROBLEM BY TRIMMING IN TWO DIRECTIONS

So what can you do in order to maintain sync when sync locks don't work? The key is to use sync locks where they work but remove them and manually set single rollers where they don't work.

Let's take a look at Figure 14.8. There's a title on V2, Men throw bricks on V1 with the sound from their work on A1 and A2, and finally the Music Cue on A3 and A4. We're happy with the way the title and music works with the picture and sync track. But, let's pretend we need to extend the head of the men throwing bricks by eight frames because we want to start the shot just as a brick is about to leave a man's hands. So we get into Single-Roller Trim mode to extend the shot.

Figure 14.8

We know what's about to happen with sync locks on and we drag the rollers left.

And indeed it happened as we predicted. As you can see in Figure 14.9, Media Composer makes sure we stay in sync. Eight frames of black fill are automatically

Figure 14.9

added to the V2 title to keep it in sync with V1, A1, and A2 (all good), but the music has eight frames of black fill added as well, cutting it into two segments (not good).

To solve this, we want to deselect the sync locks on A3 and A4, where the problem occurs, as in Figure 14.10. Now, after we get into Single-Roller Trim on V1, A1, and A2, we then hold down the Shift key and add Single-Roller Trim rollers on the Music Cue. First Shift-click on the fill side (A-side) of A3, and then Shift-click on the fill side of track A4. We now have added Trim rollers on the fill side. Notice they are facing in the opposite direction to the Single Trim rollers on V1 and A1. When we add eight frames to V1, A1, and A2, Media Composer adds eight frames of fill, keeping us in sync.

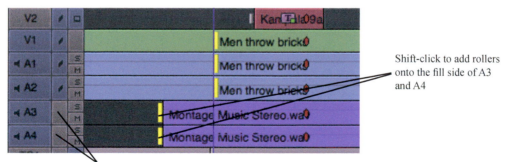

Shift-click to add rollers onto the fill side of A3 and A4

Click here to remove sync locks

Figure 14.10

What about the Title on V2? We don't need to place a roller on that track because the sync lock is on, meaning that Media Composer will keep it in sync with V1, A1, and A2. You only need to deselect sync locks when they *don't* work. Just manually add rollers in the fill area to keep everything in sync.

USING MARKERS TO CHECK YOUR SYNC

Once you've edited all of your video, music, effects, and titles in your sequence, you can place a marker on each of the tracks so they line up in a straight vertical row, as I did for this demonstration (Figure 14.11). By doing it, you have a visual sync check. It's easy to do. First select the appropriate track (and deselect the other tracks) and then press your Add Marker button. A dialog window opens, giving you a chance to write a note. Skip this and click OK.

Now, without moving your position indicator, you've got to repeat this process for each of your tracks, one at a time. Deselect V2 and click V1 and press the Add Marker button.

Figure 14.11

You don't need to put markers everywhere in the Timeline, but it's a good idea to place a vertical row of them every 5 minutes or so in your project. That way, if you get out of sync, you don't have far to go before you have a checkpoint.

LOCKING TRACKS

You can also lock your video or audio tracks to prevent accidental changes. Track locking is different from sync locking. When you lock a track, no further editing can

take place on that track. Let's say you have a video track with several sync dialog tracks, a second video track with titles, and a narration track—and all are in perfect sync. And now you need to work on your music tracks. You can lock the tracks you don't want to disturb, leaving you free to mess around with the music tracks.

To lock and unlock tracks:

1. Select the tracks you want to lock and deselect the others.
2. From the Clip menu choose Lock Tracks. A padlock icon appears in the space previously occupied by sync locks. Choose unlock Track from the Clip menu to remove the padlocks.

Figure 14.12 shows that I selected my video tracks and locked them. Now it's impossible to make any changes to them. With my tracks set up this way, I could bring in a sound editor to work on my audio tracks and not have to worry that he or she with screw up my weeks of picture editing.

Figure 14.12

KEEP IT SIMPLE

As you continue to add video tracks for titles and effects, and audio tracks for music and narration, you can become more in danger of going out of sync. We've spent a lot of time on the subject of sync because losing it can be so painful. My best advice is to keep it as simple as you can for as long as you can in the editing process. Don't add titles, music, and sound effects until you have to. Tell the story first.

Otherwise, you'll spend much of your time repairing sync, rather than editing. That said, it's true that when cutting a visual montage to music, you need the music to be there.

SUGGESTED ASSIGNMENTS

1. Remove sync locks and place a single roller (Trim Mode) on one track and not the other. Drag left and look at the sync break. Leave Trim Mode. Now go back into Trim Mode and fix the sync break.
2. Place a row of locators on your tracks.
3. Place sync locks on your tracks. Try single-roller trimming.
4. Remove sync locks from individual tracks.
5. Remove all sync locks.
6. Add sync locks to some tracks and not others and try single-roller trimming.
7. Try setting up a scenario in which you trim in two directions at once.
8. Lock one or more tracks. Try editing the locked tracks.

Power Editing Techniques

DELVING DEEPER

As we've noted on several occasions, Avid Media Composer is a complex editing system, loaded with features that give the editor tremendous flexibility. For the most part, I have stuck to the basics so that you can start editing with confidence and efficiency. Now, I'm going to delve a little deeper, and begin examining more advanced editing features.

MATCH FRAME

Match Frame is a very handy command, and something most editors use a lot. It allows you to immediately access the source clip of a shot in the Timeline—usually because you want to check what comes before or after the section you spliced in. When you perform a Match Frame on a clip in the Timeline, the entire source clip is immediately loaded into the Source Monitor. The frame the cursor is on in the Timeline is referenced by an IN point in the Source Monitor, so you can tell where you are in the source clip. You may recall we used it in Chapter 11 when we wanted to create a Freeze Frame effect.

Match Frame can be found inside the Fast menu between the Splice and Overwrite commands, or the Timeline Fast menu (Figure 15.1). It looks like a little piece of film.

Click on the Timeline Fast menu and the Tool Palette opens. Inside you'll find the Match Frame command.

Figure 15.1

If you use Match Frame as often as most editors do, you'll definitely want to map it someplace handy. You can find it in the *Other* tab within the Command Palette. (For help mapping buttons via "Button to Button" Reassignment, see Chapter 13.)

Let's try using it. Place the position indicator on a clip in the Timeline, then press the Match Frame command. You'll notice that the source clip is immediately loaded in the Source Monitor with an IN point marking the matched frame (Figure 15.2). This allows you to access all of the clip's handle before and after this moment. If you want to load the source clip from an audio track, make sure the appropriate track is selected and the ones above it are deselected.

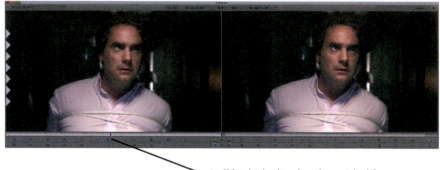

An IN point is placed on the matched frame

Figure 15.2

If you have lots of video and audio tracks, it can be a pain to deselect all of the above tracks to perform a Match Frame on say track A16. Fortunately, you can get around this by performing a Match Frame Track. Just park the position indicator on the frame in the Timeline that you want to match, and don't worry about selecting the appropriate track. Just right-click on the track selector of the track you want to match, and choose *Match Frame Track* (Figure 15.3). The Match Frame is performed in the same way as the traditional method.

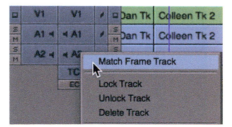

Figure 15.3

ADVANCED TRIMMING AND EDITING TECHNIQUES

There are quite a few useful techniques that we have not yet learned, but they will definitely help you during your rough cut phase. We're going to start by discussing some advanced methods of Trim Mode called *Slip* and *Slide*.

Slip

Performing a Slip Trim allows you to leave a clip parked in the Timeline—and without affecting its position—you shift the shot's content by accessing its handle (the material before or after the section you originally edited in the Timeline). This allows you to fine-tune a shot without affecting any of the surrounding clips.

When would you need to change a shot's contents? Well, maybe you originally placed your IN and OUT marks in the Source Monitor a bit too early, or a bit too late. Without Slip, the only way to fix this would be to mark the clip in the Timeline and choose a new IN point in the Source Monitor, and then press Overwrite to replace the material. If it still isn't right, you'd have to try it again.

With Slip, however, you don't need to go back to the Source Monitor. You can change the clip in the Timeline by simultaneously altering its IN and OUT points. Think of Slip as working a bit like a conveyor belt. The master clip represents the whole belt, and the portion of the belt "in view" is the segment you've spliced into the Timeline.

To get into Slip Mode, do one of the following:

- Lasso the entire clip in the Timeline from the right to the left, <u>not</u> left to right.
- Get into Dual-Roller Trim Mode and right-click the clip segment. Choose Select Slip Trim.

Trim rollers will appear at the head and tail of the shot you're slipping (Figure 15.4).

Figure 15.4

The Source and Record monitors will change to four screens as shown in Figure 15.5.

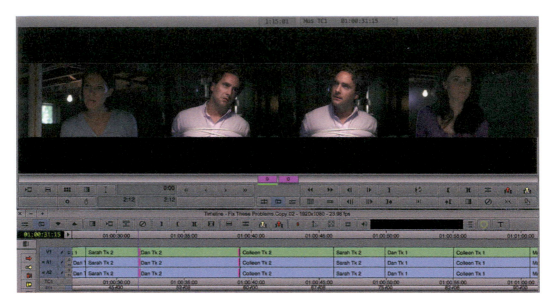

Figure 15.5

The two inner screens are the head and tail frames of the clip you are slipping. The far-left screen is the tail frame of the clip to the left, and the far-right screen is the head frame of the clip to the right.

You can slip using any method you already know how to trim—by using the Trim keys (M , . /), J–K–L Trim, or clicking and dragging either roller. The inner frames will update as you slip the shot. The outer frames will not change at all.

Trimming to the left reveals material that comes before what's in the Timeline—you are adding new frames at the head and taking away frames at the tail. Trimming to the right reveals material that comes after what's in the Timeline—you are taking away frames from the head and adding new frames to the tail. The Trim Counters in the center of the interface indicate how many frames you have slipped (Figure 15.6). The minus sign (-16) shows you have dragged to the left and the standard numbers (16) show you have dragged to the right.

Figure 15.6

Getting out of Slip is just like leaving Trim Mode:

- Click on the TC1 track, or
- Press the Trim Mode button.

Slide

Slide is the inverse of Slip; you change the shot's position, but not its content. In changing its position, you can slide it back and forth between the two adjacent shots. It's a great way to reposition a cutaway or reaction shot within the sequence. Because I'm moving a reaction shot, I'm only going to slide the picture on V1 and not touch the audio. I'll leave the audio as it is. This is usually the case with Slide— you only engage the picture track because it's most often used with cutaways or reaction shots.

To enter Slide Mode, do one of the following:

- While holding down the Shift + Option keys (Mac) or Shift + Alt keys (Windows), lasso just the video clip on V1from right to left.
- Get into Dual-Roller Trim Mode of the video clip on V1 and right-click the clip segment. Choose Select Slide Trim from the pop-up menu (Figure 15.7)

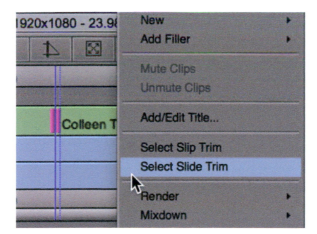

Figure 15.7

Trim rollers will appear on the outside cut points of the shot you're slipping (Figure 15.8).

Dan Tk 2		Colleen Tk 1	Dan Tk 2	Sara
Dan Tk 2				Sara
Dan Tk 2				Sara
01:01:20:00		01:01:22:00		01:01:2

Figure 15.8

The Source and Record monitors will change to four screens, like Slip Mode (Figure 15.9). This time, however, when you slide, the outer two frames will change, whereas the inner two frames will remain static. That is because you are not changing the content of the sliding shot; you are just changing where it is located in the Timeline.

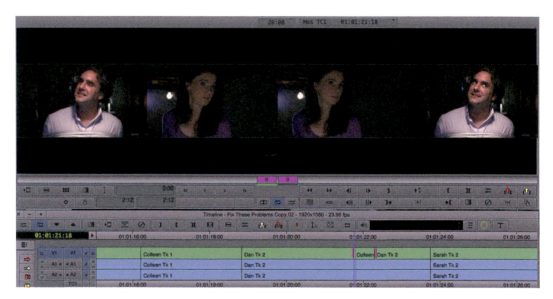

Figure 15.9

Examine Figure 15.9 closely. We have a cutaway of Colleen as she responds skeptically as Dan makes his excuses. I'd like this reaction shot to come a little earlier than it does now because right now I can see that Dan is already turning to look at Sarah, which isn't what I want. By sliding the cutaway of Colleen to the left by 13 frames, I can slide it to a place where Dan looks at Colleen *before* he turns to look at Sarah. Examine Figure 15.10. Do you see how this slight slide has made the

Figure 15.10

reaction shot more powerful, because Colleen now has Dan's full attention through-out, and he responds to Colleen's glare by turning to Sarah for help.

To get out of Slide:

- Click on the TC1 track, or
- Press the Trim Mode button.

Slip versus Slide

To review, Slip is used to change the contents of the clip you've already cut into the Timeline. Usually you are changing the picture and it's sync sound together. So when you are getting into Slip mode, you include all the sync tracks, V1, A1, and A2.

Slide is most often used to change the position of a reaction shot or cutaway that you've already edited into your Timeline. As with most cutaways and all reaction shots, you've cut the reaction onto just V1 and so you're entering Slide on just V1.

Replace Edit

Performing a Replace Edit does what you'd expect—it replaces material in the sequence with other material of your choosing. That's exactly what Overwrite does—so what's the difference? Well, unlike overwriting, Replace doesn't need IN and OUT marks. Rather, it uses the location of the position indicators to do its work. This is handy when you want to replace a shot that comprises a specific action or line of dialog with another shot with a similar action or line of dialog. All you need to do is to park the position indicator in the Timeline on the precise

moment, and simultaneously park the position indicator in the Source Monitor on the same precise moment.

When do I use this most often? I use it to replace one take I've cut into the Timeline with another take that I think might work better. Or say I have a master shot with not great audio, because it was hard to get the boom close enough to record great dialog, but the master shot really works. And I have a medium shot of the same line of dialog that has better audio. I often use Replace to steal the good audio from the medium and replace the bad audio from the master.

Let's take a look at how Replace works. We've got a medium shot of Colleen explaining to Sarah (Figure 15.11) that she's checked every inch of the house for the missing money. Without affecting anything else in the Timeline, let's see how this would work by swapping out Take 1 with Take 2. To perform the swap, you simply park the position indicator on a line of dialog. In this case, we're parking the position indicator just after Colleen says, "I did."

Figure 15.11

Then I load Colleen Tk 2 in the Source Monitor, and park the position indicator directly after the same line of dialog—"I did." Make sure the appropriate tracks are selected (V1, A1, and A2), and then click on the Replace Edit button. Replace Edit is the blue arrow in the Fast menu between Splice and Overwrite (Figure 15.12).

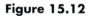

Replace Edit is found in the Fast menu tool palette between the Source and Record monitors

Figure 15.12

Once the Replace Edit is complete, we've swapped Colleen's Tk 1 with her Tk 2 (Figure 15.13). The clip remains the same length; but the new clip is overwritten, based on the location of the position indicators.

V1			Colleen Tk 2		Dan Tk 1
◀ A1			Colleen Tk 2		Dan Tk 1
◀ A2			Colleen Tk 2		Dan Tk 1

Figure 15.13

One nice feature of Replace Edit is that it can replace sound and picture even if there is a split edit! It replaces sound based on the amount of sound used in the Timeline, even if there's more sound than picture (as might happen with a split edit) in the Timeline.

Now let's try to replace some poor dialog.

In Figure 15.14 we have the master shot of Dan waking up as Sarah approaches him and says "Where's the Money?" That's the only line of dialog in the shot but it's much too quiet.

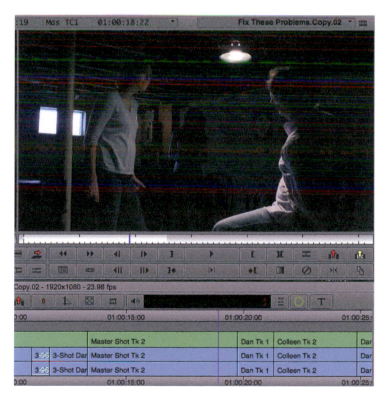

Figure 15.14

So to help me find the first syllable of the word "Where," I get into waveform mode and find it. I've landed right on the "Wh" of "Where" (Figure 15.15).

Figure 15.15

Now I go to the bin and load the Medium Shot of Sarah Tk 1 into the Source Monitor. I play the clip until I find where she says "Where." I park my position indicator on the Source Monitor position window, as you see in Figure 15.16.

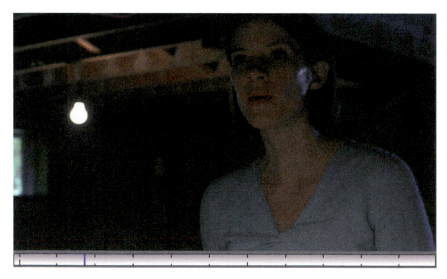

Figure 15.16

Now, with the two position indicators on the same word, I deselect the Video (V1) track in the Timeline, because I want to replace the crummy dialog, not the picture (Figure 15.17). Now I press the Replace command.

Figure 15.17

Presto! Sarah's dialog from her Medium Shot (Sarah Tk 1) replaces her dialog from Master Shot Tk 2 and it's perfectly in sync!

OK, sometimes, on longer lines of dialog, I may need to break up some of the dialog into smaller sections, using Add Edit marks, in case the dialog starts to drift out of sync.

Another technique I use is Slip, which we learned earlier in this chapter. Sometimes, when I replace the dialog, I find it's slightly out of sync. I'll get into Slip mode just on the audio tracks, and slip a frame here or there until it lines up perfectly. Figure 15.18 shows an example of how I use Add Edits to break up longer lines of dialog so that I'm replacing shorter bits, and using Slip to nudge the dialog into sync.

Figure 15.18

This technique will save you a lot of time and will win you kudos from everyone. This can often save the time and effort of having to make the actors come in

for an Automated Dialog Replacement (ADR) session, and it often will sound better than dialog recorded in a studio, because this dialog has the ambience from this location—something no studio can provide.

Single Mark Editing

As we are aware, our mantra for making an edit from the Source Monitor to the Timeline has always been *it takes three marks to make an edit*. Well, we're on our way to becoming more efficient editors now, so let's talk about how we can work more quickly when making basic edits. Single Mark Editing lets you establish a single mark (an IN or OUT point), then uses the location of the position indicator for the other two marks.

First, before performing a Single Mark Edit, we need to enable the function. To enable Single Mark Editing:

1. Go to Settings and double-click on Composer.
2. In the dialog box, click on the Edit tab, and select Single Mark Editing.
3. Click OK (Figure 15.19).

Enable Single Mark Editing in the Composer Settings

Figure 15.19

Ok, we're ready. Go ahead and place the position indicator in the Timeline where you want to perform your edit. There's no need to mark an IN. Now, go to the Source Monitor and mark an IN point. Play until you find your OUT. But instead of actually marking an OUT, use the position indicator to indicate where you want the OUT. Finally make your edit (this technique works with Splice, Overwrite, or Replace Edit) (Figures 15.20 and 15.21). There you have it—you've edited with a single mark!

To set up for Single Mark Editing, we've just put an IN point in the Source Monitor, and we've placed the position indicator at the location that we *would have* placed the OUT point.

We've also parked the position indicator at the desired edit location in the Timeline.

Figure 15.20

Then, we just press the Splice button (V), and the shot is spliced in with only one mark—the IN.

Figure 15.21

Conversely, you can mark an OUT in the Source Monitor, then locate the first frame for the IN mark in the Source Monitor, but instead of placing an IN mark, just use the position indicator for the IN.

Practice this because it's incredibly fast.

Video Quality Menu

In Chapter 16, we're going to be working with larger camera files—2K, ultra high definition, and 4K files. And in Chapter 17, we'll be doing more complicated effects. Both will tax your computer's ability to play things smoothly, in real time. Instead, you'll start to see stuttering and poor performance. When that occurs with complicated effects, you can try rendering the effects, but another technique is to change the quality of the video playback.

If you look at the bottom of your Timeline, you'll see there is a small window showing a colored box—half yellow, half green. You're in Draft Quality, which is the default setting and the one I use 90% of the time. However, by clicking on the box you can toggle among the video quality choices, or you can right-click to see a menu of the choices (Figure 15.22). Choosing Best Performance (worst quality) will turn the box yellow, and allow you to watch in real time, something that stuttered when played in Draft Quality. Best Performance doesn't look great, but if I want to see a complicated effect play in real time, that's the one I'll choose. If the effect looks good after watching it in Best Performance, then I'll render it.

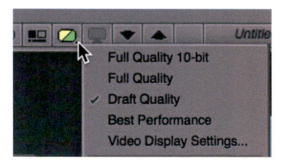

Figure 15.22

I use Full Quality when screening from the Timeline for a client, or to get feedback from colleagues and friends. In order for everything to play smoothly in Full Quality mode, I will need to render some complicated effects to make sure they don't stutter during the screening.

ADDING BLACK TO THE START, MIDDLE, AND END OF YOUR SEQUENCE

It's handy to be able to add a second of black to the beginning of your film so it doesn't begin too abruptly. You might also want to start with a title over black, and having fill (what Avid calls black) in the beginning makes it easy to do. You might also want to cut to black to have a dramatic pause in the middle of your film. What you want to do is Add Filler. So here's how it's done.

Go to the Timeline menu and select Add Filler. You'll select At Start or At Position (Figure 15.23).

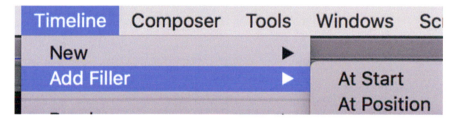

Figure 15.23

Wait!!!

There's a problem. Avid's default Add Fill is 30 seconds! You don't want 30 seconds added anywhere in your Timeline. So first go to the Settings tab, scroll down and choose Timeline Settings. There you'll click on the Edit tab and change 30 seconds to a more manageable 5 seconds, by typing in the Start Filler Duration Box (Figure 15.24).

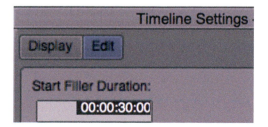

Figure 15.24

Usually I only want a second of Fill before my Sequence starts to fade in, so I'll go and mark an IN at the start and an OUT at 4 seconds and Extract. That way I'll have a second before my project fades in from black, as shown in Figure 15.25.

Mark and Extract
the excess Fill

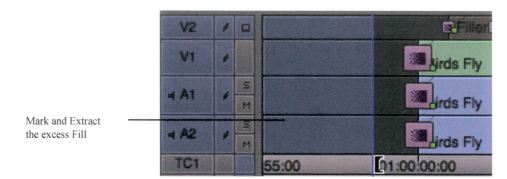

Figure 15.25

If you choose Add at Position, Media Composer will add Fill wherever you've parked the Position Indicator.

Adding black or Fill at the end of the Timeline is much more difficult. I don't know why Avid hasn't figured out that this would be handy to do easily, but here's the (awkward but only) way to do it. Concentrate.

1. Splice in a shot that contains sound at the very end of the Timeline, but deselect the V1 track and just splice in the audio, as shown in Figure 15.26.

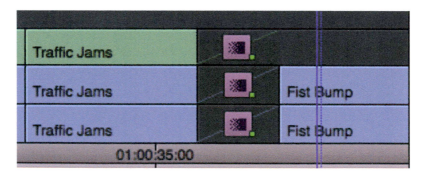

Figure 15.26

2. Now get the Audio Mixer Tool from the Tools menu and drag the audio on A1 and A2 all the way down to the bottom, as shown in Figure 15.27.

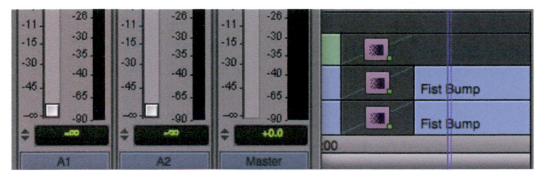

Figure 15.27

That's it. Now you have a sound clip that will act like fill. There's no picture and no sound. You can now trim it to the length you want.

POWER USER

We've really unleashed a nice collection of powerful editing techniques in this chapter. Don't worry—just practice each of these skills as much as possible as you continue to edit. Once you're comfortable with them, you'll find you use most of these during almost every editing session.

16

Beyond HD

UHD, 2K and 4K Projects

THINGS WE SHOULD UNDERSTAND

There's a lot to get our head around as we leave the now comfortable world of high definition and journey forth into ultra high definition, 4K, and beyond. In some cases, we're building on what we already know, but in others we're leaving things completely behind and starting fresh. Let's begin our journey by examining the ten distinct pieces of information that will help us travel through this new world.

1. Aspect Ratio

As we discussed in Chapter 8, aspect ratio measures the relationship between the width and height of a rectangle. You get the ratio by dividing the width by the height. Both HD and UHD share the same aspect ratio, which is called 1.78:1. This number is actually rounded up. The real number is 1.77777778:1, but that's a bit awkward. Because HD and UHD share the same aspect ratio, that means that the HD television you already own will be able to show the entire UHD picture, without any image cropping or stretching.

UHD 1.78:1 aspect ratio

We'll talk about the Digital Cinema Initiative (DCI) later in this chapter, but note that the native aspect ration is 1.9:1. Instead of 16x9, it's 17x9. Actually it's never screened in that aspect ratio. Instead the cinema aspect ratios for 2K and 4K projects are derived from motion picture film projection. The two most common aspect ratios, which have been used in movie theaters since the 1950s, are called *Flat* and *CinemaScope*. In general most dramatic films and comedies are projected in Flat—it's only slightly wider than UHD. Most science fiction films, war films,

and superhero movies are projected in Scope, which is much wider than UHD. Examine Figure 16.1 to compare the three.

Flat 1.85:1 aspect ratio
CinemaScope 2.39:1 aspect ratio

1.78:1	1.85:1	2.39:1

Figure 16.1 Aspect ratio comparison

2. Raster Size and Number of Pixels

Standard HD is 1920 pixels wide by 1080 pixels high. Its raster dimensions are 1920x1080. UHD is 3840 pixels wide by 2160 high. Its raster dimensions are 3840x2160. Note that UHDs pixel width and height is exactly twice HDs.

HD width 1920 x 2 = UHD width 3840
HD height 1080 x 2 = UHD height 2160

Yet taken together, UHD is four times larger than HD. Multiplying the number of pixels confirms this.

HD 1920 x 1080 = 2,073,600 pixels
UHD 3840 x 2160 = 8,294,400 pixels

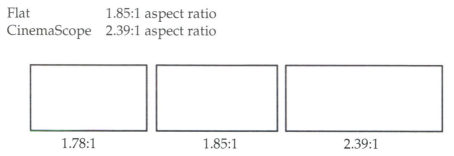

Figure 16.2 Avid's Raster Dimension and Color Space project settings for UHD.

The native raster for Digital Cinema (DCI) is 4096x2160. But the screening formats are either 1.85:1 or 2.39:1. The raster dimensions are different depending on if it's 2K or 4K.

2K Flat	1998x1080	1.85:1	2,073,600 pixels
2K Scope	2048x858	2.39:1	1,755,136 pixels
4K Flat	3996x2160	1.85:1	8,631,360 pixels
4K Scope	4096x1716	2.39:1	7,020,544 pixels

What you may notice is that 2K and 4K flat have more pixels than 2K and 4K Scope. That's because to get a wider aspect ratio, the horizontal image is cropped more.

3. Color Space

The *color space*, also know as the color *gamut*, is used to describe the range of colors a camera or recording device can capture. If you look at Figure 16.3, you'll see what is called the CIE 1931 XYZ graph. The year 1931 is when this graph was developed to try to describe the colors the human eye can perceive. Let's look at triangles that are drawn inside the CIE 1931 graph.

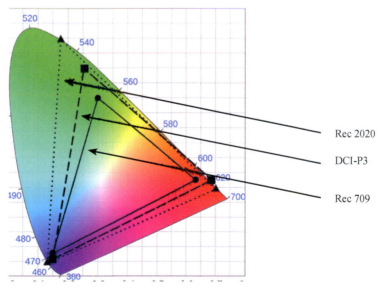

Figure 16.3

The inner triangle is Rec 709. It is the color space of all HD projects and today's UHD. Sometimes it's called YCbCr 709. You can see that it doesn't capture anywhere near all the colors the eye can see. The next triangle is the DCI-P3 color space. It is meant to better recreate the colors of motion picture film and it goes beyond what Rec 709 can achieve. The largest triangle, or widest gamut, is Rec 2020, which is the future color space for UHD television, but to date isn't in any current television broadcast or streaming service.

Unless you're working on a feature film that's intended for theatrical distribution, you'll be working in Rec 709. Even if you're working with cameras that can record a much larger color gamut than Rec 709, you're still stuck with Rec 709 in the end. Later in this chapter we'll learn how to prepare our projects for a theatrical release and how Rec 709 can be converted to DCI-P3. Keep in mind that if your camera can record more of the color gamut than Rec 709, go for it. Your colors will look better, even when turned into Rec 709.

4. Bit Depth

Bit depth describes how many color values a pixel can contain. Rec 709 is an 8 bit format. Each pixel contains 256 color values. Compare the different bit values:

8 bit	256 values
10 bit	1024 values
12 bit	4096 values
16 bit	65,546 values

HD television is an 8 bit format, but UHD can handle 10 bit.

If your camera records in 10 bit or 12 bit, by all means, bring it into Avid, which you can work at those bit depths. It's better to have more color information when editing, even when going out to HD. Working at a higher bit depth really comes into play when you are doing composite work in Avid, like green screens, when more color values makes a difference.

The 2K and 4K cinema formats offer 10 and 12 bit.

5. Color Sampling

To put this in the simplest terms, a color sampling that is 4:4:4 means all the luminance—the brightness and darkness of an image—and all the chroma information—the color—is sampled in full. Whereas color sampling of 4:2:2 means all the luminance is sampled, but a third of the color information is tossed out to

save space. The 4:2:0 color sampling tosses half the color information out. In Figure 16.4, compare the luminance and chroma between 4:2:2 and 4:2:0 with 4:4:4. Notice the luminance is fully sampled in all three. But in 4:2:0, only half the color information is kept.

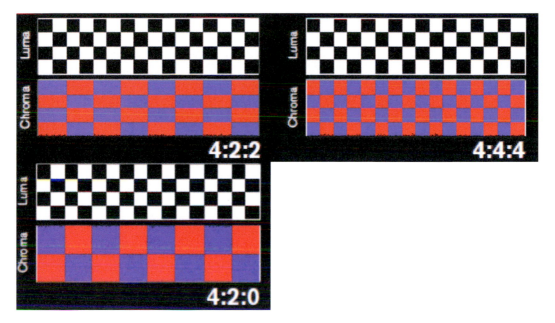

Figure 16.4

If any of the luminance were tossed out, the image would look terrible. But our eyes are much less sensitive to color, so you can take away some of the color information and no one really notices. Many of the films and popular TV shows you watch are shot and mastered in 4:4:4, even though HD television is a 4:2:0. That means you've been watching television and YouTube and Vimeo content with half the original color information missing—and I bet you never noticed.

Cinema style cameras, like the Arri Alexa XT or the Arri Amira, often have a choice of shooting in 4:2:2 or 4:4:4. A 4:4:4 color sampling will generate a digital file that it is about a third larger than 4:2:2. A number of popular 4K cameras, in the $3,000 to $6,000 price range, use 4:2:0 sampling (Figure 16.5). That's because UHD, like HD, is still distributed as 4:2:0. But when (and if) UHD televisions switch over to Rec 2020, it will have 4:4:4 sampling and you'll be amazed at how much richer and brighter the colors are.

Figure 16.5 A UHD camera from JVC that records 4K (picture courtesy of JVC).

6. Interlaced versus Progressive Scanning

In HD you have both Interlaced and Progressive scanning methods. You can choose 1080i or 1080p; with UHD and the 2K and 4K cinema formats there is only progressive. That's a good thing. Interlaced scanning is where the TV lines are not scanned one after another, but the odd lines are scanned first, and then the even lines are scanned. With progressive scanning, all the lines are scanned one after another. The progressive image looks more filmic, less like video. Interlaced causes many problems when motion effects are applied. Broadcast television (not cable or Direct TV) is still broadcast as interlaced.

7. Compression/Capture Methods

Knowing how the camera handles the image is worth knowing a bit about. Almost all digital cameras use a compression algorithm, often called a codec, to convert what the camera sees into a digital file. Codec stands for Compression/ Decompression. JPEG 2000, MPEG-2, Apple ProRes, Avid's DNxHD and H.264 are some best-known codecs. Probably the most common picture codec is H.264. It is also known as MPEG-4/H.264. A lot of the HD cameras you've shot with use this codec to create great looking images that aren't too large in file size. One compression trick H.264 uses is called *GOP*, which stands for *Group of Pictures*.

 Let's take a 15-frame clip. In GOP only the 1st and 15th frames contain all the image information. Frames 2–14 contain only the information that has changed from the frame before it. If you locked your camera on a tripod and filmed a teacher

standing at a podium in front of a whiteboard, not much changes frame to frame—really just the teacher's movements. So that would create a pretty small file.

There are some newer (high profile) versions of H.264 that don't use GOP. They record all the information contained in each frame. This is called *Intra-Frame* or *I-Frame*. I-Frame has many advantages over GOP. For one, it's easier on the editing software. Also, if one frame is damaged, all 15 aren't affected. Clearly, I-Frame recording creates files that are a lot larger than a GOP recording. The newer versions of H.264 are used by many of the UHD camera manufacturers to provide 4K images that are I-Frame, not GOP. If you do shoot with a GOP camera, when you Transcode the linked files in Avid, Avid fills in the missing information and turns GOP into I-Frame. That's one of the reasons transcoding can take a long time.

RAW is *not* a codec, but I mention it here as it's a very popular way of capturing high-quality images. Many of the large camera manufacturers have their own version of RAW (Figure 16.6). Not only is RAW not a codec, it's not even video. RAW records the luminance of every pixel, but not any of the color information. The color information is described as metadata, which refers to the image's color, brightness, white balance, and contrast. RAW looks pretty terrible. It is only during the color reconstruction process, when the colors are interpreted, using an algorithm, that the image looks as it should. The advantage of RAW is that none of the color information is baked in, so if the algorithm is ever improved, the image can be improved as well. Ten years from now, you're not locked in 2017 standards. RAW is considered future proof.

Figure 16.6 Red Digital Cinema cameras were among the first to record RAW files. This camera records in 6K (picture courtesy of Red Digital Cinema).

I've explained a lot about the picture codecs, but sound gets compressed into a digital file as well. Common audio codecs are AAC, mp3, and Linear PCM.

8. Wrapper

The thing that holds the digital file *and* the audio file is called a wrapper, or file container. QuickTime is a wrapper (.mov). It usually contains an H.264 image file and a AAC audio file. Adobe's .flv is a wrapper, as is mp4. AVCHD is a common wrapper used in many HD cameras. One of the most common wrappers in digital cinema formats is MXF. This is an abbreviation of Material eXchange Format.

9. Frames Per Second

This is important. Most digital cameras have a setting for those who want a cinematic look. It's 23.976 frames per second, also called 23.98. Now that 4K cameras are becoming commonplace, these cameras often have a 4K DCI setting, as well as UHD and HD settings. The frame per second rate for this 4K DCI choice is 24—not 23.976. The rate of 24 is only for a theatrical release to motion picture theaters that have DCI-approved motion picture digital projectors. You're much better off shooting in 4K UHD and then, if you get into Sundance, converting that to the Digital Cinema Initiative format.

Outside of the theatrical world, television is moving toward faster frame rates, and in the future, UHD television sets will deliver at higher than 30 frames per second. This isn't for slow motion. This is so that more picture information appears on the screen every second.

Lots of cameras now offer faster frame rates, but these higher frame rates are for slow motion and special motion looks, because those higher frame per second televisions are a few years away.

10. Data Rates

The amount of data being recorded and moved to the camera's storage card every second is called the data rate. It is most often described in terms of megabits per second, which is written as Mbps or Mb/s. HD cameras have data rates between 24Mb/s and 100Mb/s, depending on their compression method. UHD cameras start at 100Mb/s and go up to 240Mb/s and higher. Some of the cinema style cameras have data rates of 330 Mb/s when sampling color at 4:4:4, and at a color bit depth of 12. Still, you may have a camera set to record in 4K that has a lower data rate than an HD camera. The reason is because that particular 4K camera is recording in GOP and the HD camera is recording I-Frame.

CAMERA COMPARISON

My students find it helpful when I compare something they know about with something they want to know about. So let's look at the specifications we've been trying to get our heads around by comparing the very popular Canon C100 HD camera with an Arri Alexa XT camera. Note that the Arri Alexa is designed for use in HD, UHD, and digital cinema, so it has more choices.

CANON C100 HD

Aspect Ratio	1.78:1 (16x9)
Largest Raster Dimensions	1920 x 1080
Color Space	Rec 709
Color Bit	8
Color Sampling	4:2:0
Scanning	Progressive or Interlaced
Compression Method	MPEG-4/H.264
Wrapper	AVCHD
Frame Per Second	23.976, 29.97, 59.94, 25, 50
Long GOP or I-Frame	Long GOP
Data Rate	24Mb/s

12 minutes equals about 4 GB

Arri Alexa XT

Aspect Ratio	1.78:1 or Cinema 1.85:1 or 2.39:1
Largest Raster Dimension	5120 x 3200 (5K)
Color Space	Rec 709, DCI-P3 and Rec 2020 in RAW
Color Bit	10 and 12
Color Sampling	4:2:2 or 4:4:4
Scanning	Progressive
Compression Method	ArriRAW, LOG, Apple ProRes, Avid DNxHR
Wrapper	QuickTime, MXF
Frame Rates	23.976, 29.97, 59.94, 60 & VFR
Long GOP or I-Frame	I-Frame
Data Rate	330 Mb/s (at 4:4:4)

12 minutes equals about 160 GB

Notice the difference in data rates and therefore how many GB are used in 12 minutes of recording: 4 GB for HD and 160 GB for UHD or digital cinema. These are rough averages, used to give you a sense of size differential. What should be

clear is that when you record I-Frame and not GOP, your file size increases; when you sample colors at 4:4:4 instead of 4:2:0, your file size increases; when you record 10 or 12 bit color, instead of 8 bit, your file size increases.

OUR AVID STRATEGY AND WORKFLOW

Because the camera files we will be linking to are so large, we need a new strategy to handle these large files. The workflow we employed in Chapter 8 isn't going to work. However, we'll start off doing exactly what we did in Chapter 8. We are going to back up our camera card onto our external drive, calling the folder we place the back-up card CARD_001. Then we're going to use the Source Browser to Link to this CARD_001 folder, and work our way through that camera system's hierarchy, until all the linked clips come into a bin. Let's pretend our short film is made up of 20 shots on the camera card, all at UHD 4K. So 20 linked clips come into the bin.

Now we'll do some things a bit differently. Here's the plan:

1. We will transcode the 20 linked clips that are in the bin to a lower resolution, and create what is often called proxy files. If we have 20 linked clips in the bin, we'll have 20 .new clips at this lower resolution. We'll have 20 proxies.
2. We'll place those 20 .new clips in a new/different bin.
3. We'll edit these 20 clips at this lower resolution. We'll have no stuttering or balky editing because we're editing low-resolution images.
4. Once we're through editing and have our final low-resolution sequence, we'll relink this sequence to our 20 original, 4K clips. Avid will create a new sequence that is at our original 4K resolution. Now we can color correct, bring in the final sound mix and export at various resolutions and formats, depending on what our distribution needs are, now and in the future.

Sounds like a plan.

WORKING IN UHD

1. Let's start by creating a UHD project that was shot using the 4K JVC camera called a JVC GY-LS300. We'll call the project "Soft Shadows." As you can see from Figure 16.7, after Launching Avid and selecting New Project, in the New Project window I have selected my format as UHD 23.976, and having done that Avid selects the correct Raster Dimensions and Color Space. These are correct.

Figure 16.7

2. Now I want to link to the camera card CARD_001 that I've copied onto this project's external drive. So I go to File > Input > Source Browser (Figure 16.8).

Figure 16.8

3. When the Source Browser opens, I navigate to the CARD_001 folder and press the Link button. If it's greyed out I navigate further into the folder hierarchy until it is clickable (Figure 16.9).

Figure 16.9

4. The clips on the card are linked and brought into the open bin, which is named for the project (Figure 16.10). I rename the bin CARD_001 Linked Clips.

		Name	Duration	Drive
	230G0029	14:00	Sam's GDrive	
	230G0028	8:00	Sam's GDrive	
	230G0027	12:00	Sam's GDrive	

Figure 16.10

I can play these clips, but because they are large 4K files, they won't play smoothly at all. I've edited together a few clips in the Timeline and hit Play. Avid can't play these high-resolution clips smoothly, and it let's you know it's having trouble by displaying yellow and red alerts on the Timecode track in the Timeline. Look at Figure 16.11 to see all the distress signals Avid is sending.

230G0028	230G0027	230G0029
00:00	01:00:02:00 01:00:04:00	01:00:06:00

Figure 16.11

Even changing the Video Quality icon, as we learned at the end of Chapter 15, doesn't help much. Clearly, we can't edit like this. It's impossible. So now we will create proxies at a lower resolution by transcoding these linked clips.

5. Before we get started, let's admit that transcoding can be a time-consuming process. So a lot of editors go through the camera reports taken during the shoot to determine which clips are worth transcoding and which clips are bad takes, or out-of focus, or poor acting, etc. This step was done

all the time on feature films shot in 35mm film. Good takes were circled, and then only the circled takes would be printed to make a positive print from the negative. Film was really expensive, so why print five bad takes out of the eight takes if only takes six, seven, and eight are any good. Why spend hours transcoding bad takes that you'll never use? If there are camera reports that tell you which takes are good and which are bad, make use of them. Place only the linked clips you want in a bin called CARD_001 Linked Selects. If you don't know which takes are better, then you'll just have to transcode everything.

6. Now we are ready to transcode our linked clips. Select all the linked clips in the Bin and go to the Clip menu and scroll down until you see Consolidate/Transcode. When the window opens, click on the Transcode button. Select your external drive. Now here's where we make the low-resolution proxies.

7. Click on the Target Video Resolution pull-down menu and choose DNxHR LB MXF. LB stands for Low Bandwidth. It compresses the clips into a much smaller file size that looks pretty good (Figure 16.12).

Figure 16.12

8. In Linked Source Scaling Quality, you can choose either Full or Half (Figure 16.13). If you have a pretty robust computer, choose Full, if it's not, select Half. You could try transcoding one clip at Full and seeing how it plays. If it plays well, then use Full. If not, choose Half. Half looks pretty good too.

Figure 16.13

9. Now press the Transcode button at the bottom of the window (Figure 16.14).

	Name	Take	Format	Video
	230G0028.new.01		3840x2160p/23.976	DNxHR LB
	230G0027.new.01		3840x2160p/23.976	DNxHR LB
	230G0029.new.01		3840x2160p/23.976	DNxHR LB
	230G0029		3840x2160p/23.976	H.264
	230G0028		3840x2160p/23.976	H.264
	230G0027		3840x2160p/23.976	H.264

Figure 16.14

When the clips have been transcoded, you'll see that the video has been turned into master clips with the .new suffix. At this point place these .new clips in a Bin; call the bin CARD_001 DNxHR.

USING SOURCE BROWSER TO CHOOSE THE CLIPS

Instead of bringing in all the contents of a camera's card into your bin when you press Link, as we did in Step 3, the Source Browser let's you look at the clips in its media display area. Click on the Frame View button and navigate to the folder containing the clips. Some media won't display as individual clips, but lots will. In Figure 16.15, I have navigated in the Source Browser until I've reached the DMF folder that displays the clips as frames. In the media display area, I can actually play the clips and determine if any are unusable and not worth keeping. Once I determine the ones I want, I can drag them into my bin and leave the no-good takes behind.

Figure 16.15

BEGIN EDITING YOUR UHD PROJECT

Once you've transcoded the clips, you are free to edit your project as you normally would. You'll find that the clips in the Timeline play nicely. You can rename the clips, add dialog, music, sound effects and do everything you'll need to do—except make titles. As explained in Chapter 12, the regular Avid title tool doesn't work in UHD and larger projects. You need to use Avid's NewBlue Titler Pro tool, which we examined in Chapter 12.

At the end of the chapter, I'll explain how to relink to your original, high-resolution clips after editing the proxies. But first, let's go through the steps for a 2K and 4K cinema project.

Working in a DCI 2K Cinema Format

If we wanted to create a 2K DCI Cinema Format, chances are our workflow would be identical to our HD workflow. The difference between the file sizes is quite small and if your computer played DNxHD without a problem, it would play the DNxHR without a problem. However, if you find that your computer stutters and working in 2K is a problem, follow the 4K workflow outlined next.

Working in a DCI 4K Cinema Format

For this demonstration we'll go through the steps to create a project that is intended to be projected as a 4K cinema Flat project with an aspect ratio of 1.85:1, and not as a 1.78:1 UHD project.

When we click on the New Project button, and the New Project window opens, we'll click on the Project Format pull-down menu and select 4K DCI Flat 3996x2160 (Figure 16.16).

Figure 16.16

Once we do, we'll see that Avid has selected for us the specifications shown in Figure 16.17.

Figure 16.17

One very popular camera for shooting cinema projects is a RED camera, made by Red Digital Cinema (see Figure 16.6). That's the camera we're using for this demonstration.

PLUG-INS

From Chapter 8 we know how to get a plug-in that works for a RED digital camera. We can also check to see if one was installed when we downloaded our Avid Media Composer from the Avid website. Go to the Project window and look for the Info tab (Figure 16.18). Click on it and scroll down to see which plug-ins you have (Figure 16.19).

Figure 16.18

Figure 16.19

LINK TO THE RED CAMERA CARD

Once out 4K DCI project opens, we first follow the same steps we've done before to link to the clips.

1. File > Input > Source Browser.
2. In the Source Browser, navigate to the external drive holding the backed up RED camera card.
3. When you find the RED Camera folder, double-click to get to the level above the Red media. In this case it's the folder I created called Card_001. Inside are all the Red media and metadata (Figure 16.20).

Name

▼ 📁 **Card_001**
 📄 **102-7D9-EB4_log.txt**
 ▶ 📁 **A048_0531QL.RDM**
 📄 **digital_magazine.bin**
 📄 **digital_magdynamic.bin**

Figure 16.20

4. Click on the Card 001 folder and click Link (Figure 16.21). All the clips will open in your bin.

Name	Video	Duration
A048_C001_0531CG	RedCode RAW	21:11
A048_C002_0531MH	RedCode RAW	23:13
A048_C003_0531SK	RedCode RAW	24:04
A048_C004_0531ES	RedCode RAW	8:08
A048_C005_0531DK	RedCode RAW	47:17

Figure 16.21

5. Using the camera report or field notes, select which files you want to transcode and which ones you don't. Here I've gone through and named the clips that I want to transcode.

	Name	Video	Duration
	Sc 1 Tk 3	RedCode RAW	1:52:06
	Sc 1 Tk 2	RedCode RAW	2:27:08
	Sc 1 Tk 1	RedCode RAW	1:10:01

Figure 16.22

6. Select all the linked clips in the Bin and go to the Clip menu and scroll down until you see Consolidate/Transcode. When the window opens, click on the Transcode button. Select your external drive.
7. Click on the Target Video Resolution pull-down DNxHR LB MXF. In the Linked Source Scaling Quality select Full or Half, depending on your computer's power (Figure 16.23).

Target Video Resolution:	DNxHR LB MXF	▼
Linked Source Scaling/Quality:	Full	▼

Figure 16.23

8. Now press the Transcode button at the bottom of the Consolidate/Transcode window.

	* Linked Selects	✕
	Name	Video
	Sc 1 Tk 3.new.01	DNxHR LB
	Sc 1 Tk 1.new.01	DNxHR LB
	Sc 1 Tk 2.new.01	DNxHR LB
	Sc 1 Tk 3	RedCode RAW
	Sc 1 Tk 2	RedCode RAW
	Sc 1 Tk 1	RedCode RAW

Figure 16.24

9. Notice in Figure 16.24, the relationship between the linked clips and the transcoded clips. The linked clips are still RedCode RAW, whereas the transcoded clips are at a much lower resolution. Now I'll move these DNxHR LB proxy clips into a bin and start editing my project as I would any other project—creating a sequence, adding audio, music, sound effects, etc.

This process is the same no matter which cinema camera you used. If you shot with an Arri Alexa (Figure 16.25) or Amira in ArriRAW, or with a Sony PMW F55 camera in Sony's XAVC-I, the files would be so big that you'd need to create low-resolution proxies by following the steps we just outlined.

Figure 16.25 An Arri Alexa (photo courtesy of Arriflex)

SOME ORGANIZATIONAL PROCEDURES

Before I do my selects and transcode and start the process of changing the camera's file's name—from something like A048_C004_0531ES to a more helpful name, like Sc 1 Tk1—I take the precaution of making a copy of those camera file names in the bin so if for any reason I need to go back and find that specific camera file, I can. Here's how to do this.

1. If you recall in Chapter 5, we brought a column into My View called Take. When we did, I mentioned we'd use this column in Chapter 16. If you didn't bring in a Take column, you may do so now, by going to the Bin Fast Menu and selecting Choose Columns and selecting Take (Figure 16.26).

Figure 16.26

2. Click and drag the Take column heading so it's next to the Name column.
3. Click on the Name column and type Command/Ctrl-D. This copies the clips' names.
4. A Choose Column dialog box will open. Scroll down and click on Take. This pastes the clips' names to the Take column, as shown in Figure 16. 27.

	Name	Take	Tracks
	A048_C036_0531U7	A048_C036_0531U7	V1
	A048_C035_0531GT	A048_C035_0531GT	V1

Figure 16.27

Now I can go ahead and name my clips, make my selects, and then Transcode them (Figure 16.28).

	Name	Take	Raster Dimension	Project	Video	Duration
	Sc 1 Tk 1	A048_C036_0531U7	3840x2160p	Red Cinema Project	RedCode RAW	1:42:17
	Sc 1 Tk 2	A048_C035_0531GT	3840x2160p	Red Cinema Project	RedCode RAW	2:27:08
	Sc 1 Tk3	A048_C034_05312X	3840x2160p	Red Cinema Project	RedCode RAW	1:52:06
	Sc 1A Tk 1	A048_C033_0531P2	3840x2160p	Red Cinema Project	RedCode RAW	1:10:01
	Sc 1A Tk 2	A048_C032_05315F	3840x2160p	Red Cinema Project	RedCode RAW	39:16

Figure 16.28

I put the files in the Take column, because I knew it was empty. I could have put it in some other empty column, or in a column I created.

BEGIN EDITING YOUR 4K CINEMA PROJECT

Now you are free to edit your project as you normally would. You'll find that the clips in the Timeline play nicely. You can rename the clips, add dialog, music,

sound effects, and do everything you'll need to do—except make titles. As explained in Chapter 12, the regular Avid title tool doesn't work in UHD, 2K, and 4K projects. You need to use Avid's NewBlue Titler Pro tool, which we examined in Chapter 12.

At the end of the chapter, I'll explain how to relink to your original, 4K clips. But first, let's learn about the how and why of the Digital Cinema Initiative.

BACKGROUND ON THE DIGITAL CINEMA INITIATIVE AND DIGITAL CINEMA PACKAGE

Back in 2002, the six largest Hollywood studios were beginning to think about the transition from distributing films to theaters as 35-mm motion picture reels to a system of sending digital files to those theaters. Those six studios formed what is known as the Digital Cinema Initiative, which created standards for encoding and encrypting sound and picture. By 2012, Sony and other companies were selling thousand of digital projectors to theaters around the world. Today the transition from theaters that project motion picture film to theaters that project digital files is complete.

What does a theater get instead of reels of motion picture film? They get what's called a Digital Cinema Package (DCP). A DCP is a series of sound, picture, and cataloging files that meet the DCI standards. The DCPs made by the big studios are placed on a CRU DX11 hard drive with sophisticated encryption, like the ones shipped to your local cineplex. Many post-production facilities outside the studio system can convert your Avid exported file to a DCP using software designed for the conversion. If you're film is 12 minutes in length, they may put it on a thumb drive. For longer films, it's usually an external drive, like a LaCie rugged drive. As a student or independent filmmaker, you'll want the DCP so you can screen your film at the larger festivals, like Sundance, which require them.

If your work in HD rather than DCI 4K or 2K, you can also get a DCP. Just take your Avid project, export it to something like ProRes 422, and then have one of the post-production companies in your area turn it into a DCP. There are a couple in Boston that do it relatively inexpensively. The process isn't that complicated. The 1.78:1 HD aspect ratio is nearly identical to the 1.85:1 DCI aspect ratio, so there is just a miniscule amount of cropping on the top and bottom. You'll lose just 2% of your image. The color will be shifted slightly to conform to DCI-P3 color, and the frame-per-second rate of 23.976 will be sped up to 24 frames-per-second. The difference is tiny, just one-tenth of 1%, so no one will be able to tell.

What is tricky is finding a projector to view it on, as the projectors in most schools and auditoriums are different than the projectors used at movie theaters.

FULL APERTURE

On Avid's 2K and 4K Project Format settings there are two choices that I haven't mentioned. These are interesting choices. Let's look at their aspect ratio and raster dimension.

2K Full Aperture	2048x1556	1.3:1 aspect ratio
4K Full Aperture	4096x3112	1.3:1 aspect ratio

Here you have a lot of extra pixels and image on the vertical side to use to improve your composition. If you had a 2K or 4K camera with either of these as format settings, you would use a viewfinder when shooting that had markings which showed 1.78, 1.85 or 2.39. Then, during editing, you could choose which part of the image you wanted to select, using Avid's FlexFile. You could reframe your shot, getting precise composition and turning your image into a 1.78:1, 1.85:1 or 2.39:1 project.

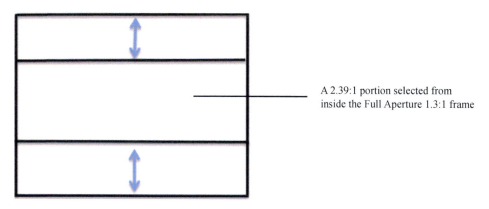

A 2.39:1 portion selected from inside the Full Aperture 1.3:1 frame

Figure 16.29

In Figure 16.29 you see that if you were shooting in a scope format, you'd have the most room to recompose your shot within the frame. Just drag the 2.39 box up or down to use the nicest part of the image. The camera operator, when shooting for you, would have the 2.39:1 lines on his viewfinder, so would do her or his best to compose the shot properly, but any errors would be easy to fix. If an actor's head popped out of the frame, just move the frame lines up to recompose the shot.

5K AND HIGHER

Lots of cinema style cameras have higher than 4K settings. The idea is similar to full aperture. The frame size is larger, so you can recompose the shot in Avid without compromising image quality. Needless to say a lot of cinematographers don't like this sort of recomposing after shooting. They feel as though they should determine the composition during production, and not be overruled by an editor in the editing suite.

In the next chapter, we'll learn about advanced effects and Avid's *FlexFrame* tool. That's the tool which gives the editor the ability to change the compositional framing of the image during post-production. Cinematographers don't love it, but everyone else does.

RELINKING TO YOUR UHD, 4K, AND HIGHER CLIPS

Once you have edited together all the clips in your proxy sequence, the one that you transcoded to DNxHR LB, let's now relink to the original clips that are 4K and then apply the finishing touches prior to outputting the project.

1. Duplicate your final proxy sequence, rename it Final Cut Proxy Sequence and place it in a new Bin called "Relinked Sequence" (Figure 16.30).

Figure 16.30

2. Now click on the Sequence to select it and make the Bin active.
3. Go to the Clip Menu and select Relink . . .
4. The Relink window will open. It's a large window with several sections. We'll start at the top (Figure 16.31). These are the default settings and should work if you've followed the instructions in this chapter. All Available Drives is often best, as Avid will figure out where things are stored.
5. Video Parameters: the middle section of the window (Figure 16.32) specifies what video format you want to relink to and which Quality you want when relinking.

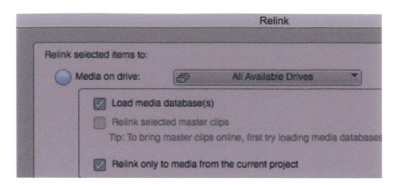

Figure 16.31

Figure 16.32

In the "Relink to" pull-down menu it seems obvious that you would want the video format of the current project. But there may be times in the future when you're working on more advanced projects that you may change the project format from the one you started working on to some other format, and then you'd want Any video format. In fact Avid recommends starting with Any video format, so try that first.

The Highest Quality is definitely the right choice for us, as we want to be relinked to the original clips, and only this choice will get us there.

6. The bottom section of the Relink window lets you choose which tracks you want to link to. Most of the time you'll want just the Video, because the audio files were either imported separately, or are of the same resolution. You definitely want the Create new sequence checked (Figure 16.33).

Figure 16.33

7. Click OK. Soon a new Sequence will appear in the bin. It will be called by the same sequence name, Final Cut Proxy Relinked. Click on it and rename it Final Cut Hi Res (Figure 16.34).

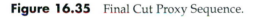

Figure 16.34

8. Now double-click on the Final Cut Hi Res sequence and you'll see that the clips in the Timeline don't have the names you gave them. Instead they have the camera file names of the original linked clips. Compare Figure 16.35, which is the Proxy sequence, with Figure 16.36, which is the Relinked Hi Res sequence.

Figure 16.35 Final Cut Proxy Sequence.

Figure 16.36 Final Cut Hi Res Relinked Sequence.

THE NEXT STEPS

If you're editing a major project, you probably wouldn't want to relink your clips now. Instead, you'd wait until you'd read through the remaining chapters. A lot of what comes next focuses on finishing the project and getting it out into the world.

We'll be discussing some advanced effects that can enhance the look of your project, or cover up big mistakes. We'll delve into the world of FlexFrame, LUTs, and color correction. Much of this work is usually done before you relink to your hi-res clips.

On the other hand, I suggest you put off doing that major project and instead try practicing the steps outlined in this chapter on a smaller project or exercise. Try linking, transcoding, editing, and relinking a small project of 15–20 clips. Then you'll be more knowledgeable and confident when you work on your major project.

17

Advanced Effects and FrameFlex

There are so many great effects inside the Effect Palette that it's hard to choose which ones to feature in this chapter. I've picked several of the ones my students and I greatly appreciate, mostly because they allow us to hide our mistakes. Also, if you master these, you can figure out how to use the hundreds of other effects on your own.

THE PAINT EFFECT

There are innumerable ways that you can use this effect, but we'll explore a couple of the most useful ones.

Obstruction

Say you interviewed a man who doesn't want to be identified on camera. You promised to disguise his features so that even his mother wouldn't recognize him. The steps are fairly simple.

1. From the Effect Palette, drag the Paint Effect (Image category) on top of the clip in the Timeline. With the position indicator on the clip, click on the Effect Mode button to open the Effect Editor (for this example, you can just use one of the clips of Dan from in *Where's the Bloody Money?*) (Figure 17.1).
2. In the Effect Editor, select one of the drawing tools along the right side (Oval, Rectangle, Polygon or Free Form tool—don't use Brush, as it behaves a little differently). Usually, the most useful one is the Polygon tool, as it

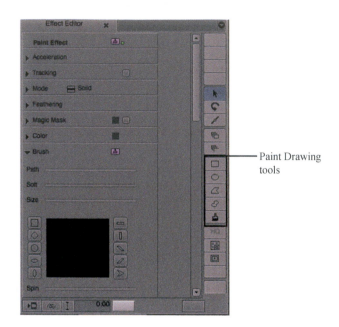

Paint Drawing tools

Figure 17.1

allows you to draw custom shapes with either straight edges or curves. The Polygon tool is also the only one that really needs any explanation:

- To draw straight edges, click with the mouse, and then release—and then move the mouse to another location, and click and release. This will produce straight lines with corners. You must then close the shape.
- To draw curves, click with the mouse—and without releasing—drag in the direction of your next point, and then release. Then, move the mouse, and click, drag, and release (Figure 17.2).

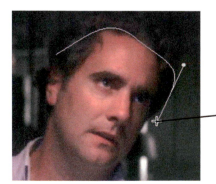

Drawing a shape with the Polygon tool

Figure 17.2

3. When you close your shape, each of the points you drew has Bezier handles, which you can access if you double-click in the shape. Then, simply click on a point, and the Bezier handles appear. You can move these around to manipulate your shape further (Figure 17.3).

Figure 17.3

4. The mode you are in by default is called Solid, which you'll almost never use. In the Mode pull-down menu (Figure 17.4), choose another: Mosaic or Blur. Here, we've chosen Mosaic.

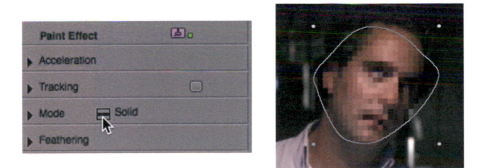

Figure 17.4

5. Okay, so his mother still might be able to recognize him. But not for long— just click on the shape, and adjust the Horizontal and Vertical parameters within the Mosaic Mode, and then open the Feathering parameter category. Adjust the Horizontal, Vertical and Bias sliders (Figure 17.5) so the shape blends nicely with the background.

Figure 17.5

If you find that the person moves outside of the shape, you can place keyframes and move the shape to keep it positioned properly throughout the duration of the effect. You can also use a very powerful tool called Tracking to automatically move the shape in conjunction with the video. We'll examine that after we learn Clone.

Clone

Clone is also one of the options within the Mode menu inside Paint. It gives you the ability to clone (or copy) any part of your frame and place it somewhere else in the frame.

Let's say you have a boom microphone, covered with a large windscreen, suddenly appear in your shot, as in Figure 17.6. Yikes! The sound recordist thought her microphone was out of frame and the camera operator and I missed it as we concentrated on the actor movement. Unfortunately it appears in all three takes! Not to worry; Clone comes to the rescue.

Figure 17.6

Using the techniques we learned above, apply the Paint Effect to the problem clip in the Timeline. Open the Effect Editor and use one of the drawing tools (like the Polygon tool) to draw a shape that covers the offending part of the frame, as shown in the left-hand image in Figure 17.7.

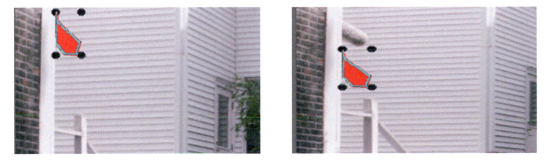

Figure 17.7

Now, drag the Paint shape to an area of the frame that looks identical to the one the microphone is over—here the white wooden siding—as I've done in the right-hand image in Figure 17.7.

Next, go to the Mode pull-down menu that says Solid, and go down the list and select Clone. As you can see in Figure 17.8, I have cloned the white wooden siding.

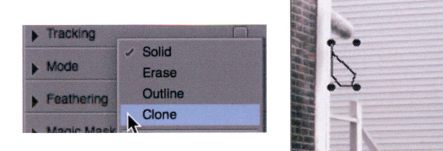

Figure 17.8

Now I simply drag the cloned shape back on top of the microphone and when I release it the microphone disappears (Figure 17.9)! If it needs tweaking, you can adjust the Feathering parameters to better blend it into the background.

Figure 17.9

These screen captures are from a film I directed called *Rachel Descending*. They show how Clone saved me and my film crew from a lot of embarrassment—and additional time and expense. Thanks to these easy-to-execute steps, we didn't have to reshoot this important scene.

MOTION TRACKING

Many effects involve movement or combine two elements that would work better if their movements were linked together. The microphone that appears like an unwanted guest, which we just painted away, didn't have a lot of motion. It was fairly static in the shot so it was easy to obscure.

So let's take a shot where the thing we want to cover up is moving quite a bit. To show you what I mean, I've taken one of the clips from the Documentary Practice project called "Traffic into the city," and combined the Paint Effect with *motion tracking*. The purpose of motion tracking in this example is to tie the Paint Effect to the moving object.

Let's imagine we want to hide the word "Taxi" so no one knows what the word says. Pretend it's a company logo and we don't have the rights to show it, but the action on screen is so important that we decide to use the shot anyway. But so we don't get sued, we want to obscure the word "Taxi." The problem is, the taxi is driving and so the word we're trying to hide is always in motion.

I drag the Paint Effect onto the clip in the Timeline and then I open the Effect Editor and, using the Paint polygon tool, I draw a box that fits around the word "Taxi" (Figure 17.10).

Figure 17.10

When the polygon tool turns Red, instead of choosing Mosaic, which I employed to hide Dan's face in the beginning of the chapter, I'll use the Blur effect in the Paint tool.

Figure 17.11

I can change the size and shape of the Blur by dragging on the handles.

I can go to the Feathering Tool in the Paint Effect to make the shape less distinct. When I'm happy with it, I hit play, and see that the taxi drives off and the blur is no longer obscuring the word "Taxi." I need the Tracking tool. I find it inside the Paint Effect and click on it.

Tracking tool

Figure 17.12

Three things happen. A Tracking window opens, a yellow box inside another yellow box appears on my image and the Blur effect is removed (Figure 17.13).

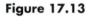
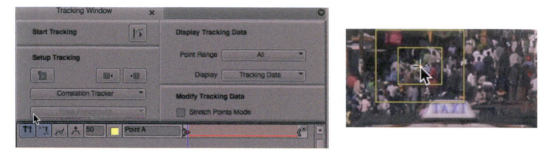

Figure 17.13

I click and drag the yellow boxes to a point on the taxi that has a lot of contrast. I tried putting it on the edge of the word "Taxi," but it didn't track very well, so I moved the box to the edge of the taxi where the window and the white siding meet, as shown in 17.14.

Once on that spot, I dragged the corner of the inner yellow box to make it smaller to better show the tracker the exact spot to track, and the outer yellow box I made a little smaller to show what area to track (Figure 17.14).

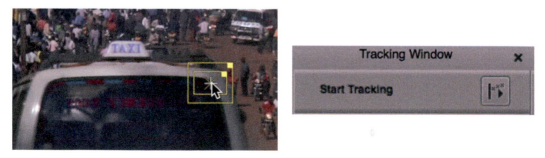

Figure 17.14

Now I go to the Tracking window and pressed the Start Tracking button. The Tracker follows the movement of the taxi as it drives away, as shown by the yellow path in Figure 17.15.

Figure 17.15

Now to see how it plays, I leave the Tracking window and go back to the Paint Effect. There I click on the Tracking disclosure triangle and then I click on the No Tracker pull-down menu to select T1 Point A.

Figure 17.16

Now I hit the Play button and watch the blur track along. It works fairly well, but about halfway through it loses contact with the taxi sign. No worries. In the Tracker window I select Effect Results from the Display menu (Figure 17.17).

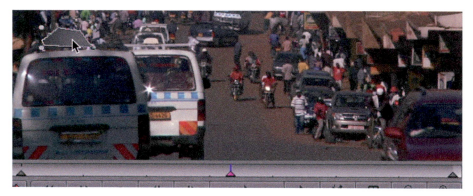

Figure 17.17

This allows me to click on the blur effect and drag it to a better position. When I do that, a new keyframe is added (Figure 17.18). I then click on the last keyframe, so it's highlighted, and drag the blur to cover the taxi sign at its final position. Using keyframes I can also change the size of the blur so that it gets smaller as the taxi moves further away.

Figure 17.18

The tracker sometimes needs help and, by adding keyframes manually, I can make the job look perfect. Keep in mind you can track multiple things in the same clip using up to four trackers.

The Motion Tracking tool isn't a stand-alone effect. Instead, it's found inside most effects, as in this example.

PICTURE-IN-PICTURE (PIP)

As you remember from Chapter 11, the Picture-in-Picture effect (or PIP) lets you manipulate some basic characteristics about an image (border, scaling, position, cropping, etc.). As we mentioned then, its primary purpose is not to just manipulate

one video layer, but to allow you to see *two or more* images on the screen at the same time. You can use it to perform any number of image juxtapositions—like creating a split-screen or combining credits with a picture. This combining of effects vertically is called stacking, or compositing.

To get set up for applying a PIP, place a foreground image on V2, just like we did in Chapter 11 when we worked with superimpositions. Once set up, from the Effect Palette drag the PIP effect from the Blend category to the clip on V2. In Figure 17.19, I've edited the "Taxi Conductor" on top of "Inside the Traffic."

		Taxi Condu		
ople	Fist Bump	Inside the Trafic		Traffic Jam
ople	Fist Bump	Inside the Trafic		Traffic Jam
ople	Fist Bump	Inside the Trafic		Traffic Jam
		01:00:30:00		

Figure 17.19

You will see a box containing the foreground image on top of the background image (Figure 17.20).

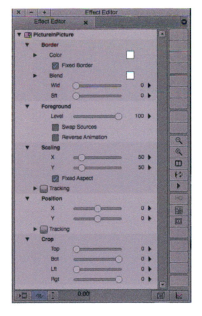

Figure 17.20

Open the Effect Editor to see the various parameters available to you. You'll need to click the disclosure triangles to open hidden parameters within each of the categories. Refer to Chapter 11 if you need descriptions of what each of these parameters can do.

Notice that by default, the effect contains no keyframes (Figure 17.21), so if you want to affect change over time, you'll need to add keyframes at your desired points of change.

Figure 17.21

At the very least, it's generally a good idea to add a keyframe at the very beginning and at the very end of the effect, so that Media Composer doesn't add a random stray keyframe in the middle of the effect when you try to make a parameter change. If you want to start off by affecting the entire effect (which, in this case, we do), Shift-click each keyframe so that they are both selected (Figure 17.22).

Add (and then select) keyframes at the beginning and end of the effect to have a better experience

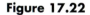

Figure 17.22

For this adjustment, we'll apply a border to the image, and then rescale and reposition it so that it is located in the upper-left corner.

First, click and drag the Width slider (Wid) to the right to get a border around the image. Then, check the box called Fixed Border so that the border is solid, rather than exhibiting a color gradient. Then, you can change its color, either with the sliders, the Color Wheel, or the dropper, which is accessible by clicking in the color box (Figure 17.23).

Double-click in the color box to access the Color Wheel.

Figure 17.23

Next, make adjustments within the Scaling and Position categories to size and position the image to your liking. Remember, to make a uniform change during the duration of the effect, you need to make sure that both the keyframes are selected. In Figure 17.24, we've added a purple border and rescaled and repositioned the image on V2 to be in the upper-left corner.

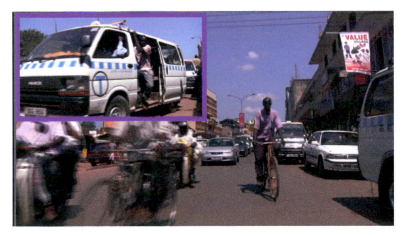

Figure 17.24

Now, let's create a change over time. We'll fade the image up slowly as the conductor climbs into the taxi, then keep him on screen while he's closing the door, and then slowly fade down the image as he shuts the door. To do this, you'll need to add two more keyframes—one about 1/4 of the way through the effect, and the other about 3/4 of the way through the effect. Then, click on the first keyframe, and bring the Foreground level within the Effect Editor down to "0." Click on the last keyframe, and do the same. When you play through the effect, your fades should be in place.

One handy trick involves copying and pasting parameter settings. Take the Foreground example just described. To quickly copy the values from the first keyframe to the last keyframe, you can click on the first keyframe after you've made the change, and press Command-C (Mac) or Ctrl-C (Windows)—as in Copy. Then, click on the last keyframe and Command-V or Ctrl-V—as in Paste—to set those attributes to the end. This is a fast way to copy all parameter values from one keyframe to another.

Here's another example. I have a PIP on V2 but now I'm adding a PIP to V1, so I have PIPs on both tracks. By deselecting Track V2, I can open the Effect Editor for V1 and basically recreate the same colored border to the "Inside the Traffic" clip on V1 (Figure 17.25). Then I move the shot to the lower right and now I have a nice split screen effect (Figure 17.26).

		Taxi Conduct Br		
	Fist Bump	Inside the T Sic		Traffic Jam

Figure 17.25

Figure 17.26

Go ahead and explore all the parameters to your satisfaction. Then, when you're done, let's look at a more complex, but more accurate way to work with effects. Those of you who have used After Effects will find this approach quite familiar.

Advanced Keyframes

Prepare a new PIP effect in the same way we just did—edit one shot above another (V2 atop V1), and apply the PIP effect to V2. With track V2 selected, place the position indicator on the clip in the Timeline and open the Effect Editor. Now go to the bottom right-hand side of the Effect Editor and click on the Show Keyframe Graphs button as shown in Figure 17.27. Now your effect is set to use *Advanced Keyframes*.

Figure 17.27

The Effect Editor expands to show a row attached to each parameter, as shown in Figure 17.28. This might look a little intimidating, but let's take it slow, and examine one parameter at a time.

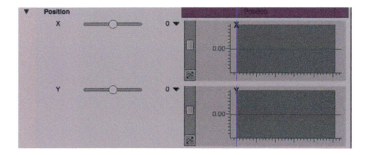

Figure 17.28

Let's first examine the Position parameter. Click on the disclosure triangle to open up the X- and Y-axis controls, and then open up each of the graphs by clicking on the disclosure triangles for each, as shown in Figure 17.29.

Figure 17.29

The X-axis allows you to move the image horizontally, and the Y-axis allows you to move the image vertically. You can precisely change the placement of the image in the frame by dragging keyframes up and down the axis.

First, however, you need to add keyframes to the parameters. To add keyframes, you can right-click in the graph and select Add Keyframe (Figure 17.30).

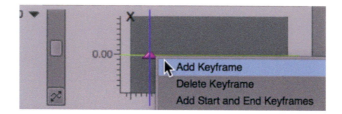

Figure 17.30

Even better, you can click on the Add Keyframe button at the bottom of the Advanced Keyframes interface. If you do this, a menu will pop up that lets you control where the keyframe will go. Examine the choices in Figure 17.31.

Click on the Add
Keyframe button

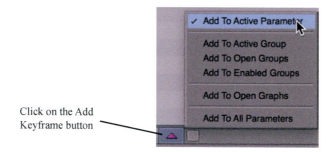

Figure 17.31

Depending on which option you choose, you can add keyframes to specific parameters, groups, or graphs. In this case, Add to Active Parameter will only add a keyframe to the parameter my cursor is on. Add to Open Graphs will add to both the X- and Y-axis, since those are the two open graphs.

Go ahead and add several keyframes, and begin manipulating the position values, making sure to see how these changes are reflected visually in the Effect Preview monitor. Once you're happy with the image's movement, you can close the disclosure triangle and open another set of parameters and adjust those.

As you can see, the advantage of Advanced Keyframes is that it enables you to fine-tune one parameter at a time without affecting the other parameters. This is a very handy feature, especially as your effects continue to become more complex.

RENDERING MULTIPLE EFFECTS

In Chapter 11, we briefly touched on the subject of rendering. When we use effects with the green dots, your Avid system and computer processor can usually show you, in real time, what the effect is doing and how it looks. However, when you have several effects stacked on top of one another and you play your sequence, the image may stutter and skip frames. You'll often notice red and yellow dots, as shown in Figure 17.32.

Figure 17.32

- *Red dots* indicate the system is dropping frames.
- *Yellow dots* indicate that the system is *about to* drop frames.

We learned in Chapter 11 that if we render the effect, it becomes new media and as new media it plays smoothly. Rendering takes time and takes up space on your drive. But if it doesn't play correctly, what else is there to do? We know we can change the Video Quality mode from Draft Quality to Best Performance. That's great for seeing if the effect is working or not. But once it is, we want to be able to play our Timeline smoothly, so we'll need to render. But Avid needs a lot less rendering than you'd think.

EXPERT RENDER

In the past, many Avid editors would mark an IN at the beginning of the section that stuttered and mark an OUT at the end of the section, enable all tracks, select Render In to Out, and then go off to get coffee, leaving the sequence to render for the next 5 or so minutes. Doing this is a tremendous time-waster and unnecessary space-filler. Why? Because when you render a stream of video, it renders the

effects on that video track, *plus* all lower video tracks, whereas in most cases, you only need render the top video track. Therefore, if you render every video track, you are being unnecessarily redundant, wasting drive space, and taking way too much time.

Instead what you should do is mark an IN and an OUT to select the stuttering section, and then follow these steps:

1. Go to the Menu and choose Timeline > Render > ExpertRender In/Out (Figure 17.33).

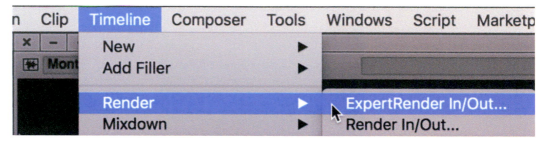

Figure 17.33

2. When the ExpertRender window appears, select the drive onto which you want the new media to be stored and click OK.

Once the render effect has rendered, the entire section will play in real time. Always use ExpertRender, even when you're exporting the finished project, which we'll cover in Chapter 21.

FRAMEFLEX

As we mention in Chapter 16, FrameFlex gives the editor the ability to change the compositional framing that the camera captured. Yet FrameFlex differs from the effects we've worked on to date; FrameFlex works on the Source clip, before it is edited into the Timeline. This takes a second to grasp. Throughout Chapter 11 and this chapter, we've taken effects from the Effect Palette and dragged them to a clip or transition already in the Timeline. Now, we'll making changes to the clip *before* it's edited into the Timeline.

You can apply the FrameFlex effect to the linked clip, before it's even transcoded, or you can do what I prefer to do, which is to Transcode the clip, and then apply FrameFlex.

Using FrameFlex:

1. In the bin holding you clips, choose the clip you'd like to reframe.
2. Right-click (Contrl-click) on the clip's icon to open the Bin Fast menu and when the menu comes up, go to the top and select Source Settings (Figure 17.34).

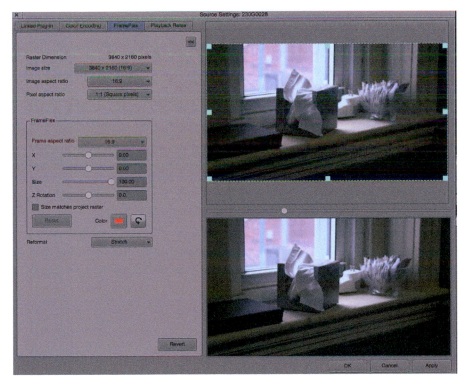

Figure 17.34

3. When the Source Setting window opens click on the FrameFlex tab.

Figure 17.35

The window that opens has several parts (Figure 17.35). The left-hand side shows you information about your clip and individual controls. The right-hand side has two monitors. The top one contains an outline with eight handles that you can drag to reframe your clip. The bottom monitor shows you how the changes you've made will look. Let's try it.

Drag any handle in the box to zoom into your clip and then use the cursor to drag the box to reposition the box within the frame. Look at Figure 17.36 and you'll see how the image was originally (left hand) and how I changed the image by dragging the boxes and repositioning the frame (right hand). Because this is a 4K project, the image will still look good even with this amount of magnification.

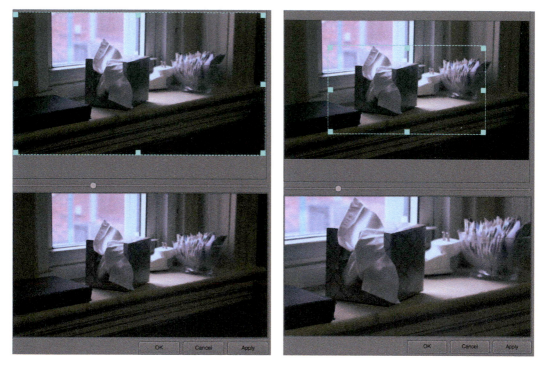

Figure 17.36

When you're happy with your result, click OK.

If you'd like to change the Z-axis—to rotate the frame in any direction—simply click on the Z-rotation button on the controls side, just to the right of the red color box (it looks a bit like headphones) and you'll have rotational control as well (Figure 17.37).

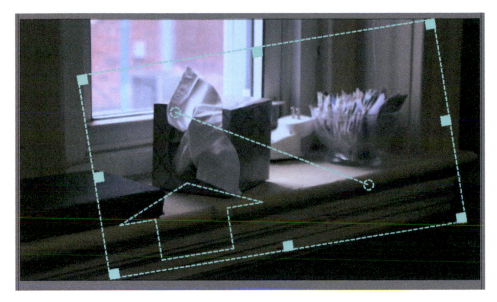

Figure 17.37

When you cut this clip into the Timeline, you'll see a little "s" icon on the video clip indicating that a Source Setting adapter effect has been applied (Figure 17.38).

Once the clip is cut into the Timeline, you can click on it and open the Effect Editor. Then you can place keyframes and manipulate the reframing over time, so you can zoom in, zoom out, and add a pan or tilt. Try it.

Figure 17.38

Removing FlexFrame

If for some reason you decide you don't want the FlexFrame applied to the clip, it's easy to remove, but how you go about it isn't obvious. Because it's an effect applied to the source clip, using the Remove Effect command won't work. Instead you need to go back to the source clip and remove it. If you know where the source clip is, go to the bin and select it. If it's one of hundreds or thousands of clips, follow these steps.

With the sequence in the Timeline, go to the clip with the FlexFrame you'd like to remove and press on the Match Frame command, which is inside the Timeline Fast menu's Tool Palette (Figure 17.39).

Figure 17.39

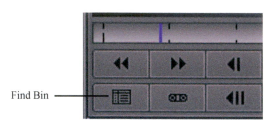

Find Bin

Figure 17.40

The source clip will be placed in the Source Monitor. Now, to find the source clip in its bin, press on the Find Bin command in the Source Command toolbar and the bin will open and the source clip will be highlighted (Figure 17.40).

Now that we've located the source clip, we will remove the FlexFrame effect. Follow these steps. Nothing will happen until you complete Step 5.

1. Right-click on the source clip and select Source Settings.
2. In the Source Settings Window, select the FlexFrame tab.
3. Click on the Reset button (Figure 17.41).
4. While still in the Source Setttings window, go to the bottom right and click OK.

Figure 17.41

5. Go to the Clip menu, scroll down to the command Refresh Sequence. Select Aspect Ratio and Reformatting Options. Now, the FlexFrame effect will be removed and the icon that was on the clip in the Timeline will disappear (Figure 17.42).

Figure 17.42

KEEP PRACTICING!

We've really unleashed a complex collection of effects techniques in this chapter. Some you'll probably find that you use all the time (PIPs), and some you'll use in special circumstances (Paint, Advanced Keyframes, Motion Tracking). Keep exploring and practicing as you continue to develop your skills.

18

Working with LUTs (Look Up Tables)

For decades, producers with serious ambition for their projects shot on film. There were only two reasons why anyone would choose a video camera over a film camera: 1) money—videotape was much cheaper than film; and 2) speed—video gave you immediate results. You didn't have to process and then transfer the film to begin editing. The reason people shot on film is clear: the images video cameras captured were far inferior to film. Video just didn't have the dynamic range. You could see detail in the shadow area, but the highlights would be blown out; or you could see detail in the highlights, but the shadows were just black blobs. With film you got detail in both. Videotape had a dynamic range of only about 5 F/stops between the detail in brightest and darkest areas, whereas film was capable of capturing a dynamic range of 12 or more F/stops.

Today's digital cameras are capable of emulating film's dynamic range. But in order to get that range, the camera manufacturers manipulate the way images are captured by using LOG or RAW. Let's examine LOG since it's more likely a beginner or intermediate editor will work with it.

The best analogy I can use to describe how LOG works is to describe the process of fitting a down sleeping bag into a tiny stuff sack. To get that body-sized bag into that small sack, you stuff it and stuff it until it's packed in really tight. And then, when you remove it from the sack, it fully unpacks, ready to keep you warm at night. With LOG the visual information is similarly squeezed, stuffed, and packed into the image file (sack), and when proper color correction or a LUT is applied, the file gets unpacked and the entire dynamic range is fully restored.

To show you what I mean, examine Figure 18.1. Both images are of the same grayscale test pattern. Both images were captured by a Canon C-300 camera. The image in Figure 18.1a was captured while the camera was set to record in standard mode. The image in Figure 18.1b was captured while the camera was set to record in C-LOG mode. Notice how the C-LOG information is more squished together. What's happening is the camera is actually capturing a lot more dynamic range in LOG mode than in standard mode, but that additional visual information is only

revealed when you apply the LUT or color correct the image. The LOG clip on the right will provide you with 12 F/stops of dynamic range when unpacked, compared with only about 7 F/stops in the standard recording mode. But without that LUT or skilled color correction, the C-LOG footage looks far worse than the image recorded in standard mode.

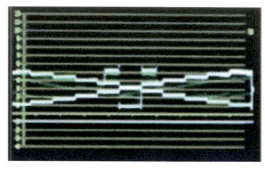

Figure 18.1a Standard camera recording mode

Figure 18.1b LOG camera recording mode

Examine the source clip of the two people (Figure 18.2) recorded in C-LOG mode. The colors are muted; there's no dynamic range. Everything looks dull, dark, and flat. The image hasn't been unpacked. It needs a LUT to release its full dynamic range.

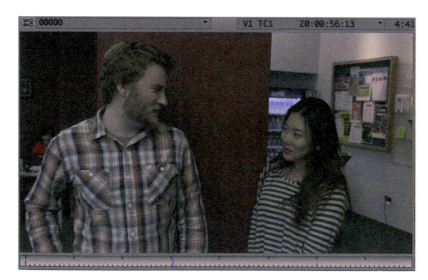

Figure 18.2

LUTS

When you apply a LUT, or Look Up Table, it's designed to transform your input image (LOG or RAW), which looks terrible, to your output image, which looks great.

LUTs are often used during production as well as in post-production. On set, during production, a LUT is often applied to the images going from the camera to the video monitor in order to transform the dull, dark, and flat looking LOG footage into good-looking images. That way the producer doesn't fire the DP for gross incompetence. These LUTs used on set aren't baked into the image being recorded. Instead they're only applied to the monitor's image to make everyone who is looking at that monitor feel good about his or her work.

During post, we apply LUTs to quickly unpack and transform our LOG or RAW source footage for the same reason. We want to make our editing decisions based on what the DP intended the image to look like. But instead of having to individually color correct every single clip—most of which will never be used—we'll simply apply the appropriate LUT.

There are different LUTs for different cameras and there are different LUTs to achieve different looks from the same cameras. Avid comes loaded with a lot of LUTs, and it's easy to install new ones, as we'll see later in the chapter.

Keep in mind that LUTs used in editing are not permanent either. We will remove them at the end of the editing process so the colorist can individually correct each shot in the Timeline. But we'll use LUTs as amazing time savers during editing.

Why are they called look up tables in the first place? The term comes from computer science. Whenever you have an application or memory device that changes a known output from a known input, it's called a look up table; the application simply looks up what the known output should be from the known input. It's a big time saver because you don't have to do all the computational work every time—you just apply what's already known. In our example, the LUT we apply to our clip looks up the known output (Rec 709) from the known input (Canon C-LOG). The word "table" is similar to the times tables we memorized as kids. Once we had memorized the times tables, we knew that the known output was 49 when the known input was 7 x 7.

WHEN TO APPLY THE LUT

Most visual effects are applied during the editing phase, to clips already spliced into the Timeline, whereas LUTs are added before editing even begins.

Applying a LUT to your Source Clips

Applying a LUT to your source clips doesn't take long if you select all the clips at once.

1. In the bin select all the clips and then right-click and choose Source Settings.
2. When the window opens, click on the Color Encoding tab at the top left.
3. Go to the Source color space pull-down menu, find your source and select it. In our case the camera was set to record in Canon C-Log, so that's the source we want (Figure 18.3).

Source color space pull-down menu

Figure 18.3

Once selected, the source color space will appear at the top of the menu list, as shown in Figure 18.4.

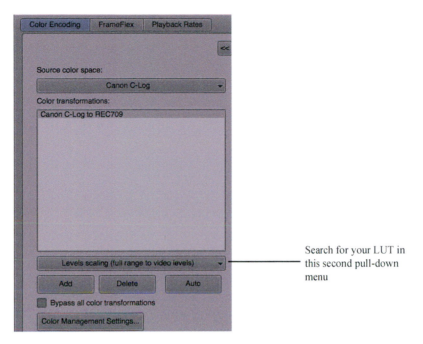

Search for your LUT in this second pull-down menu

Figure 18.4

4. Now search for the LUT in the second pull-down menu. In this case I'm looking for Canon C-Log to REC709. Once you find it, click on it so it becomes highlighted (Figure 18.5).

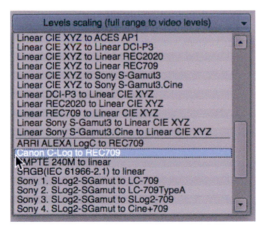

Figure 18.5

Now the LUT will appear in the pull-down menu as shown in Figure 18.6.

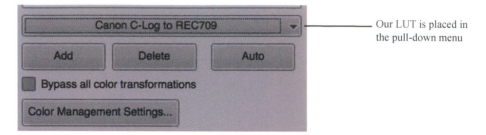

Our LUT is placed in
the pull-down menu

Figure 18.6

5. Click Add. This will place the LUT in the Color transformations box and highlight it.
6. At the bottom of the Color Encoding window, click OK.

Figure 18.7

Figure 18.7 on the left shows the clip without the LUT, and the image on the right is with the LUT. Quite a difference. Now the clip appears as the DP intended.

Now, whenever you edit your clips into the Timeline, a Color Adaptor icon appears (Figure 18.8).

Figure 18.8

PLACING A LUT ON A TRACK ON THE TIMELINE

Sometimes you may want to experiment with different LUTs before applying one to all your clips. For example, various vendors are now offering LUTs that emulate motion picture film stocks, but you're not sure if you'll like it until you see it on your clips. Or perhaps you are editing a short project with a ridiculously short deadline and you're looking to save every minute.

In either case, instead of adding the LUT to every source clip, you start by editing the clips into the Timeline *before* applying the LUT to them. You then apply the LUT to all of the clips by placing the LUT on V2 (or V3), so it impacts all of the clips below it on V1. Here's how it's done.

1. Go to the Effect Pallette and select Filters > Image > Color LUT (Figure 18.9).

Figure 18.9

2. Create a new Video Track. It can be V2 if there's nothing on it, or V3 if there is.
3. Drag the Color LUT to the top (empty) video track—it's just a placeholder until you assign the correct LUT (Figure 18.10).

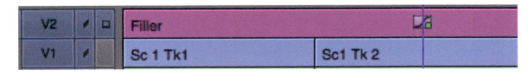

Figure 18.10

4. Place the cursor on the effect and open the Effect Editor. When the Color LUT effect opens, go to the nameless menu, click on it to open it (Figure 18.11). There are lots of LUTs to choose from. I'm looking for the LUT called Canon C-Log to REC709.

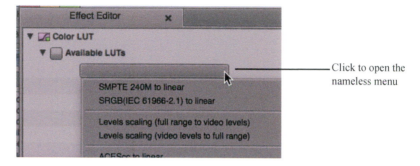

Figure 18.11

5. Select the appropriate LUT. Once you do, you'll see it at the top of the menu (Figure 18.12).

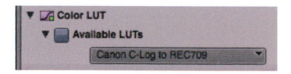

Figure 18.12

Now the LUT on V2 transforms all the clips on V1. If the clips don't transform, make sure you move the monitor icon onto the uppermost video track, as shown in Figure 18.10.

As you add shots to the Timeline, you can simply get into Dual-Roller Trim mode and extend the LUT over the new shots on the Timeline, as shown in Figure 18.13.

Figure 18.13

Because this method will slow you down on longer projects, it's best to apply the preferred LOG to all the source clips.

REMOVING LUTS

When the project reaches the stage called Picture Lock, it means that all the editing decisions have been made, the shots in the Timeline are at the right length, and it's time to color correct. The colorist wants to start fresh, by removing the applied LUTs. Why remove them all? As good as a LUT is at transforming the LOG or RAW clips, it is still a one-size-fits-all patch. A LUT isn't the same as working with each clip individually in the Timeline, as we'll learn to do in Chapter 19.

If you followed my "ridiculously tight deadline" method, and added a LUT to V2, and not to the individual clips in the bin, just remove the color LUT effect from V2, or Delete V2.

If you added the LUT to all the clips in all the bins, follow these steps. We aren't going to remove the LUT from all the source clips in all the bins—just the ones that made it into the final sequence.

1. Create a new bin called Final Color Correct.
2. Duplicate the final sequence and place it in the bin you just created. Name the duplicated sequence "Final for CC."
3. In the Final Color Correct bin, go to the Bin Fast menu at the bottom left and click on it.
4. Select "Set Bin Display" (Figure 18.14).

Figure 18.14

5. When the Bin Display window opens, click to select the "Show reference clips" (Figure 18.15).

Figure 18.15

6. Click OK.

All the clips that made up the final sequence will appear in the bin.

7. Select all the Video Master clips in the bin, then right-click and choose Source Settings . . .

8. Click on the Color Encoding tab at the top.

9. In the Color Transformations area, you'll see the LUT that you applied. Click on it and press Delete, as shown in Figure 18.16.

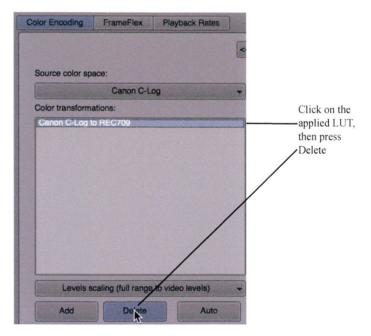

Figure 18.16

10. Click OK. Don't worry that nothing has happened to the sequence yet.
11. Now go back to the Bin Display and deselect the Show reference clips checkbox.
12. To see the changes, you will need to refresh the sequence. Go to the Clip menu and select Refresh Sequence and select Color Adapters (Figure 18.17).

Refresh Sequence ▶	Motion Adapters / Timewarps
Re-create Title Media...	Aspect Ratio and Reformatting
Remove Redundant Keyframes	Color Adapters
Refresh In-progress Linked Clips	Linked Plug-in Settings

Figure 18.17

Now all the clips in the sequence will appear dull, dark, and flat, ready for color correction.

You'll know your sequence was refreshed when you see that the Color Adapter symbol, which was on every clip in your Timeline, is removed (Figure 18.18).

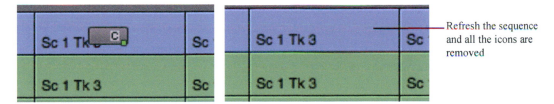

Refresh the sequence and all the icons are removed

Figure 18.18

HOW TO INSTALL AN EXTERNAL LUT

If there's a LUT you need, go to the vendor or camera manufacture's website to find it. Download it to your desktop or external drive.

1. Now go to the Settings tab, and double-click Color Management (Figure 18.19).

Figure 18.19

2. When the window opens, go to the bottom and in the Install LUT area, select either Project, Shared, or Both depending on whether or not you want this LUT available to all projects or just this project (Figure 18.20).

Figure 18.20

3. At the bottom of the dialog box, click on Select LUT file as shown in Figure 18.20.
4. Browse your computer or drive to find the LUT. Click Open to install it.

The LUT will now appear in the list of color transformation in the Source Settings. To access it, follow Step 4 in the section called "Applying a LUT" to your source clips on page 380.

ENOUGH ABOUT LUTS

In the next chapter, we'll learn how to color correct each clip in the Timeline so that all the images in all the scenes and sections have a consistent look

throughout the project. True, we'll be doing a lot of the hard work that the LUTs did for us, but we'll be able to give individual attention to each and every clip. And fortunately, Avid provides a host of well-designed tools and shortcuts to make our color grading go quickly.

Whew, that took a lot of concentration and mental activity. If you're like me, it might be time to unpack that sleeping bag. And happily, we don't need a LUT to do it.

19

Color Correction

Color Correction is a crucial phase of the post-production process—a phase that you should begin after you've achieved picture lock. Color correction allows you to not only correct problematic footage, but also to add things that were not present during the time of shooting. You have the tools to create a unique style or look to your project. If you want, you can do so much more than simply "correct" your color.

BEFORE YOU COLOR CORRECT

The first thing you need to do when color correcting a shot is to use your eyes to determine what needs to be changed. Sophisticated video monitors and scopes are great, but they can't "see" what is supposed to be white and what is supposed to be black. They don't know what look you're trying to achieve. You have to do that with your eyes.

So when you're looking at a shot (or indeed, an entire sequence), there should be several things you ask yourself before you even open the Color Correction Tool:

1. Are the blacks in the image truly black? Or are they too milky, or too shadowy?
2. Are the whites in the image truly white? Or are they too dim, or too blown out?
3. In general, does the image need to be darker or lighter? More or less contrasty?
4. Are there any unwanted color casts to the image? If so, which color is too prominent?
5. Is the image too saturated, or not saturated enough?
6. Are the flesh tones accurate?

Once you answer these questions, you'll have a better idea of how the image should be corrected, and so you'll be better equipped to carry it out.

LAUNCHING THE COLOR CORRECTION TOOL

Start by making sure that the video track containing the clips you want to correct is selected, and that all other video tracks are deselected. In other words, if you want to correct the clips on V1, make sure V1 is selected and any other video tracks, such as V2 or V3, are deselected.

You access the Color Correction Tool via the Windows > Workspace menu, or via the Color Correction icon to the left of the Timeline (Figure 19.1)

Color Correction Tool icon

Figure 19.1

Once opened, you may need to tweak the location of each of your windows, since the interface changes rather dramatically. When you have the windows positioned the way I have them in Figure 19.2, you can go back up to the Workspace menu and choose Save Current so that the configuration is saved the next time you access it.

Let's take a look at each of the windows. Across the top are three monitors that you can load with different shots from the Timeline, or with a series of reference scopes. The center monitor shows the current segment that you are correcting, which is the shot the position indicator is resting on in the Timeline. If you move

Pull-down menu to
access other images
and video scopes

Current Monitor Image
being color corrected

Pull-down menu to access other
images and video scopes

Dual Split button

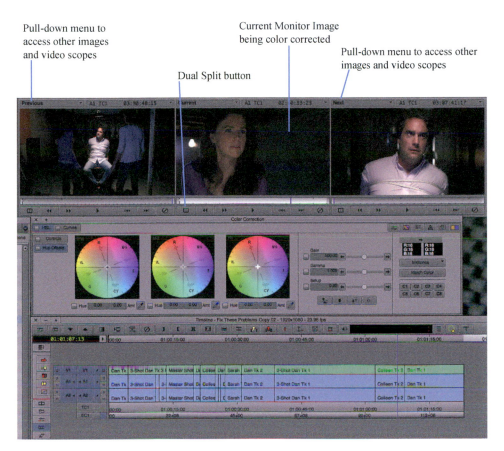

Figure 19.2

the position indicator to another clip in the Timeline, the image in the center monitor changes.

PULL-DOWN MENUS

Knowing the center monitor is the one you're working on, let's take a look at what you might put in the left and right monitors to help you in your work. By default, they show you the Previous clip (on the left) and the Next clip (on the right). In some cases, you may want to keep the monitors like this, so that you can see how the current shot relates to the shots before and after.

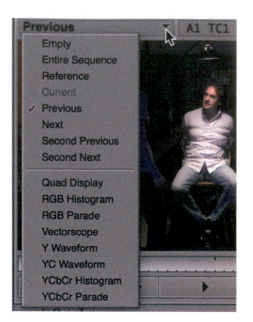

Figure 19.3

If you click and hold on the disclosure triangle above the monitor, you will see a menu that lets you change what the left (or right) monitor displays (Figure 19.3). Let's take a look at the four most helpful choices for our work:

- *Reference* lets you load a frame in either the left-hand or right-hand monitor—so that you can move through the Timeline, correcting the shots in the center monitor—but always accessing your reference clip for comparison's sake. To choose a Reference frame, you just select Reference from the pull-down menu in either the left-hand or right-hand monitor, and whatever clip is in the center monitor becomes the Reference frame. I usually use the right-hand monitor for this.
- *Y Waveform Monitor* shows a graphic representation of the clip's brightness, called *luminance*, or *luma*. Luma is the foundation of the video signal, so adjusting it is often the most important part of the color correction process. The waveform monitor displays darkest values at the bottom of the screen and brightest values at the top. The waveform corresponds spatially left-to-right with the image you are correcting.

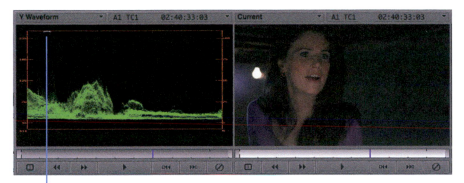

The light bulb peaks here.

Figure 19.4

Let's compare the shot of Colleen on the right with the Waveform monitor on the left (Figure 19.4). The green represents the brightness of all parts of her shot—the more green, the brighter the image. In the Waveform we see that, from left to right, there's an area of greater green where the light bulb casts some light on the walls, then there's the small overexposed peak at the top, which is the light bulb itself. Then we have the bush-shaped area of green that is Colleen's face and shoulders, and then everything to the right of that has very low levels of green, representing that dark wall behind her. Overall this shot needs to have the luma or brightness increased.

- *The RGB Parade* breaks out the video signal into its three color channels of red, green, and blue, displaying both luma and chroma information. This scope is used to compare the balance between the color channels, and is used as a guide to bringing them into color balance. Looking at the RGB Parade of Colleen, I see that the difference between the three channels isn't far off from what we want, so the color balance doesn't need a lot of correction (Figure 19.5).

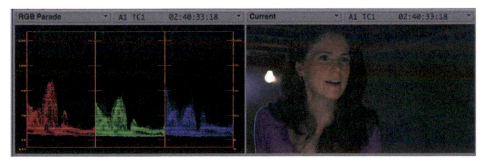

Figure 19.5

- *The Vectorscope* (Figure 19.6) analyses the clip's color, often called *chrominance*. It measures chrominance by plotting the hue and saturation values.

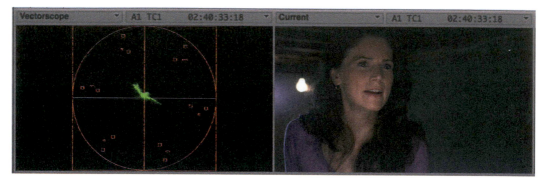

Figure 19.6

We often use this tool when measuring Caucasian flesh tones. With those flesh tones, the hue should reside on an imaginary line right between red and yellow, called the flesh tone line—also called the i-line. In this case, our shot of Colleen falls nicely on the flesh tone line, but it's going to need more saturation and brightness as the green i-line should be much longer—more like a third of the way to the circle.

Flesh tone line, or the i-line

Figure 19.7

There are other video scopes that you can choose from the pull-down menu, but these tools will help you correct most luma and chroma issues with your footage, as we'll learn shortly.

YOUR TOOLS: GROUPS

Before correcting our shots in the Timeline, let's explore the tools we will use.

There are two primary modes of correction: the HSL (Hue, Saturation, Luminance) mode and the Curves mode. You choose one or the other by clicking on the tab. If you make adjustments in one mode, then you go to the next mode and make additional adjustments; the changes are cumulative. One piece of advice, though—you'll most likely make a mess of things by jumping from one mode to the next. So, try to use one and make all your changes there.

We're going to take a look at the HSL group, which is the easiest mode to master. Curves is a bit more complex, and we won't have the space to delve into the Curves group in this book.

The HSL Group itself has two tabs: Controls and Hue Offsets.

Hue Offsets

This is the group of tools you see as soon as you open the Color Correction Tool, and it may look a little daunting. In fact, it's fairly easy to use, and you'll be able to use the tools within Hue Offsets to make precise luma and chroma adjustments.

Figure 19.8

Here are some basic controls in the Hue Offsets Group, which you'll find to the right of the color wheels:

- *Gain*. Allows you to adjust the image's brightness. By increasing the gain you brighten the image. By decreasing the Gain you darken the image. It mainly affects the highlights.

- *Gamma.* Allows you to adjust the image's midtones, making the image more weighted toward the shadows or more weighted toward the highlights.
- *Setup.* Allows you to adjust the image's black point. Your goal is to align the blackest part of your image at 16 bits. When you do this you are making the blacks look rich, not milky. Adjusting the Setup lets you tweak the darkest values without affecting the highlights or midtones much.

 You can drag the sliders left or right, but to make finer adjustments on any of these parameter sliders, click on the left or right arrows to increase or decrease the amount of change, or Shift-drag the sliders to the left or right.
- *ChromaWheels.* The ChromaWheels are separated into three separate controls; from left to right, they are the Shadows, Midtones, and Highlights. By adjusting the crosshair in the center of each wheel, you can add or subtract certain chroma (color) values into the Shadows, Midtones, or Highlights. To add a certain color, you drag toward that color in the ChromaWheel; to subtract a certain color, you drag away from that color in the ChromaWheel (thereby adding its complementary color).
- *Color Match Swatches.* The two boxes on the far right side of the Color Correction Tool are called the Color Match swatches. They are used to match colors within your image (which is beyond the scope of this book), but they can also be used for a very basic, but very powerful purpose. If you click in a Color Match Swatch, your cursor turns into an eyedropper. Then, if you move into the main part of your image within the Color Correction monitor the eyedropper gives you color readings—the Red, Green, and Blue values will be displayed within the Color Info box that pops up. This is a great way to "check" how a particular area is measuring in terms of its color channels. It works best when you have a white, black, or neutral area in the shot, because you can get a good sense of the color balance by dipping the eyedropper into the neutral area and seeing if it has a color cast. A spread of five points is fine, but much more than that shows that the neutral area has a color cast—meaning the entire shot does as well. Here in Figure 19.9, I have placed the eyedropper on the metal pipe behind Dan. If I go up and down the pipe with the dropper the RGB color numbers stay quite close. The farthest apart they got was five between the R and B. This means the overall shot has a tiny bit more Red than Blue.

Now let's look at the other part of HSL—Controls. Just click on the Controls tab to switch from Hue Offsets.

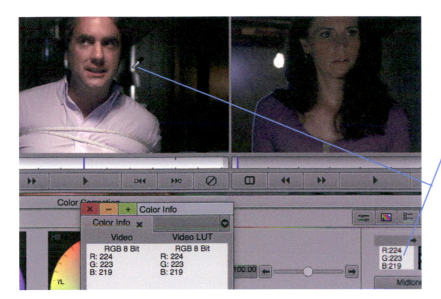

Clicking in the Color Swatch here, turned the cursor into an eyedropper, allowing me to measure the neutral pipe

Figure 19.9

Controls

This group of tools contains some very basic controls for adjusting luma and chroma, although not as precise as those in the Hue Offsets group. However, it contains two very important controls that the Hue Offsets group does not have: Saturation and Luma Clip—represented by the Clip Low/Clip High controls (Figure 19.10).

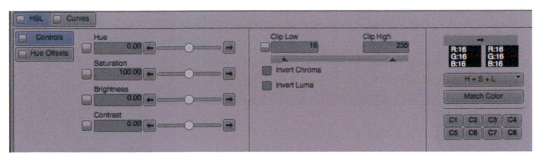

Figure 19.10

Here are some basic controls in the Controls group:

- *Hue.* Shifts the hue of the image around the color wheel. Not as easy to work with as the ChromaWheels in the Hue Offsets group.
- *Saturation.* Adds or subtracts saturation, or intensity, of chroma (color). This is an important control, because there are no Saturation controls in the HSL's Hue Offset group, so you must use this one if you want to affect saturation. I use it sometimes to make a color clip turn B&W by dragging the Saturation all the way to the left.
- *Brightness.* Adds or subtracts the luminance of the image. Adjusting brightness is similar to adjusting the Setup parameter in the Hue Offsets group. I much prefer doing this in the Hue Offsets Group, not here.
- *Contrast.* Adds or subtracts the amount of contrast in the image. Adjusting contrast is similar to adjusting the Setup and Gain parameters in the Hue Offsets group, but without as much control.
- *Clip Low/Clip High.* Clips the high (white) and low (black) luma values in the image. The default settings for these controls are 16 and 235 (the broadcast values for video black and video white), so any pixels with a luma value lower than 16 will be clipped at 16, and any pixels with a luma value higher than 235 will be clipped at 235. This is another important control in the Controls group, because clipping does not exist within the Hue Offsets group.

COLOR CORRECTION WORKFLOW WITH AUTO CORRECT

Let's try going through the best practices color workflow using a sequence from *Where's the Bloody Money?* We're going to use Avid's *automatic color correction* tools to help us out. Using the auto tools is like having an expert colorist sitting next to you. She gives you her opinion about what looks good, and then you decide if you agree, or if you want to make creative adjustments using the manual controls. Unfortunately, the Director of Photography on this project, Helena Bowen, and her gaffer, Trevor Taylor, and the AC and DIT, Peter Brunet, all did an amazing job and there's not a lot of color correction needed. Still, even the best cinematographers in the world rely on a colorist to make them look great.

We'll start by loading the sequence you edited of the scene, or if you didn't edit a sequence, go to the Chapter 3 folder, make a duplicate of Trim Practice sequence and load that into the Timeline. Now select the Color Correction Tool from the Windows > Workspaces menu. We're going to stay in the HSL Group, and start in the Hue Offsets tab.

Let's correct a shot of Dan Tk 1. So park the position indicator on his medium shot, and let's proceed through the auto color correction workflow.

Make sure that the Color Correction Tool is open, with the Hue Offsets controls visible. We'll be using the Auto Correction controls, which are on the right portion of the window (Figure 19.11).

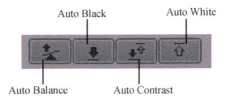

Figure 19.11

1. *Analyse the image for color correction with your eyes.*
 This shot looks a bit dark, and the blacks appear to be a bit milky, but Dan's color looks realistic (Figure 19.12).

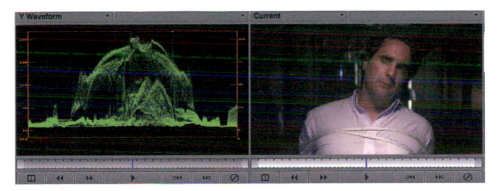

Figure 19.12

2. *Adjust your blacks, watching your corrections using the Y Waveform scope.*
 Load the Y Waveform in the left monitor by choosing it from the pull-down menu. Right away I see why the blacks look milky—the blacks are well above 16, as shown in Figure 19.13. They need to be pulled down.

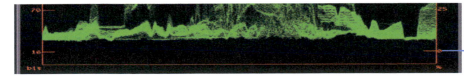

Figure 19.13

So the first Auto tool I'll use is Auto Black. When I click on it, suddenly the Y Waveform shows me that the blacks have been brought down to 16, where they should be, and the blacks in Dan's medium shot look crisp and no longer milky. I can see that the Setup changed, showing me that the blacks were brought to -7.00 to achieve the correct black levels of 16 (Figure 19.14).

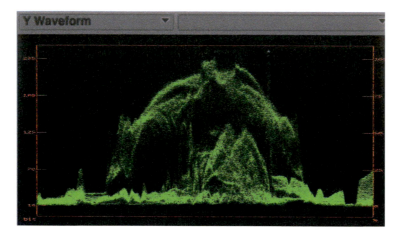

Figure 19.14

3. *Adjust your whites, watching your corrections using the Y Waveform scope.*
 Dan looks a little dark to me. With the Y Waveform on, I press the Auto White button. Looking at the image I see the Auto White command didn't change the brightness much at all. And when I look at the Gain box I see, in Figure 19.15, that it added only a tiny amount of brightness.

Figure 19.15

So here I'm going to reject the advice of the Auto White because my eyes say Dan is still too dark. Plus I think I know what threw off the Auto White. So, I'm going to manually drag the Gain slider to the right to 114.67 in order to add brightness, as shown in Figure 19.16.

Figure 19.16

Now, let's look at the Y Waveform and at Dan (Figure 19.17).

Figure 19.17

Dan looks better when the slider is dragged right, to around 115. So why did the Auto White not fix the shot? The Auto White doesn't want any part of the image to peak over legal video white, and you can see that when I raised the gain, the small bright areas behind Dan's head peaked far above video white, as shown by all that white noise—illegal clipping—at the top of the Y Waveform. Now if this show is for Broadcast TV, that's a problem because they are in the illegal range. But I know that I can fix the illegal clipping later while maintaining the brighter image. And if it's not going to be distributed to Broadcast TV, I can ignore the blown out area altogether.

In fact, I chose Dan's shot for this practice exercise because it has those really bright areas where the metal behind him is clipping. I wanted to show you how this is one instance when Auto White doesn't work. You need to treat glinting metal like this as if it was a shining light, or sunlight glinting off of water or glass, or any other "specular highlights." These specular highlights will *always* be blown out. So don't worry about them clipping. Fix the image by raising the gain until he looks good, and don't worry about those specular highlights.

Special Note: In steps 1 and 2, I used Auto Black and then Auto White. More often than not I use the Auto Contrast command button to do both—fix my blacks and whites at the same time. I did it the two-step way, using Auto Black first and the Auto White, because it was easier to explain what they do. But for the next clip you need to color correct, try using Auto Contrast (Figure 1918).

Auto Contrast corrects both
Blacks and Whites in one step

Figure 19.18

4. *Remove any color casts, monitoring your corrections using the RGB Parade scope.*
Now load the RGB Parade in the left monitor. We can see that the Red, Green, and Blues are all fairly well balanced. But let's see what the Auto Balance command thinks. Press the Auto Balance button. As we thought, the image doesn't contain many color balance problems, so you won't see much change when you perform an Auto Balance. But notice that the Auto Balance repositioned the crosshairs in the middle of the three ChromaWheels just a bit and made some minor adjustments to the Shadows and Highlights as well.

Figure 19.19 Notice the slight changes in numerical values from the top image, showing before, and the bottom image, showing after Auto Balance.

If you recall on page 398 when we used our eyedropper to measure the pipe behind Dan, we saw there was a tiny bit more Red in the frame. So I'm not surprised when I clicked Auto Balance and the crosshairs all moved slightly toward Blue, to give the shot a bit more Blue.

5. *Adjust the flesh tones, monitoring your corrections using the Vectorscope.*
If your shot is a medium shot or tighter, load the Vectorscope in the left monitor to check the flesh tones. Having adjusted the brightness already, you can see that the saturation values are a little higher than they were before, but they are still desaturated, as seen in Figure 19.20.

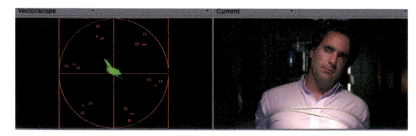

Figure 19.20

Now, go ahead and switch the Color Correction Tool over to the Controls tab, where your Saturation control resides. There is no Auto Saturation button, so you will manually drag the saturation slider to the right a bit, until the Vectorscope registers that the flesh tones extend about 1/3 of the way from the center of the circle (Figure 19.21).

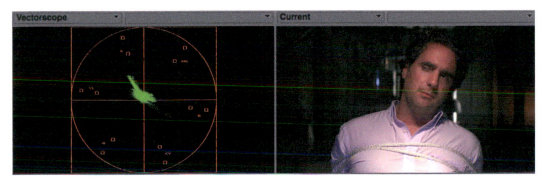

Figure 19.21

6. *Clip the luma values at legal broadcast levels.*
 Finally, if we are preparing for Broadcast TV, in order to keep the luma levels within legal limits, you'll need to clip your high and low luma values. All you need to do is stay in the Controls group and check the box to the left of Clip High/Clip Low, and your luma values will be clipped to 16 and 235. Doing so will keep your luma measurements broadcast safe. Everything else will stay the same. Don't bother if it's for Vimeo, YouTube, or a film festival.

SPLIT SCREEN—BEFORE AND AFTER

The Split Screen button is great because it shows you the way your image was before you corrected it, and after. In Figure 19.22, I have toggled on the Split Screen command and then dragged a white triangle to the right so I can bisect Dan's face by the split line in order to see and compare how my efforts have changed his face and shirt.

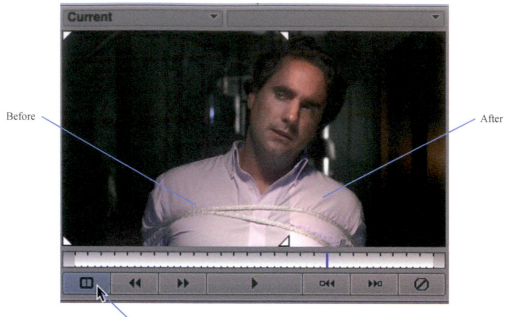

Before

After

Split Screen command

Figure 19.22

SAVING THE COLOR AS A TEMPLATE

To save the color correction that you just created, just drag the rainbow-colored icon in the upper-right corner of the Color Correction tool to an open bin (Figure 19.23). You should immediately name the Color Correction template so that you can easily identify it (like Dan's MS CC). Then, you can later drag this template to any other shot in the Timeline. This is one way to adjust all of the shots of a certain subject at once.

Color Correction
Template

Figure 19.23

Returning to Default

Whenever you make a change, the Enable buttons are highlighted to indicate that a change has been made. If you want to see what it was like before you made the

change, toggle the Enable buttons on and off to see before and after you made your changes (Figure 19.24).

Click on the enable button to temporarily disable the parameter

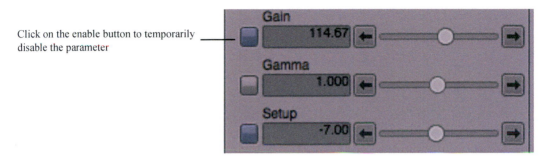

Figure 19.24

If you don't like what you have done with any control, you can remove your changes and return to the 0 or default setting. To do that, just Option-click (Mac) or Alt-click (Windows) the Enable buttons.

- Option-click (Mac) or Alt-click (Windows) the individual buttons to reset.
- Option-click (Mac) or Alt-click (Windows) the group button to reset everything—all the settings—in that group.

So now that you know how to easily undo your actions, play around with the various Hue Offset sliders and drag the three crosshairs of the ChromaWheels around to get a feel for the changes they create in your clips.

COLOR BUCKETS

Another way of saving your color correction work involves placing your choices into color buckets. This is faster than dragging the Color Effect icon to a bin. You can create up to eight different template settings and have them available for use during your session by placing them in one of the eight buckets.

For example, after correcting Dan's clip so it's just right, simply Option-click (Mac) or Alt-click (Windows) on C1. A Color Effect icon will appear above the bucket on C1 (Figure 19.25). Now correct Colleen's medium shot and then Option-click (Mac) or Alt-click (Windows) on C2. After working to perfect Sarah's clip, place her settings in C3. Same with the master shot—place it in C4. Now, as you go along your Timeline, just click on the appropriate correct bucket for each time

Figure 19.25

you're on Dan, Colleen, Sarah, or the master shot. Soon, the entire scene is color corrected.

If you have four or more working buckets, you might consider taking a pen and paper and writing that C1 is Dan's medium, C2 is Colleen's medium, C3 is Sarah's medium and C4 is the master shot—in case your memory fails you, as mine does now and then.

These buckets will disappear as soon as you quit the application; so if you need to save them for another day, drag the icon to a bin.

Keep in mind that different takes will be able to use the same color bucket. If you correct Dan Tk 1, and place those settings in a color bucket, when you come to a part of the Timeline where you've chosen to use Dan Tk 2 instead, the color bucket will work because nothing will have changed in terms of lighting or exposure. This might not always be true with exterior locations, but it should hold true with interiors.

WHAT ABOUT GAMMA

I don't tend to use Gamma that much because boosting it can make my image look harsh by providing too much contrast, while lowering the Gamma makes my shot too flat and removes the nice snap I've worked hard to achieve. But play with it and see. There will be a time when you shoot on a cloudy or foggy day, when your shots lack snap and you need Gamma to give your images more pop.

CALIBRATED MONITOR

Just about all post-production facilities have calibrated monitors that their editors use to determine how things look. Since this book is for students and people learning Avid Media Composer, I'm concentrating on what you can do on a laptop or desktop computer. Clearly, if you have access to a calibrated monitor, you should do all your color correction using the monitor and not your computer screen.

SUGGESTED ASSIGNMENTS

1. Load a sequence into the Timeline, and park the position indicator on the first shot. Make sure you select the appropriate video track.
2. Open the Color Correction Tool, and make sure you start in the Hue Offsets tab within the HSL group.

3. Look at the clip, and analyze its color correction needs with your eyes. Are the blacks black? Are the whites white? Is the contrast ok? Any color casts? Accurate flesh tones?

4. Load the Y Waveform monitor in the left monitor, and set your blacks and whites using first Auto Contrast and then manually adjusting the Setup and Gain controls.

5. Load the RGB Parade into the left monitor, and remove any existing color casts using the ChromaWheels, making sure to take "measurements" in the black and white areas with the eyedropper. Click Auto Balance to see what your assistant thinks.

6. If there are Caucasian flesh tones, place the Vectorscope into the left monitor, and adjust the hue, if necessary, with the ChromaWheels. Also, make sure to adjust the Saturation, if necessary (via the Controls tab).

7. Clip the High/Low luma levels.

8. Save the Color Correction template in a bin, and name it. Then, drag it onto a similar clip in the Timeline, and tweak the values, if necessary.

9. Place your settings for each different shot in a color bucket. And then change a similar shot later in the Timeline by clicking on the appropriate bucket.

20

Media Management

I realize this chapter lacks sex appeal. Examining the ins and outs of media management is a bit like discussing one's dental work or attending a two-hour lecture on library cataloguing systems. So I'll try my best to make it brief.

BACKING UP YOUR PROJECT FOLDER

Computers crash, external drives stop working, and things get lost or mistakenly deleted. So when those bad things happen, it's good to be ready for them. If you're prepared, it's just an irritant rather than a complete catastrophe.

All you need is a USB flash drive for this.

1. At the end of every editing day, when you quit out of Avid, go to the drive containing your Avid Project Folder. It's probably on your external drive.
2. Drag the Project Folder to a USB drive, Dropbox folder, or Cloud. Here I'm dragging it to a USB thumb drive connected to my computer (Figure 20.1).

Name		Date Modified	
▶ 📁 Where's th...ody Money	˅	Jun 17, 2016, 4:30 PM	
▶ 📁 Scene Audio 6		Aug 3, 2011, 9:56 PM	
▶ 📁 Reel 07		Nov 14. 2015. 7:12 PM	

Figure 20.1

3. Once it's copied over, rename it by just adding the day's date. That way you can save a current version of the project every day.

You're not backing up the media; instead you are saving all the key information about your sequences, your clips, your bins, your audio settings, and all the decisions you've spent hours making.

After the Crash

If there is a bad crash or your external drive is stolen (it happened to me), it's not hard to bring your project back to life. Simply get a new external drive and drag the most recent Project Folder onto it. Now go to the back-up drive containing your camera cards and sound cards and reimport and relink to the media. You'll most likely have to transcode everything again, which is a big pain, but once you do, your sequences should come back, filled with the proper material. This all might take six hours, but re-editing could take hundreds of hours.

DRAG AND DROP YOUR MEDIAFILES FOLDER

If you want to avoid having to go all the way back to your camera cards and audio cards, then back up your Avid MediaFiles folder. Just drag and drop the folder from the editing drive to the back-up drive, as I've done in Figure 20.2.

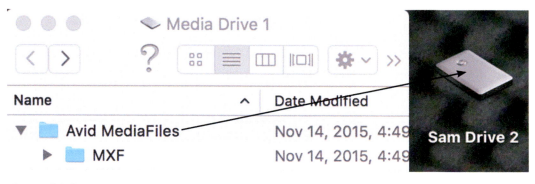

Figure 20.2

MEDIA OFFLINE

Sometimes it happens that your Timeline turns red and the Source and Record monitors contain the warning "Media Offline." What's happened is the link to the media has been lost or broken. With my students it most often happens because they are editing at one Avid workstation, and as they import, link, or create material

it is mistakenly saved to the editing station and not to their external drive. When they move to another workstation, that material is no longer available to them because it's back at the old workstation. So pay attention to where your media is stored.

Renaming folders, camera cards, and media drives is also a bad idea. Avid can't link or relink if it doesn't have the right name or address because it's been renamed. Also, when you first name a folder that contains original media, limit the name to 14 characters, and only use letters, numbers, and underscores. Never use symbols like slashes (/). Avoid moving things inside folders. Don't change the pathway to your media.

When you Link to camera cards and all the clips come into a bin, you can start editing from the linked clips or Transcode the clips. But either way, don't delete the linked clips or the bins.

If you do find yourself in the situation where you have somehow lost the link to the media, try selecting the clips that are missing and going to the Clip menu and choosing Relink. There are lots of choices, but you want All Available Drives and Any video format. If the clips were imported, you can always import them again by going to File > Input > Import Media.

MEDIA CREATION

One way of keeping track of where your media gets stored is to use Avid's Media Creation tool. If you go to Settings and scroll down to Media Creation, you'll see that there are various tabs that you can choose from. The one I suggest you open is Import (Figure 20.3).

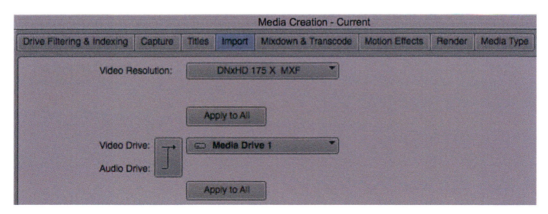

Figure 20.3

The key here is the "Apply to the All" button. The top part tells Avid to turn any media you import into DNxHD 175X (or whatever resolution your project is set at). If you click Apply to All, then the other tabs will adopt that resolution, so the titles you create, the clips you transcode, everything will be created at that resolution. The bottom part shows where the media should be saved, and by choosing your external drive and Apply to All, then everything you create or import will be saved to your drive. That way it won't get saved to the computer you happen to be editing on that day.

FINDING MISSING ITEMS IN THE ATTIC

Avid's attic is like the attic in a house, where old items are stored. In this case the old items are previous versions of your work. These items are your bins and they are stored in the attic every time you hit Save, or Avid does an Auto-Save. If there is a crash and you lose a sequence or a bin, it's been saved to the Attic.

Retrieving a File from the Attic

1. Close all your bins.
2. Minimize Media Composer in Windows. On a Mac hide Media Composer by pressing Command-H.
3. Open your hard drive on the desktop—not your external hard drive.
4. Look for the Attic Folder inside the Users or Shared (or Public) folder. Figure 20.4 on the left shows where it's located on my computer.

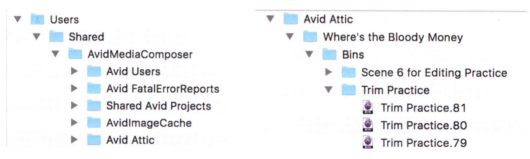

Figure 20.4

5. Open the Attic folder and look for the project you are now editing. Open it.
6. In the Bins folder, look for the folder name for the bin you want and open it. In Figure 20.4 on the right you can see I've opened the Trim Practice

bin and there are 81 saved versions in the Attic. The largest number is the newest version.

7. Click on the one you want. It may be the one before the most recent. Look at the time and size columns to find it. If you mistakenly deleted your master sequence, look for the bin right before the size changed to become smaller.
8. Copy this bin by Ctrl-C (Windows) or Command-C (Mac).
9. Paste this bin on your computer desktop by pressing Ctrl-V or Command-V.
10. Now open Media Composer from the dock or taskbar.
11. Go to the File menu and select Open Bin. Navigate to the bin you just pasted to the desktop and click Open.
12. Double-click on the Attic bin inside the Project Window to open it.
13. Create a new bin called, "Restore."
14. Find the sequence you want and drag it into the Restore bin.
15. Select and Delete the back-up bin in the Other Bins folder.
16. Select and Delete the bin on the desktop.

BE PREPARED!

You might not think drive failure or data loss will happen to you, but the odds are good that, eventually, it will. You don't want to be the editor who can't finish the project because the external drive died and nothing was backed up. Make sure your media is backed up on another drive and perform the daily back-up of your Avid Project Folder. If you do, then when the big crash comes, you'll be everyone's hero.

21

Outputting Your Sequence

OUTPUTTING

Let's face it, a lot of people start films and videos, but not everyone finishes them. It's easy to give up, to run out of steam, or to take a never-ending break from a project. After all, making a film or video is a lot of hard work, and often, you do it for little reward. One of the biggest rewards for finishing, however, is having the final product. Whether it's a BluRay, Vimeo link, web series on YouTube, or network premier, it's a tremendous feeling to be able to show the world the result of your labor.

There are quite a few ways to output your project, but most of them involve a process called exporting (or the command Export). You'll find that the two terms "output" and "export" are used often interchangeably.

Here are several situations in which you might want to export sequences or even a single frame from Media Composer:

- Create a production still for publicity purposes. You could export a still frame from a sequence, retouch the image in a program such as Photoshop, and e-send it to festivals asking you for production stills, or create a movie poster with it as the central image.
- Export to Pro Tools for a professional sound mix and then reimport the mixed tracks into Media Composer.
- Export a QuickTime movie for posting on YouTube, Vimeo or your company's website.
- Export a file for use in a BluRay authoring program.
- Export a Material Exchange Format Operational Pattern 1a for delivery to CBS, ABC, NBC, or other network or cable broadcasters.

In addition to outputting files directly for distribution, there are lots of software programs out there to sweeten, enhance or correct your project. To really learn about exporting, you should try to be familiar with the software application you may be

exporting to. Often, you will export files to applications such as Pro Tools (to fix the audio), After Effects (to create a special visual effect), or DaVinci Resolve (to do some targeted color correction). Sometimes, you'll be the one using these third-party applications, but often, you'll just be passing off your video and/or audio to graphic artists, sound engineers, and animators. Post-production truly is a collaborative endeavor and learning how to send files to others is key to that collaboration.

Preparing to Output

There are several things you should do to make sure your export goes smoothly:

- Include a second of black before the start of the sequence, so things don't start abruptly.
- If you are exporting a *sequence*—or the audio tracks from a sequence—you should duplicate the sequence before initiating an export. So first, create a new bin for the duplicate, and move it into there before exporting. Then, if anything goes wrong, you have an original to return to.
- If you're exporting a *frame*, you do not have to duplicate anything.
- If you are exporting more than one video track (V1), make sure the video track monitor is on the highest level.
- Make sure the material you want to export is selected.

 - If you want to export a sequence, click on the sequence in the bin.
 - If you want to export a frame, mark the frame by marking an IN point.
 - If you want to export some (but not all) of your tracks, select the tracks (via the track selection panel) to indicate the ones you want, and deselect the ones you don't.
 - If you want to export a section of a sequence, place IN and OUT points in the Timeline.

Video Mixdown

If your sequence contains multiple video tracks, you can save a lot of time in the export if you create a video mixdown of the video tracks before doing the export. This is especially true with UHD and 4K sequences.

Create a new bin called Mixdown and place a duplicate copy of your sequence inside the bin. Now with the duplicated sequence in the Timeline:

1. Mark and IN and an OUT of your entire sequence.
2. Select the Video Tracks.

3. Go to Timeline > Mixdown > Video.
4. When the Mixdown window appears, choose the appropriate resolution. The choices depend on your project. Here are settings for a 4K, UHD, and 1080p HD project. Look for the setting that matches your Avid project settings (Figure 21.1).

Figure 21.1

5. Once you click OK, Avid creates a new master clip that contains only video. Double-click to put it in the Source Monitor and then Overwrite it onto V1. You can delete V2 or V3 tracks, and any clips, such as TitlerPro titles, as they will be part of the new mix.

This is an important step, especially with UHD and 4K projects, which can take many hours to export. There is also an option to mixdown your audio tracks if you have many of those. I don't mixdown my audio tracks unless I have so many that they make editing difficult. You can mixdown some tracks and not others if you choose.

CHECK YOUR SOUND TRACKS

One of the decisions you'll need to make is whether you will be the sound mixer using Media Composer's audio tools, or you will hand the job to a sound mixer who'll fix and sweeten the audio using Pro Tools, Avid's industry standard audio software. Having a knowledgeable sound mixer tweak every clip is a wonderful gift to your project, and we'll learn how to send your project to a Pro Tools mixing station in the next section.

If you're going to be the sound mixer, using just Media Composer, that's fine. Avid has given you many tools, which we've worked with ever since Chapter 6. But since you're the last person between the audio tracks and the world, here are a couple of tips. Whenever I'm about to output a project, I first get a pair of isolating headphones that prevent me from hearing anything other than what's coming through the earpieces, and then I go through the Timeline start to finish. As I listen to each clip in the Timeline, I watch the levels, listen for glitches I missed, or disproportionately loud or quiet sections. Make sure the audio at the start of the project represents the entire project. Too often beginning filmmakers will have a wildly loud opening section that has festival judges scrambling to lower the volume. And then, seconds later, dialog comes in that is much lower and they scramble again to raise the volume. Pretty soon, they've given up playing sound mixer and moved onto the next film. Also, open the Audio Mixer and make sure that your dialog tracks are centered. You'll need to fix any dialog or narration that is panned left or right.

The second thing I do is bring it to a large classroom or auditorium and play it through the room's speakers. How does it sound now? Is it filling the room? Is the room's ambient sound canceling out my quieter sounds? Are the levels consistent from the beginning to the end, or does everything get louder over time. Usually I take notes and go back and make adjustments until it's just right.

SENDING TO PRO TOOLS

If you tracks are in bad shape and need the services of a talented mixer, it's fairly easy to send your project to Pro Tools, because it's Avid's own product. Since I'm assuming you're not a Pro Tools expert and not working at a large post-production facility with Media Composer and ProTools interconnected, I'm going to explain how to put everything you need onto a empty, separate external drive that you'll give to your Pro Tools Mixer. But before you follow these steps, check with your mixer. She/he might want things done slightly differently.

Start by connecting an external drive that is without any Avid media files or Avid projects.

1. Create a new bin, and place a duplicate of your final sequence inside.
2. As described at the end of Chapter 11, add a Timecode Burn-In effect to the Timeline.
3. Click on the sequence in the bin and go to File > Output > Send to > ProTools > QuickTime – Consolidate Audio (Figure 21.2).

Figure 21.2

4. When the window comes up, click on Set, so you can navigate to your external drive (Figure 21.3).

Figure 21.3

There are two Export Settings: one is for exporting a QuickTime video and the other is for the audio tracks. The only change I've ever made to any of these settings is in the Send To QT Movie settings, where I've gone into Options and changed the Display Aspect Ratio to assign my project size to 1920x1080.

When you click OK, Avid exports all your audio files and places them in a folder, exports a QuickTime file, and finally creates an AAF file. Bring this drive to your Pro Tools mixer. She will send you a finished audio file that you'll import into your project. Usually I just delete my tracks, and then Overwrite the mixers tracks where my tracks used to be. Since this is a duplicate sequence, I can always go back to the original sequence.

EXPORTING A PRODUCTION STILL

Exporting a frame from a sequence to create a production still is an important task, especially as many budgets don't include money for a still photographer. Instead, you get your production stills right off the Timeline.

Load a sequence in the Timeline, and mark an IN point on the frame you would like to export (you can also export from a clip loaded in the Source monitor, if you want). If possible, choose a frame that has as little movement as possible. Now, after clicking on the Timeline to make it active, go to the File menu and then Output > Export to File (Figure 21.4).

Figure 21.4

The Export As . . . dialog box appears. Go all the way to the bottom of the window and you'll see an Export Setting menu, where you can find lots of templates for all sorts of exports. Macintosh or Window Image NTSC should work fine, but instead of clicking Save, click on Options (Figure 21.5).

Export setting Macintosh Image NTSC ◇

Options...

Cancel Save

Figure 21.5

Most of the default settings will work fine, but one that Avid often gets wrong is the WIDTH × HEIGHT setting, so I always go to Options first before exporting. Let's examine the options. In Figure 21.6, I've changed the default settings I don't want.

1. In the Export As . . . menu, Graphic is selected because we asked for the Macintosh Image or Windows Image—which is a still graphic.
2. Because we are exporting a specific frame, Use Marks is selected because we placed an IN point on the frame we wanted to export. Use Selected Tracks because we selected the appropriate video track.
3. In the Graphic Format box, we want TIFF (not the default PICT).
4. I've changed the value in the WIDTH × HEIGHT Fast menu to 1920 × 1080, because mine is a HD project.
5. Choose Size to Fit.
6. Because it's a graphic, we choose Scale from Legal to Full Range—which in older versions of Avid is the same as selecting RGB.
7. Click Save.

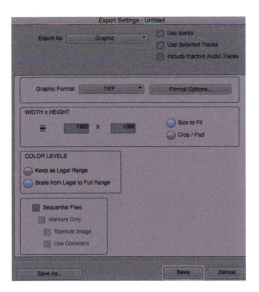

Figure 21.6

You'll be returned to the Export as dialog window (Figure 21.7). Now go to the top section, name the file and choose a destination.

Figure 21.7

OUTPUTTING MOTION VIDEO

When you need to export your project, QuickTime is usually your first choice. QuickTime is not a video codec (codec stands for Compression/Decompression). Instead it's a wrapper that contains the video and the sound as separate files wrapped together. We'll apply a codec to the video, another codec to the sound, and then place them both inside the QuickTime wrapper that will give us a single QuickTime.mov file. We'll be spending some time going over the various QuickTime settings in this section because one size doesn't fit all. You'll want versions that are highly compressed and quick to download and play, and you'll also want high-resolution versions with little or no compression for back-up and for submission to film festivals. And in between are the versions for streaming over the internet.

Test Time—Exporting a Small Portion of Your Sequence

Because exporting a QuickTime movie takes time, it's a good idea to export a short portion of your sequence (10 seconds or less) by marking an IN and an OUT. Then, you can choose your Export settings and test to make sure everything looks and sounds right. If you're happy, you can go ahead and export the whole sequence. That way you won't spend hours waiting for the export to finish, only to find out it has a problem. The only different settings you'll use to conduct your tests are shown here in Figure 21.8. By checking Use Marks and Use Selected Tracks, you will be exporting only the short section marked by your IN and OUT, and only the

selected tracks. You will want to deselect these checkmarks after conducting your test export. When those checkmarks are off, Avid ignores any IN and OUT marks and Exports the entire sequence.

Trust me on this testing business. I've wasted many hours of my life exporting with the wrong settings because I've ignored my own advice.

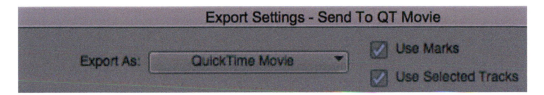

Figure 21.8

Exporting a High-Resolution Same as Source QuickTime Movie

The first time I export my finished project I export it as *Same as Source*. It's the highest quality export because it's at your project's native resolution—the same resolution we used to link or import the files. This prevents any compression from degrading the image. If I'm taking part or all of my sequence to After Effects or another program for tweaking, I'll use this setting. I also think of this as my back-up master. I keep it in a safe place in case anything bad happens to my computer and drives. Also, it's the fastest export of all the choices because there's no compression.

Here we are using Avid's video codec inside a QuickTime wrapper. The only problem with using Avid's codec is the computer that's playing it needs to have Avid installed or have downloaded the Avid codecs from Avid's website. At Boston University, our students export their final projects Same as Source for our end-of-semester screenings because the computer we project from has Avid installed. But if I'm sending the film to festivals or uploading to the internet, I don't use Same as Source because I can't be sure they have Avid's codec installed. For that I'll use the H.264 video codec instead of Avid's video codec, which we'll learn about in the next section.

To export a *Same as Source* QuickTime movie:

1. Select the sequence in the bin, then go to the File Menu > Output > Export to File. You can also click on the sequence in the bin and right-click and choose Output > Export to File (Figure 21.9).

Figure 21.9

2. From the Export Settings list, choose *Send to QT Movie*.
3. Click on *Options* (Figure 21.10).

Export setting Send To QT Movie

Options...

Figure 21.10

4. Select *Same as Source* (Figure 21.11).

Figure 21.11

5. Select the options within this window as necessary:

- *Use Marks/Use Selected Tracks.* If you want to export a portion of the sequence select either or both of these options. If you want the entire sequence, including all the tracks, deselect both Use Marks and Use Enabled Tracks.
- *Include Inactive Audio Tracks.* I don't ever select this because I don't want inactive tracks as part of my export.
- *Use Avid Codecs.* In general, leave this option de-selected when working in a collaborative environment where there are non-Avid systems that have access to the exported media.
- *Video and Audio/Video/Audio.* Select if you'd like your sequence to be exported with video, audio, or both.
- *Color Levels.* Choose Keep as Legal Range. This is the same as choosing Rec 709.
- *Display Aspect Ratio.* This option lets you set the image size for the video you are exporting. Normally I choose my aspect ratio (16:9) and square pixels.

6. Now click Save. When you are returned to the Export As . . . window, name the file and choose a destination for the file.
7. Click Save.

UNDERSTANDING QUICKTIME AND H.264

Think of H.264 as the world's first choice when it comes to video codecs. There's nothing more universally accepted than H.264. Since it's a video codec, it needs to be placed inside a wrapper (container), like QuickTime, which is one of the most accepted wrappers. We'll spend a lot of time here going over the many choices that you'll want to make inside the H.264 dialog box, but once you've made those choices, Avid will bundle that H.264 video codec with your sequence's sound tracks inside a QuickTime wrapper. When you press Save, you'll have a QuickTime movie sitting on your desktop or external drive, ready to be watched by just about anyone in the world.

I'll explain all the various settings as we go along.

1. Select the sequence in the bin, then go to the File Menu > Output > Export to File.
2. From the Export Settings list, choose *Send to QT Movie*.
3. Click on *Options*.
4. When the Export Settings dialog box opens, click on the Custom button, just below Same as Source. As soon as you do, you'll see a new button appear called Format Options (Figure 21.12).

Figure 21.12

5. Click on the Format Options button. You will see a new window like the one in Figure 21.13. There are several sections to this Movie Settings box, but we'll start with Video.

Figure 21.13

6. Click on the Video Settings button. (We will never use Filter or Size.) When you do, another window opens and it is here we'll look for and select H.264 in the Compression Type pull-down menu (Figure 21.14).

Figure 21.14

Now that we are inside H.264 settings (Figure 21.15), I'll go over each one, from top to bottom, explaining when and why you'll choose them.

Figure 21.15

- *Frame Rate.* Current is the default and you should leave it at that. "Current" is the same as native frame-per-second rate—the rate the project was set up at. For my project that is 23.976. It's always best to keep the native frame rate.
- *Key Frames.* This refers to how the file is compressed, not the frame rate. Keep at default. For my project default has the Every radio button checked and 24 selected for Frames. Check the Frame Reordering box as this allows better compression efficiency.
- *Data Rate.* This is the same as Bit rate. This setting controls the size of the exported file and the video quality. There are two radio buttons here.

 - *Automatic.* If you select Automatic you have control over the Compressor Quality slider. You can choose Best or Least, or anywhere in between.
 - *Restrict to.* If you select "Restrict to" the Compressor Quality slider is ignored (it drops to High, but it's meaningless). Instead of controlling the quality with the slider you enter a number, which specifies the Bit rate

you want. The higher the Bit rate the higher the quality. This is where you'll look at the Vimeo and YouTube tables I've created on page 434 to determine the suggested kbits/sec to type in to the box (Figure 21.16)

Figure 21.16

- *Optimized for*. This is only available once you are in Restrict To mode. Here you will most likely want select Optimized for Streaming
- *Compressor Quality*. As already mentioned, when the Automatic button is selected, you can choose a quality with the slider. If I want to email a file to a friend, I'll put it on Least and my email software won't reject it as too large. For a film festival, I'll chose Best.
- *Encoding*. I always choose Best Quality (Multi-Pass) as this provides two passes during the encoding, one for figuring out how to assign the bits and the second pass to do it. But Faster encode (Single pass) is twice as fast, and really isn't that much worse, so if you're pressed for time, try it.

EXPORTING AN H.264 BEST QUALITY

Now that we understand how Avid's H.264 settings box is organized and we've examined the choices, it's easy to create different versions. By putting the Data Rate button on Automatic allows me to use the Compressor Quality slider to create different quality files. Most often I want to slide it to Best. The resulting export will look great and be a fairly reasonable file size. It's not as high quality as the Same as Source, which we just learned to make, but, unlike Same as Source, it's bound to play everywhere you take it. The settings I've chosen in Figure 21.17 and 21.18 are the ones I'll choose if I'm asked to send a file to a festival, or a colleague who wants to show it to his class or group, or if I'm going someplace to screen my film and I'm not going to bring my laptop.

To export a *Best Quality* QuickTime movie:

1. Select the sequence in the bin, then go to the File Menu > Output > Export to File.
2. From the Export Settings list, choose *Send to QT Movie.*
3. Click on *Options.*

Figure 21.17

4. When the Export Settings dialog box opens, make sure your project's Width x Height is entered correctly in Video Format (Figure 21.18). Here mine are 1920x1080. If the Width x Height is correct, then the Native Dimensions in the Display Aspect Ratio area will be correct. There's a pull-down menu to change to other predetermined pixel dimensions if the wrong ones appear.

Figure 21.18

5. Click on the Custom button, just below Same as Source. As soon as you do, you'll see a new button appear called Format Options. Click on Format Options.
6. Click on the Video Settings button and in the Compressor Type pulldown menu, find H.264.
7. Now follow my settings in Figure 21.19 and drag the Compressor Quality slider to Best.

Figure 21.19

8. Click OK.

You'll be returned to the QuickTime Movie settings box, where you'll select the sound codec settings. If you're in a hurry, turn to page 435 to QuickTime Movie Sound Settings. Otherwise, keep reading as we examine how to configure H.264 for internet streaming.

EXPORTING H.264 FOR STREAMING ON VIMEO AND YOUTUBE

A lot of what you'll export will wind up on the internet, and no doubt you'll be placing many projects on Vimeo and YouTube, or whatever else comes along. Both services make it easy and almost foolproof to upload just about anything. Just drag the file in and press upload. What I'm about to explain here might be viewed as too much

information. But I figure you want your files to look great and play seamlessly, so knowing what they are looking for and how to give it to them isn't a bad thing.

Both Vimeo and YouTube will take a video in any resolution and aspect ratio, but these are their preferred resolutions and Width x Height pixel settings, which are the same settings we get when we start a New Project in Avid.

		Width x Height	Aspect Ratio
Standard Definition	480p	640x480	4:3
High Definition	720p	1280x720	16:9
High Definition	1080p	1920x1280	16:9
Above High Definition	2K	2560x1440	16:9
Above High Definition	4K	3840x2160	16:9

Aspect Ratios for Vimeo and YouTube

Standard Definition's aspect ratio is 4:3 and that's the aspect ratio for SD projects on both services. After that it's all 16:9. HD, 2K and 4K are all turned into 16:9 (1.78:1). There aren't any 1.85 flat or 2.39 scope choices. If you upload a project wider than 16:9, Vimeo and YouTube will place it inside a 16:9 frame with black bars on top and bottom.

Data Rates for Vimeo and YouTube

You shouldn't use the H.264 Best Compressor Quality file that we just made for streaming on the internet. For internet sites, it's better to have something a bit smaller and optimized for streaming. For both Vimeo and YouTube, we do this by going to the Data Rate section of our H.264 settings window and restricting the Bit rate to a specific number of kilobits per second and then selecting Optimized for Streaming. All the other H.264 settings we used before will remain the same.

Let's examine Vimeo and YouTube's desired settings while looking at our H.264 settings window in Figure 21.20. They both want you to:

- Use H.264 as the video codec.
- Select Current in the Frame Rate area just as we have in Figure 12.20.
- Choose Key Frames just as we have in Figure 12.20.
- Choose the Restrict to button and choose Optimized for Streaming.
- Choose Encoding: Best Quality (Multi Pass).

Figure 21.20

Vimeo describes its preferred Data Rate as a range of Kilobits per second—just like Avid does. But YouTube describes its preferred Data Rate as a fixed number of Megabits per second. In case you forgot what you learned in high school math, a Megabit is 1000 times larger than a Kilobit. So if Vimeo wants 8,000 kbits/second, that's the same as YouTube asking for 8 Mb/second.

Here's a table that shows Vimeo's preferred Data Rates:

	kbits/s
Standard Definition	2,000–5,000
720p HD	5,000–10,000
1080p HD	10,000–20,000
2K	20,000–30,000
4K	30,000–60,000

Here's a table that shows YouTube's preferred Data Rates (I've done the conversion to kbits):

	Mb/s	**kbits/s**
Standard Definition	2.5	2,500
720p HD	5	5,000
1080p HD	8	8,000
2K	16	16,000
4K	35–45	35,000–45,000

So, depending on your project, simply plug in the number from the chart. Where there is a range, as with all of Vimeo's rates, and YouTube's 4K rate, I suggest you pick a number in between the range and see how that works.

Figure 21.21 shows my Data Rate settings for my HD 1080p project for both Vimeo and YouTube.

Figure 21.21

So, again, use the settings from Figure 21.20 and then, in the Data Rate area enter the suggested number in the kbits/sec box. Then click OK. You'll be returned to the QuickTime Movie Settings window, where you'll set the sound codec, as we'll learn next.

Now in all cases these are suggested rates, and you might find the file is too large or the quality isn't satisfactory, so by all means experiment by changing rates.

QUICKTIME MOVIE SOUND SETTINGS

When we started this section on exporting QuickTime, we jumped right to Avid's QuickTime video settings. Now let's address the sound codec.

As you can see in Figure 21.22, I have set the Video Settings to H.264 for Best Quality, not for streaming, and the catalogue of settings show this. Now I want to select the appropriate sound quality codec, and for that I click on the Sound

Figure 21.22

Settings button. The Sound Settings window that opens has a number of pull-down menus; we'll start with Format.

Figure 21.23

Figure 21.23 shows the only two choices you'll probably ever need:

- PCM is for best quality QuickTime movies for festivals, back-up, and screenings of your film.
- AAC is the correct choice for streaming over the Internet, with Vimeo, YouTube or any other website.

PCM Sound Codec Settings

Whenever I create a QuickTime movie with my compressor setting at Best Compressor Quality, I want to have the best audio quality to go with it and that's PCM. It's not compressed the way AAC is. Figure 21.24 shows the way you should set yours up. Once you've made sure your settings match these, click OK.

Sound Settings

Format: Linear PCM ————— Click here to access the Linear PCM format

Channels: Stereo (L R)

Rate: 48.000 kHz

☑ Show Advanced Settings

Render Settings:

Quality: Normal

Linear PCM Settings:

Sample size: 16 bits

☑ Little Endian
☐ Floating Point
☐ Unsigned

Cancel OK

Figure 21.24

AAC Sound Codec Settings

For Vimeo and YouTube, they both prefer that there be some compression of the audio file and AAC codec does that. Here are my settings when I choose AAC (Figure 21.25). Click on the blue arrow menus to select the correct settings.

Figure 21.25

As an aside, Vimeo wants a Constant Bit Rate whereas YouTube doesn't declare a preference, so I use Vimeo's encoding strategy for both. Both want 320 Target Bit Rate.

FINAL QUICKTIME H.264 MOVIE SETTINGS

Here in Figure 21.26 are my final QuickTime settings, showing the H.264 video codec and sound codecs. On the left are the settings for Best Quality and on the right for streaming on YouTube.

Once you click OK, you'll be returned to the Avid's Export Settings dialog box.

Best Quality

YouTube

Figure 21.26

In Export Settings, make sure your project's Width x Height is entered correctly in Video Format. For an HD project, 1920x1080 is correct. If the Width x Height is correct, then the Native Dimensions in the Display Aspect Ratio area will also be correct (Figure 21.27).

Figure 21.27

When you click Save, you'll find yourself at the Export As . . . window, where you'll name the file and select a location for the exported film (Figure 21.28).

Export As...

Save As: YouTube Version.mov ^

Tags:

Media Drive 1

Figure 21.28

Now click Save, at the bottom of the Export As window and your export will begin.

Other Width x Height Numbers

I don't often do it, but you can change the project's Width x Height by entering new numbers or using the menu to select different predetermined ones. Why would you do this? Let's say you were creating a small-sized clip to be used in a smart phone application. But most of the time, make sure the Width x Height matches your project's dimensions, and then the Native Dimensions will be correct.

4K AND UHD QUICKTIME MOVIE SETTINGS

Exporting a QuickTime version of your UHD or 4K projects involves the exact same process as we learned above. Once you enter the H.264 settings window, set the Data Rate to Automatic to create varying compressor quality files, or select Restrict to and then enter the suggested kbits/s from my chart on page 434. Figure 21.29 shows my UHD settings for Best Quality and uploading to Vimeo and YouTube. I chose 35,000 kbits/s because both just started 4K offerings and so I'm being conservative in my Data Rate.

After you click OK, you're returned to the Export Settings page. Just make sure your project's Width x Height is correct. If it is, your Native Dimensions will be

Figure 21.29 Best Quality (left); Vimeo and YouTube (right)

correct as well. Notice in Figure 21.30 my Width x Height is 3840 x 2160 and so my Native Dimensions match that.

Figure 21.30

A QUICK REVIEW OF QUICKTIME EXPORTS

We've gone over each of these exports in some detail in the preceding pages, so let's look at a quick summary of what we've learned.

- QuickTime is the wrapper that contains our choice of video codec and sound codec.
- When we choose Same as Source, we are creating an uncompressed QuickTime file using Avid's video codec.
- When we choose Custom, we usually want to select H.264 as our video codec since it is the most universally accepted video codec.
- Inside H.264 settings, the variable we most often change is the Data Rate. If we want a high-quality file, we choose Automatic and then Best. If we want a file for internet streaming, we select Restrict to and type in the appropriate number.
- There are two sound codecs we'll choose in the Format section of the Sound Settings window. We'll choose Linear PMC to go with our H.264 Best Quality exports and AAC for combining with our H.264 Vimeo, YouTube, and all internet exports.

Now that you have a QuickTime movie file on your desktop. If it's set up for Vimeo or YouTube, you can click the upload button in your Vimeo or YouTube account, fill in the information, and you're done (Figure 21.31).

Figure 21.31

USING APPLE COMPRESSOR OR ADOBE ENCODER

I must confess that I often take my exported Avid Same as Source file to Apple's Compressor software to have it make me all the other versions I want. Avid's export choices are great, but Avid doesn't offer all the options and settings a dedicated

piece of software can provide. I recently needed a MPEG-4 version of a project, and I used Adobe Encoder to create it. Avid's MPEG-4 is the MPEG-4 video codec inside QuickTime, so it's not a true MPEG-4. With Apple Compressor, creating a file for sending to the internet is so easy. Just drag your Same as Source file in and then drag the appropriate Video Sharing Services icon (Figure 21.32) on top and that's practically all you need to do.

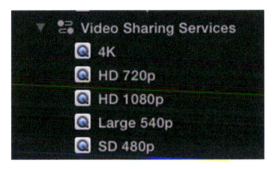

Figure 21.32

MORE QUICKTIME OUTPUT OPTIONS

Depending on your computer and the codecs that come with it, there are other options. Figure 21.33 shows the choices on my Apple computer, on which I have installed Apple's ProRes codecs. These ProRes choices wouldn't be found on a Windows computer. Some outside vendors who make BluRay discs for you may ask for one of these choices. The Apple ProRes 422 HQ is a popular choice. The Avid DNxHD and DNxHR codec are similar in quality to the ProRes, and something an outside vendor may want you to create for them.

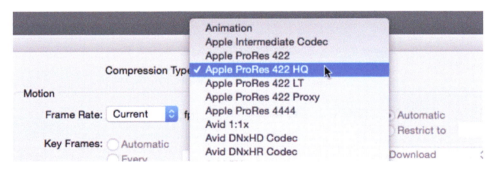

Figure 21.33

The ProRes QuickTime codec window is a bit different than the H.264. You should try to stick with the default selections, as shown in Figure 21.34, unless told by your vendor to do something else.

Figure 21.34

When you're returned to the Movie Settings window, make sure to select the Sound settings button and choose the Linear PCM sound codec settings, as you learned to do earlier in this chapter.

MORE EXPORT OPTIONS

If you go to the File menu and choose Output, there's a menu item called AMA File Export which we've ignored until now (Figure 21.35). This option allows you to send to a folder, which you create ahead of time, several different file types that are used by Broadcast television networks, or to create motion picture film outs.

Figure 21.35

Depending on your software and computer system, here are the choices (Figure 21.36).

Figure 21.36

- AS-11 was originally used in the United Kingdom for delivery to broadcasters. New versions are now used in the US and Canada as well.
- DPX is for making a film print and it creates a series of DPX/Cineon images that can be recorded onto film.
- MXP OP1a stands for Material Exchange Format Operational Pattern 1a. This is a self-contained file. It's sort of like a videotape, where each file represents the entire program. Many US broadcasters use it.
- XAVC is Sony's video codec, which is placed in a MXF wrapper. Avid and Sony have a close collaboration and Avid sequences can be exported directly to Sony drives, decks and cameras using this File Type.

These are a bit beyond the scope of the book, but with guidance from your broadcast company or outside vendor, you'll be able to send these files to a folder you created on an external drive, and take that to your vendor or broadcaster.

WORKING WITH OUTSIDE VENDORS

In most cities there are companies that will create DVDs, BluRay discs and even Digital Cinema Packages for you. Most often they'll want you to export your sequence as Same as Source, H.264 Best Quality, or ProRes 422 HQ—all of which we've covered here in great detail. You'll want to speak with them well ahead of time and get a quote, as well as their advice for exporting your project. Don't be shy or pretend you know what they're talking about if you don't. Ask questions; seek help; request a written, step-by-step guide. They do this every day whereas this may be your first time ever. They'll want it to go well, so they'll be happy to help, but you have to ask and be willing to say, "Huh? I don't understand." I'm good at that.

SUGGESTED ASSIGNMENTS

1. Duplicate your sequence and add a second of black fill to the start of your sequence (see Chapter 15 if you need guidance).
2. Check and fix all sound tracks.
3. Export a production still from a frame of video.
4. Combine several video tracks into a single track by performing a mixdown of your video tracks.
5. Export three movie files from this sequence: a Same as Source, a Best Quality QuickTime movie, and a QuickTime movie for YouTube or Vimeo.
6. Play each of these QuickTime movies, and compare them, in terms of their size and image quality.

22

Present and Future

WHERE DO YOU GO FROM HERE?

You should now feel confident that you can go forth and edit your own projects and those of your friends and future clients. Although you've learned a lot, I hope this is a beginning, not an end. I hope you use this as a gateway to knowledge and that you continue to learn and grow, not just your Avid skills, but your editing skills as well.

There are a few books on the art of editing that are worth reading: *The Technique of Film Editing* by Karel Reisz and Gavan Miller; *On Film Editing* by Edward Dmytryk; and *In the Blink of an Eye* by Walter Murch. The first two were published decades ago but are valuable for their insights and the historical perspectives they provide. Another helpful book is called *Archival Storytelling*, by Sheila Curran Bernard and Ken Rabin, which explains how to find and edit material produced by someone else.

Avid provides pdf manuals within the Help menu of Media Composer. They provide excellent guidance for just about every command, menu, and workflow. One problem with most manuals is that everything is treated as if it is of equal importance, when some things matter a lot more than others. That's why I wrote this book in the first place, but by now I think you're able to discern what you really need to know.

INFORMATION ON THE INTERNET

Avid has a well-maintained website (www.avid.com), where you'll find information about new products and upgrades as well as a robust Learn & Support section where Avid as well as Avid users around the world come together to support the entire Avid community (Figure 22.1).

Figure 22.1 Avid's User Support website.

In addition, there are some wonderful how-to websites like Lynda.com, where gifted editors and teachers like Ashley Kennedy offer short demonstration videos. Ashley combines general editing tips, interviews with editors, and clips from instructive feature films and shorts to explore the entire art of motion picture editing. Creative Cow is another website containing helpful Avid tutorials (www.creativecow.net).

OTHER AVID PRODUCTS

Most of your favorite shows, from *Game of Thrones*, *The Voice*, to *Sherlock*, or the most complicated features films, such as *Mad Max: Fury Road*, *Star Wars*, or *The Martian* are all cut on Media Composer. However, unlike the standalone editing we've covered in the book, these projects all work with Avid's storage and networking systems like Nexis (Figure 22.2). Nexis allows multiple editors to edit on different Media Composer systems while sharing the same media and often working from the same Timeline.

Figure 22.2

But Media Composer and Nexis are just two of many products that Avid makes and sells. Pro Tools is perhaps the best known Digital Audio Workstation (DAW) in the world and it comes with a full range of hardware products that make it easy to store and mix the most complex audio projects. Avid also has a lineup of devices for mixing live performances and concerts. Avid is also a big player in broadcast journalism and sports broadcasting, with iNews and a host of broadcast graphic tools, branding devices, and football- and soccer-related products that help sports broadcasters isolate and enhance the action. Visit the Products and Solutions page on Avid's website to get an idea of the scope of Avid's other products.

AVID VERSUS OTHER EDITING SOFTWARE

I encourage my students to learn other editing software and many of them already know Adobe Premiere, which has replaced Apple's Final Cut as Avid's main competition. In 2011, Final Cut Pro became Final Cut Pro X, and professional editors abandoned it because it's built for novices and no longer a serious editing program. Black Magic's DaVinci Resolve is now capable of more than color correction and some people are using it as an editing platform. Sony Vegas has devoted followers, as does Edius, a Windows-only editing software.

Yet Avid is still the editing software most often used by networks, studios, and the world's most ambitious projects. This is in large part because many of the world's best editors love Avid and have made their careers by cutting projects on it. But all of these editing platforms are just tools to tell stories, and depending on where you land in the editing world, you may need to know one software over another at any given time. But honestly—what's important isn't the software we use, it's the projects we produce. Let's keep pushing ourselves to make projects that matter. We live in a world that needs more compassion, greater understanding, and better communication from all of us.

FINDING A CAREER AS AN EDITOR

You may simply edit your projects yourself, or you may enjoy editing so much that you decide to make it your career. Which brings us to the business of finding a job as an editor. I have many, many former students working as editors. Some of them edit network shows, while others edit feature films, commercials, music videos, documentaries, and corporate projects. So let's examine how they got there.

It's all about networking. Join groups, attend workshops, stay in touch with classmates and professors, use LinkedIn, make lists of people to reach out to and then do it. Ask for an informational interview. That's like the Trojan Horse of job

seeking. You're not asking for a job; you just want to find out how they got started and what advice they might have for someone in your position. People love to talk about themselves and pretty soon they're thinking, "Wow, I like this person. She/he asks good questions—very perceptive. Maybe I could use another person to help us move forward."

I happily give credit to Eve Light Honthaner, author of *The Complete Film Production Handbook,* and a long-time Hollywood production manager, who came to one of my classes and talked about what it takes to make it. She was talking about film production, but her advice is applicable to all facets of post-production. In fact, any job seeker should heed her five Ps, as she calls them. In order to be successful in a highly competitive field you need to be:

- Passionate
- Persistent
- Pleasant
- Positive
- Patient.

If you have these qualities, you'll find work and everyone will want you on their team. If you don't have them, as I tell my students, you need to develop and nurture them inside you. People respond to someone who is passionate about editing, or any particular job, even if it starts with getting coffee. If you are persistent, you'll keep trying even when things are tough and not going your way. Pleasant—thank people, smile, laugh, make it fun, ask questions, be helpful, and don't make everything about you. Be positive. Everyone likes people who bring positive energy. Positive people make long days fly by. And the last P, be patient, is perhaps the hardest. Try to understand that a career is a long time. You won't be in the job you want right away. Things take time. If you're patient, and take the long view, you'll see others dropping out, and suddenly the way forward is opened for you.

Lots of my students started out as interns, both paid and unpaid, for post houses, television stations, and production companies. Most cities have Avid user groups that meet regularly and attending those meetings is a great place to start. It may be wrong to generalize about people, but it's often true that editors are the most down-to-earth and helpful people in the film and television industry and many enjoy sharing their knowledge. Once you get a foot in the door, seek out a mentor and ask her or him what she or he knows in exchange for loyal and dependable assistance. Ask if you can stay after hours and try your hand cutting the day's work. Employee turnover at some houses can be amazingly fast and you may find yourself moving up the ladder quickly.

My last piece of advice is this: always say, "Yes." By that I mean that if you say no, you're stuck where you are. Nothing has changed. But if you say yes, you're doing something different, meeting new people and trying new things. You have gained a new perspective because you changed positions from where you were before.

So good luck, remember the five Ps, and I challenge you to use your talents and skills to make this a better world.

Appendix: Different Ways to License Avid Media Composer

Starting with Media Composer version 8, Avid expanded the ways you can get Media Composer from the Avid Store website (http://shop.avid.com). First of all you can buy Media Composer software, like you buy any other software. If you don't want to buy it, you can get a monthly subscription, which is like renting the software. If you manage a large post-production company or institution, there's a third option; you can also get a pack of 20 or 50 licenses, so that multiple editors can cut on Media Composer simultaneously. Since I don't believe that many of my readers are in a position to hire 20+ editors quite yet, I'll leave out the details on this option.

So let's compare and contrast the two choices you might want to consider—to rent or purchase. In the chart and information in Figure A.1, I'm using the prices Avid has posted on their website (as of today) and I'm using the whole dollar amount. So I call it $10, when it's actually $9.99. (Don't you hate it when they list something as $9.99—as if we're idiots.)

RENT MEDIA COMPOSER SOFTWARE

Most of my students decide to rent. They choose to get a subscription for a year and pay the incredibly low student rate of around $10 per month. So for around $120 they get a year's worth of Avid Media Composer. Once they graduate, they tend to choose the Individual Month-to-Month rate, which is around $75 per month. Usually they have a freelance project they want to cut, but will be doing other things, like working as an assistant editor for a company that already has Avid licenses. If they're really doing a lot of freelance editing, or editing their own projects, they'll get the Individual Annual, which costs $50 per month for a year.

	Term of Subscription	Monthly Fee
Individual	Month-to-month	$75
Individual	Annual	$50
Students and Teachers	Annual	$10
Educational Institutions	Annual	$40

Figure A.1 Rent Media Composer Software—Get a Subscription.

BUY MEDIA COMPOSER SOFTWARE

Some people don't like the subscription model. They want to own the software outright, and so Avid has kept that option available. If you're a student or teacher, you might say, this is a no-brainer—let me buy it outright. As you can see from Figure A.2, a student or teacher could own Avid forever—have a perpetual license—for only $295. The only reason you might hesitate has to do with upgrading your software and getting support. With the subscription model, you get automatic upgrades, jazzy extras, and Avid's tech support—for as long as you are a subscriber. However, when you buy a license, you get upgrades, jazzy extras, and Avid's tech support, but for only one year. Yes, you still own the software forever, but you don't get new versions or support—unless you also purchase a yearly support contract.

	Public	**Students and Teachers**
Media Composer Software License	$1300	$295
Yearly Support and Upgrade Contract	$300	$100

Figure A.2 Buy Media Composer Software.

AVID SUPPORT AND UPGRADE CONTRACT

If, after the first year, you buy a yearly contract with your perpetual license, you get free upgrades and all that great technical support.

Think about it; if you're a company that does a fair amount of paid work, or a busy freelancer who is recently out of school, it might make sense to get a perpetual license. Then, for only $300 a year, you're getting free upgrades and technical support.

THE APPLICATION MANAGER

Another new feature of Media Composer is the Application Manager. This piece of software keeps you updated on available upgrades, webinars, and trial offers. It tells you which Avid software version is installed and which third-party applications are part of your package. Here you can get upgrades, buy add-ons, and activate or deactivate your software options.

When I started subscribing to Media Composer, the Application Manager appeared on my computer's menu bar at the top of my Mac screen. Click on the application icon and when the application opens you'll see it has a clean, intuitive interface, as shown in Figure A.3.

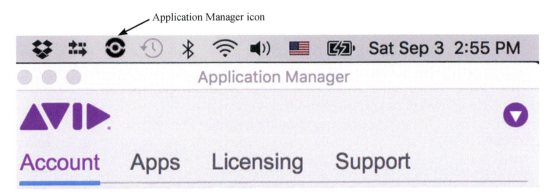

Application Manager icon

Figure A.3

The Application Manager is an easy, painless way of staying connected to Avid so you remain current with changes in the software. You will be automatically notified of offers, training session upgrades, and support options.

Index

Note: Italicized numbers indicate a figure